W9-BYU-444

Illuminated Manuscripts

Illuminated Manuscripts

THE BOOK BEFORE GUTENBERG

GIULIA BOLOGNA

Weidenfeld & Nicolson
New York

Frontispiece: Page with designs for fortifications, from
Trattato di Architettura Civile e Militare, by Francesco
di Giorgio Martini, a manuscript book of the fifteenth
century (Biblioteca Laurenziana, Florence)

Published by Weidenfeld & Nicolson, New York
A Division of Wheatland Corporation
841 Broadway
New York, New York 10003-4793

Published in Canada by General Publishing Company, Ltd.

Library of Congress Cataloging-in-Publication Data

Bologna, Giulia.
[Manoscritti e miniature. English]
Illuminated manuscripts / by Giulia Bologna - lst ed.
p. cm.
Translation of: Manoscritti e miniature.
Bibliography: p.
Includes index.
ISBN 1-555-84275-5
1. Books – History – 400-1400. 2. Writing – History. 3. Manuscripts – History.
4. Scriptoria – History. 5. Illumination of books and manuscripts. I. Title.
Z6.B6513 1988
002 – dc19

 8810101
 CIP

Created and produced by Fenice 2000.

Editorial director Lorenzo Camusso
Editor-in-chief Riccardo Mezzanotte
Art director Adriano Zannino
Managing editor Orietta Colombai
Production Renzo Biffi
Translation Jay Hyams
Separations Sebi s.r.l., Milan
Typesetting Fotocompograf s.r.l., Milan
Printing and binding Sagdos s.p.a., Brugherio (Milan)

First American Edition
10 9 8 7 6 5 4 3 2 1

Contents

'I shall make you love books more than your mother'

from *The Instruction of Dua–Khety*
Egyptian text of the time of the Middle Kingdom

The umbrella leaves of the papyrus plant once grew thick to a height of six meters in the swampy delta soil. A sacred plant with infinite uses, today the papyrus has nearly disappeared from Egypt; perhaps in some angle of the Sudan, along tropical rivers, its forests still flourish. According to Egyptologists, the name we use for the plant probably comes from a Greek word meaning 'regal', for the manufacture of writing material from the plant's trunk was a state monopoly.

To say that the history of the book begins with papyrus is not completely accurate, but from the time Egyptian scribes began to write on papyrus, using a bamboo reed and ink made from soot, the book has moved through our culture by steady and coherent steps. This book about books is thus the offspring of ancient forefathers.

As is well known, until a little more than five centuries ago, there were no books in the West that were not written by hand. How many? How? The numbers of ancient books cannot be compared to the numbers of contemporary books. It is known that during certain periods of Roman history the number of books produced—using manual methods, but in a certain sense, typical of ancient economies, industrially—was great, as it must also have been in the Egyptian, Hellenistic and Arab worlds. In Rome, expensive *literati* slaves copied Latin texts that were to become classics and copied translations of Greek texts that already were classics; literary society and the public met for 'promotional' meetings in the *tabernae librariae*, the bookshops. Then, for all the Middle Ages, the book was rare, and the demand for books was scarce. The Middle Ages lasted a thousand years; during those swirling centuries the production of books breathed in unison with the movements at the depths of history. It is significant that the Vatican Library had only 340 books when, during the fifteenth century, Tommaso Parentucelli of Sarzana became Pope Nicholas V. Since, according to Vespasiano da Bisticci, Nicholas wished to spend on two things only, 'which were books and buildings', at his death the Vatican had 1,160 books and was the largest library in Italy. Enormous effort; tiny numbers. Besides, in fifteenth–century society the production of manuscripts had arrived at a singular level of organization in the hands of *stationarii*, who were at the same time booksellers and organizers of scriptoria, laboratories in which artisans produced books.

Gradually, synchronically with the development of European society, book production moved from the sphere of the church to that of the laity. Another well-known notion is that culture during the Middle Ages was concentrated in a few isolated posts, for the most part religious, peopled by a few learned people ('A few hundred, perhaps a thousand, in every generation', noted Georges Duby). The preservation of the book and the culture it contained was their work. In the tenth century, Abbo Floriancensis, theologian, chronicler and counselor of Hugh Capet, urged that scholars should first learn to 'move with ease through the profound ocean, tumultous and risky, of Priscian's [Latin] grammar'; then, so that they could learn 'the meaning of

Genesis and of the Prophets', they should read 'models of good language', such as Virgil, Statius, Juvenal, Horace, Lucan, or Terence. Here, expressed in a text from the High Middle Ages, is the 'functional' motivation for the work done by monastic copyists on 'pagan' authors (during the same period as Abbo, the abbess Hrotswitha of Gandersheim, worried about the overly liberal Terence, attempted an expurgated version for her nuns).

Then came the time of the 'manuscript hunters'. The texts of Greek and Roman culture that had circulated during antiquity in *volumina*, papyrus scrolls, and that had been copied with the pious intentions explained above on parchment codices were sought out in monastic libraries, restudied and with a renewed spirit once again copied, this time on paper codices. This was the work of the humanists. One of the most active and fortunate among them was Poggio Bracciolini of Valdarno, apostolic writer of Boniface IX. In two years of frantic activity, during the second decade of the fifteenth century, he discovered ten orations of Cicero, the *De rerum natura* of Lucretius, works by Quintilian, Valerius Flaccus, Statius, Silius Italicus, Apicius and Ammianus Marcellinus in the abbey of Cluny, in the convent of San Gallo and other convents nearby, in the abbey of Fulda, at Langres, and in the library of the cathedral of Cologne.

The history of the manuscript book, adventurous and admirable, intimately tied to the history of society and culture, is the major thread of this book: glancing at the chapter 'From scroll to illuminated codex' and the appendix 'Libraries and their manuscripts', one sees a relatively unknown universe, the surviving heritage of one of mankind's greatest cultural creations.

The manuscript itself is inseparable from the illustration, the illumination. This fascinating aspect is the other theme of this book; dedicated to it are the surprising and vast selection of "A thousand years of masterpieces" and the appendix 'List of illuminators'. From ancient Egypt, source of the oldest examples of book illustration, to the high Renaissance, this art of marvelous works, fragile and hidden (rightly so, in libraries), rivals the quality of the major arts and in certain moments surpasses them because of the shortage or rarity of examples. It has been observed both how natural it is that book illustration, almost a form of unwritten communication, appears as early as the great culture of the Nile, where writing itself was mixed with ideograms, or images, and that the rare examples of illustrated Greek scrolls are joined stylistically to the images of the Egyptian papyri. Such parallels and concatenations are not surprising: their discovery is one of the intense emotions of the study of illustrated books and illuminations. Moreover, Franz Wickhoff penetrated the 'illusionistic' values of Roman art, there where one saw only decadence and barbarousness, starting with an illuminated manuscript from late antiquity, the *Vienna Genesis*, and Jurgis Baltrusaitis went on, following illumination to *Le Moyen Age Fantastique*, in which 'the metamorphoses of forms and spirit unleash fantasy and the imagination'. Thus, every illuminated codex introduces a polyform intellectual adventure of varied appeals, illuminated excursions into the heredity of the

past, including history, taste, chronicle, customs, science and beauty. One single example: the *Dioscorides Constantinopolitanus*, which a Hapsburg ambassador bought from the Hebrew doctor of the sultan of the Turkish capital. It was illuminated around 512 for Anicia Juliana, daughter of Galla Placidia, and is a copy of a medical text from the first century, a work by the Greek botanist Dioscorides of Anazarbus. Some of the illustrations are believed to be derived from botanical sketches made by Cratevas, doctor of Mithradates VI Eupator; others constitute a stylistic link between Graeco–Roman art and Byzantine illumination—one of these represents the mandrake and its famous legend, and another shows Dioscorides intent at writing a description of the plant in the attitude in which medieval illuminators were to picture the Evangelists. The representations of the botanical-medical species, finally, transmigrate into the Gothic International miniatures of the *tacuina sanitatis* of the late fourteenth century.

In the end, the printing press arrived, 'an invention more divine than human', as Louis XII of France stated in an ordinance of 1513. A few years earlier (1492) the erudite Giovanni Tritemio, faced with the growing number of printed books, had warned, 'Even if we possess thousands of volumes, we must not stop writing [that is, producing manuscript books] because printed books will never be as good'. One can smile at his dismay at the new. The history of the manuscript was, is, a finished history, but as Walter Pater said, 'Nothing that has ever had value for the living can ever completely lose its vitality'.

The Publisher

From scroll to illuminated codex

Scholarly books or popular books, collectors' books, antiquarian or modern, papyrus scrolls or precious parchment codices, all remind us of the fascinating physical reality of the book, of its functions and diffusion through the centuries, and of the many and varied methods and techniques of its making, adopted at different times in different places and under varied economic and social conditions. The history of the book over more than five thousand years is an inseparable part of the history of civilization. The human aspiration to create with words something enduring, something that will survive its creator, has made the book an indispensable agent for the transmission from generation to generation of the human spirit's creativity. A book, however, is more than a grouping of words and images, ideas and information. It is an object endowed with certain technical and formal properties, and with the passing of time, these properties have been subject to change. Much of what we know of the book in its earliest times comes to us only through the evidence of archaeological excavations.

FORERUNNERS OF THE BOOK
Ancient materials

Before assuming its present form, the book went through various phases according to the materials used in its composition. One of the earliest writing-materials was tree-bark. Indeed, the word 'book' is derived from the Latin word *liber*, which means the secondary bark of a tree. In Kashmir and Central Asia, books were written on birch-bark; in China, on vegetable fibres such as bamboo bark, as well as on wood and silk.

Very few written records have survived from the third and second millennia BC. We know, however, that, particularly in China, there was a rich literary production at an early date, accompanied by a well developed art of bookmaking that had its beginnings three thousand years before Christ. In the second millennium BC scribes who were members of priestly orders prepared and sold books for their cult and not for personal gain.

The first material used in China for writing was wood. The writer began in the lower right corner of the tablet and continued the text upward. In 213 BC the Chinese emperor Shih Hwang-ti, attempting to eliminate works critical of his political activity, ordered the destruction of the written wooden tablets. This was followed by a period of intense literary activity – an attempt to make up for the disaster – during which silk came into use for writing. This was performed with a reed pen or camel-hair brush, and ink make of lampblack and gum solution, later known as China or Indian ink. Silk had many good qualities, like the papyrus in use during the same period in Egypt, among them suppleness and a bright surface, but it was expensive.

In Mesopotamia, between the Tigris and Euphrates rivers, clay tablets provided a writing-surface. In the early third millennium BC, the Sumerians developed cuneiform script, a system of writing which continued in use in Western Asia until the last few centuries BC. The script was made up of the impressions on soft clay of a wedge-shaped instrument (hence the name cuneiform, Latin: *cuneus*, wedge, and *forma*, shape). The city of Nippur (modern Nafter, south-east of Baghdad in Iraq) had an archive of more than 500,000 clay tablets dating from the late third to the late first millennium BC, and including literary as well as administrative texts. Fragments of clay tablets impressed with writing have been found (see fig., left). The clay was particularly fine; the characters were pressed into it with a stylus of metal, ivory or wood, and the tablets were dried in the sun or baked in an oven. More than ten thousand large tablets with cuneiform writing were found during excavations at Boghazoköy, the site of the Hittite capital Hattusas, to the east of Ankara in Turkey. This reached the height of its prosperity between 1900 and 1200 BC. A large archive and library were found also at Ras Shamra, ancient Ugarit, in northern Syria, an important and sophisticated centre during the period of the Hittite Empire.

PAPYRUS, SCROLL AND SCRIBE
The book in ancient Egypt

Among the many achievements of ancient Egypt was a flourishing literature. The writing material for the Egyptian book was principally provided by the papyrus, an aquatic plant which then flourished along the banks of the Nile. *Cyperus papyrus* plays a vital role in the history of the book, and hence in the history of civilization in general. Its name comes from the Greek *papyros*, of unknown etymology; Pliny the Elder believed the plant originally came from the island of Cyprus, sacred to Venus. Throughout antiquity, the plant grew abundantly in the Nile delta, although today it is very rare. Making the writing-material from the plant involved several stages. Information concerning this processing is derived from other sources than the Egyptians themselves, for although the Egyptians told us so much about their daily lives, in tomb-paintings

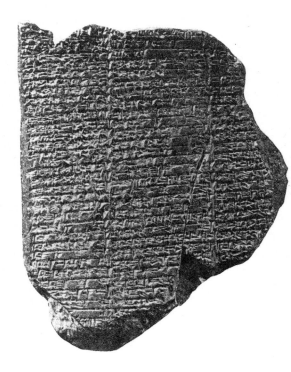

In Mesopotamia, dates and other information were recorded on clay tablets with a system of writing known as cuneiform (wedge-shaped) because of the impression left by the writing-instrument. Terracotta's virtual indestructibility gave this predecessor of the book an advantage that was lost with the vegetable (papyrus), animal (parchment), and paper writing-surfaces that followed. This fragment of a cuneiform tablet is inscribed with a hymn to a Babylonian god

and on papyri, they never depicted or mentioned the processes used in the manufacture of papyrus. This suggests that the manufacture was a royal monopoly, and that details were deliberately kept secret. Our knowledge of the process is gained from a few depictions found in Thebes and from information supplied by Pliny the Elder (23-79 BC) in his *Natural History*, amplified by the researches of modern Egyptologists. However, the lengthy descriptions Pliny gives of the manufacture of papyrus did not prove to be entirely practical when an attempt was made by researchers to follow them.

The umbrella-leaves and roots from the plant were discarded; only the stem, triangular in section and as long as five or six metres, was used. It was first soaked in water. Then the green outer stem was stripped off and the reed was split lengthwise into narrow strips, using a tool called an *acu*. The strips, called *philirae*, 'cards', were laid side by side and sprinkled with water, then a second layer was laid over the first at right-angles (*texendi labor*), and pressure was applied to bond the two layers. The sheet was left in the sun for a few days to dry. The sheet so obtained (*plagula*) was again dampened, beaten flat and smoothed with an ivory tool. The *plagula* was then cut and trimmed to give sheets of equal size; their width was usually 12-32 cm and height 22-33 cm, according to the intended use. There was no fixed ratio of width to height. The thin strips and the layers were bonded together either with adhesive or simply by the application of pressure (*kollesis*). The plant itself secretes a sticky substance (*turbidum liquoris glutinum*) that dries as a glue so strong that even today the fabric holds firm in surviving examples. At this point the sheets were rolled up to become a *scapus* or *volumen*, and put on sale.

The best-quality papyri were light in colour – yellowish or almost white – while the inferior quality were usually brownish. The Egyptians produced several grades. The 'priestly' variety was the oldest and finest. 'Hieratica' was a term applied to this quality of papyri used in Rome at the time of Pliny. The name *leucosica* described the ordinary variety; the 'sacred' was the whitest and thinnest, destined for use in religious books. This last kind could be the choicest, or 'royal', or of second choice, called by the Romans 'Livian' after Livia, wife of the Emperor Augustus.

The preparation of papyrus developed into a considerable industry, and papyri were sold in bales from which the desired quantity could be cut. The Egyptians maintained a monopoly of papyrus-production for more than three thousand years, during which time they exported their wares to all parts of the ancient world. During the third millennium BC a level of quality was attained that was never to be improved upon.

The Egyptian 'book' took the form of a scroll, usually composed of twenty sheets, each of the same dimensions, rolled round a wooden, bone, or ivory bar or cylinder, which the Romans called an *umbilicus*. The terms *plicare* and *explicare*, used to indicate, respectively, the act of rolling and unrolling, are the origins of the word *explicit* used to denote the end of a manuscript text, even in a book of an entirely different form. The writing used on papyri ran parallel to the horizontal fibres, and was usually only on one side, in narrow columns that were progressively numbered. (Papyri for private use were sometimes written on both sides.) The columns were termed *paginae*, and also *schedae*; the first page was called the *protokollon*; the last, *exactokollon*. Each column was composed of a variable number of lines (*versus, gramme*); at the end of the roll the total number of lines it contained was stated (*sticometria*) and the fee paid to the scribe was determined by this number. The length of scrolls varied according to need; one known example is 20 metres long and composed of 110 pages.

A cursive form of hieroglyphic was developed for use on papyri, as distinct from inscriptions. It was succeeded by an even more cursive (joined) form of script called demotic (popular).

Egyptian scribes used a reed pen cut crosswise, which, depending on how it was turned, could draw either thick or thin lines. In the third century BC, scribes began to use a reed cut to a point, known as a calamus, that permitted finer writing, and this instrument was universally adopted. The ink was made of lampblack, or charcoal grated into a cooking-pot and mixed in a light glue solution. This ink was indelible, so permanent that even today examples of these writings are a deep black. Red ink, used for titles and the openings of chapters, was made of red ochre finely ground and mixed in a glue solution.

The scribe kept his writing-tools in a long wooden or ivory case with containers, some of which had lids, for the calamus, the tablets of dry ink and the small container for water needed to dissolve the ink. Egyptian scribes are usually represented squatting or standing, holding the page of papyrus in their left hand, supported on the palm and forearm, while writing with their right hand, and holding under their arm the pen case

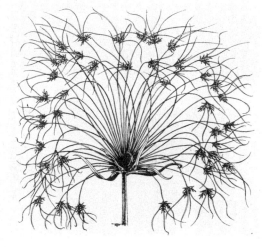

A marsh plant, papyrus once grew abundantly in the Nile delta. Papyrus was made into a writing surface using the plant's stalk and following a relatively complex process that is known to us from a detailed description written by Pliny the Elder

and a piece of cloth with which to wipe off the ink in case of errors.

Papyrus scrolls were stored in special wooden or clay containers. Because insects frequently damaged the stored papyri the containers were first soaked in cedar-oil as a repellent. The worst enemy of the papyri, however, was humidity. Papyri survived better in the dry air of Upper and Middle Egypt than in the Graeco-Roman world, where they were in use for more than a thousand years, but soon deteriorated due to humidity. Most existing papyri owe their survival to the practice of depositing them in tombs, since the burials were usually in dry places. Such Egyptian papyri commonly contained religious texts and prayers, and were enclosed in special holders to protect them during the journey to the Kingdom of the Dead. The papyri now known as the *Book of the Dead* are a collection of prayers, incantations, mythical stories and rituals to ease the soul's passage through the nether world, and they are so called because they were discovered placed on dead individuals' bodies. They were actually entitled by the Egyptians the Book of the Coming Forth into Day, to Live after Death. The papyri were executed by priest-scribes who prepared and embellished them, more or less richly, leaving to be added only the name of the deceased. The priests oversaw the sale of these scrolls, the only form of bookselling known from ancient Egypt.

Almost nothing is known of Egyptian libraries of the New Kingdom period (*c.* 1500-1085 BC). In Egypt as elsewhere, no distinction was made between collections of books and collections of administrative or formal documents, since both took the same shape and required the same conservation procedures. In general, libraries were associated with temples or other religious centres. At Edfu, in southern Egypt, the wall of a Temple of Horus was decorated with a list of the works in the library. In the tombs of a father and son found near Thebes, inscriptions include the title 'librarian'; both men undoubtedly belonged to the priestly class. In Egypt the art of writing was both taught and performed by priests.

Books and bookselling of Greece and Rome

Papyrus appeared in Greece around the seventh century BC. Not until the fifth century BC, however, did the importation of Egyptian papyrus become sufficiently common for it to pass into general use.

The Greeks called the unwritten sheet of papyrus *charters*, which in Latin became *charta*, hence *card*, *chart*, *charter*. The Greeks called the papyrus scroll *chilindros*; the Romans, *volumen*, *liber*, and in early medieval Latin *rotulus*; the Greek *tomos* and Latin *tomus* was originally the scroll made of a series of documents glued together; it later came to mean a particular part cut from a scroll, giving us the word *tome*, still used for a 'volume' forming part of a larger work.

The oldest surviving Greek papyrus is from the fourth century BC. A large number of Greek papyri were found in excavations undertaken in Egypt and Asia Minor during the nineteenth century. These date, however, to the third century BC, by which time Greek influence had reached Egypt following the invasion by Alexander the Great in 332 BC, and the papyrus had become a symbol of Greek culture. Relations between the two countries became closer after Ptolemy I Soter (d. 283 BC), who, after the fall of Alexander's empire, consolidated his power in the Nile Valley and made Alexandria the Egyptian capital, and one of the most civilized and cultured cities of the world, visited by many Greek scholars. His son Ptolemy II Philadelphia (285-246 BC), with his second sister-wife Ardinove II, founded the famous Alexandrian Library, with the intention of bringing together all Greek literature in the best copies, edited and assembled with the help of such celebrated Greek men of letters as the poet Callimachus, who was in charge of the library for a time. It was said that the library held some 700,000 papyrus scrolls; were this so, more than one copy of some works must have been included.

The text of long works was divided among several scrolls, keeping the length of each portion more or less the same, while respecting chapter-breaks; short texts, on the other hand, were joined together in a single scroll, indicating a tendency to adopt a uniform length: about 6 or 7 metres, making, when rolled, a cylinder of 5 cm or 6 cm diameter, convenient to hold in the hand. The width of the small scrolls varied from 12 cm to 15 cm, or the large from 20 cm to 30 cm. It is doubtful that the works of Thucydides or Homer were put on single rolls, for the length of such rolls would have been around 80 metres; however, some Egyptian papyri measured 45 metres. Scrolls so long were naturally difficult to store, prompting Callimachus to comment, around 260 BC: *Mega biblion, mega kakon*, 'A big book is a big nuisance'. For this reason, the Romans put suitable books such as poetry on small scrolls, though historical works were on scrolls of a larger format. The nature of the scroll forced authors to publish their works in relatively short sections, hence the divi-

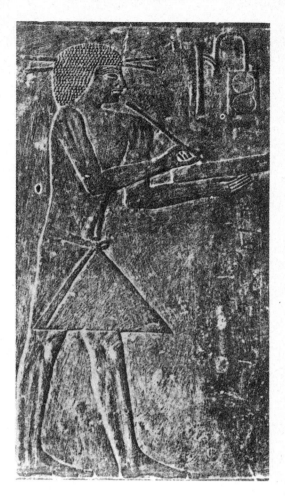

Writing was performed on papyrus with black or red ink using a reed cut crosswise into a point. Scribes were frequently represented in Egyptian art: in this relief a scribe writes standing, supporting the page with the palm of his hand and his forearm

sions into 'books' of the major works of Latin authors, and the somewhat short lengths of each book.

The bar or cylinder of wood or bone, the *umbilicus*, had two knob-like protruding ends called *cornua*, which might be made of ivory, gold, silver or gem-stone, according to the value of the manuscript (see fig., left). A strip bearing the identification of the work was glued on to the outside of the scroll, and was called the *index* or *titulus*. The scrolls were sometimes tied together in bundles for storage, but since papyri are friable, they were wrapped in a covering such as bark and placed in a wooden or stone case, called by the Greeks *bibliotheke*, a word that eventually came to denote all the books in a collection; in Latin, this container was called *cista* or *capsa* or *scrinium*, or even *pandectae* or *bibliotheca*.

The papyrus text was written with a hollow reed, the end of which was shaped to a point like a modern steel pen-nib. The script was large, without spaces between words: instead, the end of each paragraph was indicated by a rule under the last line. The Greek word for this line was *paragraphos*. When, much later on, works came to be given a title, this was written at the inner end of the scroll, probably because placing it at the centre of the roll served to protect it. Illustrations were not uncommon, although very few have survived.

The art of book-making was well-organized in Greece, and books were exported. Initially, the copyist and the bookseller were one and the same person; only around the fifth century did book-dealers, called *bibliopoli*, begin to form a separate profession and carry on their trade in shops open to the public. Besides being the places where books were sold, these shops were meeting-places where, according to custom of the time, the educated gathered to listen to readings of the newest works, to determine whether to buy or hire them. Such readings offered the producers and sellers of books alike a chance to assess popular taste in order to meet it with new works.

At first, producing and selling books was undertaken by people well enough educated to offer their clients correct texts. However, as the trade began to expand, and the number of copies of each work in circulation to increase, we know from Lucian and Strabo that not all were equipped for the demands of their profession. Many were accused of ignorance, or of being unable to collate copies correctly, or of hiring inept copyists. The active book trade in the Greek world is confirmed by several celebrated public and private libraries. Pisistratus, Tyrant of

Athens, founded a public library in 550 BC; Aristotle's private library was well known, and at his death his books went to the Library of Alexandria. Book copyists found themselves in a thriving trade. Indeed, in the search for even greater profits, they were not above creating spurious works or editions bearing the names of noted authors. Pliny records the tradition that at the beginning of the second century BC Ptolemy VI refused to supply papyrus to the King of Pergamon, Eumenes II, for fear that Eumenes could organize a library that would outshine Alexandria's. In fact, the library of Alexandria contributed to the expansion of the book trade, and hence the use of papyrus, in acquiring great numbers of important works that were then copied to become saleable items.

Rome was heir to Greek civilization, including the art of the book. Victorious Roman generals returning to Rome brought with them, among the spoils of war, collections of Greek books, stimulating new interest. As in Greece three centuries earlier, the introduction of papyrus gave a powerful impetus to literature. Papyrus was more convenient and easier to handle than bark, or rolls of lead, or linen, the materials the Romans had hitherto been using for their books. Greek immigrants organized an active and profitable book trade. As in Greece, at first the copyist and the bookseller were the same person.

Books intended for sale were copied by literate slaves called *scriptores, amanuenses, librarii*, or *antiquarii*. *Librarius* originally meant 'writer of literary works', but it came to mean also a person who organized a workshop where slaves copied texts for sale. According to Seneca (*De beneficiis*, VII, 6), the term was also sometimes used for a bookseller in the modern sense. The term *antiquarius* was originally used for a copyist of ancient texts, but during the period of the Late Empire it was already being used simply to indicate a bookseller.

Around the first century BC there appears the 'editor'. The first and most famous of these was Titus Pomponius Atticus, a friend of Cicero's. He was also a librarian. He gathered around him a large number of copyists, and patiently trained them himself. These copyists worked to create both works for his personal library and works to be sold. It is known that Titus Pomponius paid for the publication of the works of Cicero and recovered his costs from the sale of the books. Nothing like author's royalties then existed. Indeed, no law protected literary property and everyone was free to copy any text and sell the book at any price.

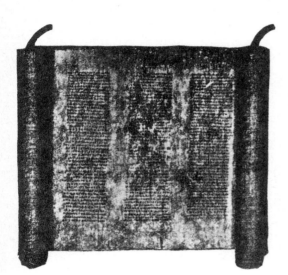

Papyrus arrived in Greece during the seventh century BC and then passed to Rome. Shown is a papyrus scroll with a Greek text written in columns

Two other notable editors, mentioned by Horace, Martial, Quintilian, Pliny, and Seneca, were Socia, who kept a shop in the Forum of Julius, and the freedman Secundus Quintus Valerius Pollio.

Most of the libraries in Rome were in a street called the Argileto, near the Theatre of Marcellus. The entrances to the shops, *tabernae librariae*, bore lists of the works currently available with the names of the authors. As in Greece, so in Rome: the shops were gathering places of men of letters, who would read aloud passages from their works to critics and interested members of the public.

These editor-booksellers needed to have a good cultural background in order to know whether the books that left their shops were correct copies and met the requirements of their customers. And their customers were demanding: they wanted perfect texts, so much so that a Roman going to buy a book would take along an expert to verify that there were no errors in the copies on sale. Great store was set on the text that had been

him-
test
of

ors,
ost
eir
m.
so
ith
00
in
ice
he
of
es.

he
on
ar
ry
es
ps
ed
he
to
g
s,
ks
e.
as

too did manuscripts signed by well-known authors.

One category of book aimed at a particular public and assuring steady returns – even if sold at low prices – was the school textbook.

A 'bestseller' was a collection of works by Nero, who, in his vanity, considered himself a great poet, and ordered that his verses be studied in schools. Another successful publication was Lucan's *Pharsalia* – his bookseller made a fortune from this book.

Roman booksellers prepared catalogues of the works they had for sale, listing the name of the author and the first words of the text. Volumes were stored on shelves called 'nests', (see fig., right) customarily laid flat, and frequently protected by a purple dustcover. The book-business spread outside the city into the Roman provinces, to Spain, Gaul, Lyons, and the British Isles. During the Augustinian period the number of copies made of some works reached one or even two thousand; the price per copy varied from 4 sesterces for a work of Martial to 5 denarii for the work of a less celebrated author, if well bound and ornamented, or from 6 to 10 sesterces if without ornament and with a poor-quality binding.

Thus, first in Greece and then in Rome, a great quantity of papyrus was used. The market was flooded with papyrus on sale under various high-sounding names, such as Augustus or Claudius. During the later years of the Empire, the Romans imported from Egypt untreated papyrus that was then manufactured into rolls, ready for writing, in local factories. At this point the Ptolemies, attempting to safeguard their industry, put a tax on the export of papyrus, and later made the papyrus industry a state monopoly. An official seal called a *protokollon* was applied to the first page of each bundle. Alexandria exported papyrus to the entire world, which was to say, throughout the Roman Empire. The Egyptian control of the market lasted until the Arab conquest in AD 641.

Medieval papyri, surviving scrolls

Though the papyrus industry continued, particularly at Alexandria, through the centuries, even after the fall of the Roman Empire, with exports going throughout the known world, the plant was becoming rare in Egypt as early as the seventh century AD, to the extent that Coptic writers had to ask their clients' patience for delay in delivering works, attributing it to the difficulty of finding suitable materials. The conquest of Egypt by the Arabs in 641 slowed down the export of papyrus, which had already become irregular, especially in those countries that were not part of the Arab Empire. Use of papyrus gradually diminished until its end around the middle of the eleventh century. Various economic and social factors contri-

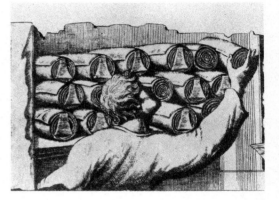

The Roman bas-relief partially shown in this illustration was discovered during the seventeenth century and is the only known representation of an ancient library. Scroll books were stored on shelves called nests; a label attached to the end of each scroll indicated the work – such a label was called an *index*, or *titulus*

15

Portion of an Egyptian papyrus with Greek text from the fourth century BC; below, a Ravenna papyrus from the sixth century with writing in Ravenna chancellery script, derived from New Roman cursive

buted to the disappearance of papyrus. First was the high cost of shipping, increased by the losses due to sea-water spoilage of the bundles. There was drought in the Nile Valley, and the Arabs reclaimed some of the swamplands for agriculture.

The Arabs introduced the cultivation of papyrus to Sicily, particularly around the city of Syracuse, and even today the plant flourishes there. Papyrus grew wild along the Anapo and Alcantara rivers from around the seventh century; in the Middle Ages it was cultivated near the fountain of Arethusa, and along the Ciane River, as reported by the Arab Ibn Haukal (tenth century) and Ugo Foscaldo (1145). A variety of papyrus called *Papyrus syriaca vel sicula* was recently renamed by botanists *Papyrus syracusanus*. Sicilian papyrus was known by several names during the Middle Ages, including *paperio* or *pampero, parrucca* or *pilucca*.

In 1780 the naturalist Saverio Landolina rediscovered the papyrus growing along the Anapo River and revived the industry. He used a different procedure from that described by Pliny, gathering the stems late, not early, in the spring. He made very thin strips which he laid to form a page about 20 cm square. Like the Egyptians, he placed a second layer at right-angles to the first, and then bonded the two layers in a press for two days. As he described the next stage: 'Having thus formed the folio, or page, I lightly applied a glue of breadcrumbs and boiling water with a dash of vinegar. After having carefully dried the page out-of-doors to keep it from shrinking, and to prevent the strips from coming apart, I pressed it again in the press in order to make it thinner. Finally, in order to unite the parts even more, I hammered them, and smoothed them with ivory to make them clean.'

An Arab traveller visiting Sicily in 972-3 reported that Palermo was then scene of a papyrus industry. It is possible, therefore, that the papyri then used in Ravenna and Rome were of Sicilian origin, small-scale though that production may have been.

So we see that production of papyrus was at first limited to Egypt. It spread to Greece and Rome, the source of most remaining examples. The two largest surviving groups of papyri are those discovered in Egypt and those at Herculaneum. The most important Egyptian group consists of several thousand discovered around Al-Faiyum, beginning in 1877. Today, some of these are in the collection of the British Library in London. These documents date from the fourth to the eleventh centuries. Most are from Greece and the Far East.

The Herculaneum papyri, discovered between 1752 and 1754 in a villa excavated at Herculaneum, are preserved in the National Archaeological Museum in Naples. They number 1,806. A small room containing them was fitted with wooden shelves on which they were placed, and must have been a library. Its owner was the Epicurean Gadara, teacher of Lucius Calpernius Piso Caesoninus.

Not all the papyri have been unrolled. To the present only 24 works are known. These were all enclosed in one container. For the most part they are of the third century AD, and are written in Greek.

Medieval papyri comprise both works of literature and formal documents, but only five literary papyri are known. Of these, the most important is the sixth-century *De Trinitate*, by St Hilary, Bishop of Poitiers, now in the Österreichische Nationalbibliothek, Vienna, apart from one page which is in the Vatican Library. The eighth-century *Antiquities of the Jews* by Flavius Josephus, translated by Rufinus of Aquileia, is in the Biblioteca Ambrosiana, Milan.

Wax tablets

Papyrus was not the sole material used as a writing surface in the Graeco-Roman world: apart from linen scrolls there were tablets. As early as the time of Homer and throughout the period of the Roman Empire, there were wooden tablets, called *dealbatae*, covered in a white varnish or, more often, with wax (*ceratae*). In Greek these were called *pinakes*, in Latin *codices, codicilli, cerae, tabellae,* or *pugillares,* the last term because they were held in the hand (*pugnus,* fist). The rectangular wood or ivory block had a narrow raised edge round the four sides, like a frame. A mixture of wax and coloured pitch was spread over the central surface, and writing was performed on this with a stylus, a pointed instrument made of hardwood, metal, ivory or bone (see fig., right). At the other end of the stylus was a small scraper with which the writer could erase the writing and smooth the surface, starting to write anew. Because it was so easy to erase the writing, wax tablets were widely used for school exercises, accounts and notes, even for first drafts of poetic works (Horace, *Satires*, vol. 1, X, 72-73), '*saepa stilum vertas, iterum quae digna legi sint scripturas*' ('Turn the stylus frequently if you wish to write something worthy of being reread'). Usually, several tablets, waxed on both sides or only on one, were joined by a cord or by clasps, thus forming a kind of book. According to the number of joined

tablets, one had a diptych (two leaves), a triptych (three) or a polyptych.

Roman tablets from the first, second and third centuries AD were found during archaeological excavations. They are private or legal records such as contracts of sale or hire. For the most part diptychs or triptychs, they usually contain the full text on the inner faces, which are closed with a binding and sealed, and have an abbreviated version or summary on the outer faces. In the event of controversy one could open the sealed texts and check the full text, and the signatures of the witnesses.

The most important group of surviving tablets is that found in 1875 at Pompeii in the house of the banker L. Cecilio Giocondo, and now in the National Museum, Naples. There are 127 tablets, dating from AD 15 to 62, and comprising receipts from the municipal administration for which Giocondo was a contractor. Other tablets were found between 1788 and 1855 in gold mines at Veraspatak in Translyvania; unfortunately, most of these have been lost or damaged. The remaining twenty or so tablets, called Dacian tablets, are mostly triptychs from AD 131 to 167, and are private documents; they are now in Budapest Museum.

Few wax tablets survive from the fourth to the twelfth centuries. Their use during this period was limited, but references to them exist. Rules established by St Benedict in the sixth century, for example, expressly state that the monks could not possess without the permission of the abbot, 'neque codices', 'neque tabulas', 'neque graphium'. In his *Life of Charlemagne*, Einhard (*c.* 770-840) writes that Charlemagne used wax tablets for writing exercises. Indeed, the personal use of wax tablets continued through the twelfth, thirteenth and fourteenth centuries. Sermons were often drafted in a kind of shorthand on wax tablets. The anonymous compiler of the sermons of St Bernardino of Siena (1380-1444) explains that the sermons were gathered in 1427 by a certain Benedetto, a cloth-trimmer by trade, who while listening to the sermons wrote on wax tablets with a stylus. The texts were then copied, and the tablets, scraped clear and rewaxed, were used again.

Consular diptychs were similar to the wax tablets described, but were made of richly carved ivory (p. 58). They were presented by consuls and other magistrates to authorities and friends on the occasion of their appointment. Seventy-one such diptychs survive, of which the oldest is a sacerdotal diptych of 388, now at Madrid. These consular diptychs have survived because they were employed during the Middle Ages to make luxurious bindings for Gospel-books and Missals. An important series of consular diptychs is now in the Biblioteca Trivulziana in the Castello Sforzesco, Milan. This collection owes its existence to research by the Trivulzio brothers, Teodoro and Carlo, who like others, began to appreciate and collect such items during the eighteenth century.

THE BOOK AS CODEX

The folded and sewn manuscript book is properly called a 'codex'. During the early first century AD the scroll or *volumen* met competition from, and was then replaced by, the codex. The codex is a group of quires sewn together, each quire consisting of a number of folded sheets. The word *quire* is derived from the Latin word *quaterni*, meaning a set of four: usually a quire consisted of four sheets folded in half to make eight leaves or folios, i.e. sixteen pages. The word 'codex' comes either from the Latin *caudex*, 'tree-trunk', or strictly, 'bark', or from *goda*, which meant 'table' in Chaldean.

Notwithstanding loss and dispersal, many thousands of codices, copied during the ten centuries that preceded the invention of printing in the West, have survived. During the Middle Ages, a golden age of the codex, parchment, known throughout the Mediterranean world from antiquity, came into wide use and eventually replaced papyrus.

The study of the codex is of assistance for our knowledge of history, and also for establishing accurate versions of literary works prior to the invention of printing; indeed, the more remote the period, the greater the codex's value for the historian and philologist. This individual or comparative study of the codex, the archaeology of the book, is today called codicology.

Many unanswered questions still surround the techniques used by craftsmen to make parchment codices, from late antiquity and through the Middle Ages. Their tasks included preparing the skin, arranging the parchment sheets in quires, and folding the quires into folios. With meticulous care they matched up together the clear, smooth sheets from the inside of the skins and the darker and rougher sheets that came from the hair-side. Horizontal lines were drawn across the sheet before folding. Drawing such lines was easier to perform on the side that had originally held the hairs, where the parchment was more resistant and accepted the drawing better. It was the craftsman who made the choice of dimension of the book, determining the size and shape of the pages on which the text would be harmoniously written by the scribe.

Wax tablets came into use at the time of Homer and became universally popular for taking notes and drafting literary compositions. They were still in use the fifteenth century; above is a wax tablet dicovered at Pompeii with writing in cursive capitals

A fifteenth-century German parchment-maker, from the book of a Nuremberg guild. The skin has been stretched on a wooden frame, and the craftsman is about to scrape it to remove the fat

Writing surfaces
Parchment

While treated skins had been used as a writing-material by many peoples – the Egyptians, the Jews, the Assyrians, the Persians, the Greeks – the improved manufacture of parchment for writing for general use is credited to the library of the kings of Pergamon, about the third century BC.

Founded by Attalus I, but enlarged during the reign of Eumenes II (195-158 BC), the library surpassed the older and more famous library of Alexandria (see p. 14). Manufacture on a large scale certainly did take place at Pergamon, and the city gave the material its Roman name *pergamineum*, from which our word 'parchment' is derived.

The term 'parchment' appeared for the first time in the edict *De pretiis rerum venalium* of AD 30. The original name, in both the Greek and Roman worlds, was *membrana*, which continued in use in various versions during the Middle Ages, like the designation *charta*, which had originally been used for a page of papyrus.

The skins of various animals were used to make parchment, but most widely used were those of sheep, goats and calves (vellum). The skins of antelopes and gazelles were probably used in Egypt. The quality of the parchment was determined by the source of the skin, but also by the workmanship, which reached an extremely high level between the second and sixth centuries AD. One can thus distinguish the parchment produced in Italy and Spain, which is white and fine, from that made in France and Germany, which is thicker and darker. The fourteenth-century Greek scholar Planudes Maximus complained that the parchments sent to him to make codices were of such poor quality that they seemed more like 'skins of donkeys than sheep, more suitable for making shields and tambourines than codices'. A very fine and white parchment was obtained from the skins of newborn or unborn lambs; this material was called *carta virginea*.

From a description in a codex in the library of Lucca we know that in the eighth century the skin was cleansed by being covered in lime for a few days; then, while still soft, it was scraped and shaved on both sides to remove the fat and eliminate any marks; then it was smoothed with pumice-stone until reduced to the desired thickness; and, finally, any cuts in the skin were closed with stitches and sutures.

The oldest known example of parchment is a fragment of *De bellis macedonicis* (see fig., p. 25) dated to the second to third century,

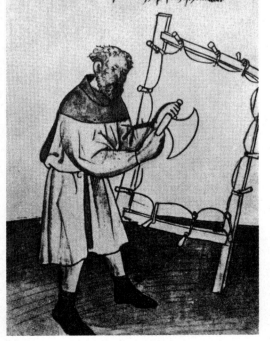

and already in the shape of a codex. However, we know from written references of codices made from animal skins in the classical world. In one of his Letters, St Paul asks Timothy to bring him not only the papyrus books but especially the parchments that he had left behind at Troas (Timothy 4, 13). In classical antiquity, parchment was not widely used because it was considered a barbaric writing material: Greeks and Romans used it for notes, just as they used wax tablets, and only in rare cases for making books, which were rolled like papyri. The use of parchment for manuscripts became more widespread during the third and fourth centuries AD. Its growing popularity arose from two factors: first, that the technique of its manufacture had been perfected, producing a smoother, whiter surface, more pleasant to write on as well as easier to correct (by scraping away errors) than papyrus; and, second, that by its nature it was suitable for folding, and it was adopted as the book was transformed from the scroll to the codex. Parchment was the unchallenged writing material from the fifth century to the thirteenth, at which time paper made from rags began to come into general use. The use of parchment for books continued for longer in Italy than in other countries, particularly for legal documents.

The oldest surviving parchment documents are from the seventh and eighth centuries; among them are twenty in France, including the foundation charter of the monastery at Bruyère le Château from 10 March 670. In Italy, the oldest known parchment document is from 716, and is in the Milan Archives. The papal curia used papyrus for Papal Bulls until *c.* 1051, when it began using parchment regularly.

The parchment used for books was thinner and smoother than that used for single-sheet documents. For the latter, it was smoothed and written on one side only.

A luxury material was coloured parchment. According to Juvenal, Quintilian and Isidore of Seville, the Romans dyed parchment yellow or red because the white skin too easily became soiled and offended the eye. Purple was used for luxury books, which were written with gold or silver. Such books contained the Gospels and other liturgical texts; many examples were made during the fifth to seventh centuries and during the Carolingian period. The most famous was the *Codex Argenteus* (p. 44), a sixth-century Italian Bible in a Gothic translation with script written in silver. During the humanist period script was again written in gold, although purple codices remained a feature chiefly of the Middle Ages.

Purple was the most important of the various colours used for parchment during the humanist period. There are rare examples of parchments coloured with saffron, or they might be black, like the Sforza codices now in Vienna, which have black panels with writing in gold and silver. Also found are pages coloured violet, blue and green.

Palimpsests

During the High Middle Ages it was common to re-use parchment pages (*codices rescripti*). The parchment was prepared by being soaked with milk and rubbed with pumice-stone to remove the ink. Such re-written parchment is called a palimpsest. The re-use of parchments was particularly frequent during the seventh and eighth centuries, a response to the high price of new parchment, rather than, as some sources have suggested, a sign of contempt on the part of medieval monks for books of pagan literature. Indeed, religious as well as profane texts were erased. This practice has sometimes been of great benefit in preserving works or fragments that would otherwise have been lost forever. The state of preservation of earlier texts in palimpsests is variable; sometimes the cancellation of the script was so effective that one can discern nothing beyond the fact that the parchment once carried earlier writing; in other instances it has been possible to strengthen the cancelled text with chemicals to make it legible. Occasionally the scratching-out of the original text was so superficial that the original text can be fully recovered simply by tracing over it. Sometimes the original text was left untouched, and the new text was written at right angles to it. A book in the library at the University of Messina contains writing from the sixth, ninth and twelfth centuries. The largest group of palimpsests is that of the monastery of Bobbio in Emilia-Romagna. Forgeries are rare, but a forged document by Berengar, now at Venice, overlays a document of the Emperor Charles (Charles the Fat, 875), whose seal is genuine.

The study of palimpsests began in the eighteenth century. Many were uncovered by Angelo Mai (1782-1854), an official of the Biblioteca Ambrosiana, Milan, and the Vatican Library. His most famous discovery was of the *De republica* of Cicero, from the fourth century, beneath a work of the seventh century by St Augustine, in a book found at Bobbio. The book is in two portions, one in the Biblioteca Ambrosiana, Milan, and the other at the Vatican. Today lost writing can be studied with ultraviolet light.

Paper

The oldest known Italian document written on paper is a letter, in Greek and Arabic, by the Countess Adelaide of Sicily in 1109, preserved in Palermo. The oldest known notary's register on paper is at Genoa, which begins with the imbreviature of the notary Giovanni Scriba (1154), the first pages of which are written on the remains of an Arabic roll, and then on pages joined in groups of five sheets. However, it was only during the thirteenth century, with the beginnings of the famous papermakers of Fabriano, that organization for the manufacture of paper began. Other papermakers soon began working at Bologna, Colle di Val d'Elsa, Prato, and in other cities. Italian paper was highly appreciated and valued, and for a long time Italy furnished paper to the Western world. During the fourteenth century the use of paper became general, but even so, difficulties were encountered. In 1231, Frederick II prohibited its use in Sicily for official documents; in the imperial, pontifical, and ducal chancelleries, the use of paper was restricted to letters, and it was not used for ceremonial documents. Even if paper's advantages over parchment were clear – among them the fact that it is less easily scraped clean and so not as easily falsified – the prohibitions against it continued for notary acts. Paper was still prohibited in Florence in 1517.

Paper originated in the Orient. According to tradition, it was originally invented in China by the director of the Emperor's scribes, Ts'ai Lun, who, in AD 105 had the idea of making a paste of mulberry-bark, hemp, and scraps of silk and other cloth. Possibly the idea was an older one, and Ts'ai Lun merely perfected the technique of manufacture. The oldest known pieces of Oriental paper are from the third century AD; in a cave in northwest China were found thousands of rolls of paper written in various languages (among them Chinese, Tibetan and Sanskrit) that have been dated to the fifth to eleventh centuries.

The art of papermaking spread from China to central Asia in the fifth century, and to India in the sixth. At Samarkand in 751, Chinese captives revealed to the Arab conquerors of Turkestan methods of papermaking which had been kept secret for seven hundred years. This knowledge arrived in Baghdad in 793, then crossed Syria into Egypt, where, at the beginning of the tenth century, paper gradually replaced papyrus, and then spread across North Africa. It reached Spain in the eleventh century, Italy in the twelfth, France in the fourteenth,

A page of palimpsest, a parchment page scraped clean and rewritten (Johannes de Bonis, *Carmina*, fourteenth century): due to imperfect scraping, the original writing can be seen in the bare areas – it is Gothic bookscript, with larger characters. The study of palimpsests has led to the recovery of classical texts that would otherwise have been lost

The opening, or *incipit*, of the *Officium beatae Mariae Virginis*, a codex of the fifteenth-century Florentine school. The first words are 'Incipit officium beate Marie virginis secundum consuetudine romane curie'

and finally, was disseminated throughout the whole of Europe.

The terms used for paper had previously been applied to other writing-materials. Thus *charta*, the word for the other vegetal writing-material, papyrus, continued in use for paper, usually with the addition of a reference to the place of origin, as with Bombycine (from the name of a famous Arab paper-mill of Bambyce, Syria), *cuttunea* (from the Arab word *kattau*, 'cloth'), and *pannucea*. Even the word 'papyrus' is used to denote paper in some modern languages, ignoring the different materials that paper is made from. As recently as the nineteenth century it was believed that Oriental Bombycine paper was made of natural cotton, while that made in the West was produced from rags. A great deal of argument surrounded this subject until scholars demonstrated that the entire notion of raw-cotton paper was unfounded, and that Oriental paper was made of rags just as surely as paper produced in the West. The differences in appearance and consistency between European and Oriental papers in the thirteenth and fourteenth centuries were the result of differences in the methods of preparing size: the Europeans used animal size and Oriental papermakers starch size; and of a more complete crushing of the fibres for European papers, obtained by using machinery.

The method of making paper remained essentially unchanged from its origins to the nineteenth century, and still continues unaltered today for some luxury hand-made paper. As an example, shredded scraps of hemp, cotton, and linen are beaten or crushed until reduced to a thin homogeneous paste, which is poured into a vat. A tray or mould is then dipped into the vat. This rectangular frame has ribs strung with thin brass wires, and copper filaments spaced 8-80 mm apart. On the frame, a movable box determines the thickness of the paper. The paper, formed by fibres trapped by the wires when the water has run through, is dried with felt and by exposure to air. It is then sized and smoothed, or calendared (pressed between rollers). The pattern left in the paper by the wires served to identify the origin of the paper.

Naturally methods of paper manufacture underwent some modifications and improvements through the centuries. At the end of the seventeenth century the Dutch invented a mechanical method of pulping the rags using bladed cylinders; in the second half of the eighteenth century, James Whatman of Birmingham and the Montgolfier brothers at Annonay developed a paper without wire-marks. During the eighteenth century, the increasing cost of rags led to various attempts to make paper out of new materials, but no new material went into production until 1844, when Friederich Keller invented a machine for processing wood-fibre. An interesting development was the watermark, the company's or papermaker's distinctive motif incorporated in the paper. These included initials, animal-motifs, flowers or fruits, implements or utensils. Brass or silver wire is twisted into the mould, reducing the thickness of the paper to produce the translucent design. The oldest watermarks date to the thirteenth century (before 1271), and they become increasingly numerous from the fourteenth century onwards. Watermarks are useful in the study of the history of the paper industry. They are of value in bibliographic research if they can establish that the paper on which they appear was in use by known printers at specific dates, although this evidence has to be interpreted with caution.

Form and composition of codices
Format and layout

It is not known with certainty when the codex superseded the scroll. Wax tablets joined together had already anticipated the form of the codex, and its adoption gained momentum with the use of parchment, a material particularly well suited to being folded. During the first century AD, it had been employed for volumes intended as gifts, or for books to be taken on journeys, and for account-books and schoolbooks. The poet Martial (AD 40-104) expressed his astonishment at the small dimensions to which even the longest books – the *Iliad* and the *Odyssey*, all the works of Virgil, or the 142 books of Livy – could be reduced by the new book-making method. Codices, he wrote, did not over-fill libraries, were perfectly suited to travel, and could be read held in one hand, whereas scrolls required two. From the fourth century onward, with the ascendancy of parchment over papyrus, the codex gradually took the place of the *volumen* as the normal form of book.

The format, that is, the height and width of the page, became known as *forma* or *volumen* during the Middle Ages. The oldest format was square. This was followed by a rectangular shape with the height greater than the width. Codices, as mentioned, were composed of quires, a number of sheets folded and sewn as a group. Quires, as indicated by the word's derivation (*quaterni*, set of four), originally meant a gathering of four sheets which after folding made eight

leaves or sixteen pages, but the meaning was broadened to include a gathering of two sheets, or up to five, ten, or even more. In a special category are miniature volumes, or books of unusual shapes and sizes. Some were created for practical reasons, others merely as exercises of virtuosity. Books appear in the shape of hearts or lilies; there are round books and triangular books, and original ways of folding and binding.

Both on papyri and parchments, coypists followed precise rules that date to the first centuries AD to establish the relationship beween the text area and the margins. These are based on the page height and width; usually this was a proportion of around 4 to 5. They performed this work of establishing the page-layout (called in Latin *quadratic*) using a knife and a square. To assure the regularity of the writing and the harmony of the page, horizontal lines to guide the writing were drawn between the two vertical lines that indicated the margins.

This was at first done without ink, using a metal point (*circinus* or *punctorium*), and from the second half of the eleventh century with a lead point (*plumbum*), the use of which rapidly spread. By the end of the twelfth century, scribes were drawing rules with black ink; then followed coloured ink, particularly pink. Two series of tiny perforations were punched to keep the lines straight and parallell.

Headings and endings

Like their predecessors papyrus scrolls, medieval manuscripts usually did not have title-pages. Instead, a phrase from the beginning of the text was written at the head of the text. The name of the author was not stated. Attention was drawn to the opening phrase by the use of red ink and large capital letters (headings are known as 'rubrics' because they were written in red). In medieval manuscripts this initial phrase written in a contrasting colour was sometimes skillfully embellished with geometrical or architectural motifs, forming display scripts.

Information about the author and the work's title were placed at the end of the book, introduced by the word *explicit* (from *explicare*, 'to unroll'). Medieval manuscripts often ended abruptly, without a formula or date, merely with the words *finis operis* or *explicit liber*. Sometimes, however, the copyist added his name, the date, the place, and the name of the book's purchaser (together known as a 'colophon'). More elaborate information can be found in the codices from the fourteenth and fifteenth centuries; the copyists were proud of their work, asked

recompense for the finished labour, and invoked divine blessings on themselves and their readers (see figs., right). They might add also the name of the corrector, who was sometimes an important person in the scholastic world; or, in some cases one finds that the book was copied, not by a professional scribe, but by a scholar, or even a friend of the purchaser. All this information provided a guarantee as to the accuracy of the text, and helped make a high price for the work acceptable. Elements of the signatures used in codices were later adopted by the first printers in their colophons.

When the scribe had finished his work, the indexer began his, writing in red ink a list of the chapter titles, and ornamenting the initial letters of each phrase with a vertical line. Commentaries or notes on the text were arranged, rather at random, between the lines and in the margins, even though this might sometimes make the page less attractive. After the foundation of universities, copyists working on textbooks adopted a larger format so that the text could be completely encircled with notes. These were written in smaller script, arranged carefully.

Composition

Since the large number of quires needed to make a codex could easily be gathered in the wrong order in the binding, copyists developed the custom of 'numbering' the quires with marks on the last page; such marks are called signatures. A more refined method came into use around the middle of the eleventh century, with the catchword, which consisted in writing at the end of every quire the first words of the next. In the thirteenth century, after the founding of the first universities had increased the demand for books, a system was needed that would also indicate the order of the pages within each quire, to permit the designer and illuminator to work in sequence on the same volume without confusion. Folios were marked with a letter to indicate the quire to which they belonged, followed by their number within the gathering. By the end of the thirteenth century, a period of great changes in the techniques used in making manuscripts, the folios were sometimes numbered throughout a volume.

Through the centuries the variety of postures in which people have been depicted writing both religious and secular works has been enormous. From this iconography we know that Egyptian scribes wrote in a crouching position; the Evangelists, following the Graeco-Roman tradition, wrote with the scroll or book resting on their knees, while

Three examples of *explicit*s from manuscripts: (from top to bottom) G.F. De Castellione, *Alexandreis*, thirteenth century; P. De Crescentiis, *Ruralium commodorum*, Book XII, 1471; Dante, *The Divine Comedy*, 1460. These *explicit*s include the name of the author, the title of the work, the name of the copyist, and a closing phrase invoking a blessing (Milan, Biblioteca Trivulziana)

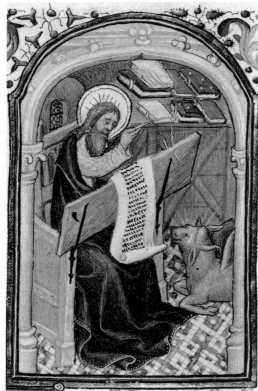

St Luke writing, from Books of Hours of the French school of the fifteenth century. Top, the Evangelist is seated on a wooden chair covered with a cushion; he writes with a goose-quill pen on parchment supported by a writing-stand while holding the page steady with a scraper held in his left hand; at his side below is an inkpot. Above, across the Saint's knees is a board attached to the arms of the chair with brackets; an inkpot and erasers are slotted into the board

the medieval monk wrote bent over a board placed on the lap. During the Renaissance the surface of the writing desk was inclined, and it might be set on a base and surmounted by shelves on which books were placed, laid flat.

Writing tools
Inks

In classical times scribes used black ink; the Greeks called ink *melanion* or *enkanston*, the Romans *atramentum*. Pliny makes a distinction between *atramentum librarium* used for writing and *tectorum* used for drawing; the colouring *sutorium* was used to dye skins. The common word for ink during the Middle Ages was *encaustum*, which became *incaustum*. The word *encaustum* gave Italian *inchiostro*, the French *encre*, and the English 'ink'. From the Latin *tincta* is derived the German *Tinte*, the Spanish *tenta*, and the English 'tint'. The container used to hold the ink was called an *atramentarium* or *scriptorium*.

Ink was made of various ingredients, but basically of lampblack and gum solution. It was easily wiped off, particularly when fresh, with a wet sponge called a *spongia deletilis*. The story goes that the Emperor Caligula did not bother with sponges, but used instead the tongues of slaves, or of persons he wished to punish.

During the Middle Ages the composition of ink changed with the addition of metallic elements. From the many formulae for ink then published, it seems that ink was usually composed of vitriol, oak-gall, gum, beer and vinegar. The inks of the ancients had been a deep black, but by the Carolingian period (eighth to ninth centuries) they were beginning to be reddish, and, according to the amount of oak-gall included, they became even redder during the eleventh and twelfth centuries. Then they became very black with the addition of more vitriol. A certain amount of discoloration has resulted from exposure to air, light and humidity. In such cases, the vitriol base can be restored with the application of reagents, but to do this produces a stain that becomes darker with time – many documents and manuscripts have been irreparably damaged and rendered illegible in this way. Nowadays such problems are avoided through the use of ultraviolet and infrared photography, and particularly sensitive emulsions.

Black ink was normally used for general writing, red for certain types of official documents such as royal diplomas. Red was widely used in codices. In classical codices the first lines are written in red, as are initial letters, titles, descriptions of the chapters, the opening lines of paragraphs and the notes in the margins. In liturgical books it was common to use red ink for the portions of the text that referred to ceremonies (rubrics). Codices written entirely in red are a rarity: the Bibliothèque Nationale, Paris, has a few examples.

Beginning in the twelfth century, blue and green were added to red for colouring initial letters. Green was used for the subscriptions of Eastern princes and prelates.

Writing in gold or silver on a purple background is of Byzantine origin, but it was adopted in the West in Carolingian luxury manuscripts destined for liturgical use – an ostentation deeply lamented by St Jerome. In early purple codices the text is written in silver, while gold is reserved for initial words, titles and proper names, especially sacred names. As noted, the library of the University of Uppsala has the *Codex Argenteus* written in silver, with gold used for the first three lines of the Gospels, the Paternoster, and a few initial letters (p. 44). In the new flourishing of luxury manuscripts during the Carolingian period a number of codices were written in gold. A Gospel-book with gold letters on purple was kept in the Imperial Treasury in Vienna; according to tradition it was used at the coronation of the Emperor. Other remarkable gold and silver codices belong to the ninth century (p. 63, left). A Gospels presented by the Abbey of St Denis to Charles II was written in 870 with gold on natural parchment (Munich, Bayerische Staatsbibliothek).

Codices continued to be written in gold and silver until the eleventh century. The art had a limited revival during the Renaissance (p. 152, above). A notable example is a codex in the Biblioteca Comunale of Bergamo: a Life of Bartolomeo Colleoni by Antonio Cornazzano written entirely in silver on extremely white parchment, with a few illuminated initials. The Biblioteca Trivulziana, Milan, has a humanistic codex in purple with silver writing and titles in gold, of the *Rime* of Gaspare Visconti.

Many Renaissance manuscripts were written on black backgrounds with titles, initial letters and sacred names in gold and silver. The Österreichische Nationalbibliothek in Vienna has two 'black' prayer-books made for the use of Gian Galeazzo Maria Sforza, Duke of Milan, and his sister Bianca Maria, and a Book of Hours (p. 135).

Stylus, pen, pencil, knife

We have seen with the cuneiform system that the type of instrument used to write can

determine the form of writing. On wooden tablets writing was done with both styli and brushes; writing on wax tablets was done with the stylus, or *graphium*, which was a rod of bone, iron, silver or ivory. The use of the stylus is evidently very ancient. It is mentioned in the Bible: '*Delebo Jerusalem sicut deleri solem tabulae: et delens vertam, et ducam crebrius stylum super faciem eius*' 'I will destroy Jerusalem as one used to cancel marks on a tablet: and destroying, I will turn and rub across it many times the stylus' (2 Kings 21, 13), and its use continued over a long period. It was employed on soft clay, and sometimes even on metal. Wax tablet and stylus were still in use during Roman times, throughout the Middle Ages and up to the fifteenth century.

In late classical times, writing with ink was performed with a calamus; according to Ausonius, the ancients sharpened the reed and then cut the end to form a divided point much like that of modern pen-nibs. The pens were kept in a *theca calamaria*, frequently of bronze, in which were also stored the knife for sharpening the pen (*cultrum*, or *scalprum librarium*), a ruler (*regula*), a razor used to shave or cut parchment (*rasorium*), and an awl (*punctorium*) or lead point (*plumbum*) used to mark lines and margins. The compasses used to mark the distances between the lines with small perforations at the edges of the page were called *circinus*, or again *punctorium*. The use of the calamus continued until the end of the seventh century, at which time it was replaced by the quill pen made of a feather, particularly a goose-feather, known as a *penna*.

The brush, *pennicillus*, was used rarely, and generally only for writing in gold and for painting the elaborate ornamental initial letters in codices.

To hold the page steady for writing and to scratch out errors, the scribe usually held in his left hand a curved-bladed instrument. The Graeco-Roman habit of writing on a board across the knee was followed for parchment, and the ink-pot was sometimes fixed to the board, or it might be worn suspended from the belt or slung from the shoulder.

The first written mention of pencils is by the Florentine painter Cennino Cennini (*c.* 1370-1440). When deposits of graphite (called plumbago) were discovered, the material was adopted as a writing-tool, and was enclosed in a wooden cylinder to protect it. The best graphite came from Cumberland, so for a long time pencils came from England. However, the pencil came into common use for writing only during the eighteenth century.

Writing styles and scripts

The origins of writing are lost in the remote past. The earliest forms of writing, dating to the fourth millennium BC, were the pictographs of the ancient Egyptians, Hittites, Cretans, Indians and Chinese. This form of writing underwent a slow evolution among the peoples living along the Mediterranean coast as they discovered systems better suited to their needs. Thus, writing went from pictographs to ideographs, symbolic representations; to syllabification; and, toward the fifteenth century BC, to the use of alphabets, one of the most important creations of the human mind. The credit for this creation goes to the Phoenicians, and from their alphabet were derived those of the Greeks, the Etruscans and the Romans.

The evolution of Roman writing

Roman writing from the classical period is known from inscriptions and papyri. The letters were inscribed on stone, metal, terracotta, or on wax tablets, using a chisel, brush or stylus. Inscriptions made with a chisel are of a monumental nature, but their *ordinationes*, that is, the tracings made by an *ordinator*, sometimes reveal the forms of contemporary writing. Many hundreds of papyri offer examples of writing in ink, dating to the end of the first century BC, found for the most part at Faiyum at Tebtunis and Oxyrhynchus in Egypt, and at Dura-Europos on the banks of the Euphrates.

The writing of inscriptions is all in capital letters of the same height. The term 'capital' is derived from *capita*, 'head', hence 'headings'. During the first century AD these letters were already of two types. In one, the forms were large and thick, assuming monumental proportions; such letters were used only in luxury books, when they are known as 'rustic capitals', or for inscriptions, when they are known as 'square capitals'. In the other, small characters formed a cursive or flowing, rapid type of writing, making use of shapes transformed by long use, and embracing varied personal writing-styles. Names used for this type of writing are 'common classical writing', 'cursive capitals', or 'Old Roman cursive'. Both styles maintained the same angle of writing – acute – and the same duct, or ductus, i.e. direction and sequence of strokes to form a letter.

Examples of the first kind of script include an election inscription from AD 79, a papyrus fragment of the *Gramatica* of Palaemon from around the year 148, and, from a later period, the fourth to fifth century, the *Palatine Virgil*, the *Roman Virgil* and the *Vatican*

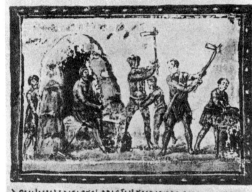

Page from a fourth-century Virgil in the Vatican Library, written in Old Roman rustic capitals. The name 'capital' is derived from the use of upper-case letters for titles, or for the first words or letters of chapters, and is from the Latin *capita*, 'head'

Page from a codex (*Sacramentary of Pope Gregory the Great*) with uncials written in gold, early ninth century. The name 'uncial' comes from a passage in S. Jerome in which he refers to large writing: 'letters an inch high', and is from the Latin, *uncia*, 'inch'

The development of Latin writing styles

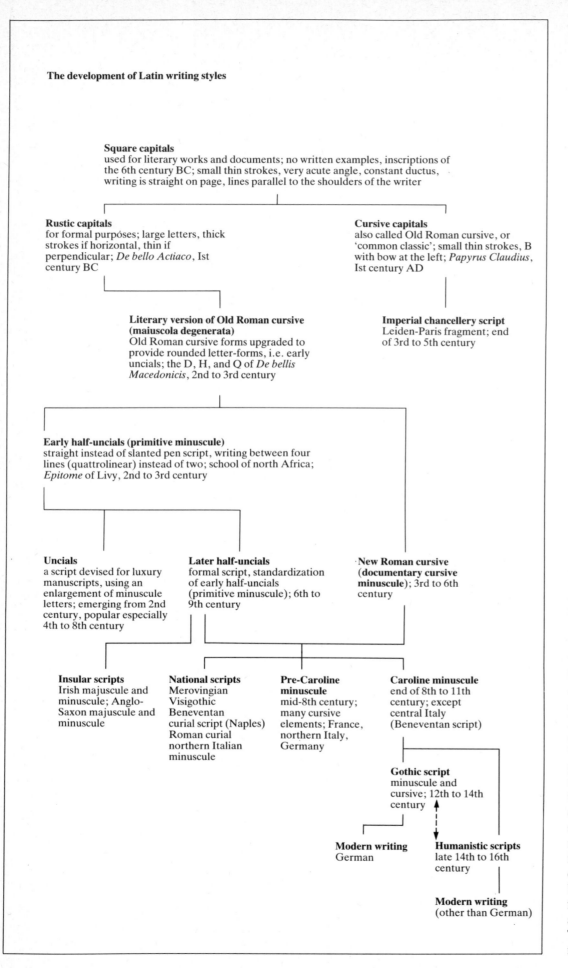

Virgil (see fig., p. 23), among others. The letters are regular, with the thickness of the bars very much differentiated; the crossbars and bars descending obliquely from left to right are thick; bars ascending from left to right are thinner; thicker than the latter are vertical lines extending from top to bottom. The scribe wrote holding the calamus (reed pen) so that it formed an acute angle with the line being written. This is known as a 'slanted pen script'. Each letter was drawn several times, and each redrawing called for one or more strokes.

A good example of the Old Roman cursive style is provided by the *Papyrus Claudius* (see fig., opposite) from the mid-first century AD, which has script of smaller and lighter lines, with almost imperceptible variations in their thickness. It was written with a very hard instrument, in a rapid form.

Around the second to third century, a transition took place from the 'Old Roman' writing of rustic capitals and cursive capitals to two new writing styles: one is the 'New Roman cursive', also termed 'cursive minuscule' or 'new common writing', and the other, 'uncials'. Two documents attest to this transition: one, a fragment of a parchment book, *De bellis Macedonicis*, with rustic capitals, but also some Old Roman cursive forms upgraded into new, more rounded bookscript letters prefiguring uncials; the other, a fragment of an *Epitome* of Livy's Histories with a rounded lower-case script known as 'early half-uncials'. Much of this transition was due to a change in materials, with parchment in regular use and the pen cut in a different way to produce a 'straight-pen script'. Some letter-forms that appear in these new scripts are more suited to writing with a flexible pen than with the stylus or chisel (see figs., opposite).

While capitals (or majuscules) were written between two parallel lines, minuscule forms of writing with their longer ascenders and descenders were written between four. 'New Roman cursive' was light, and included frequent ligatures.

Uncial script, evolving around the same period as New Roman cursive, is a luxury style of large, precise handwriting, not spontaneous, with mannered letters following constant angles, and a rounded character suited to the pen. A considerable number of manuscripts (traditionally 390) were written in this style during the fourth to eighth centuries. 'Later half-uncials' – termed 'half' because they are uncials with cursive influence – were a third style of writing, appearing during the sixth century.

The development of Latin handwriting was not a gradual evolution from capitals (maju-

scules) to lower case (minuscules), but a decisive break from both capitals and uncials, which henceforth were restricted to titles and other ancilliary parts of the text.

If capitals and uncials saw only limited development as formal bookscripts, the 'New Roman cursive' or 'cursive minuscule' became the handwriting for all the classical world, even as it approached its decline. Variations in style from one document to the next are explained by the use of more or less hard writing instruments, by alteration in the angle of writing, or simply by personal differences or the speed with which the scribe was writing: the fundamental unity of this writing style remained unchanged.

Styles of the early Middle Ages

The barbarian peoples who settled in Western Europe in the fifth and sixth centuries assumed, along with the Latin language, the common Roman handwriting. They had little effect on this handwriting, hence to call scripts Lombard, Visigothic or Merovingian is to ascribe to these peoples a role in the creation of the handwriting styles of the sixth to eighth centuries that they did not have. During this period, however, economic and social changes did affect the art of writing. With the weakening of economic activity during this period, the production of commercial luxury books ceased. The near-disappearance of Egyptian papyrus and the limited production of parchment also had restrictive effects on writing. While classical culture declined, the quickening of religious life stimulated by Western monasticism during the sixth and seventh centuries opened a new era in the production of books. St Benedict's Rule (p. 37) assumes the existence of a library in every monastery. The expansion of the liturgy increased the number of books needed in each church. Writing codices became one of the chief occupations of monks.

Insular script. During the fifth to seventh centuries, Ireland and England received Roman culture by way of Christianity. Episcopal centres like Canterbury and monastic centres like Durrow and Lindisfarne were foci of active intellectual life where codices were copied. These codices were luxurious illuminated manuscripts written in imposing uncials or half-uncials, like the Lindisfarne Gospels (p. 55) and the Book of Kells of the eighth to ninth century, and also books and documents in smaller minuscule script, such as Bede's *Ecclesiastical History* of the eighth century, with angular pointed letters and characteristic ligatures. This writing was brought by Irish and Anglo-Saxon monks to

the continent, where it rapidly flourished, particularly at the Irish St Columban's foundation at Bobbio in Italy.

Visigothic script. During the Visigothic period in Spain, a handwriting appeared that while having its own peculiarities was closely connected with Roman script. It was used from the eighth to the twelfth centuries, both for documents and for manuscripts such as St Ildefonsus, *De virginitate Sanctae Mariae* (p. 84) of the tenth century, and a Mozarabic Breviary (p. 73) of the ninth to tenth century.

Merovingian script. Compared to its modest evolution in other regions, Roman script developed numerous variations in post-Roman France. This diversity arose from the great number of monastic and episcopal centres which received influences from both north and south. The styles used in books assumed elegant forms, varying sometimes even between books made in the same scriptorium. The style used at Lyons is called *a-z* because of the bizarre form of the last letter; at Corbie is found the type called *a-b* because of its *a*, which is formed of an *i* joined to a *c*, and its *b*, on which the horizontal line is close to the bar over the bow on the right (p. 63). These were in use from the sixth century to the late eighth century, prior to the Carolingian reform.

Beneventan script. Montecassino dominated southern Italy, and its scriptorium developed a very original type as seen in the *Martyrologium Cassinese* from 1087 (p. 95). It remained in use until the thirteenth century. It was also used at Cava, Capula, Bari, and in Dalmatia.

Curial script. Used particularly in the Naples court, and by the public scribes of Gaesta and Amalfi, this writing was very artificial (as in a Deed of Gift of 961). Papal chancelleries used *Roman curial script*, with ample curves and long ascenders and descenders, and lines very spaced, especially in the *curiale antica* (as in a Privilege of Pope John VIII in 876). The later form had smaller letters, a result of the replacement of papyrus by parchment (as in a Privilege of Pope Alexander II in 1071).

Cursive minuscule of northern Italy. Insular forms were influential around Bobbio, while the Verona, Vercelli and Lucca schools remained faithful to uncials or to the common handwriting of the preceding century. Notaries used characters similar to those of Ravenna until the eleventh century.

Top: The *Papyrus Claudius* of the mid-first century, an example of Old Roman cursive, i.e. capitals written cursively. (Berlin, Neues Museum)

Above: Fragment of the *De bellis Macedonicis*, of the second to third century, with rustic capitals and rounded letters that are the precursors of uncials. The D, H, and Q are written cursively (British Library)

Fragment of an *Epitome* of Livy's Histories written in early half-uncials, the new rounded, lower-case letters. Second to third century (British Library, London)

Page of Caroline minuscules from St Ambrose, Bishop of Milan, *Tractatus de poenitentia, De officiis ministrorum*, written at Como during the eleventh century (Milan, Biblioteca Trivulziana)

The Carolingian reform: the Caroline minuscule

The scriptoria of France, Italy and Germany used the cursive minuscule until, from around the middle of the eighth century to the beginning of the ninth, they sought to improve the forms of writing by returning to the 'primitive minuscule' and the half-uncial. The results of these earlier efforts are known as the 'pre-Caroline' scripts. Important types in France included those in Burgundy, and two known as the Leutcarus and Maurdramnus, named for abbots who lived during the second half of the eighth century. At the end of the eighth century the scriptorium of Corbie played an important role in developing an early form of Caroline minuscule (p. 63, above). Tours, too, was an important centre, especially the scriptorium of St Martin, where the Anglo-Saxon monk Alcuin, Abbot from 796 to 804, stimulated the activity of copyists. There were various types in northern Italy also, such as those practised in the cathedral schools of Ivrea, Novara, Vercelli, Verona, and Lucca, and the monasteries of Bobbio, Nonantola, Novalesa, and others. In Germany, the writing spread through the area between Coire in Switzerland and Murbach in Alsace, within the boundaries of ancient Rhaetia; hence it came to be called 'Retica'. The most important scriptoria were at Coire, St Gall, Reichenau and Costanza.

After giving rise to the formation of local varieties of common Roman script (the pre-Caroline), interest in calligraphy at various places at the same time led in the early ninth century to the development of a new common type. Because the formation of this new type occurred during the intellectual, cultural and religious revival in Charlemagne's reign known as the Carolingian renaissance, the writing style is known as the Carolingian or 'Caroline' minuscule. During the period of Abbot Fridugisus (806-34) writing at Tours gained uniformity of style and perfect regularity, becoming the true Carolingian script.

After much hypothesis and controversy, it has been concluded that the creation of Carolingian script occurred at about the same time in several centres, and that exchanges of codices and comparisons of styles led in the first decades of the ninth century to a definitive style, developed in the scriptoria of the area between the Rhine and the Loire, the heart of the Carolingian empire, focal points of civilization during Charlemagne's reign (768-814). If the roles of the Emperor and Alcuin in bringing about this writing reform were less direct than was once believed, evidence suggests that it nevertheless owed much to their scholastic and liturgical reforms, that led to the creation of the Palatine school and episcopal and monastic schools throughout the empire, bringing about a renaissance of letters and learning. In promoting education and culture, replacing the Gallic rites with the Roman, urging the revision of liturgical books (23 March 789), Charlemagne promoted the production of a considerable number of codices. This in turn encouraged the development of scriptoria, where, in order to produce rapidly texts that were legible and pleasing to the eye, efforts were directed to developing a clearer writing. The development of the Carolingian script was therefore not spontaneous, but the result of a deliberate programme. This new style soon went into common use.

While the style was developed from Roman writing of the fourth and fifth centuries, the influence of uncials can be seen in its regularity, and in the introduction of its letter *a*. Insular styles, too, played their part in forming the handwriting of Carolingian scribes. Carolingian script, by 820 to 830, consisted of letters with an almost fixed form, small and of even height. Ligatures were rare.

The history of medieval and modern writing begins with the ninth-century introduction of Carolingian script. The subsequent medieval styles, including Gothic, followed the form and the ductus of the Caroline minuscule, and were, indeed, only variants of it. The so-called Roman type-faces frequently used in books today are derived from humanistic scripts of the fifteenth century which are largely based upon the ninth-century Carolingian script.

The second half of the ninth century and the beginning of the tenth were a golden age for Carolingian script. With its clarity and regularity of characters, it was adopted for both books and documents, and became rapidly diffused throughout all the territories of the Carolingian empire, which formed a cultural as well as a political unity. It spread more slowly into Spain, to the British Isles and southern Italy, and entered there not by replacing other styles, but by gradually influencing the local minuscule forms. By the first half of the ninth century, all the writing centres in France, the Rhineland and northern Italy made exclusive use of the new minuscule. The style's introduction to England followed the ecclesiastical reforms carried out by King Edgar (959-975) with the help of St Dunstan of Canterbury, Aethelwold, Bishop of Winchester, and St Oswald, Bishop of Worcester, subsequently Archbishop of York. Ireland, however, con-

tinued to use the Insular minuscule. In Catalonia, even with the establishment of Carolingian power, Visigothic script resisted the rivalry of the Caroline minuscule in the ninth century; but in the course of the tenth, both were used, and by the first years of the eleventh, the scriptorium of Ripoll, in touch with monasteries in southern France, had begun using Carolingian script.

In the other Christian states of northern Spain, religious reform by French Cluniacs opened the way for the penetration of this writing, and its adoption was helped by the abolition of the old national liturgy at the Council of Burgos in 1080, and, around the beginning of the twelfth century, by the movement of French prelates into Castile's bishoprics. The first example of the use of Carolingian script in Castile is a manuscript of St Augustine that belongs to the church of Toledo (1105).

The papal chancelleries abandoned the old curial writing at the beginning of the twelfth century. A conflict took place between the two styles during the eleventh century; while the popes were served by Roman notaries the curial script held its position; but with the admission into the chancelleries of clerks from Germany, France, Italy and other regions around the middle of the eleventh century, the Caroline minuscule began to come into use.

In the imperial chancelleries, Carolingian diplomas were written with the same thin elongated letters, with the bars very high and with many ligatures, that had been used in the Merovingian chancelleries, until, toward the end of Charlemagne's reign and under Louis I (Louis the Pious, 814-40), the ligatures disappeared. With Charles II, the form of the letters approached the classical Caroline forms, with the exception of the high, thin, and slightly inclined uprights.

Carolingian script remained almost unchanged from the eighth to the twelfth centuries, and gave western Europe a unified handwriting, even if each country had its own style, and each scribe his own hand.

Gothic writing

Cultural changes during twelfth century affected both the character of codices and the forms of writing. Until then, books and scholarship had been almost exclusively the preserve of clerics, so much so that writing-schools were found only in monasteries and in the most important bishoprics, and these furnished codices for both religious use and teaching. During the twelfth century, however, culture began to spread increasingly through the secular classes, accompanied by

the foundation of the first universities. Thus was born the scholastic centre at Bologna, which received imperial recognition in 1158, and, later, the University of Paris, which promulgated its statutes in 1215. A number of other universities were founded, and flourished under the protection of popes and princes. Cities were transformed into centres of learning, to which flocked students of every country and social condition. Bureaucracies also required books: local administrations, the legal system with its notaries, the Church with its chancelleries and ecclesiastical offices. The growth of commerce and banking also increased the demand for writing. As in the Roman era, books proliferated, and paid copyists were in demand. In this new environment the appearance of codices changed as they became both luxury and popular books, made for sale. Writing assumed new calligraphic styles in the grander codices, and styles with smaller and less mannered characters for other books. Documents were written in a great variety of cursive styles.

'Gothic' was the name later applied by Italian humanists to distinguish these cursive forms from the *antiqua*, 'antique', by which they meant the Caroline minuscule. The name 'Gothic' had no connection whatsoever with the Goths; rather, it was a reflection of the contempt the humanists felt for the 'medieval' scripts, which they considered barbarous in comparison with *antiqua* which they believed to be Roman. They named it for one of the peoples responsible, in their judgment, for the fall of Roman civilization. The name given to this writing was to be applied also to a style of architecture which aesthetically was similar, and soon followed it.

For simplicity of classification and nomenclature, Gothic may be divided into two styles, 'bookscript' (fig., right; pp. 106, 114), also known as 'textura' or 'textualis', and Gothic documentary script, or 'Gothic cursive' (p. 28, below). The two styles eventually came into collision, creating a hybrid style, the Gothic 'bastard' or 'bastarda' script.

Gothic bookscript

Gothic bookscript was not so much a new style that replaced the Caroline minuscule over a period of a century, but rather, was the same Caroline minuscule during the final period of its development, when it became mannered and hardened. After much research, it has been determined that the reason the Caroline minuscule became Gothic script had nothing to do with questions of style, or even with a quest for

An example of Gothic bookscript of the thirteenth century (from *Chartarium Monasterii Ripalte*, containing copies of monastic documents)

An example of rounded Italian Gothic book-script from a codex of Dante's *Divine Comedy* of the mid-fourteenth century. In opposition to such Gothic script, the humanists favoured 'antique writing': the Caroline minuscule, which they believed to be of Roman origin. Below, an example of fifteenth-century Gothic cursive (from *Commento alla Commedia*, 1475). It includes many abbreviations

beauty (since the work of Carolingian scribes, with their pages of beautifully proportioned letters, satisfied the aesthetic sense as fully as did the finest codices of the Gothic era). Only a technical change in the instrument with which scribes wrote can explain the revolution produced in the art of writing.

The Carolingian script was written with a goose-quill cut with a straight head, producing a 'slanted-pen script'; Gothic book-script was written with the head of the pen cut obliquely to the left, producing a 'straight-pen script'. The writing used in England after the Norman Conquest, during the period of William II (1087-1100), termed 'protogothic', was characterized by irregularity and thick and thin lines which could be achieved only with an obliquely-cut 'straight' pen; thus the theory has been advanced that the new technique originated in England, whence it spread to western France and much of the continent.

The first examples of Gothic appear in northern French manuscripts at the end of the eleventh century and the beginning of the twelfth, such as a Psalter of 1105 in the Bibliothèque Nationale, Paris. By the end of the twelfth century the new script had developed in France its characteristic uneven and angular form, with high, straight letters and thick lines. Gothic art, architecture and writing spread throughout the Christian world, and the style remained dominant until the sixteenth century.

The script was fully developed during the thirteenth century, when it was characterized by well-spaced and well-formed letters and a limited number of abbreviations. From then on the letters become more compressed and acute. Because the principal characteristic of Gothic was angularity, from the fourteenth century it was also called 'Fraktur' (from Latin *fractura*, breaking). Curves were replaced in Gothic writing by acute angles, the letters were very close, perfectly vertical, the lines thick and thin, and very accentuated, the initial lines of the bars developed with thin strokes that became part of the letters to create a strong contrast with the thick lines. Also in the fourteenth century, abbreviations became numerous, particularly in technical manuscripts and those concerning theology, philosophy, law, medicine and mathematics; deciphering such works became difficult.

For capitals in titles, a special alphabet was fashioned, also called Gothic, derived in large part from uncials, with exaggerated curves, thickening, and doubling of ornamental marks and lines.

The greatest development of the Gothic calligraphic style appeared in Missals and liturgical books, and in general in luxury codices, with very large letters of an almost geometric regularity, each word seemingly woven from letters almost like a fabric, for which reason the style was called *textura* by the Germans. It was called *lettre de forme* in France, because the letters were designed with a form or model, and 'black letter' in England.

Less grand codices employed less imposing forms. Italy came to Gothic towards the end of the thirteenth century, after a period of transition. Neither in the most important manuscripts nor in those more modest did it have the heavy appearance common in Germany, but developed large round forms with spacious, well-proportioned letters.

The universities became centres of a flourishing book-production. Bologna, Naples, Paris, Oxford, and the rest, attracted great numbers of expert copyists. Sharing common concerns they formed during the course of the thirteenth century the variants of Gothic minuscule characteristic of the great university centres.

When the humanists revived Caroline minuscules during the fifteenth century, Gothic script remained in use in Italy for liturgical books, and in Germany, where humanism never gained a real hold, Gothic continued, and is still in occasional use today.

Gothic cursive

As well as book Gothic, the thirteenth century saw the growth of Gothic cursive, much in use for deeds, letters, registers and account books, but also for codices, particularly those in the vernacular. This style was distinguished particularly by angularity and ligatures between letters. Each word was written without lifting the pen, creating ligatures, while high lines with loops and curlicues grew from the bottom or top of the last letter of each word, and joined abbreviation signs. The widespread use of Gothic produced a great variety of types, individualized by each country and chancellery, as well as by the writer's personal style.

Yet another type of cursive was that used in the books and correspondence of Florentine merchants. Called 'mercantile minuscule', it was less formal, simpler and written more rapidly, producing even more ligatures.

The humanistic reform

In its more perfect expressions – the *rotonda Italiana* and the French *lettre de forme* – Gothic writing reached during the fourteenth century the height of elegance. The

pages of luxury codices offered pure pleasure for the eye, but they were not easy to read, and represented much labour on the part of scribes. Thus, this perfect expression of a style carried within it the seeds of its destruction.

Petrarch was the first to declare his displeasure with the state of writing, and to call on writers and scholars to join in a common effort to restore writing to its expressive function. He proposed a sober and neat style that would also please the reader's eye, and offered as an example small minuscules – clear and elegant, without excessive irregularity, even if still Gothic, as can be seen from his signatures.

This handwriting reform was the true work of the humanists, who in their travels round the libraries of the monasteries discovered innumerable codices of classical authors that had been written in Caroline minuscule during the ninth to the twelfth centuries. They copied many of these texts and imitated the handwriting which inspired their admiration, and which they called *antiqua* as though it were the writing of the Romans. The humanists' imitations were based on the most perfect form of the Carolingian script, predominant in Italy in the eleventh and twelfth centuries, and their reproductions of this style were so accurate that at first sight it can be difficult to distinguish the copies from the originals.

The humanist Ambrogio Traversari (1386-1439) offered his brother various suggestions for achieving good imitations. Another to express love for the old styles was the Florentine Niccolò Niccoli (1364-1437), whose greatest joy, wrote a contemporary, was 'to see a beautiful old letter, which he would not consider pretty and good, if it were not in the antique form with many dipthongs; and regardless of how good it might be, no book pleased him unless it was written in the antique style'. An active preference was shown by Poggio Bracciolini (1380-1459), famous as a discoverer and copier of classical texts. In 1403, having been asked by Coluccio Salutati to copy Cicero's *Philippics* and the *Orations against Catiline* from an example by Jacopo da Scarperia, he used his skill to create a perfect imitation of the Carolingian style.

The earliest examples of the style called 'humanistic *libraria*' are from the first years of the fifteenth century. Bracciolini's work received unconditional praise from fellow Florentine humanists, who urged others to learn the style, and ordered from copyists transcriptions of codices into it. Thus humanism was both a cultural and an artistic force.

Florence is considered the cradle of this writing reform; books in the new style spread from that city, and the style was admired and copied in other Italian centres. It is only after the mid-fifteenth century, however, that one can speak of humanistic writing schools outside Florence.

Humanistic writing had appeared in two types: round or 'rotunda' (p. 133), and cursive (p. 149, below). The style was used by those who also wrote in Gothic, so that there were reciprocal influences between the two styles. Fifteenth-century copyists added elements from Gothic to the 'round humanistic' style, which reproduced in its general appearance the most advanced Carolingian script. During the second half of the fifteenth century the humanistic style reached perfection in the various types: those used by the teachers and scribes who had created it; the variations introduced by those who came to Italy from other parts of Europe and were drawn to use it; and the group styles of copyists working under the guidance of teachers with their own personal styles. Some of the personal style-characteristics of the writing of Julius Pomponius Laetus, for example, were passed on to his pupils, so that through his school he had a considerable influence on the development of Roman humanistic writing during the late fourteenth century. Even when, with the invention of printing, handwriting lost much of its importance, the round humanistic script lived on, appearing also as a font of printing characters, 'Roman' type, with humanistic cursive forming the 'italic' typeface.

The first examples of the cursive humanistic style appeared about ten years later than the round. It is of uncertain origin, deriving either from Italian Gothic or from cursive copying of the round humanistic script. The cursive humanist script was light, drawn with a sharp pen, at first upright and then forcefully inclined to the right, with all the letters joined. It was used primarily in letters and documents – those of the papal chancellery from the end of the fifteenth century or early sixteenth offer the best examples – but it appeared in books also.

Abbreviations

Abbreviations represent an important element in the evolution of writing. Abbreviations were used rarely or frequently, sometimes very frequently, according to the period and particular writing-style, but – and this must be emphasized – no style of medieval Latin handwriting was totally without at least some abbreviations. They were used

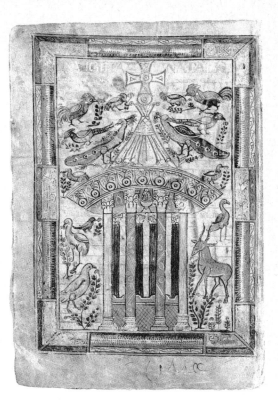

A full-page illumination from a Rhenish Gospel-book (c. 781-3), made by the copyist Godescalc for Charlemagne and his wife, Hildegarde. The symbolic design commemorates the baptism of Charlemagne's son Louis I in S. Giovanni in Laterano, Rome

The technique of painting miniatures is described in the fourteenth-century codex *De arte illuminandi*, the work of an Italian monk, perhaps a Neapolitan. Below is seen a page from that book (Naples, Biblioteca Nazionale)

both to make the work of writing easier and to economize the use of writing-materials. Two systems of abbreviations were employed: one involved representing a word with a conventional sign, the other, shortening words by one, two or more letters. The first of the two methods, used in particular to record political and courtroom speeches, was similar to modern stenography, and was known as *notae Tironianae* ('Tironian notes') because it was supposedly invented, or at least first applied to oratory, by Marcus Tillius Tiro, Cicero's freedman. Because Tiro was an expert stenographer, Cicero made him a secretary. Tiro's system, based on just over two hundred signs, was later extended and perfected. Its use then spread both among citizens and in public administrative offices. Students adopted it to take notes. The system was further modified, based on the principle of dividing words into syllables and expressing each syllable with a sign. This syllabic tachygraphy was further developed, but Tiro's symbols remained in limited use.

Reducing the length of words by omitting letters could be done in three ways: by the use of 'suspension' or 'initials', i.e. by indicating one or more of the first letters of the word only (*inc.* for *incipit*; *a* for *anno*); or by 'contraction' involving joining the beginning of a word to its end leaving out the intermediate letters (*oia* for *omnia*; *tpre* for *tempore*): or by 'aphesis', used more rarely, involved writing a few letters from the middle of the word only ($\frac{o}{g}$ for *ergo*, $\frac{i}{g}$ for *igitur*). The oldest of the 'suspensions' were used by the Romans. *Notae iuris* were abbreviations used in law books, beginning around the second century; contractions were used for *nomina sacra* in religious texts.

Abbreviation signs in codices

Three basic abbreviation signs were used: the period (full stop), the dash and the superscript letter. These signs were used with either an indeterminate meaning, to indicate only that a word had been abbreviated, or with a relative, determinate, meaning, to indicate which element is missing, such as *p* used for *per*; *p̄* used for *pre*.

The period, the oldest abbreviation sign, was for a long time the only form used in books (*B.* for *bus*; *Q.* for *que*). Dashes were first used as a sign of differentiation for numbers; they were placed above a numeral to indicate a thousand or multiples of a thousand. The dash began to appear as an abbreviation during the first century, and came into widespread use for inscriptions during the second and third centuries. The

oldest examples in documents are from the third to fourth centuries. The use of the dash increased with the introduction of contractions, since it was a more suitable indication sign than the period. The dash had various meanings: placed over a vowel, it took the place of an *m* or *n*; written in a wavy form, it was used with the value of *r*, with or without a vowel; over a *t* it signified *ter* or *tur*; cutting across the second line of the letter *r*, it indicated *rum*. Superscript letters were vowels or consonants that indicated the suppression of one or more letters: $\frac{a}{q}$ for *qua*; $\frac{o}{r}$ for *ratio*). Special signs were not true abbreviations, but marks used to facilitate faster writing, and were conventional, or derived from tachygraphy (pp. 106-107). Among the best known are *ff.*, used in place of *digestum*, a common word in juridical works, and probably a modification of the word written out; ꝯequivalent to *con*; ، equivalent to us; ꝛ equivalent to *et*, all of them derived from tachygraphic signs.

Punctuation marks

Several systems of punctuation were devised in antiquity to assist in oration. Punctuation signs to assist in silent reading appear only in the early Middle Ages. Together with the spread of the minuscule styles came the invention of new signs, and the search for perfection characteristic of the Carolingian period inspired a greater care for punctuation, which was used both to make reading easier and to assist comprehension. Even then, however, no single codified system was established, and the use of punctuation marks varied from manuscript to manuscript. Marks used frequently during the ninth century include a period placed in the middle of the line (·) to indicate a brief pause; a period followed by a comma (.,); a period over a comma (;); and two periods above a comma for the final pause (˙,˙). The rules of the thirteenth-century *ars dictandi* stipulated a period and a solidus (./) for a brief pause; a period or two periods (. or ..) for a middle-pause; and a period and comma for the final pause (;). It is important to remember that in classical and medieval manuscripts, punctuation did not serve the purposes it does today; instead of distinguishing logical or grammatical elements, it was employed to make the rhythms of the phrases clear.

The question mark, in regular use from the eighth century, appeared in various forms. The best known of these was a period over which was drawn an obliquely curved line. Rarely used, the exclamation mark appeared in various forms. The mark used to

indicate a paragraph, i.e. to divide the parts of a text, was of ancient use: originally it was a capital Greek letter gamma (γ), then a *C* or a *K* (the first letters of *Caput, Kaput*); from the capital *C* of the thirteenth century were derived the symbols adopted by printers, among which is the modern *O*. For deletion marks a period was sometimes used, applied with care so as not to destroy the elegance of the page with cancellations. Marks used to indicate sections needing eventual additions were placed in the margin beside them. Accents were placed like apices on long monosyllables and as tonic signs. From the use of accents was derived the habit of indicating the modulation of the words for singing.

Numerals

Until the thirteenth century, Roman numerals were used exclusively in Latin manuscripts. Originally from India, Arabic numerals consisted of the initial letters of the names of the numbers in Sanskrit, and Arabic works on arithmetic had used these numerals from the eighth century. This system of writing numbers then passed into use in Europe. The first examples of Arabic numerals in Latin codices are from Spain, in two manuscripts in the library of the Escorial dating from 976 and 992. In other parts of Europe, Arabic numbers were known but not used in arithmetical calculations; it was the mathematician Leonardo Pisano who spread the way of performing addition, subtraction, multiplication and division with Arab numbers, compiling his *Liber abaci* in 1202. However, these numerals came into general use only in the fifteenth century. Their use was for a long time prohibited in official account-books because they seemed easy to alter.

Miniature and ornament

The history of the illustrations and ornaments used in books through the centuries is intimately related to the evolution of the major arts, so much so that a complete panorama of the development of book illustration would present perhaps one of the simplest initiations into history of art in general. The illustrated book constitutes one of the most refined products of our civilization, giving impetus to as well as receiving inspiration from other fields such as sculpture, tapestry, glass and enamelwork.
The study of the illuminated manuscript began only during the last century, when the beauty of the so-called minor arts was reco-

gnized, and research began into the artistic personalities who dedicated themselves to the decoration of books. This study demonstrated the importance of the miniature as artistic expression, and its role in the general history of culture. The illuminated book represented a unity of writing, decoration and illustration. Its portability allowed it to contribute to the diffusion of culture and taste.
The need to accompany a narrative or technical text with explanatory pictures gave rise to the illustration of books, first among the Egyptians, who used illustrations in the papyri of the *Book of the Dead*, and later during the Graeco-Roman period, when the impulse was more aesthetic than informative, even though still basically practical.
The earliest examples of illustrations in both papyri and codices interrupt columns of writing, and they are therefore small-format. The full-page illustration arrived only with the codex, in which the picture's format was provided by the size and shape of the page.
The desire to emphasize the first letter of a text, or section of a text, led to the decoration of initial letters, which were originally distinguished only by their larger size. Medieval artists took these initial letters and made them into a decorative element with distinct features.

Techniques and tools

The term miniature is derived from *miniare*, which means 'to colour in red': *minium* is the Latin name for cinnabar or mercuric sulphide. This red, used in wall-paintings at Pompeii, was put to common use colouring the initials of early codices, hence its name became the term used to indicate pictures in manuscript books. During the eleventh century in Europe the verb *alluminare* (to illuminate) came into use in Europe. The word was used by Dante (*Purgatory*, XI, 79-81):

Oh! diss'io lui, non se' tu Oderisi,
L'onor d'Agobbio e l'onor di quell'arte
Ch'alluminare chiamata è in Parisi?

Art thou not Oderisi? art not thou
Agobbio's glory and the glory of that art
Which they of Paris call the illuminator's skill?

The verb 'alluminare' may mean to paint using a substance obtained from the reaction of *alum* crystals with vegetable colorants, such as extracts of madder or orris root. The Latin *alumen* is perhaps derived from an ancient term *al-lu-ha-rum*.
We learn of the techniques of illumination

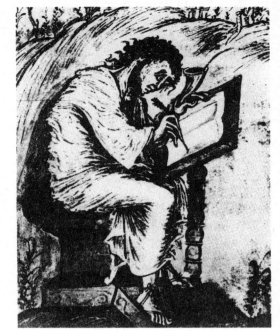

The tools used by the miniaturist or illuminator included a remarkable number of objects. The colours were kept in pots, seashells, or ox-horns. Such a horn can be seen in this ninth-century Gospel-book from Rheims, with one of the Evangelists writing at an inclined desk

from two sources: from uncompleted manuscripts that allow us to observe the interrupted stages of the work, and from the directions compiled by medieval authors. These describe the tracing of the design with ink or lead pencil, the laying down of a first layer of colour, and the painting of the objects and figures. The stages of work had to be interrupted by long breaks to allow drying to take place. Gold was applied first, whether as liquid gold or gold leaf. Gold leaf was applied on a gesso foundation, and was smoothed and polished by burnishing.

The technique of the miniaturist is described in a fourteenth-century codex, *De arte illuminandi* (Biblioteca Nazionale, Naples; p. 30), written by an Italian monk, perhaps a Neapolitan. From this work and from other sources we gain a detailed picture of the procedures followed by medieval illuminators. The scribe would prepare his own colours, his glues, tempera, leaves of gold or silver, and sometimes even make the burnishing tools and other instruments. It was the relative isolation in which artists worked, whether or not they were members of a religious order, which forced them to perform for themselves all the ancilliary operations, even to preparing all the substances required.

Before writing or painting on bare or previously tinted parchment, which is by nature somewhat oily, the artist needed to prepare the surface to receive ink or colours. This could be done with a light size composed of clay or a colourless powder mixed in gum arabic or fish glue (isinglass), or with a mixture of ox-bile and egg-albumen, or by rubbing the surface with cotton-wool dipped in a diluted glue-and-honey solution.

Of especial importance for the illuminator were the pens and brushes of various forms, size and quality. The brushes used for illumination were made of hairs from the tails of squirrels (vair) tied into a bunch and inserted in a quill as a holder, the type of feather – of a vulture, goose, hen or pigeon – being chosen according to the size desired. This brush was then supplied with a wooden holder tapered to a point at the other end. The brush-hairs could either be cut to equal length with scissors, or be shaped by rubbing on porphyry to wear the tuft to a fine point. Writing and designing borders with ink or fluid colours called for the use of the classic goose-quill.

The sketch of the design was executed with the lead stylus, a point made of an alloy of two parts lead to one part tin, inserted in a wooden holder. Cancellation of marks was done by rubbing with bread-crumbs, and the residue was removed with a hare's-foot duster or tuft of cotton wool. A series of knives with various blades (*cultella*) was used to sharpen pens, to cut parchment and the leaves of gold and silver, to scrape the dust of the ground colours from the porphyry stone, and to scratch away errors or marks on the parchment. Other tools required included the square and the ruler, and sometimes compasses. Calami for black or red ink were carefully placed in cotton-wool to avoid blunting. The equipment included a cloth (*colatoria*) for straining liquids or colours, or conical filters (*lingua canis*), or a small filter bag (*sachecta de tela*). The mortars and pestles used to grind the mineral colours or to prepare mixtures were made of marble, serpentine or porphyry. Very hard minerals such as lapis-lazuli and red jasper were crushed in bronze mortars (*mortarium aereum, mortarium brunzi*), and precious metals in a small gold mortar (*mortariuolus aureus*).

The preparation and storage of liquids and solids required a range of glass or terracotta pots and phials, ox-horns, leather sacks (for storing colours), seashells and tortoiseshells. Polishing-sticks for burnishing gold or silver-plating, and also for smoothing pages of parchment, were stored away from humidity, and when used had to be absolutely dry and warm. The remaining equipment used in the illuminator's workshop included boards, marble slabs on which to spread and cut pages, and lecterns or desks. Preparing for a gouache illumination involved the use of binding agents and fixatives for the colours, colloids made of animal or vegetable substances still in use today. One binding agent frequently used during the Middle Ages was gum arabic and egg-albumen; less frequently used was isinglass. A mixture might include sugar, honey or gum arabic and albumen, which with honey gave a brilliant, glass-like finish to the work when applied in thin layers over the colours. To these solutions were added such preservatives as realgar, camphor, cloves, even vinegar or oil of garlic. Ear-wax was used to remove the froth from beaten egg-whites. Ox-bile, as mentioned, was used to prepare the parchment surface for a watercolour, but was also applied to enhance the colours, and it was used in mixing temperas. Mineral or sugar crystals were used to prepare the colours based on vegetable extracts.

Gold and silver had been used to embellish pictures from antiquity – even, though rarely, on Egyptian papyri. In the Byzantine period, gold and silver embellishment of books became more usual. Gold and silver were used for broad backgrounds, or for writing on coloured parchments.

The *Schedula diversarum artium* by Theophilus is an extensive encyclopedia of medieval artistic techniques as practised in monasteries. The first of the three books that compose the work (of which the first page is illustrated here) deals with illumination, and includes detailed precepts

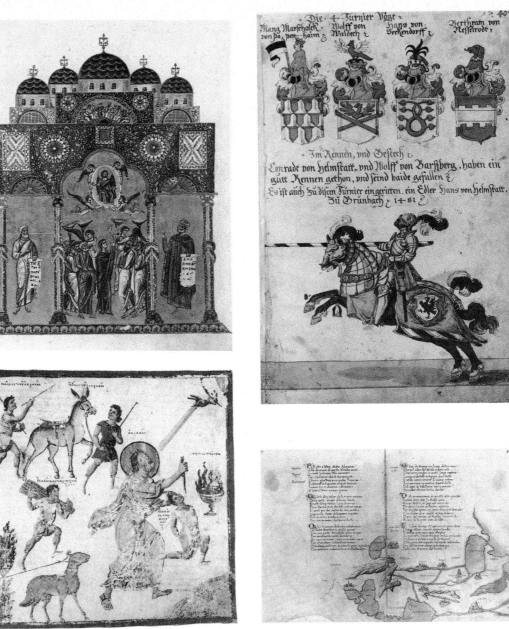

In order to make metals adhere to the rougher kinds of parchment, illuminators needed to develop effective mordants; there are at least forty different formulae for gilding and silvering, and the variations usually involve the mordant used.

At an early period, however, the method of decorating parchments with powdered gold and silver was learned. Illuminators also sought ways to imitate the effect of gold with cheaper substances, of which the most important was mosaic gold, an alloy of copper and zinc. The common substitute for silver was tin-plate, burnished, and varnished with albumen or other transparent substances to protect the metal from oxidation without dimming its brilliance.

Every colour used by the medieval illuminator had its own characteristics. Ultramarine, the prettiest and most durable of the blues used in antiquity, was obtained – as it had

been in the Mesopotamian civilizations and in Egypt – by grinding the semi-precious stone lapis-lazuli, which during the Middle Ages was taken from the mines of Badakshan, described by Marco Polo in 1271. It was called ultramarine because it was imported from the Levant, and was distinguished from the cismarine, or German blue. Until the twelfth to thirteenth centuries, painters used lapis-lazuli that had been simply ground and washed; later, a paste was made from the powdered mineral with wax, oils and resins, and the liquid ultramarine separated out with ash lye so that the impurities remained in the wax. For red, brasilium was widely used during the Middle Ages. Before the discovery of America, Europeans imported from the East Indies the wood *Caesalpinia sappan*, which was called *brasil* or *brezil* following Arab terminology. Later the name of this wood was given to the

The art of illumination of manuscripts offers a vast variety. At lower left is one of the eighteen full-page miniatures of the *Topografia cristiana* of Cosmas Indicopleustes (ninth century), made in the style of Constantinople and based on an Alexandrian model probably of the sixth century (Vatican Museum). At upper left is a page of the *Homilies* of Jacobus (James), monk of Kokkinobaphos, an important Byzantine codex of the Comnene epoch; the scenes from the life of the Virgin were inspired by apocryphal stories of which they are the only representation (Vatican Museum). At top right is a page of the *Book of Tournaments*, a German manuscript of the fifteenth to sixteenth century; above a galloping knight in full armour are coats of arms with elaborate crests of the four noble participants in a tournament (Vatican Library). At the bottom right are two pages from an illuminated codex, *Sfera*, by Goro di Stagio Dati, with a map showing the Black Sea, the eastern Mediterranean to the Persian Gulf and the Indian Ocean (Florence, Biblioteca Riccardiana)

Above: The unfinished opening page of the Gospel of St Luke from an English manuscript of the mid-twelfth century. The letter Q from the first word, *Quoniam*, is completed by a fantastic animal, represented in outline but not coloured (London, British Library)

territory in South America: Brazil. This red Oriental wood contains a glucoside that, decomposing, becomes *brasiliana*, which oxidises to give the water-soluble red substance. During the Middle Ages it was prepared with urine, and the colour was precipitated with alum crystals, with procedures more or less complicated.

Medieval authors did not always apply the same names to the identical substances, being ignorant of their constituents. Classification was based almost entirely on appearance, producing misleading analogies, and the nature and function of some of the substances used by illuminators remain even today a mystery.

After the writing was finished, the illuminator would use the lead stylus to trace the main outlines and the folds of the garments, and to indicate the areas of dark and light. When the sketch was complete a mordant was applied, if required, then the gold leaf was laid on, smoothed and burnished. The illustration was drawn and painted in a manner more or less elaborate, according to the current style and the availability of colours.

At first (from the fourth to fifth centuries) the usual kind of background was monochrome or gold, and against this the illustrations, usually simple paintings using few colours, stood out boldly. Techniques were refined during the Carolingian period, and remained little changed throughout the Middle Ages. The delicacy and transparency typical of illuminations was displayed in an increasingly wide range of colours applied in ever more complex layers.

A work by Theophilus, *Schedula diversarum artium* (Chs. 3-14), sets out highly elaborate rules for the colouring of miniatures that were followed with more or less fidelity even after the twelfth century:

(1) Prime the bare-skin parts [of the parchment] using a skin-colour.
(2) On this background, using a greenish tone, draw the eyebrows, eyes, nostrils, mouth, chin, the hollows around the nose, the temples, the wrinkles, the outlines of the faces, the young men's beards, the joints of the hands and feet.
(3) With skin-colour deepened with cinnabar [*rosa prima*] slightly redden the cheeks, the lips, the lower part of the chin, the forehead-wrinkles, the temples, the bridge of the nose, the top of the nostrils, the joints.
(4) With skin-colour lightened with white lead [*lumina prima*] place light tones on the eyebrows, the nose, and with fine lines, round the eyes and the lower part of the temples, and in the centre of the neck and in the curves of the hands, feet and arms.
(5) With grey [*veneda*] made of white and black, fill in the pupils; with a lighter grey paint the eyes beside the pupils, and with pure white indicate the borders between this colour and the pupils; then shade with water.
(6) With dark olive-green [red ochre and green earth] fill the area between the eyebrows and the eyes, the lower part of the eyes, the under-chin area, the space between the mouth and chin, the curls of the young men's beards, the middle of the palms of the hands near the thumb, the feet over the minor joints, the faces of children and women from chin to temple.
(7) With red [made with *rosa prima* and cinnabar, or *rosa secunda*] outline mouth, cheeks, neck and forehead, and indicate the folds of the palms and the joints of the limbs.
(8) If a face seems too dark, lighten the skin-colours with white [*lumina secunda*], tracing everywhere under the chin.
(9) With two black-and-yellow-ochre mixtures (the one more ochre, the other more black) prime the hair of the children and youths respectively; heighten with *lumina secunda*. Prime the hair and the beards of the old men with grey [white lead and black], add to the grey a little black and red, and heighten with white lead.
(10) With red-ochre mixed with a little black [a colour called *exedra*] outline the pupils, trace under the chin, between the mouth and the chin.
(11) With red ochre indicate the eyebrows, finely tracing between eyes and eyebrows and lower part of the eyes; on faces seen frontally trace the nose's shadow, according to whether the light is from right of left; outline the forehead and jawline of old people.
(12) With black make the young men's eyebrows, without completely covering up the red; outline eyelids, nostrils, the sides of the mouth, ears and fingers.
(13) Outline the body and fingernails with rose-red ochre.

During the late Middle Ages miniature painting increased in sophistication with the modelling of forms frequently performed over the background-colour with a pen. The use of diluted colours and fine pens gave the artist new freedom. When the painting was complete, the illuminator varnished the work with gum arabic and albumen, to impart a brilliant finish and protect its delicacy.

Styles and schools of illumination

The medieval codex in the West has three distinct decorative elements: the initial letter, the border and the illuminated picture or miniature, which are often all found on the page together (p. 121).

The custom of ornamenting manuscripts with elaborate initial letters was already widespread by the seventh and eighth centuries. In the northern, Insular Gospel-books (pp. 54-55) the letters and area round them are decorated with ribbon interlace, spirals, foliage and stylized zoomorphic motifs in colours such as yellow, red and green. The rich embellishment, sometimes occupying the whole page, was more the work of calligraphers than illuminators.

Merovingian manuscripts (those of Gaul and Germany, *c*. 500-750) were decorated in bright colours (p. 56, left), and this decoration was elaborated along with the diffusion of the Caroline minuscule during the Carolingian renaissance (eighth to tenth centuries). Various schools can be distinguished, some of which reached their fullest development during the first half of the ninth century, others in the tenth century. Among them, the Trier school produced a group of imposing manuscripts, Gospel-books or Psalters, for Charlemagne and members of the imperial family that are characterized by rich borders with foliage, birds, jewels, and the frequent use of gold. The Rheims school (p. 71) developed an 'expressionist' tendency. The Palatine school, centred in Aquisgranum (Aachen) is typified by a sober style with a more realistic depiction of the human figure (p. 119, left). The Tours school represented a variety of subjects, in both religious and secular works, with extremely lively ornamentation, but of a classical sobriety in the harmony of the design (Bible of Charles the Bald, p. 75), particularly in the initial letters. The pages were frequently framed with columns and arches, with Oriental lamps, vases or crowns.

Under the Ottonian emperors in Germany (919-1024), illumination was already evolving into the Romanesque, as at Reichenau (pp. 83, 102 right) and the Rhine schools of Echternach and Einsiedeln (p. 93). These schools were influenced by the Irish and Northumbrian illuminators whose motifs included dots arranged in lines around the initial letters, or forming decorative patterns (pp. 54-55). Insular motifs are also found in Beneventan codices, together with Oriental, and, in particular, Byzantine influences. There are large polychrome letters in yellow, red, green, blue and violet, with interlace ornament and animal motifs, particu-

larly dogs. The golden age of this school, best seen at Montecassino, was the eleventh century (p. 95); the colours had become even richer, gold was used profusely, and the figures displayed a liveliness of expression and movement. The style declined during the twelfth century, and by the thirteenth century the school had lost its special characteristics. The Spanish Mozarabic school (tenth to twelfth centuries) used yellows, reds, blues, and greens to create a decorative effect with bizarre borders, and with the livelines of folk art in the figures

The small example of a book-cover opposite below is a fifteenth-century Roman Missal made for Cardinal Ippolito d'Este; it is in yellow and red brocade with a floral design, and has gilded silver corners, studs, and clasps. The cover below is a fifteenth-century binding of wooden boards covered with dark-brown leather with gilt stamped designs. In the shield at the centre is a raven on a golden branch. It is the coat of arms of Matthias Corvinus, for whom this book – a Latin miscellany – was made

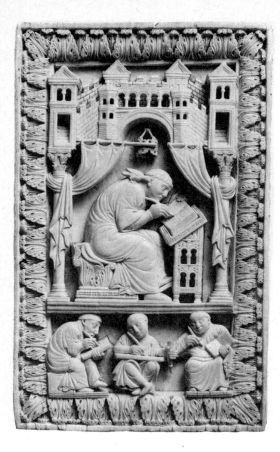

Ivory book-cover of the tenth century. St Gregory the Great writes a text; below, it is replicated by three copyists (Vienna, Kunsthistorisches Museum)

and fantastical animals: for example in codices of the Commentary on the Apocalypse by Beatus, Bishop of Liebana (pp. 98, 99). The illumination of the Reichenau school (p. 82) was influenced by Byzantine art (p. 102, below), with stately figures on gold backgrounds, in luxury codices. The Winchester school in England developed an unmistakeable type of figure – elegant, elongated, with complex drapery (p. 85). The Salzburg school in the eighth century was characterized by the Insular style, modified by Carolingian and Byzantine influences (p. 61).

Until the twelfth century the art of illumination was generally practised by the clergy. Even during the Carolingian and Ottonian periods, characterized by productions of luxury codices under the patronage of emperors, illuminators' workshops were confined to the monasteries. With the founding of universities and the secularization of book production, the art of illumination became a profession practised by lay professionals who worked on commission, presenting bills for their work – so much for an illustration, a vignette, or a letter. Several collaborators were involved in the production of an illuminated manuscript, working under the head of the atelier or workshop. Beginning in the fourteenth century, an illuminator might be given the secondary parts, such as decorative letters and borders, while a painter was charged with executing the most important work, the illustration or miniature. Nevertheless the painter might have limited personal initiative. A repertoire of drawing models existed; and for the subject and composition, the illuminator might have to content himself with following instructions written in the codex (by the chef d'atelier, with clerical guidance) such as 'hic ponatur papa genuflexus, hic ponatur una mulier in habito viduali' ('Put here a kneeling pope; put here a woman dressed as a widow').

From the thirteenth century, ornament was increasingly applied to secular works: statutes, literary texts, romances of chivalry. The frames around initial letters gradually sprouted branches that became known as bar borders as they lengthened to surround the entire page in ornament (p. 125). The figures drawn inside large initial letters also developed, until they were elaborated into small scenes – 'stories' or ystoires, hence the term 'historiated' initials – often pictures of great quality (pp. 137 left, 146-7). Famous schools of illumination were those of Bologna, Florence and Paris.

In the fifteenth century, illumination flourished splendidly in Italy, above all in the schools of Florence, Siena, Venice, Milan, Ferrara, Urbino and Naples – which is to say, at the Renaissance humanist courts. There were important European schools, also, in Flanders, France, Germany and Spain. It is impossible to describe in brief the richness, variety and artistic level of European illumination during the Early and High Renaissance: it is an art linked to the great painting schools of the period.

Binding

The evolution of binding is closely related to the changing form of the book. As noted, both the Greeks and Romans enclosed papyrus scrolls in boxes or cases. During the first century AD, papyrus sheets or parchment quires (gatherings) were inserted between two wooden tablets, or were covered with pages of papyrus glued together. The earliest examples of this type of binding are from the Middle East and Egypt, where the dry climate favoured their preservation.

Various methods were used to sew together the folded sheets and attach them to covering boards. A thread was passed through the pages a few millimetres from the fold, for instance, as is still done with Chinese books. Another method uses two needles and thread, firmly joining the gatherings, as in Coptic Egypt and Ethiopia, examples from which have survived. The seventh-century Gospel-book of Queen Theodolinda of Monza (which has a cover made of a thin sheet of gold with eight cameos arranged in the form of a cross) had the quires sewn to doubled ribs formed by leather cords placed along the spine. Until the eleventh century these cords were brought together at the front plates before sewing. Later the two boards were fixed after the sewing.

With the gathering fixed to the boards, the binding could be covered in different ways. Luxury books, particularly those with religious texts, might be covered in gold, with enamel-work or, from the Carolingian period, precious stones. Consular diptychs were covered in ivory. Decorated leather or fabric was used to cover the more ordinary manuscripts. Studs and corners of metal protected the book-boards. Books were stored horizontally on shelves, hence titles were written along the length of the spines, or on labels applied to one board.

The earliest surviving leather binding is thought to be the seventh-century Stonyhurst Gospel (Stonyhurst College, Lancashire, on loan to the British Library). The binding is blind-stamped (i.e. not gold tooled) with some decoration. At first, motifs were stamped on the leather using punches, as for decorating copper or silver at the

period; but later, leather decoration took a separate course. The decorative motifs used followed those used in contemporary illumination, whether Romanesque or Gothic – foliage – ornament, animal motifs, scenes, coats of arms, etc.

Overall gilding of stamped leather with the application of liquid gold had long been practised by Islamic craftsmen in Persia, Egypt and North Africa. An entirely different method of gilding was known in Morocco as early as 1256: this was 'gold-tooling', in which gold leaf was applied to book-covers by impressing the leather with a heated tool. The technique was in Persia by the mid-fourteenth century, and arrived in Venice shortly after 1450, to be used for ornament of circles and points of gold, and in Naples about 1475, where the binders of the court of Aragon applied the technique for decorations of foliage and flowers.

In the fifteenth and sixteenth centuries, during the Renaissance, the bindings of classical and other secular as well as religious works received decorative attention. Besides leather, codices were covered in silk, damask or velvet, or were embellished with gold embroidery, or had decorative metal bosses and clasps for closing. The earliest European gold-tooled leather binding so far identified is a copy of Strabo's *Geographia* (now in the Bibliothèque Rochgude, Albi), written in Padua in 1459 for presentation to King René of Anjou.

The Renaissance courts of Europe established libraries in which every volume was richly bound, notably those of the Aragonese Kings of Naples; Matthias Corvinus, King of Hungary; the great Italian families of the Medici, the Malatestas, the Viscontis and the Sforzas, the Estensis and the Gonzagas; in France, the Duke of Berry and the Dukes of Burgundy; in Spain, Alfonso XI of Castile, Peter IV, John I, and Ferdinand and Isabella the Catholic.

Book production and commerce
Scribe and scriptorium

St Benedict's Rule, which established every particular of the monastic life in the sixth century, prescribes (Ch. 48) that during Lent '*accipiant omnes singulos codices de bibliotheca*' ('each shall take a codex from the library'), and shall daily read '*a mane usque tertiam plenam*' ('from the morning until the third hour'). Every monastery was assumed to have a library during the Middle Ages. The saying went that '*claustrum sine armario est quasi castrum sine armamentario*' ('a cloister without a book-room is like a military camp without weapons').

The room in a monastery set aside for writing was called the scriptorium, and the monks who worked in it were *scriptores*. They divided among themselves the work given to them by a monk who was in charge of the production. One monk might correct the text written by another, a third prepare the ornaments, and others again prepare the parchments and inks. A monastery might have several scriptoria, each with a number of copyists working, or there might be separate cells each with one copyist, or the work might be done in the cloisters. As F. Barberi describes the scene: 'Let us imagine a scriptorium: a more or less large room, according to the number of amanuenses, who, however, do not all work together. The director of the room distributes the work: rarely is a manuscript given to only one amanuensis; rather, several monks work on the same text, exchanging portions. Generally the quires to be copied are distributed to amanuenses who must pay careful attention to the order to ensure that each ends his part on the same word. The director gives special attention to beginners; he frequently writes a line of a page so his model shall inspire their work; he must also review and correct the work done in the scriptorium, and control the quantity of materials used.' Sometimes the humble wielders of the pen sought relief from their labours: 'In the silence imposed on them, some amanuenses permitted themselves the diversion of writing brief notes in the margins of the manuscript: an Irish monk uses his own language, unknown probably to the director of the room, to allude to the director's severity and, certainly responding to one of the director's observations, writes: "This page was not copied slowly". Others at Laon wrote such humdrum comments as: "The lamp gives bad light", "It's time for us to get to work", "This parchment is certainly hairy", and "I don't feel well today". Writing hour by hour, 'with eyes intent and the neck aching', led to the comment that: "Three fingers write, but the entire body toils. Just as the sailor yearns for port, the writer longs for the last line."

Monks usually worked for their church and their monastery, but there were communications between monasteries, even the most distant. Manuscripts were lent by one monastery to another, and served as models. For example in 860 the Abbot of Ferrière asked the Pope to send a copy of Cicero's *De Oratore* and Quintilian's *Institutio Oratoria*. And since, even then, books lent were not always returned, precautions were sometimes taken. Notker of St Gall assured the Bishop of Sion (Switzerland) that he had

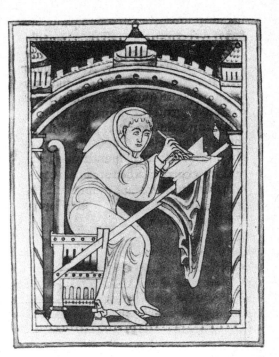

A monk at work, creating a manuscript book. This is Laurence, Prior of Durham during the mid-twelfth century. He holds a pen and eraser. The material he is writing on is supported by a peculiar device attached to his chair.

Page with the Office for the Dead from a Book of Hours made in Bruges (London, Victoria and Albert Museum). It is dated around 1520

lent two books of Cicero to an abbot only after having obtained as pledges other books of greater value. Even though there was no true commerce in books during the Middle Ages, there is evidence that books were sold. Charlemagne provided that his wonderful library should be sold at his death, and the money be distributed to the poor; the sale of these books caused a sensation.

Lay-copyist, bookseller and bibliophile

With the decline of copying in monasteries around the thirteenth century and the development of secular book-production, even the monasteries made use of paid writers: it is recorded that at Abingdon in 1100-35 the abbot instructed '*scriptores, praeter claustrales, qui missalia, graduali, antiphonaria, lectionaria et caeteros libros ecclesiasticos sibi scriberent*', 'copyists, other than those of the cloister, who wrote for him Missals, Graduals, Antiphonals, Lectionaries, and other liturgical books'. During the thirteenth century the librarian of the monastery of St Geneviève in Paris was given permission to engage writers for pay. In Italy, a class of professional writers had existed even during the early Middle Ages, for the schools, universities and notaries had led to its development. Evidence is offered by Gerbert, later Pope Sylvester II, who wrote in the tenth century: '*Nosti quot scriptores in urbibus ac in agris Italiae passim habeantur*' ('You should know how many writers there are in Italy, spread in the cities and the countryside').

Upon the foundation of the universities, a true 'book-business' began, although of a rather specialized nature since it was chiefly scholastic. Books once again became objects of commerce. The secular copyist and bookseller reappeared, though in a different guise. In Bologna, for instance, during the second half of the thirteenth century, many people took to copying books, women among them. Many of these copyists were Tuscans, particularly from Arezzo, where from the first years of the thirteenth century there had been a school of jurisprudence. The writers of Bologna were outstandingly able, so that codices in *littera bononiensis* are mentioned and celebrated even in later periods. The way the work was organized was described by Petrarch: '*Sic apud nos alii membranas radunt, alii libros scribunt, alii corrigunt, alii, ut vulgari verbo utar, illuminant, alii ligant et superficiem comunt*' ('As is our way, some scrape parchments, some write books, some correct, some, to use the common word, illuminate, some reread').

Not only did scholars need copies of books already written, but the new works they themselves wrote added to the supply of texts to be copied.

Louis IX (1214-70) applied himself to increasing the number of books in existence. He expressed the desire to gather together in one place, accessible to all, copies of the variety of manuscripts present in France. This public library project came to nothing because, at his death, he left his books to be divided among various monasteries.

Part of the earnings derived from copying a book went to the book's owner, who hired it to the copyists. Such hirings were arranged by brokers called *stationarii*. The name is derived from *statio*, used by the Romans for the shop in which books were sold. Today we have the word *stationery*, used for cards and writing materials. Italian and French university regulations included particular arrangements for these *stationarii*. Statutes from Bologna from 1217 and 1270 state that they must sell genuine and well-corrected texts, and demanded of them, therefore, a certain level of education, so that they might understand and value their merchandise. They could sell or hire books only to the scholars living in Bologna, or within thirty miles of the city.

The salaries paid to copyists and the way they were calculated varied according to the place and time: in medieval universities, the unit of measure was the *pecia*, an unbound, numbered section of a manuscript book. (The book was lent or hired out in sections so that more than one copyist could work on it simultaneously.) The study of these sections may help to determine the date of a book, and to establish its provenance.

As a 'measure' of text, a unit for paying copyists, the *pecia* was established in the statutes of the artists of Padua in 1331 as being 16 columns of 60 lines, each line with 32 letters. For documents it was a page or double page with 25 lines. The writing of the *peciae* was supervised in universities by *peciarii* who ensured that the copies were correct; the *peciae*, once written, were deposited with *stationarii* who lent them to be copied at established prices.

While secular activity increased during the fourteenth century, that in the monasteries declined. Boccaccio found the library at Montecassino in a deplorable state of abandonment. Richard de Bury, Bishop of Durham from 1333 to 1345 and known as the father of bibliophiles, wrote in his *Philibion* that monks were more interested in the study of emptying glasses than copying codices.

The humanists stimulated research and the copying of books. They themselves copied the texts they valued most, and exchanged

them with friends; thus, we have copies made by Petrarch, Boccaccio, Ambrogio Traversari, Poggio Bracciolini and others. As a result of such literary activity, true bookshops began to appear. These employed amanuenses to make copies of texts, and also sold the materials necessary for writing, particularly paper. The most celebrated of these booksellers, Vespasiano da Bisticci (1421-98), lived in Florence. An indefatigable collector of codices, he also employed copyists, and supervised the work of transcription and correction. When Cosimo de' Medici decided to establish a library at the church of S. Lorenzo in Florence, Bisticci enlisted 45 writers, and succeeded in making them copy 200 manuscripts in 22 months. To augment his already precious library, Matthias Corvinus, King of Hungary, employed Bisticci: when the King died, 150 codices commissioned by him were in preparation. Some of them were taken by his successor, Ladislaus II, and brought to Hungary, some acquired by the Medici.

In addition to the demand for books by universities and monasteries, princes and humanists, the manuscript-producing industry was stimulated by the expanding middle class, the members of which wanted, most of all, contemporary works of prose or poetry, whether religious or secular, written in the vernacular. There was also the popularization of medical works, which created an enormous demand.

Copyists were not all trusted: '*correctores, seu magis corruptores*' – 'correctors but really corruptors' – evidently it was better to buy books already written than have them written. Neither did booksellers always meet with approval. Barberi quotes an anonymous rhyme printed during the first years of the sixteenth century, 'The ills of all the arts': 'It's best to avoid the sellers of books / who make a lot of pages from a single parchment / and buy very old writings / then scrape them so they look like new ones. If you bring them a book to bind / some child will make a mess of it; / it'll be illuminated anyhow, and badly bound.'

The manuscripts of the fifteenth century are of three main kinds: books 'for the pew', that is, liturgies, and Books of Hours which were prayer-books for lay-persons; books for the study, i.e. for the universities and the humanists; and small format books for reading, literature to be carried on travels, or larger, luxury literary volumes.

Epilogue

'*Non calami stili aut penne suffragio*' ('Without the aid of calamus, stylus, or pen'):

thus reads the colophon of one of the first printed books, a 1460 edition from Mainz attributed to Gutenberg. It could almost stand as an epitaph for the manuscript book. Johann Gensfleisch, called Gutenberg, of Mainz (*c.* 1394-1460), began printing in Mainz, together with a rich merchant named Johann Fust. The first known page of printed text bearing a date is an Indulgence granted by Nicholas V to anyone contributing to the war with Turkey. Shortly afterwards, in 1456, appeared the great Latin Bible. Soon after, Gutenberg's typographic equipment was seized for debt. With his son-in-law Peter Schoeffer, Fust went on to develop the art of printing with greater success than its inventor.

Typographical printing was a relatively rapid success. Printing shops started at Strasbourg in 1460, at Cologne around 1465, at Nuremberg in 1471, and at Ulm in 1473. By the end of the fifteenth century, printing presses were established in fifty-one German cities or regions. Nor was the rest of Europe far behind. At the invitation of the Spanish cardinal Juan de Torquemada, two Germans, Conrad Sweynheym and Arnold Pannartz, began printing books at Subiaco (1463 to 1465): they then moved to Rome, where another German, Ulrich Han, was already working. In 1469 printing was introduced to Venice. In the 1470s typography began in France (1470), Holland (1471), Hungary (1473), Spain (1474), and England (1477). It has been calculated that by the end of the fifteenth century about six million books had been published, comprising thirty thousand titles, by some one thousand printers.

Even though it took at least six months for a speedy professional copyist to produce a single copy of a four-hundred-page book, printing did not immediately bring to an end the production of manuscripts. For the cultural, social and political élites, illuminated manuscripts for long maintained a special prestige. Vespasiano da Bisticci claims that the great bibliophile Federigo da Montefeltro, Duke of Urbino, would have felt shame to have had a printed book in his library. Well after the invention and diffusion of printing, splendid illuminated manuscripts were being commissioned and created in every part of Europe. In Italy, the art of Hebrew miniaturists was flourishing even during the sixteenth century. Bernardo Buontalenti, the last important Italian artist to dedicate himself to illumination, died in 1608. The late day and evening of the art of illumination are perhaps almost as fascinating as the dawn.

An early example of xylographic printing (printing from wooden type): a page from *La operina da imparare di scrivere littera cancellarescha*, a small book of sixteen pages made in Rome in 1522. By that date, millions of copies of books had been printed and the story of the manuscript book was about to reach its end

Book of Hours
Second half of 15th century, 131 x 89 mm, 366 ff., Gothic bookscript (textualis). Milan, BT, Cod. 470
This richly illuminated codex, made in a French-Burgundian scriptorium, has twenty *grisaille* miniatures in wide borders, and twenty-two pages with borders and elaborate, ornamented initials as well as numerous other decorated initials. The binding, which is original, is brown leather with stamped ornament. Every page is harmoniously designed and exquisite in execution, like the example shown, with the scene of the Angel appearing to the Shepherds. The colouring is chiefly tones of brown and gold. The miniatures are attributed to an artist of the circle of Philippe de Mazerolles, who died at Bruges between 1470 and 1480.

One Thousand
Years
of Masterpieces

Vatican Virgil
End of 4th to beginning of 5th century, 220 x 200 mm, 75 ff., in Latin, rustic capitals. Rome, BAV, MS Vat. lat. 3225
This manuscript contains fragments of Books III and IV of the *Georgics* and Books I to XI of the *Aeneid*, with numerous and large lacunae. It is an Italian work, possibly made in Rome. The fifty illuminations include a variety of different compositions, but all are broadly in late classical style. The scenes and characters are portrayed in a manner reminiscent of Roman Imperial portraits. The scene illustrated represents the moment when Creusa implores the armed Aeneas to stay, the hair of their son Iulus catches fire, and the old man Anchises interprets the event as a sign of benevolence from Jove (*Aeneid*, II, 671-91). The characters' intense and painful participation in the drama has been well conveyed by the artist.

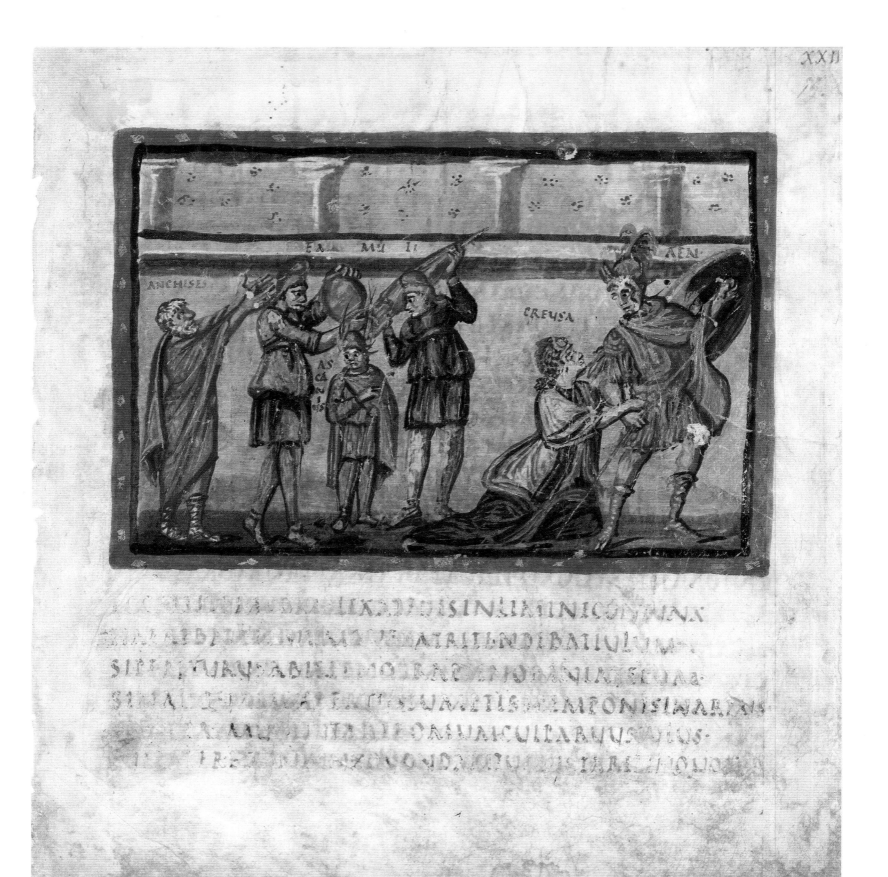

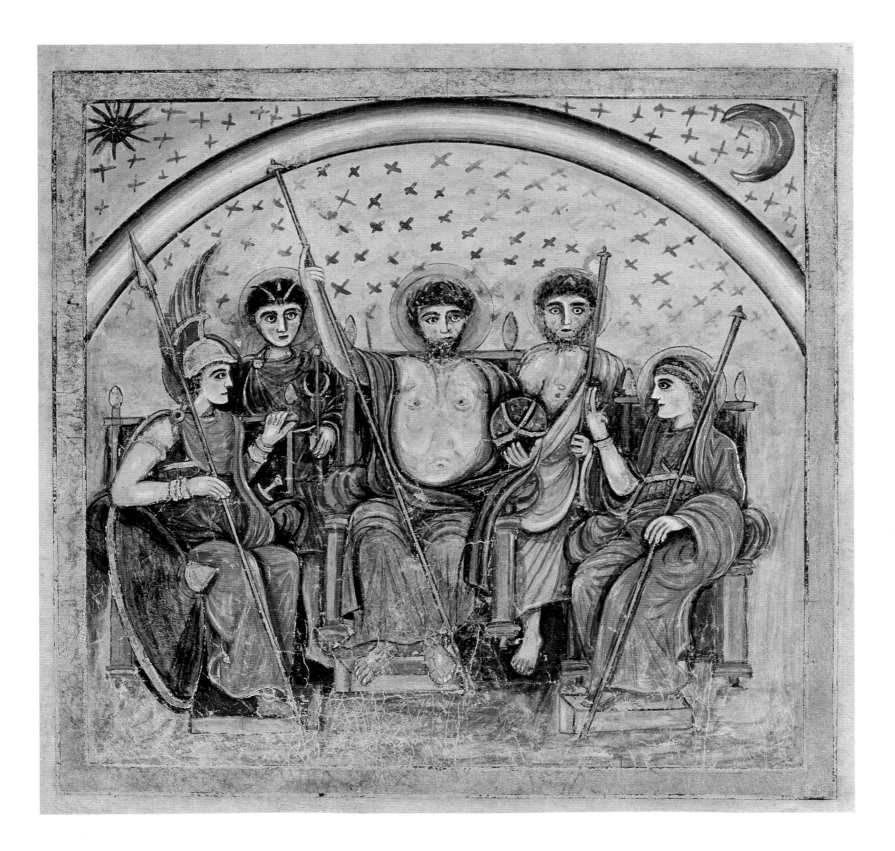

Roman Virgil
5th century, 332 x 323 mm, 309 ff., rustic capitals, Rome, BAV, MS Vat. lat. 3867
This book, containing Virgil's *Eclogues*, *Georgics* and *Aeneid*, was probably made in Italy, perhaps at Ravenna. In the thirteenth century it was in the Abbey of St Denis in Paris; in the fifteenth century it entered the Vatican Library during the papacy of Sixtus IV (1471-84). It is

finely written. Besides the illustrations of the text, three survive of an original six portraits of the author. The style of the compositions is no longer late classical but has become two-dimensional, with objects and figures depicted in a linear and colourful manner. The page reproduced shows a meeting of the gods, with Mercury second on the left and Jupiter in the centre. The figures are not at all idealized: only their em-

blems or haloes indicate their divinity. The features and profiles are sharp, while the depiction of their bodies and clothing – draped but not elegant – recalls the taste for sturdy simplicity of the period of the Tetrarchs, the end of the second century to the beginning of the fourth century. The strong base colours of the painting are broken up with white and darker shades to give modelling and variety.

Below: *Codex Argenteus*
Early 6th century, 187 ff., Gothic alphabet, uncials, purple parchment, written in silver and gold. Silver cover of the 17th century. Uppsala, UB

The text follows a translation of the Bible from Greek into Gothic made during the fourth century by Bishop Ulfilas, who created a Gothic alphabet for the purpose, taking the Greek alphabet as his model. The manuscript was made during the period of Theodoric, the first quarter of the sixth century, in a scriptorium in the Po Valley, then part of the Ostrogoth kingdom, or possibly in that kingdom's capital Ravenna, or in Brescia. The manuscript was in Werden, owned by the German emperor, during the sixteenth century; in 1648 during the last stages of the Thirty Years War it was taken as booty by the Swedes to Stockholm and entered the library of Queen Christina. When the Queen abdicated and went to Rome, it was given, probably as a payment, to one of her librarians, the Dutchman Isaac Vossius. In 1662 the manuscript returned to Sweden when Count M.G. De La Gardie obtained it from Vossius and in 1669 gave it to the University of Uppsala.

The script is so clear and uniform that has even been suggested it was made with stamps. Recently, however, two different hands been distinguished, one for the Gospels of Sts Matthew and John, the other for Luke and Mark. The ornamental motifs are very simple: a few large framed initial letters, and, at the foot of each page, a row of simple columns with arches, and the monograms of the Evangelists.

Opposite: *Vienna Dioscorides* (*Constantinopolitanus*) 6th century (shortly before 515), 365 x 300 mm, 491 ff., Greek uncials. Vienna, ÖNB, Cod. Med. Gr. 1

This book was made in Constantinople. In an acrostic on f. 6v the inhabitants of Honoratae praise Anicia Juliana, daughter of the Emperor Olybrius, for building a church, which according to Theophanes was completed in 512. It is probable the book was made for presentation to Anicia to mark the church's completion. The illumination includes 400 carefully detailed miniatures of plants, 25 of snakes, and 47 of birds. Human figures are still represented in late classical style. Illustrated are, top to bottom, a wagtail, an owl and a golden oriole.

ΚΑΘΙΕΛΕΤΦΗΟΥΡΦΗΕΥΜΑΡΦΘΟΤΗΓΓΟΛΙΕΚΘΠΠΗΘΙΗ
ΕΤΑΜΘΝΟΟΑΛΛΥΘΙ:

περι
χελιδο
ΤΟΥΟΑΠΤΟΑΛΛΟΥΟΟΡΓΟΙΜΑΙΘΟΜΘΟΟΥΟΘΙΠΟΤΙΤΦΝΑΠΦΝΑΟ
ΛΗΓΘΚΟΥΟΛΕΘΙΛΟΙΘΗΤΑΙΟΟΛΛΙΟΥΓΘΡΧΟΡΟΥΘΟΘΠΘΤΟΤΕ
ΓΑΛΛΑΥΤΦΗΟΟΘΡΑΦΟΙΓΡΟΟΙΟΝΤΘΟΘΟΑΚΟΥΟΘΙΗΚΑΠΕΡΟΟ
ΤΟΠΠΟΚΟΠΛΑΥΤΑΟΘΙΟΤΟΠΘΝΘΒΑΛΙΓΓΟΥΟΘΠΧΡΟΠΟΠ

περι
γλαυκος
ΛΙΓΕΜΗΝΓΛΑΥΚΘΟΟΤΓΓΦΙΠΓΡΟΒΑΤΦΠΛΑΡΦΘΛΙΓΑΥΤΟΗ
ΟΥΔΕΜΙΑΠΦΟΡΟΥΘΟΘΠΒΑΛΒΠΙΑΛΛΑΘΚΘΠΠΟΙΘΟΠΠΓΘΡΙ
ΛΥΤΦΗΟΠΓΓΟΥΟΜΥΡΜΗΚΑΟΑΠΟΚΦΛΥΟΠΓΦΠΙΛΑΦΗΒΥ
ΛΟΜΘΝΟΙΘΟΠΓΦΠΙΘΠΠΗΚΑΛΟΙΑΚΑΡΑΙΑΠΘΧΟΥΟΘΠΗΝΥ
ΚΤΕΡΙΛΟΟΦΟΤΦΗΜΥΡΜΗΚΦΠΛΠΤΟΛΠΓΟΠ ΚΑΙΓΟΥΘΟ
ΛΥΤΦΗΦΑΛΟΟΥΘΜΡΟΥΜΘΙΦΠΙΘΠΠΥΚΤΕΡΙΛΟΟΤΙΟΘΠΗΙ
ΤΟΙΟΟΘΠΚΥΡΔΙΑΠ:

περι
ιερικου
ΙΚΤΕΡΟΟΤΙΟΟΡΠΙΟΑΠΤΟΤΗΟΧΡΟΙΑΟΟΝΟΜΑ
ΓΛΑΟΘΤΟΥΤΦΤΙΟΑΠΗΡΕΧΟΜΘΝΟΟΘΠ
ΙΤΑΟΑΠΑΥΤΙΚΑΤΗΠΗΠΟΟΟΠ:

45

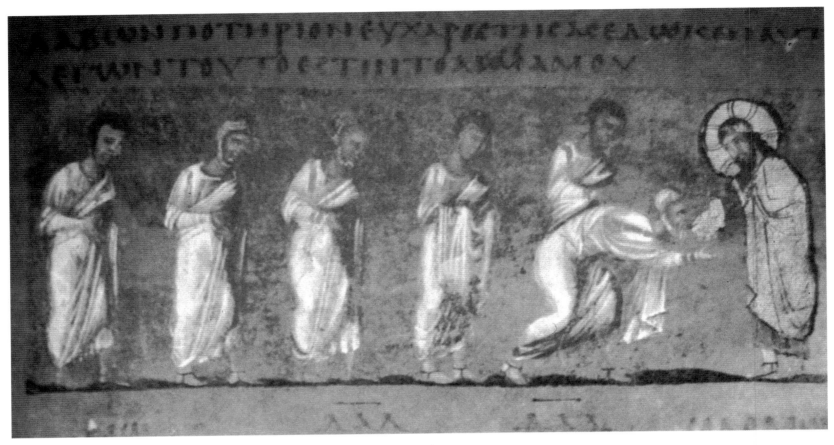

Above: *Rossano Gospels*
Purple parchment, 6th century, 307 x 260 mm,
188 ff., Greek uncials in two columns, with silver
letters and some lines in gold. Rossano Cathe-
dral, Calabria, BA
This Gospel-book is from Greece or the eastern
Mediterranean, possibly from Antioch in Syria or
Caesarea in Palestine. It reached Italy probably
between the seventh and ninth centuries. The
illumination represents six Apostles approaching
Christ to receive wine from a golden chalice.

Right: Eusebius of Caesarea, *Canon Tables* (in
Greek); Rufinus of Aquileia, *Treatise on the
Blessings of the Patriarchs* (in Latin)
6th to 7th century, 115 ff., rustic capitals. Vienna,
ÖNB, Cod. lat. 847
This book may have been made in Ravenna. In
the ornament shown, within a circle the cross-
tree stands on the hill of Golgotha. At either side
are paired birds and plant-motifs.

Opposite: *Corpus Agrimensorum Romanorum*
5th to 6th century, 315 x 244 mm, 157 ff., uncials.
Wolfenbüttel, HAB, Cod. Guelf. 36.23 Augu-
steus 2°
The page reproduced was made in Ravenna.
Between the lines of writing, which has the first
lines of paragraphs indicated in red, is a perspec-
tive view of a house and its surrounding land, and
(below) a map giving the boundaries of a proper-
ty, an interesting view of a country property of
very early date.

AGER EST ARCEFINIUS QUI NULLA MENSURA
CONTINETUR FINITUR SECUNDUM ANTIQUA
OBSERVATIONEM FLUMINIBUS POSSIS MONTI
UIIS ARBORIBUS ANTE MISSIS AQUARUM DIUER
CIES ET SI QUA LOCA ANTE POSSESSORE POTUERUT
OPTINERI NAM AGER ARCEFINIUS SICUT AIT BARRO
A BARCENDIS OSTIBUS EST APPELLATUS QUI POS
TE A INTERUENTU LITIUM PER EA LOCA QUIBUS
FINIT TERMINOS ACCEPERE COEPIT IN HIS AGRIS
NULLUM IUS SUBSICIUORUM INTERUENIT.

SUBSICIUUM EST QUOD A SUBSECANTE LINEA
NOMEN ACCEPIT SUBSICIUUM SUBSICIUORE
GENERA SUNT DUO UNUM QUOD IN EXTRIMIS
ADSIGNATURA GRORUM FINIB CENTURIA EXPLORI NO POTUIT

ALIUD GENUS SUBSICIUORUM QUOD IN MEDIIS.
ADSIGNATIONIBUS ET INTEGRIS CENTURIIS
INTERUENIT QUIDQUID ENIM IN TER LIMITES

Idem, qui proximus superior. s. consilij iudicijque de finibus et controuersijs agrorum; tracs.

Præses.

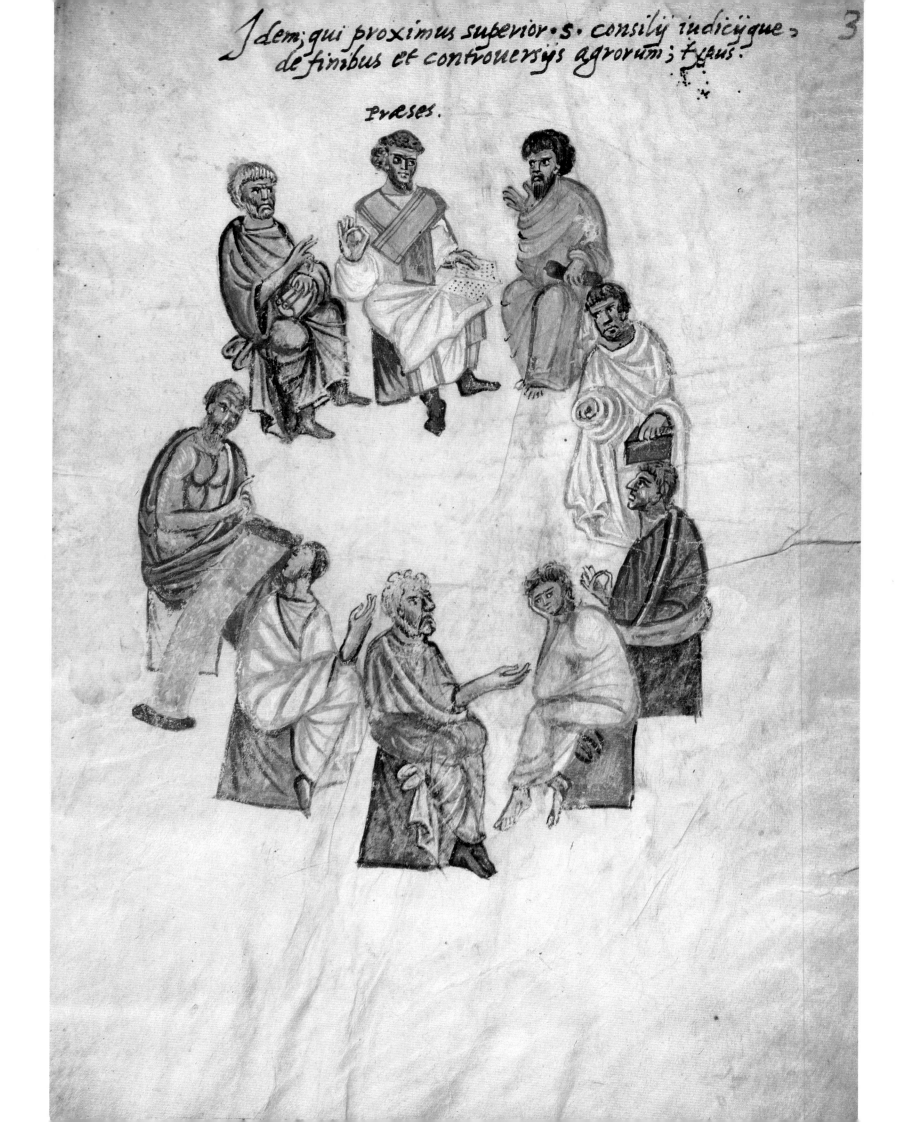

Idem, qui proximus superior. s. consilij iudicijque de finibus et controuersijs agrorum; tracs.

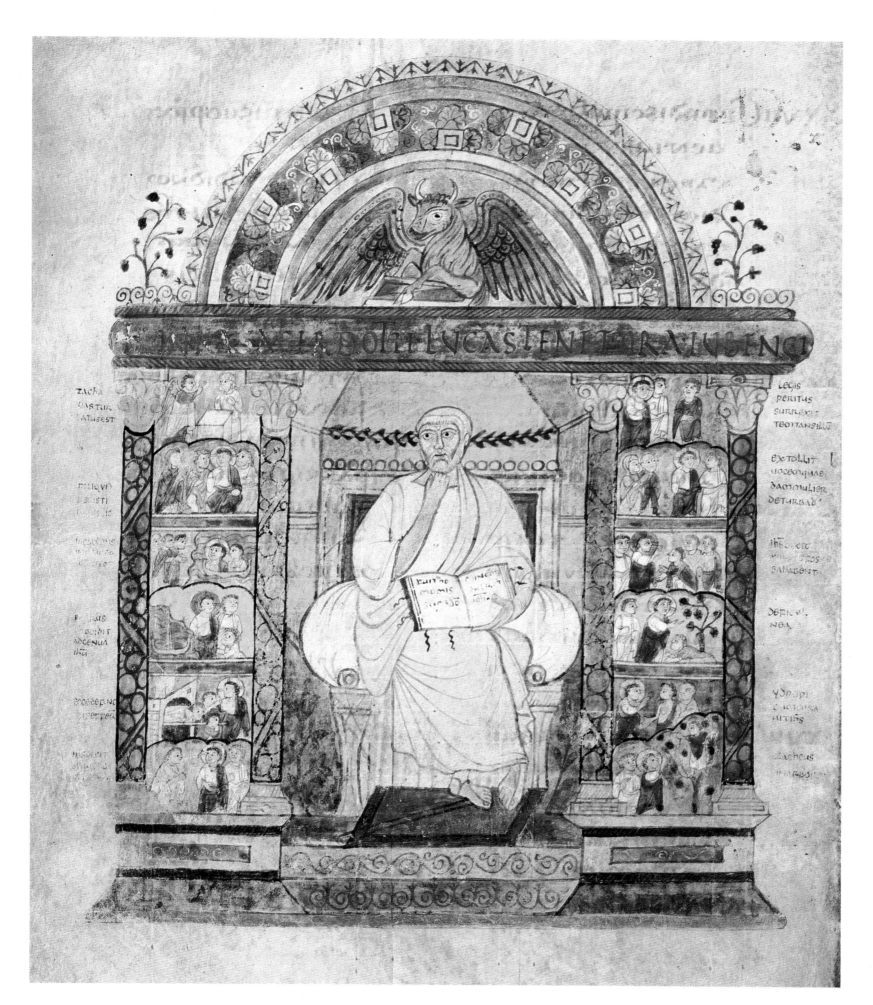

Page 48: *Agrimensores*
9th century, Caroline minuscule. Rome, BAV, MS Palat. lat. 1564
This manuscript, copied in the Abbey of Fulda, is modelled on a sixth-century work probably made in Ravenna. The illumination reproduced shows a circle of land-surveyors engaged in discussion. The style of the illumination is Carolingian, more varied and richly pictorial than that of Merovingian manuscripts. It displays an artistic vitality that absorbs and renews characteristics of both late classical and Byzantine styles.

Page 49: St Augustine's Gospels
End of 6th century, 250 x 190 mm, 270 ff., Roman uncials. Cambridge, CCC, MS 286

Produced in a southern Italian scriptorium, or in Rome, this Gospel-book was brought to England, possibly by St Augustine, in the sixth century. The portrait of St Luke reproduced is one of the manuscript's two illuminated pages. St Luke holds his Gospel open towards the viewer.

Above: *Evangelia antehieronlymiana*, the *Codex Brixianus*
First half of 6th century, 280 x 215 mm, 418 ff., in Latin, uncials. Brescia, BCQ
This canon tables page is an example of writing on purple parchment with gold and silver. It was probably made in northern Italy, possibly in Ravenna. It comes from the monastery of SS. Salvatore e Giulia, Brescia.

Opposite: *Xanten Gospels*
Purple parchment, *c.* 6th century, 260 x 220 mm, Brussels, BRA, MS 18.723
This page, thought to be of an early date, probably sixth century, was inserted into a Gospel-book written in a Caroline minuscule (f. 17). The quiet simplicity of style suggests late classical painting, and recalls the best of the few surviving late classical manuscripts such as the *Roman Virgil* of the fifth century (p. 43) or the *Vienna Dioscorides* which was illuminated in Constantinople at the beginning of the sixth century (p. 45). The subject may well be the author at work, since it was common during late antiquity to begin a manuscript with such a portrait.

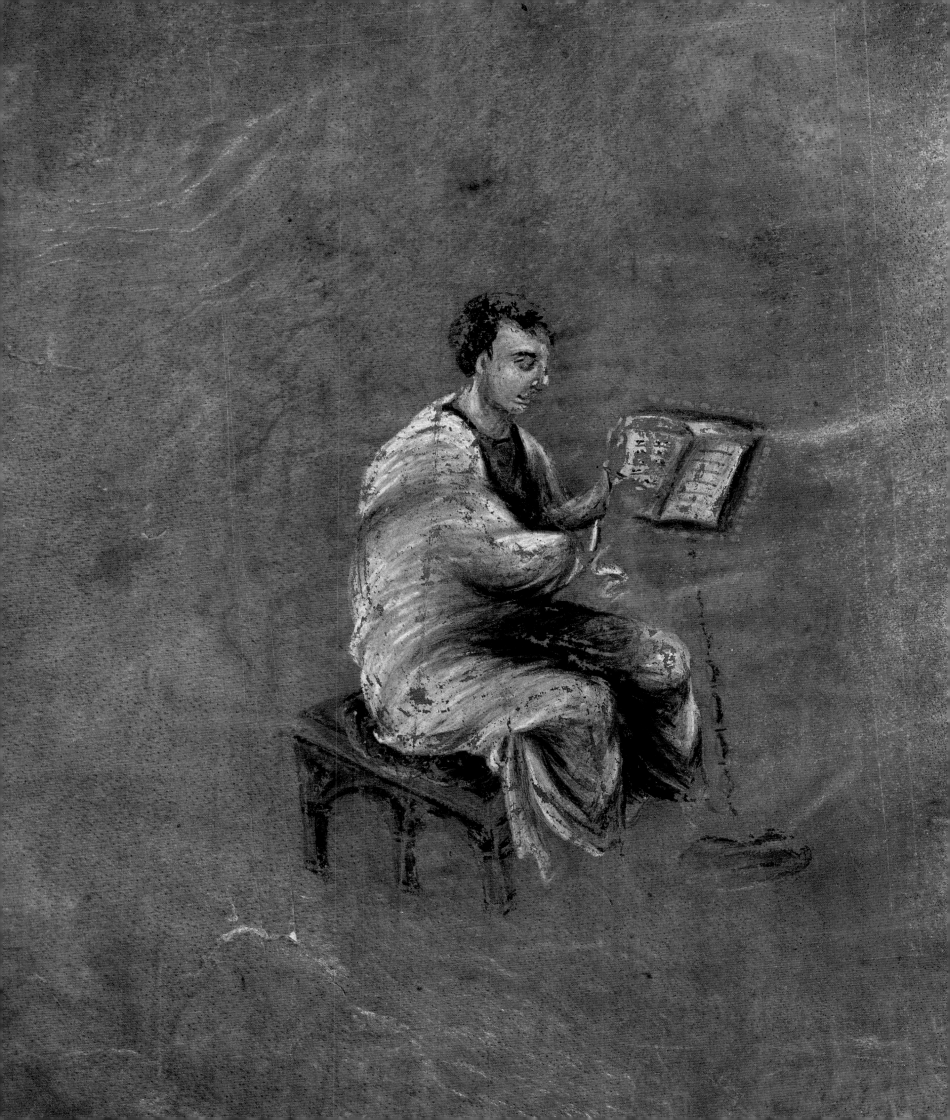

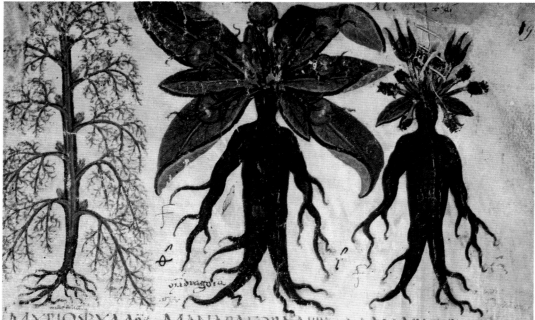

MYPIOФYAA· MANДPAГOPAAPPE· ΔIANΔPAГOPAOHA·

[Greek text in manuscript columns reproduced as illustration]

Above: *Dioscorides*
7th century, 290 x 250 mm, 172 ff., Greek uncials. Naples, BN, Cod. Gr. 1
This manuscript belonged to the monastery of S. Giovanni at Carbonara; it was brought to Italy from Constantinople by the Greek humanist Demetrios Calconila. This *Dioscorides* is related to the one in Vienna (p. 45), but differs in illustrating solely plants, which are realistically depicted in the upper part of the recto of the folios. The illumination is an example of early botanical illustration, finely drawn.

Opposite: *Ornamental page*
6th to 7th century, 290 x 220 mm, detached leaf. Paris, BN, MS lat. 12190
This carpet page, or page of over-all abstract decoration, is composed of five rectangles containing interlace ornament, each pattern different but all together forming a harmonious composition. While the style does not readily locate the work, Carl Nordenfalk ascribes it to a southern scriptorium, possible that of Vivarium, the monastery founded by Cassiodorus at Squillace (Calabria) during the sixth century.

Page 54: *The Book of Durrow*
Second half of 7th century. 245 x 145 mm, 248 ff., in Latin, early Insular half-uncials. Dublin, TC, MS A.4.5. (57)
This Gospel-book is an Insular product, one of a group of great northern Gospel-books produced in the British Isles during a period of flowering of the art of illumination there during the early Middle Ages. The page illustrated is the beginning of St Mark's Gospel. The large In (*Initium evangelii*) has fused together the letter I and the first stroke of the letter N. The script starts large at the head of the page and then reduces in size, a feature known as the *diminuendo* motif, and one commonly found in Irish and Anglo-Saxon manuscripts. The I and N are ornamented with interlace and spirals, and on the oblique bar of the N the dynamic design of spirals produce an effect of rotation.

Page 55: *Lindisfarne Gospels*
End of 7th or early 8th century, 340 x 240 mm, 258 ff., in Latin, Insular display capitals and half-uncials. London, BL, Cotton MS Nero D. IV
The Gospels' later colophon states that it was written by Eadfrith, bishop of the church of Lindisfarne, on a small island off the northeast coast of England. St Mark's Gospel opens with a large In (*Initium evangelii*), a typical example of the elaborate ornament of Insular Gospel-books. The letters I and N, which extend the whole depth of the page, have here become more decoration than writing. The colour range is limited but highly effective. The design of the page as a whole is magnificent, unified and coherent.

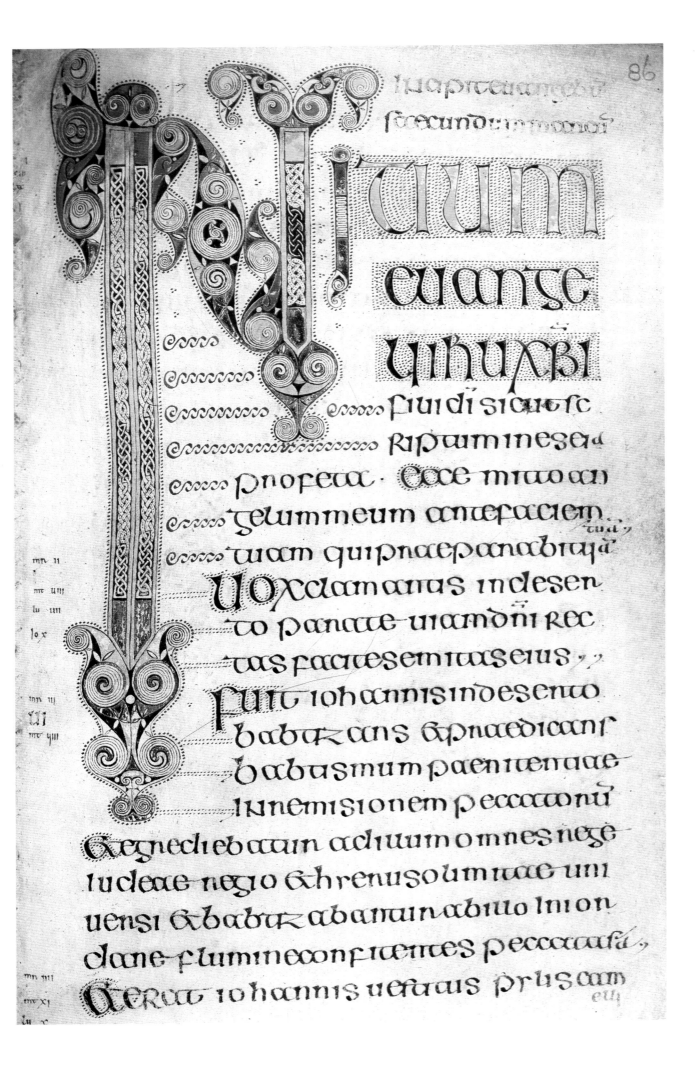

INitium

euange

lii ihu xpi

filii di sicut sc

riptum in esa

propheta · ece mitto an

gelum meum antefaciem

uiam qui praeparabit uia

UOX clamantis in desen

to parate uiam dni rec

tas facite semitas eius ·

fuit iohannis in deserto

babtizans & praedicans

babtismum paenitentiae

in remisionem peccatorum

& egrediebatur ad illum omnes rege

iudeae regio & hierusolimitae uni

uensi & babtizabantur ab illo in ior

dane flumine confitentes peccata sua

& erat iohannis uestitus pilis cam

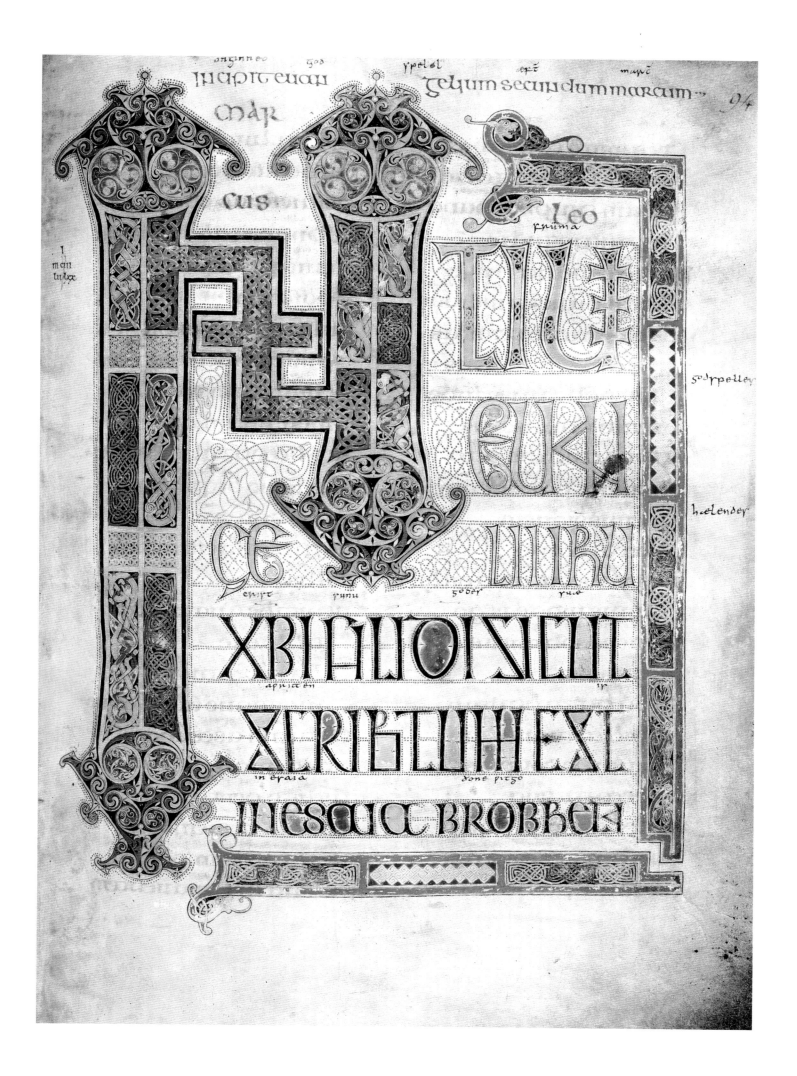

Above left: Gregory of Tours, *Historia Francorum*
Late 7th century, 260 x 215 mm, 99 ff., in Latin, Merovingian minuscule. Paris, BN, MS lat. 17655
The monks of the scriptorium of Corbie in northern France, founded during the seventh century, wrote and illuminated this manuscript, although some of the first pages have script and illumination characteristic of the monastery of Luxeuil. It is probable that it was begun by a Corbie scribe who had first been at Luxeuil. The Irish missionary-monk St Columban had founded Luxeuil during the sixth century, and monks from that monastery joined in the formation of Corbie; it was thus through Luxeuil that Irish influence reached Corbie. The small initial letter illustrated, with geometric and zoomorphic motifs (fish and birds) in red, green and yellow, is typical of the Merovingian style of illumination.

Above right: Paulus Orosius, *Chronicle*
End of 7th century, 210 x 150 mm. 53 ff., in Latin, half-uncials. Milan, BA, MS D. 23 Sup.
This codex was made in the monastery founded at Bobbio in Italy by the Irish missionary-monk St Columban, who also founded Luxeuil in France. It was given in 1060 to Cardinal Federico Borromeo and placed by him in the Biblioteca Ambrosiana, Milan, the library which he himself had founded. The style of illumination is influenced by Insular art: for example, the uprights and oblique bar of the large intial N, shown, are outlined with dots (compare the Book of Durrow and Lindisfarne Gospels, illustrated on the previous pages).

Right: *Lectionary*
7th to 8th century, 295 x 180 mm, 248 ff., in Latin, Merovingian minuscule. Paris, BN, MS lat. 9427
This book of Gospel-readings was made in one of the Irish monk St Columban's foundations, probably Luxeuil in eastern France, or perhaps at Morigny or Corbie. The codex was at Luxeuil around the year 1000. It illustrates the Irish influence on Continental production, with initial letters formed of fishes or birds, or ornamented with floral motifs. An elegant arch with birds frames the title of the Martyrdom of St Julian.

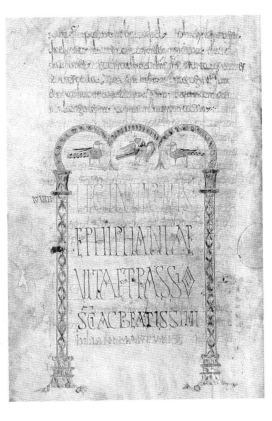

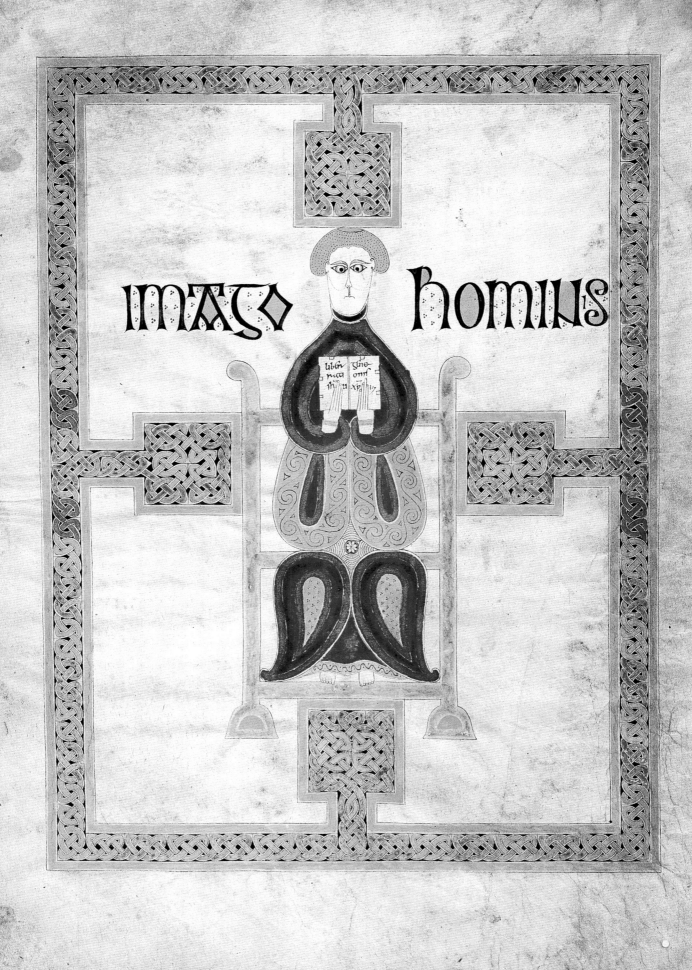

Below: *Codex Amiatinus*

... of 7th to 8th century (before 716), 505 x 340 ..., 1030 ff., in Latin, uncials. Florence, BML, ... Amiatinus 1

...de in Northumbria in the combined monaste-... f Jarrow-Wearmouth, this great Anglo-Saxon ...gate Bible was intended for presentation to ...e Constantine or Pope Gregory II. It was

wholly or partly copied from an Italian model, or models.

The page reproduced gives the order of the books of the Old and the New Testaments according to St Jerome. Although not finely copied, the codex is important as providing a probable model for later and more elaborate Insular manuscripts.

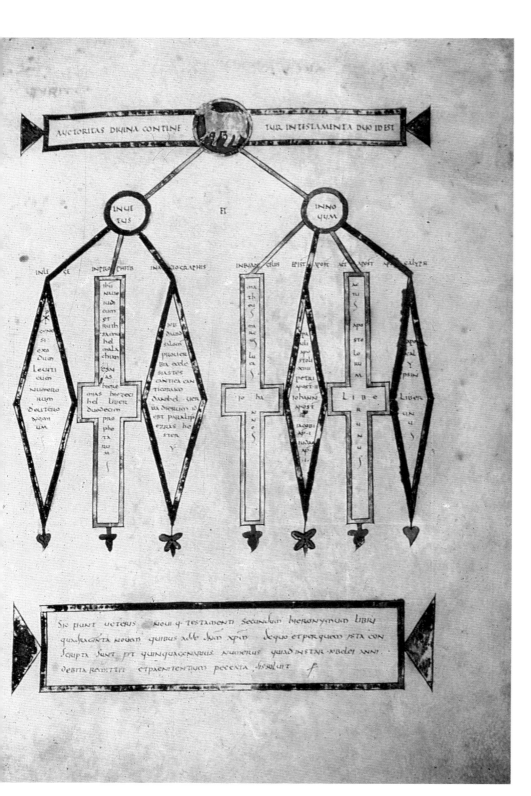

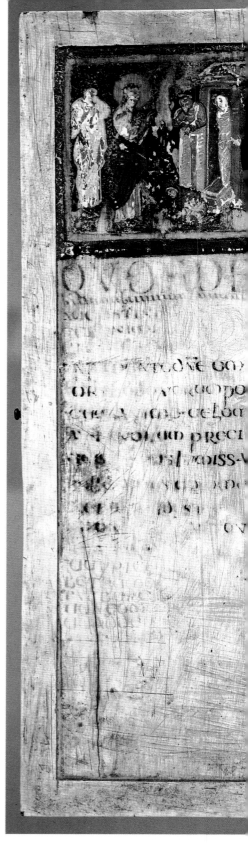

Above: *Consular Diptych of Boethius*
Ivory panels, fifth century, 350 x 126 mm. Illu... nations from the 7th century, uncials. Bres... MCEC

The exteriors of the panels are carved with p... traits of the philosopher Severinus Boethius; ... inside, illustrated, shows the scene of the Rais...

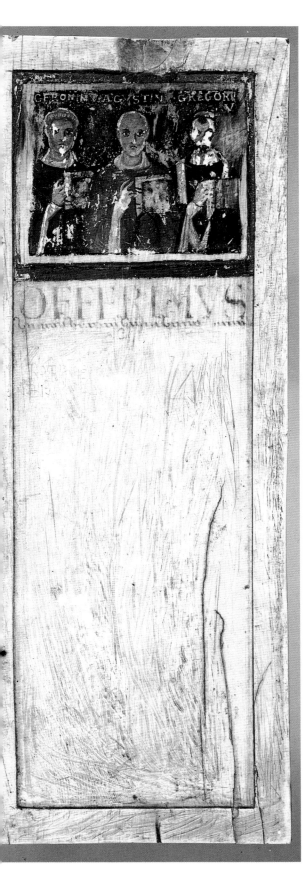

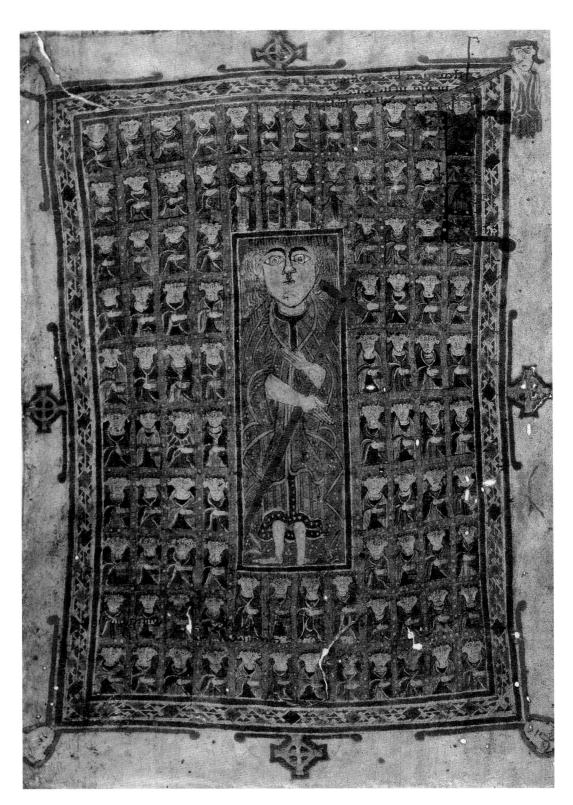

Below: *Gospel-book*
8th century, 215 x 145 mm (originally 280 x 196 mm), 4 detached pages (of an original 189), in Latin, Irish half-uncials. Turin, BN, MS O. IV. 20
This codex was produced in Ireland, and belonged to the monastery of St Columban at Bobbio in Italy before passing to the Cistercian abbey of Staffarda (Cuneo). It was almost entirely de-stroyed in a fire in 1904, and the four surviving pages are damaged. The page reproduced shows Judgment Day, with Christ surrounded by the elect, books in hands. At one corner of the ornamental border an angel blows the trumpet for the Last Judgment. As in contemporary Irish illumination, realistic representation gives way to a stylized design that yet conveys a profoundly religious atmosphere.

of Lazarus (left), and Sts Jerome, Augustine and Gregory (right), each pointing to a codex. The diptych probably belonged to the monastery of SS. Salvatore e Giulia, Brescia; in 1717 it passed into private ownership, and went to the Biblioteca Civica Queriniana, Brescia, after the death of Cardinal Guerini (1755).

Below: St Jerome, *Chronicon*; Isidorus, *Chronicon*; *Liber Pontificalis*; *Collectio Canonum*; Bede, *De natura rerum*, *Genealogiae Bibliae*
8th to 9th century, 263 x 190 mm, 355 ff., in Latin, script variously capitals, Visigothic minuscule (showing Italian influence), uncials, Caroline minuscule and other scripts. Lucca, BC, MS 490
According to Schiapparelli, this manuscript in a number of different hands is a product of a single scriptorium, most probably that of Lucca. Shown in the opening (*incipit*) of the *Genealogiae Bibliae*

in alternating lines of red and black. At the Good Shepherd's side is a wineskin on a table.

Centre: *Sacramentary*
8th century (755-787?), 300 x 180 mm, 275 ff., pre-Caroline minuscule. Paris, BN, MS lat. 12048
This manuscript was made for the Abbey of Falvigny, Autun. Of the zoomorphic initial E's shown, three are derived from uncial script while the fourth (upper right) is a capital.

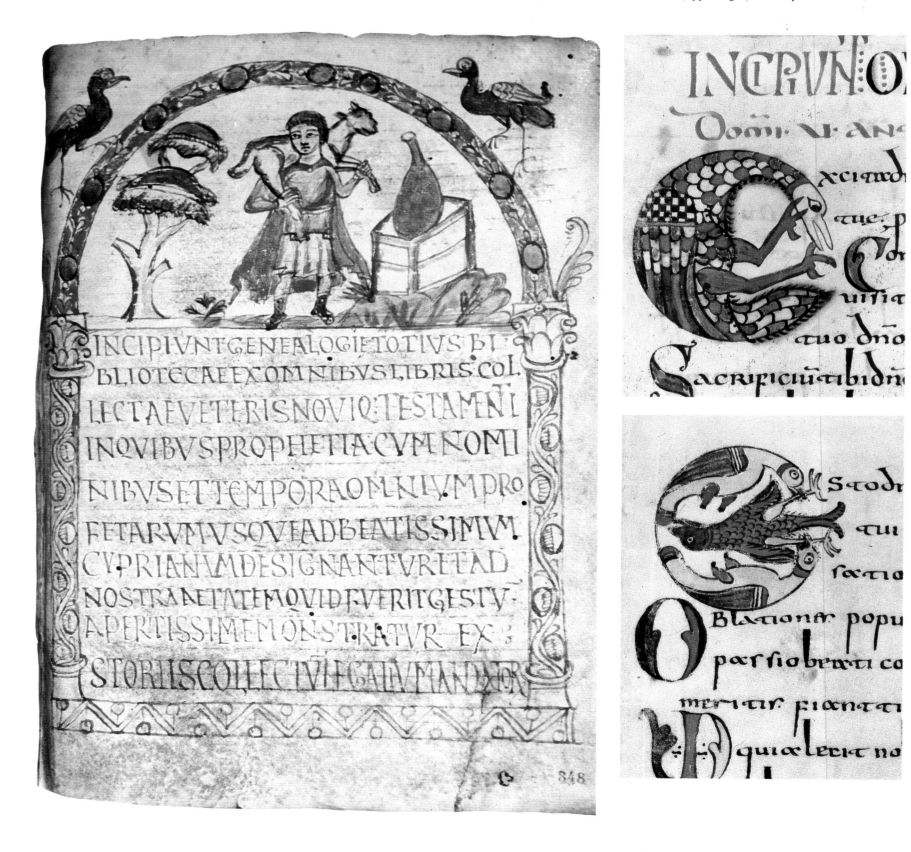

Below: *Cutbercht Gospels*
End of 8th century, 310 x 238 mm, 205 ff., in Latin, Insular half-uncials in two columns. Vienna, ÖNB, Cod. 1224

This Gospel was written and illuminated at Salzburg by the scribe Cutbercht, probably an Anglo-Saxon copyist. The bishop at Salzburg from the mid-eighth century to 784 was an Irishman, Virgilius (Feirgil), who had been at St Columba's foundation, Iona, on a small island off the west Scottish coast. The ornament includes eight pages with the canon tables beneath arches – a motif commonly found in Insular manuscripts as well as Merovingian and Mediterranean Gospel-books generally – initial letters with interlace and animal motifs, and four portraits of the Evangelists, bordered with similar ornament. The colours are predominantly orange, green, yellow and a clear blue, together with black and brown.

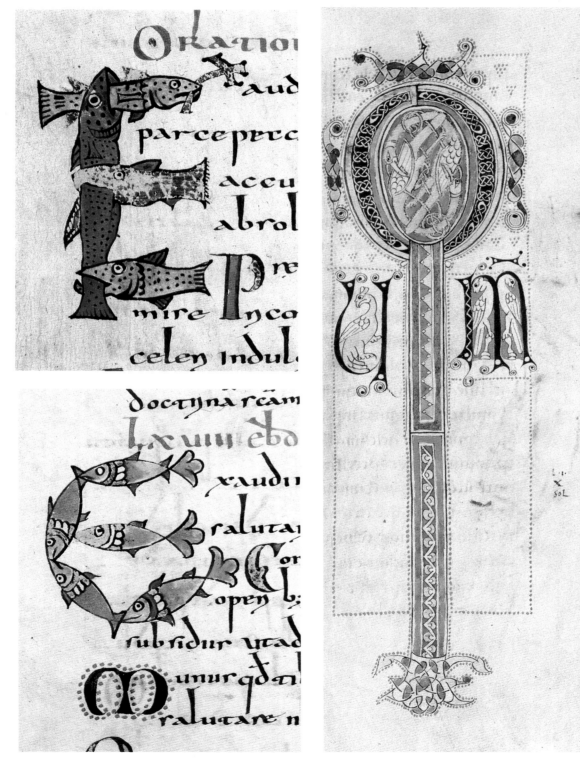

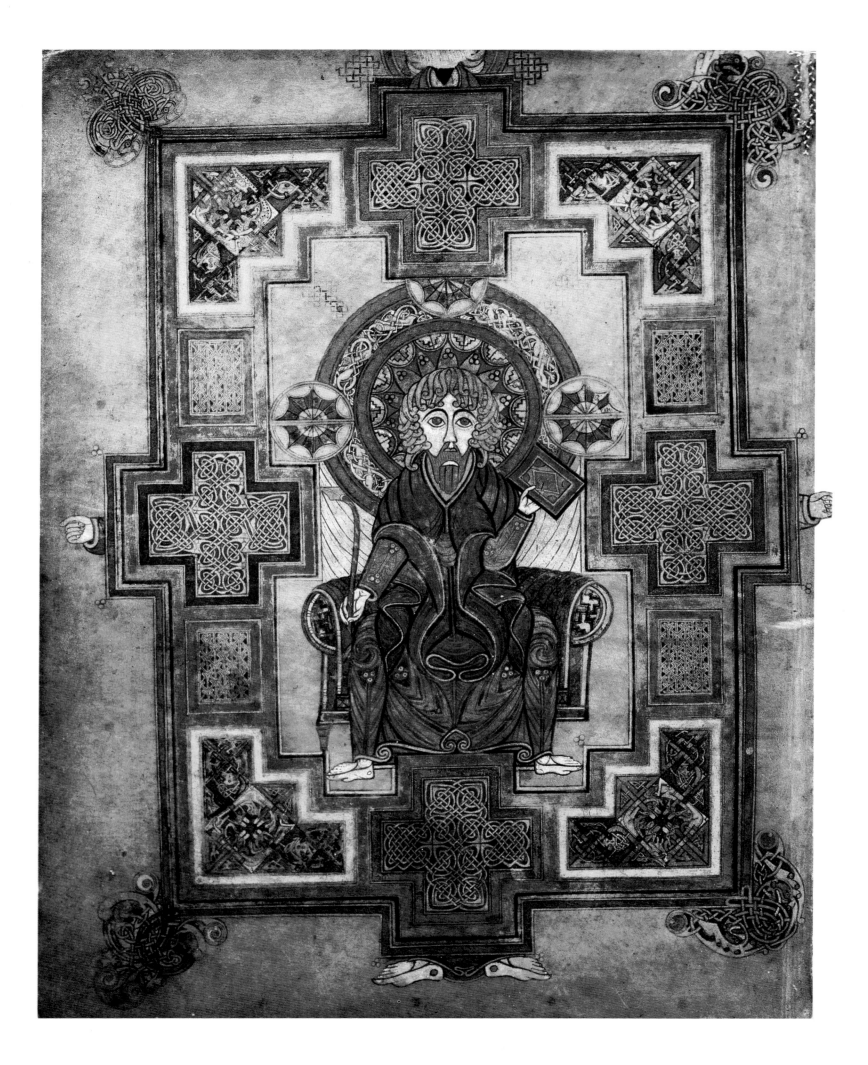

Above: St Isidore of Seville, *Etymologies*, Books I-X

End of 8th century, 315 x 200 mm, 291 ff., in Latin, pre-Caroline minuscule, type *a-b* from Corbie. Brussels, BRA, MS II. 4856

This manuscript was made either at Corbie or near-by in northern France. Among the decorative elements is a notable frontispiece with a Moresque arch and numerous coloured titles and initial letters such as those shown, with geometric or zoomorphic forms, such as birds or fish.

Left: *Lectionary*

8th to 9th century, 330 x 225 mm, 198 ff., uncials and minuscule in silver and gold, on purple parchment. Paris, BN, MS lat. 9451

The style of this work suggests that it was made in northern Italy, possibly at Monza. The initial letter I (*In illo tempore*) is ornamented with a bird's head with a hooked beak at the top.

Opposite: *The Book of Kells*

8th to 9th century, 330 x 250 mm, 340 ff., Insular half-uncials. Dublin, TC, MS A. 1.6. (58)

There is a tradition that this great Gospel-book was begun in the monastery founded by St Columba in the sixth century on Iona, an island off the west Scottish coast. In the eleventh and twelfth centuries it was in the monastery of Kells (Co. Meath, Ireland), to which the monks of Iona had fled to escape the Viking raiders. The book remained at Kells until 1654, when Kells was occupied by Cromwellian troops, causing the Governor of the town to send the book to Dublin for safe keeping. In 1661 it was presented to Trinity College, Dublin, by Henry Jones (1622-82), Bishop of Meath.

The introductory pages of the Book of Kells display remarkable full-page portraits of the Evangelists, including St John, shown here. He is depicted holding a quill in his right hand and his Gospel in his left.

Below: *Gospel-book*
8th century (between 736 and 760); 355 x 275 mm, 240 ff., in Latin, uncials. London, BL, MS Add. 5463
This Italian example was made near Benevento. The ornamentation includes the canon tables pages, initial letters and rubrics. The page is shown as an example of uncials, a type of writing originating around the early fourth century, and still in use until the eighth century (and for titles and initial letters until the twelfth). It became diffused throughout the countries that had formed the Roman Empire. The large rounded forms, written with regularity and care, give the page an elegance that makes it ornamental, even though it has no decorative elements.

Above: Iulianus Antecessor, *Epitome latina Novellarum Iustiniani*
Late 8th century, 270 x 185 mm, 247 ff., with two paper pages at the beginning and end of the volume, rubrics in display uncials, cursive minuscule from northern Italy. Milan, BT, Cod. 688.
This book was written either at Novara, or, according to more recent studies, at Pavia. The page shown is an example of a pre-Caroline minuscule script. Six lines (an *explicit* and an *incipit*) are written in large capitals, with the *a*, *e*, and *m* in uncials.

Below left: Gregory the Great, *Dialogues*
8th century (*c.* 747), 330 x 217 mm, 247 ff., in Latin, uncials. Milan, BA, MS B. 159 Sup. This manuscript almost certainly comes from the Irish monk St Columban's foundation at Bobbio in Italy. Ornamental motifs include coloured initials decorated with spirals, hands, heads, serpentine and zoomorphic forms like the motif illustrated, all in lively colours such as we find in medieval bestiaries.

Below: *Lives of the Saints and Their Teachings and Sermons*
8th century, 230 x 170 mm, 160 ff., in Latin, uncials. Milan, BA. MS F. 48 Sup. This manuscript was probably made in northern Italy, and belonged to St Columban's foundation at Bobbio. It has been in the Biblioteca Ambrosiana, Milan, since 1606. The style of the work suggests that it was made in a scriptorium exposed to northern or Insular influences. There are, however, some Byzantine features, such as, in the portraits, the large, wide-open eyes that give the faces an expression of impenetrable steadiness. As can be seen in the page illustrated, the manuscript is carefully written. The I is ornamented with abstract geometric motifs, the D is a head encircled by two fishes.

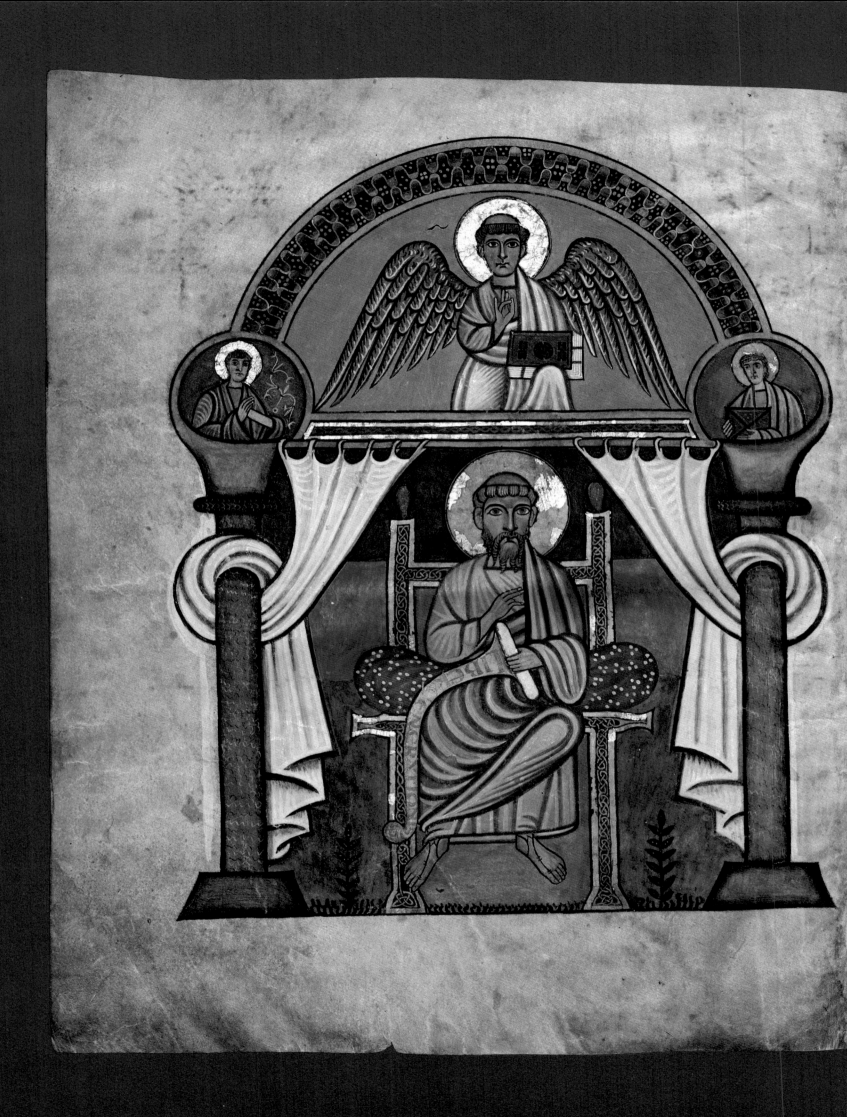

XP AVTEM
GENERATI
SICERATCVMESSETDS
DNSATAMATERIVS
MARIAIOSEBANTEGA
CONVENIRENTINVENTA
ESTINVTEROHABENS

Ond forðon ðe ꝥ noldan ðæt ðas halgan beoc longe Indchre hæðnisse punaden, ⁊nupillað heo gsellan Inno
cyrtc cristan gode tolofe ⁊topuldre ⁊topponðunga ⁊his ðropunga todoncunga, ⁊ðam godcundan gehirpe forto brucone
ðe Incristnisse cristan ðætspanlice godhfloc ⁊ihnad, tobanghiade ðæt heomon apede ælcre monaðe fon ælfred
⁊fon hiburge ⁊fon alhðryðe heora saulum tobeum lece dome, ða hpile ðe god gestgen hæbbe ðæt fulpiht æt
ðeorre ꝥofe beon mote., Eic pelce ic ælfred dux ⁊hiburg biddað ⁊halsiad ongodes almæhtiges noman ⁊onallra
his haligra ðæt nænigmon sieto ðondgedyrstig, ðæte ðas halgan beoc aselle oððe aðeode fromcnytc cirican ða hpile

INCIPIVNT OMIL SCI CAESARII EP
QVALITER VERBVM DNI VEL DESI
DERARE DEBEAT VEL REQVIRI
INTER RELIQVIAS BEATITVDINES

QVAS IN EVANGELIO DNS ET SALVATOR
NOSTER ENVMERARE DIGNATVS EST ETIA
HOC ADDIDIT DICENS, BEATI QVI ESVRI
VNT ET SITIVNT IVSTITIAM QVONIAM
IPSI SATVRABVNTVR, FELICES SVNT QVI
BVS ISTAM PRAECLARAM FAMEM ET DESI
DERABILE SITEM DS DONARE DIGNATVR
QVOMODO AVTE ESVRITVR IVSTITIA
FRATRES IVSTITIA ESVRIS SI VERBVM DI
PATIENTER ET LIBENTER AVDIRE VOLVE
RIS, DE TALI ENIM CIBO DICTV EST, QVI E
DVNT ME ADHVC ESVRIVNT, ET QVI BIBVNT
ADHVC SITIVNT. QVAMVIS ENI MELIVS
SIT FACERE QVAM NOSSE PRIVS TA
MEN EST NOSSE QVAM FACERE, DEBET
ENI DISCERE QVOD OPTAT IMPLERE, DEV
QVE AVDIS CRIPTVRA DICENTE, OMNIS
QVI NON DIDICERIT IVSTITIA SVPER TER
RA VERITATEM NON FACIET, ET ITERV
ZELVS ADPREHENDET POPVLVM INDNE

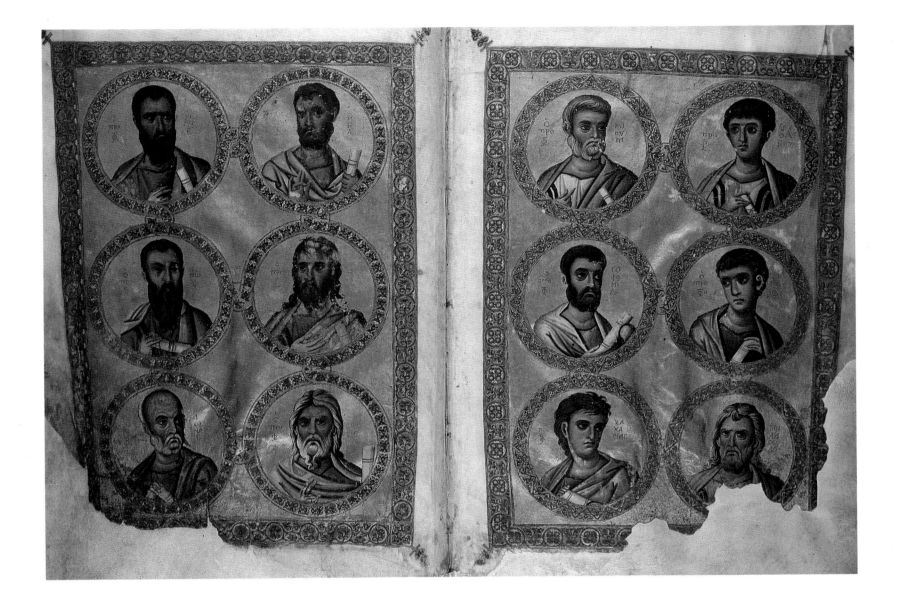

Pages 66-7: Stockholm *Codex Aureus*
Mid-8th century, 395 x 314 mm, 193 ff., in Latin, display capitals and uncials, later addition in minuscule. Stockholm, KB, MS A. 135
This manuscript was probably produced at Canterbury. The canon table pages are decorated with architectural motifs, and white pages alternate with purple. The portraits of the Evangelists St Matthew (illustrated) and St John are not in the Insular style but closer to classical Mediterranean models. There is some typical Anglo-Saxon ornament. The large *XPI* (*Christi autem generati*) is typical of Anglo-Saxon decoration, a rich and elaborate composition with zoomorphic motifs, scrolls, interlace, spirals, animal-motifs, dots, etc., extending the entire width of the first line of writing. As in other examples of Insular art, script and ornament unite in a composition of astonishing virtuosity.

Opposite: *Liber sermonum vel adhortationis patrum ad profectu monachorum*; St Césaire d'Arles, *Homilies, Commentary on the Gospels*
8th century (*c.* 700), 270 x 195 mm, 178 ff., in Latin, uncials by various hands. Brussels, BRA, MS 9850-52
The frontispiece (f. 4v) bears the name of Abbot Nomedius who commissioned the manuscript. The decoration is in the style of the schools of Luxeuil and Corbie. The twenty-eight initial letters are made up of geometric motifs, interlace, vegetal and, more rarely, zoomorphic motifs. The titles are written in capital letters and coloured.
The opening (*incipit*) of the *Homilies*, illustrated, is written in capital letters with a large decorated initial I (*Inter reliquas beatitudines*). During the Merovingian period decoration was confined almost exclusively to initial letters.

Above: Theodorus, *Commentary on the Twelve Minor Prophets*
9th century, 338 x 241 mm, 93 ff., Greek alphabet, uncials and minuscule. Turin, BN, MS B.I. 2
This manuscript suffered damage during a fire in 1904 that led to the loss of nearly one third of its 135 pages. The volume includes fine illuminations of the Byzantine school with echoes of the style and methods of classical painting.
The twelve medallions illustrated are the portraits of the minor prophets, depicted against a gold background within decorated borders. The prophets' austere dignity of expression conveys their sense of mission.

69

Opposite: Cresconius, *Concordia canonum, Collectio canonum,* and other works

9th to 10th century, 468 x 378 mm (ff. 357-62 were added at a later date and are of a smaller format), 362 ff., in Latin, Roman minuscule (ff. 1-30), Beneventan minuscule (ff. 31-3), Caroline minuscule (ff. 34-280), with the text in two columns. Rome, BV, MS A 5

The style of the illuminations indicates the school of Rheims, while the variety of the calligraphic styles points to a monastic scriptorium somewhere in the Roman provinces. The codex at one time belonged to the church at Ravenna. There are two full-page illustrations (ff. 14v, 15r), several titles in red and black borders, numerous initials with Carolingian-style interwoven geometric borders and several with zoomorphic motifs. The miniature shown is of a group of Apostles. Their accentuated, curving postures and the thick, nervous lines of the drapery indicate the influences of the Rheims school, in particular a certain 'expressionist' tendency that developed there. The bold border has a geometric motif.

Left: Antonius Musa, *De herba betonica*; Pseudo-Apuleius, *Herbarium*; Sextus Placitus Papiriensis, *De bestiis*, etc.

9th to 10th century, 235 x 165 mm, 129 ff., Beneventan script (Caroline minuscule on ff. 120r to 121v). Florence, BML, MS Plut. 73.41

This is probably a southern Italian codex, possibly made at the Benedictine monastery of Montecassino. It illustrates medicinal plants, animals (in *De bestiis*), and also scenes with human figures: sixteen pen-drawings (ff. 122r to 129v) show surgical operations, of which the illustration is an example. The style of the drawings indicates the Byzantine and Greek influences diffused in southern Italy.

Above: *Apocalypse*

9th century, 270 x 200 mm, 40 ff., in Latin, Caroline minuscule. Valenciennes, BM, MS 99

This manuscript is believed to have been written and illuminated in the north-east of the Carolingian empire, perhaps at Liège. Included are thirty-nine illuminations on the rectos of the pages. The style of the illuminations and ornament suggests an Insular model, probably from Northumbria. The page illustrated is a scene from the Apocalypse: an angel shows St John a woman, the 'great whore', seated on the back of a beast; a symbol of Rome which had dominated many peoples (Revelation 17, 1-5).

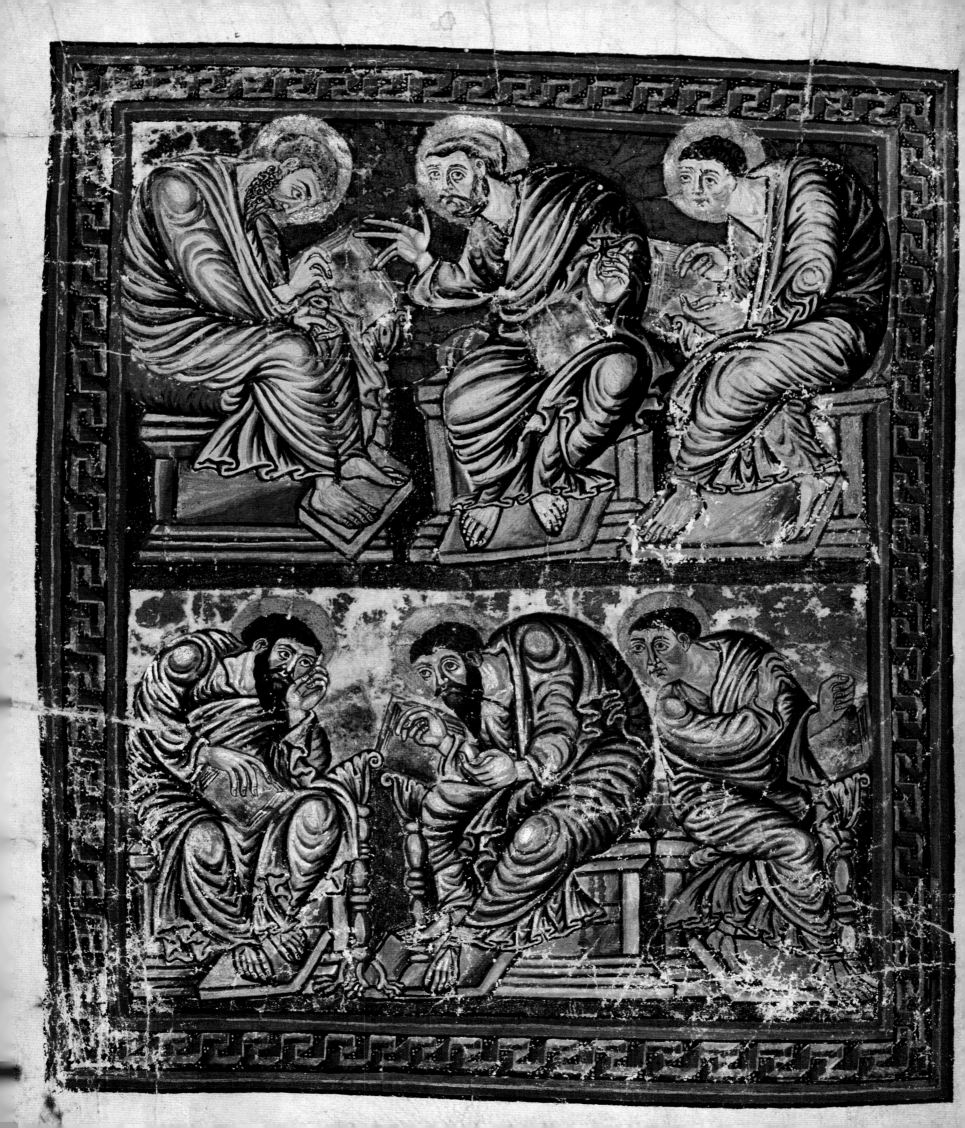

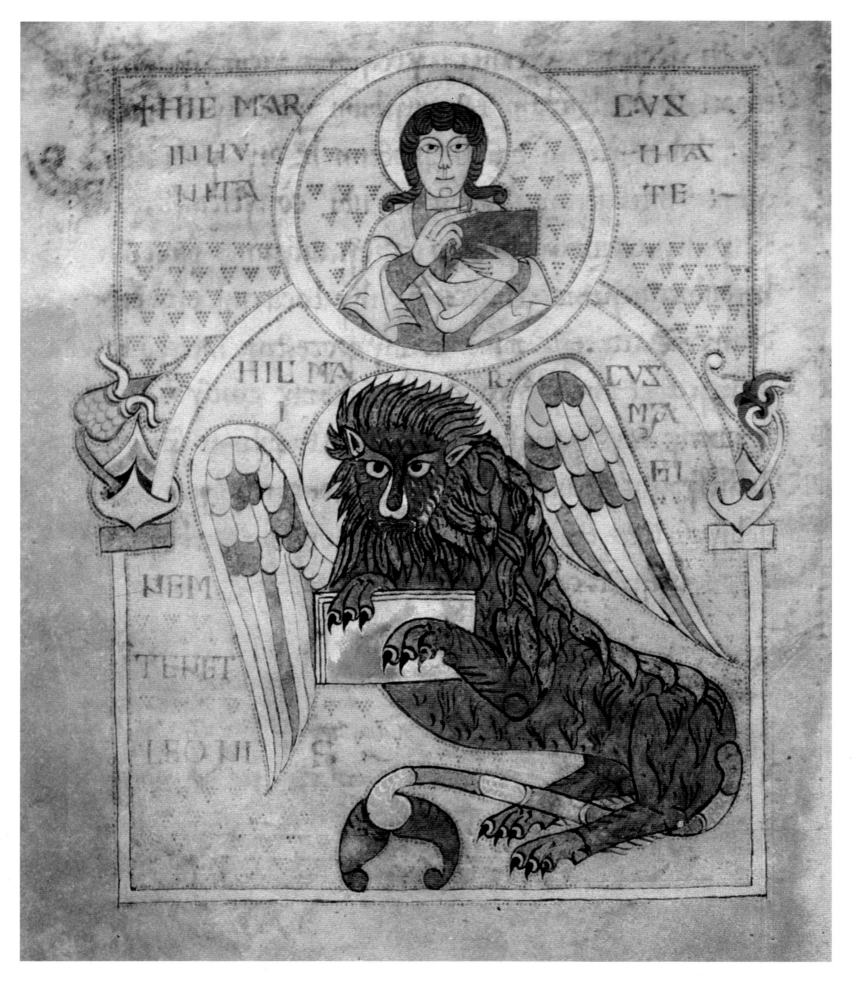

Opposite: *The Book of Cerne*
First half of 9th century, 320 x 184 mm, 98 ff., Insular minuscule. Cambridge, UL, MS L1.I 10
Later associated with the Abbey of Cerne, founded in 987, this manuscript has four full-page miniatures in an Insular style depicting the Evangelists and their symbols, and many illuminated initial letters in the earliest Anglo-Saxon style. The Evangelists are shown half-bust within circles, like St Mark, illustrated, with his symbol the lion below. The colours are unusual: deep blue, dark red, with much yellow, white and orange, reminiscent of the *Codex Aureus* in Stockholm (pp. 66-67).

Above left: Eterius and Samson, *Works*; St Augustine, *Dicta ex libro quaestionum*
9th century, 225 x 180 mm, 188 ff., in Latin, Visigothic minuscule. Madrid, BN, MS 10.018

This manuscript is from Toledo Cathedral. Like most Spanish manuscripts of the Mozarabic period, the eighth to ninth centuries, it has few decorative elements, its aesthetic value being chiefly calligraphic. The first page, illustrated, is ornamented with a Moresque arch coloured green, red and ochre.

Above right: *Mozarabic Breviary*
9th-10th century, 330 x 260 mm, 172 ff., Visigothic minuscule in two columns. Madrid, BN, MS 10.001
This manuscript, according to the colophon, was transcribed by the copyist Maurus for the priest Abundantius. It comes from Toledo Cathedral. The decoration is in the style of Toledo, with many initial letters decorated with a variety of figures, animals and interlace ornament, all coloured in the soft tones seen in the illustration.

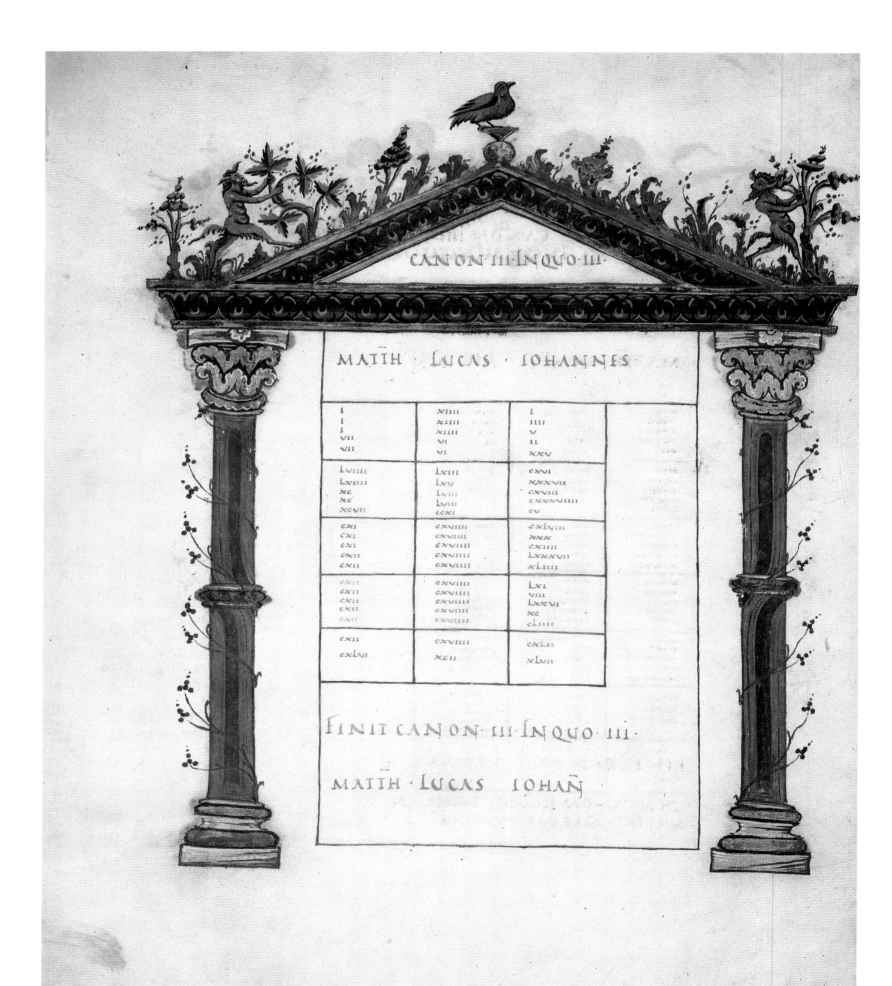

CANON III INQUO III

MATTH	LUCAS	IOHANNES
I	XIIII	I
I	XIIII	IIII
I	XIIII	V
VII	VI	II
VII	VI	XXV
LVIIII	LXIII	CXVI
LXVIII	LXV	XXXVII
XC	LVIII	CXXXVIIII
XC	LVII	CV
XCVIII	CCXI	
CXI	CXVIII	CXLVII
CXI	CXVIII	XXX
CXI	CXVIII	CXIIII
CXII	CXVIII	LXXXVII
CXII	CXVIII	XLIII
CXII	CXVIIII	LXI
CXII	CXVIIII	VIII
CXII	CXVIIII	LXXVI
CXII	CXVIIII	XC
CXII	CXVIIII	CLIII
CXII	CXVIIII	CXLII
CXLVII	XCII	XLVII

FINIT CANON III INQUO III

MATTH · LUCAS · IOHAN

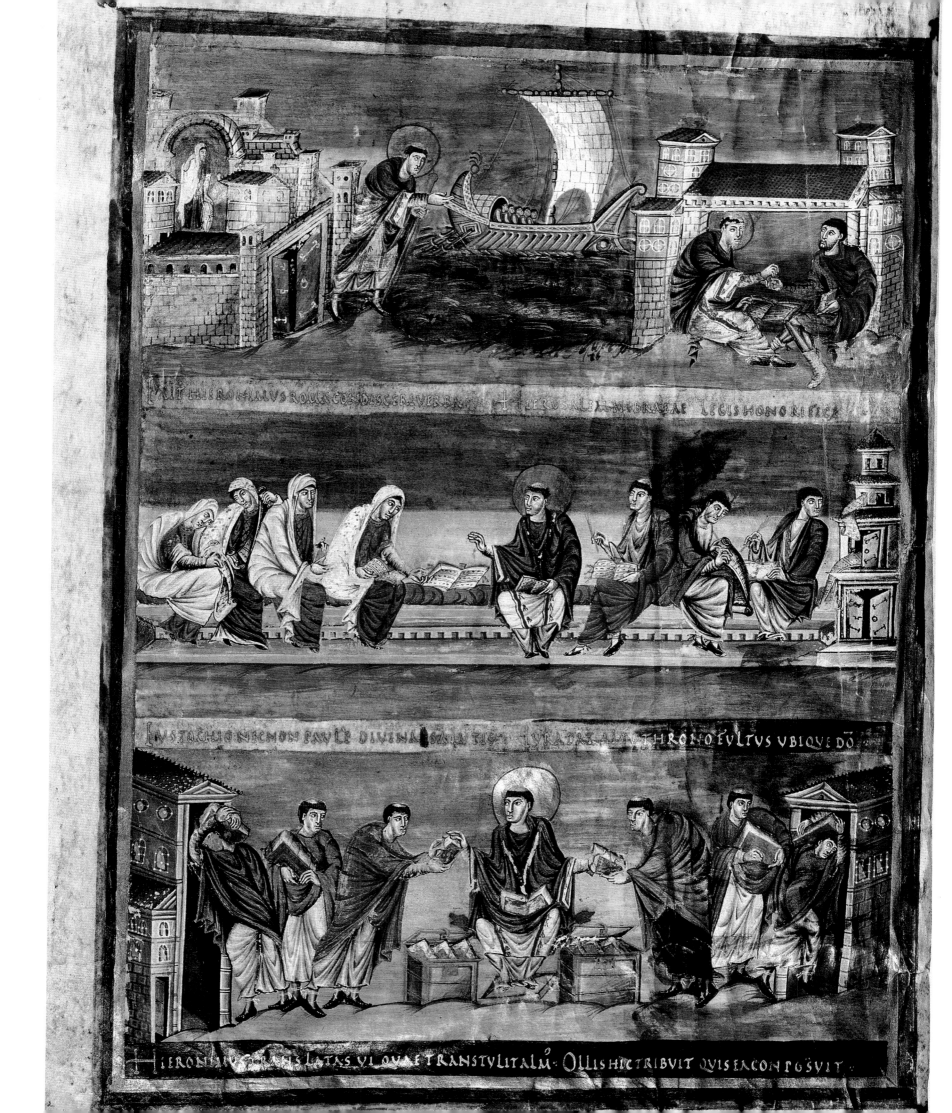

UT HIERONIMUS ROMANOS DISCERNUERAT · HIERUSALEM VBRATAE LEGIS HONORIFICE

IUSTOCHIUM NECNON PAULE DIVINA SENA FIGI · IURA PATRIA LATHRONO EVLTUS VBIQUE DŌ

HIERONIMUS TRANSLATAS VL QUAE TRANSTULIT ALM · OLLIS HIC TRIBUIT QUIS EA COMPOSUIT

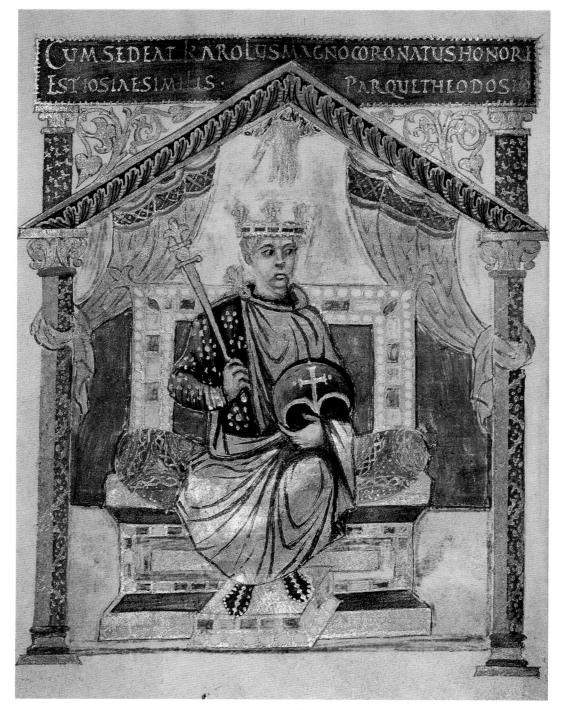

Left: *Psalter of Charles the Bald*
9th century (between 842 and 869), 240 x 195 mm, 173 ff., gold capitals and uncials, except for 6 ff. in minuscule. Cover 9th century, wooden boards, leather-covered, with precious stones and two ivory plates. Paris, BN, MS lat. 1152
This manuscript was made for Charles the Bald in the scriptorium of Corbie in northern France. Corbie had played an important and innovative role in the development of illumination during the eighth century.
The decoration of the Psalter consists of coloured initial letters, an *incipit* and titles in gold on a purple background, borders with palm-leaf motifs, geometric or dotted ornamentation, and purple borders. Three large miniatures represent King David, St Jerome and Charles the Bald, the latter (illustrated) shown seated on an inlaid throne in an architectural setting. Two curtains with folds delineated in black create the impression of an interior setting.

Opposite: *Drogo Sacramentary*
9th century (*c.* 850), 265 x 215 mm, 130 ff., uncials. Binding of Carolingian ivory panels with scenes of the Life of Christ and representations of church ceremonies. Paris, BN, MS lat. 9428
This manuscript is a product of the school of Metz, probably made for Drogo, bishop of that city (826-55). The decoration consists almost exclusively of initial letters of varying size, in gold with pale green and purple, with foliage motifs and scenes from the life of Christ, etc. The decoration of the letter C illustrated (f. 71v) depicts Christ's Ascension: the small composition on three levels fits harmoniously inside its acanthus border.

Page 74: *Gospels*
9th century (845-82), 305 x 254 mm, 188 ff., rustic capitals and Caroline minuscule. New York, PML, MS 728
A manuscript written and illuminated at Rheims, in one of the scriptoria developed during the Carolingian renaissance which took its inspiration from the classical art of Rome and Roman Gaul. This canon table page has an architectural frame on the top of which flourishes a fantastic garden with a bird and two satyrs.

Page 75: *Bible of Charles the Bald*
9th century (*c.* 846), 495 x 375 mm, 423 ff., in Latin, rustic capitals and Caroline minuscule in two columns, Paris, BN, MS lat. 1

This Bible is a product of the school of Tours. A dedication in verse at the end of the volume states that the manuscript was given to Charles the Bald by Abbot Vivien of the monastery of St Martin of Tours. The decoration includes eight full-page illuminations, eighty large coloured initials, borders, small figures ornamenting the titles, and titles in gold and silver capitals on purple bands. The page illustrated shows episodes from the life of St Jerome, author of the Vulgate (*editio vulgata*), the Latin translation of the Bible (revised from older translations and the original Hebrew and Greek texts). At the top, St Jerome is shown about to leave Rome for Jerusalem; at the centre he is surrounded by scribes and assisted by his disciples; below, he is seen distributing his new Bible.

...ONCE...
...qs...
NI
T

NA
UNI
NITU
UM RE

TOREM NOSTRUM ADCAE
LOS ASCENDISSE CREDI
MUS·IPSIQUOQ: MENTE IN
CAELESTIBUS HABITEMUS:
PER EUNDE DNM NOSTRU
ihm xpm FILIUM TUU: qui

ΑΡΙΘΜΟΙ ΚΟΙΝΟΙ		Μ	Α Ζ	Β Ζ
ΡΙϚ	CΛΘ	Β	ΛΔ	ΙϚ
ΡΙΖ	CΛΗ	Β	ΛΗ	Μ
ΡΙΗ	CΛΖ	Β	ΜΓ	Ō
ΡΙΔ	CΛϚ	Β	ΜΖ	ΙϚ
ΡΚΕ	CΛΕ	Β	ΝΑ	Μ
ΡΚϚ	CΛΔ	Β	ΝϚ	Ō
ΡΚΖ	CΛΓ	Γ	Ō	Ō
ΡΚΗ	CΛΒ	Γ	Δ	Ō
ΡΚΘ	CΛΑ	Γ	Η	Ō
ΡΛ	CΛ	Γ	ΙΒ	Ō
ΡΛΑ	CΙΘ	Γ	ΙϚ	Ō
ΡΛΒ	CΙΗ	Γ	Κ	Ō
ΡΛΓ	CΙΖ	Γ	ΚΔ	Ō
ΡΛΔ	CΚϚ	Γ	ΚΗ	Ō
ΡΛΕ	CΚΕ	Γ	ΛΒ	Ō
ΡΛϚ	CΚΔ	Γ	ΛΕ	Μ
ΡΛΖ	CΚΓ	Γ	ΛΘ	ΙϚ
ΡΛΗ	CΚΒ	Γ	ΜΕ	Ō
ΡΛΘ	CΚΑ	Γ	ΜϚ	ΙϚ
ΡΜ	CΙϚ	Γ	ΜΘ	Μ
ΡΜΑ	CΙΘ	Γ	ΝΓ	Ō
ΡΜΒ	CΙΗ	Γ	ΝϚ	ΙϚ
ΡΜΓ	CΙΖ	Γ	ΝΘ	Μ
ΡΜΔ	CΙϚ	Δ	Γ	Ō
ΡΜΕ	CΙΕ	Δ	ϛ	Μ
ΡΜϚ	CΙΔ	Δ	Η	ΙϚ
ΡΜΖ	CΙΓ	Δ	ΙΔ	Ō
ΡΜΗ	CΙΒ	Δ	ΙΔ	Ō
ΡΜΘ	CΙΑ	Δ	ΙΖ	Ō
ΡΝ	CΙ	Δ	Κ	Ō

ΑΡΙΘΜΟΙ ΚΟΙΝΟΙ		Μ	Α Ζ	Β Ζ
ΡΝΑ	CΘ	Δ	ΚΒ	ΙϚ
ΡΝΒ	CΗ	Δ	ΚΔ	Μ
ΡΝΓ	CΖ	Δ	ΚϚ	Ō
ΡΝΔ	CϚ	Δ	ΚΘ	ΙϚ
ΡΝΕ	CΕ	Δ	ΛΑ	Μ
ΡΝϚ	CΔ	Δ	ΛΔ	Ō
ΡΝΖ	CΓ	Δ	ΛϚ	Ō
ΡΝΗ	CΒ	Δ	ΛΗ	Ō
ΡΝΘ	CΑ	Δ	Μ	Ō
ΡΞ	C	Δ	ΜΑ	Μ
ΡΞΑ	ΡϞΘ	Δ	ΜΓ	Ō
ΡΞΒ	ΡϞΗ	Δ	ΜΕ	Ō
ΡΞΓ	ΡϞΖ	Δ	ΜϚ	Μ
ΡΞΔ	ΡϞϚ	Δ	ΜΗ	ΙϚ
ΡΞΕ	ΡϞΕ	Δ	Ν	Ō
ΡΞϚ	ΡϞΔ	Δ	ΝΑ	Μ
ΡΞΖ	ΡϞΓ	Δ	ΝΓ	ΙϚ
ΡΞΗ	ΡϞΒ	Δ	ΝΔ	Ō
ΡΞΘ	ΡϞΑ	Δ	ΝΔ	Μ
ΡΟ	ΡϞ	Δ	ΝΕ	ΙϚ
ΡΟΑ	ΡΠΘ	Δ	ΝϚ	Ō
ΡΟΒ	ΡΠΗ	Δ	ΝϚ	Μ
ΡΟΓ	ΡΠΖ	Δ	ΝΖ	ΙϚ
ΡΟΔ	ΡΠϚ	Δ	ΝΗ	Ō
ΡΟΕ	ΡΠΕ	Δ	ΝΗ	ΙϚ
ΡΟϚ	ΡΠΔ	Δ	ΝΗ	Μ
ΡΟΖ	ΡΠΓ	Δ	ΝΘ	Ō
ΡΟΗ	ΡΠΒ	Δ	ΝΘ	ΙϚ
ΡΟΘ	ΡΠΑ	Δ	ΝΘ	Μ
ΡΠ	ΡΠ	Ε	Ō	Ō

ΑΡΙΘΜΟΙ ΚΟΙΝΟΙ		Μ	Α Ζ	Β Ζ
Ϛ	ΤΝΔ	Ō	Λ	Ō
ΙΒ	ΤΜΗ	Ō	Λ	Τ
ΙΗ	ΤΜΒ	Ō	Λ	Θ
ΚΔ	ΤΛϚ	Ō	Λ	ΔΙϚ
Λ	ΤΛ	Ō	Λ	ΠΙΕ
ΛϚ	ΤΚΔ	Ō	Λ	S
ΜΒ	ΤΙΗ	Ō	Λ	ΙΑΛ
ΜΗ	ΤΙΒ	Ō	Λ	ΓΙΕ
ΝΔ	ΤϚ	Ō	ΛΑ	Ε
Ξ	Τ	Ō	ΛΑ	ΓΙΕ
ΞϚ	CϞΔ	Ō	ΛΑ	ΙΑΛ
ΟΒ	CΠΗ	Ō	ΛΒ	Ō
ΟΗ	CΠΒ	Ō	ΛΒ	ΔΙϚ
ΠΔ	CΟϚ	Ō	ΛΒ	SΙ
Ϟ	CΟ	Ō	ΛΒ	ΓΙϚ
ϞϚ	CΞΔ	Ō	ΛΓ	Ε
ΡΒ	CΝΗ	Ō	ΛΓ	S
ΡΗ	CΝΒ	Ō	ΛΓ	ΔΙϚ
ΡΙΔ	CΜϚ	Ō	ΛΔ	Ι
ΡΚ	CΜ	Ō	ΛΔ	ΓΙΕ
ΡΚϚ	CΛΔ	Ō	ΛΔ	Ε
ΡΛΒ	CΚΗ	Ō	ΛΔ	Ō
ΡΛΗ	CΚΒ	Ō	ΛΕ	Ε
ΡΜΔ	CΙϚ	Ō	ΛΕ	ΓΙ
ΡΝ	CΙ	Ō	ΛΕ	SΙ
ΡΝϚ	CΔ	Ō	ΛΕ	ΙΑΛ
ΡΞΒ	ΡϞΗ	Ō	ΛϚ	ΔΙϚ
ΡΞΗ	ΡϞΒ	Ō	ΛϚ	ΓΙΕ
ΡΟΔ	ΡΠϚ	Ō	ΛϚ	ΓΙΕ
ΡΠ	ΡΠ	Ō	ΛϚ	Ō

78

EXPLICIT TITVLI :

INCIPIT APOCALYPSIS

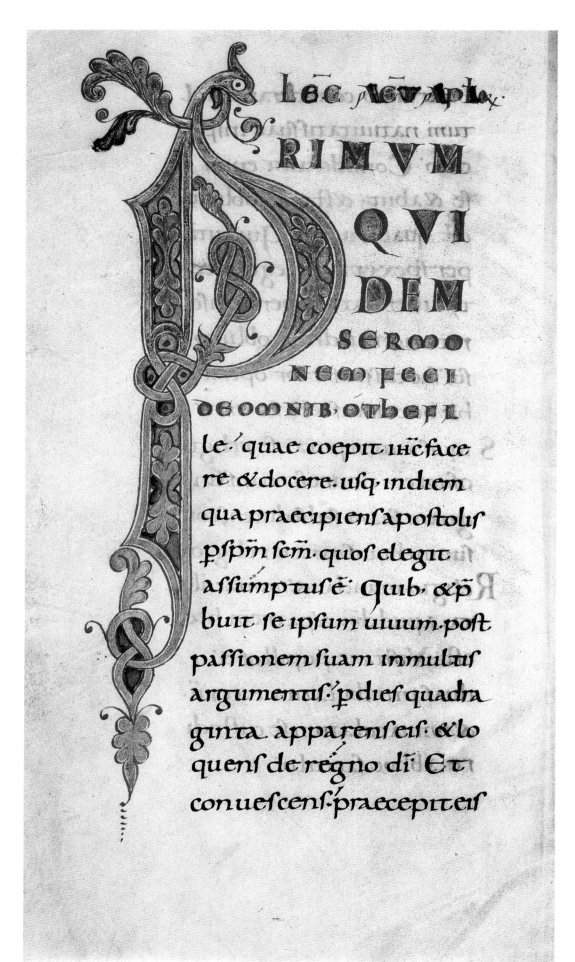

Page 78: Ptolemy, *Tables*
9th century (828-35), 281 x 204 mm, 95 ff., Greek capitals and uncials. Rome, BAV, MS Gr. 1291
This manuscript was probably made in Byzantium between 828 and 835. The various tables are embellished with symbolic figures. The page shown here gives the lunar tables, with the personification of the moon in the lunette on the right.

Page 79: *Acts of the Apostles, Epistles, and the Apocalypse, with commentary by the Venerable Bede: the Jovenian Codex*
8th-9th century, 313 x 230 mm, 101 ff., display capitals and uncials. Rome, BAV, MS B 25²
This codex, written or commissioned by 'Iuvenianus subdiconus', was probably made for a church or monastery of S. Lorenzo, Rome. It is regarded as one of the masterpieces of Roman illumination of the first quarter of the ninth century. The style is marked by its independence of classical models, and is extremely simple yet finished. The page illustrated is written in uncials followed by an *explicit* in capital letters, and below the illustration, '*Incipit Apocalypsis*'. The sleeping St John receives, in a dream, the revelation of the Apocalypse. Unlike the other illuminations in the codex, this shows the influence of Carolingian models.

Left: *Lectionary*
9th century (*c.* 850), 314 x 155 mm, 88 ff., display capitals, uncials, and Caroline minuscule. Geneva, BPU, MS lat. 37a
This manuscript is one of the creations of the school of the Abbey of St Gall during the period of Abbot Grimald (841-72). The style of the decoration is influenced by Irish art. The large P of *Primum quidem*, introducing a reading from the Acts of the Apostles, is embellished with a stylized plant-motif and surmounted by a small animal-head.

Opposite: St Gregory the Great, *Moralia in Job*
10th century, 433 x 295 mm, 229 ff., in Latin, Caroline minuscule. Milan, BA, MS B. 41. inf.
This manuscript came from Turin, and was acquired for the Biblioteca Ambrosiana in 1607. There are various large illuminated initials, with geometric and ribbon motifs, vegetal and zoomorphic decorations and human figures that sometimes form the letters. The range of colours includes red, green, blue, yellow and brown, with white lead highlights. Shown is the large initial Q of *Quorundam mentes* that introduces Book VII, with Job seen lying on a bed attacked by a devil. A quadruped with a snake in its mouth completes the letter Q with its long tail.

INCIPIT LIBER VII QUORUMDAM

mentes plus flagella quá conuitia cruciant.
quorundaú plusconuitia quá flagella
castigant. Nam sepe contra nos quib libet
penis durius tormenta uerberum seui
unt. cuq nos ad defensione erigunt. in
impatientia sternunt. Unde beati iob

nede esse temptatio ulla potuisset. ñ solum
hunc flagella desup feriunt. sed grauiora apla
gis amicoru conloquia affligunt. ut sci
uiri anima hinc inde pulsata. ad motu ira
cundie elationis erupe. z qceq modu uixerat.
pcontumania supe locutionis inquinaret.
Sed tactus plagis quas retulit. lassitur ú
tecta respondit. ipsius ú innotescit. quá
p minimo salute carnis habuerit. loques
quoq indicat. quá sapiens tacebat. Sed q
dam eius uerbis admixta s. que apud hu
mana iudicia patientie limitem transire
uideantur. que nos uere intelligim si supni
sententia iudicis meoy examinatione pen
semus. Ipse quippe beati iob ipm contra suu
aduersariu ptulit dicens. Uidisti seruu meu
iob. q ñ sit ei similis sup tram. ut simplex
z rectus ac timens dm z recedens amalo.
Ipse p pbatione amico eius redarguit dices
non estis locuti cora me rectum sicur seruu
mis iob. Restat q ut cu mens inbeati iob
sermonib fluctuat. eorú pond exeiusdem
ystorie initio ac fine ppendat. Ab eino eni
iudice. nec casur laudari potuit. nec lapsus
pferri. Si q in ambiguitati tepestate dep
hensi. pma huius ystorie z postrema consi
picimus. nauis cordis considationis sue fu
nibus quasi aprora z pupi restringitur. ne
in errotis saxa pducatur. Nullus q ignoia
tie ñe pcellis obruimur. si tranquillu supne
sententie litus tenemus. Ecce eni dicit q que
stione ñ modica animu lectoris moueat. S;
quis hoc ñ rectú dicere audeat. q in dì auni
bus rectú sonat? Utina appenderent peccata
mea quib iram merui. Et calamitas quá
patior in statera. quasi arena maris hec q
uior appareret Quis alius statere nomine
ñ dì z hominu mediator exprmit. qui ad pe
sandu uite ñe meritu uenit. Ac secu iusticia
simul z misdiam detulit. Sed mie lance ipo
dans culpas ñas parcendo leuigauit. In ma
nu eni patris quasi statera miri libramini
factus. hinc inse calamitate nrm z illinc

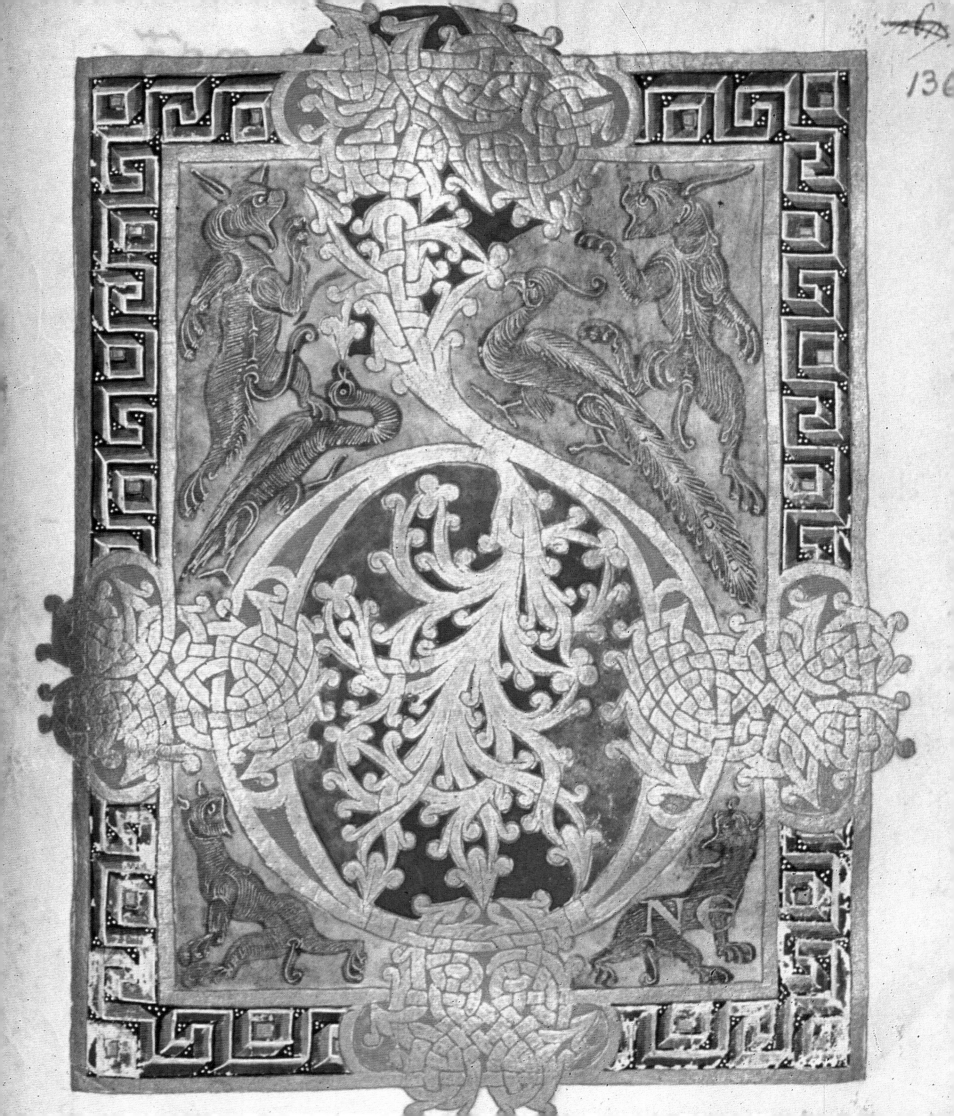

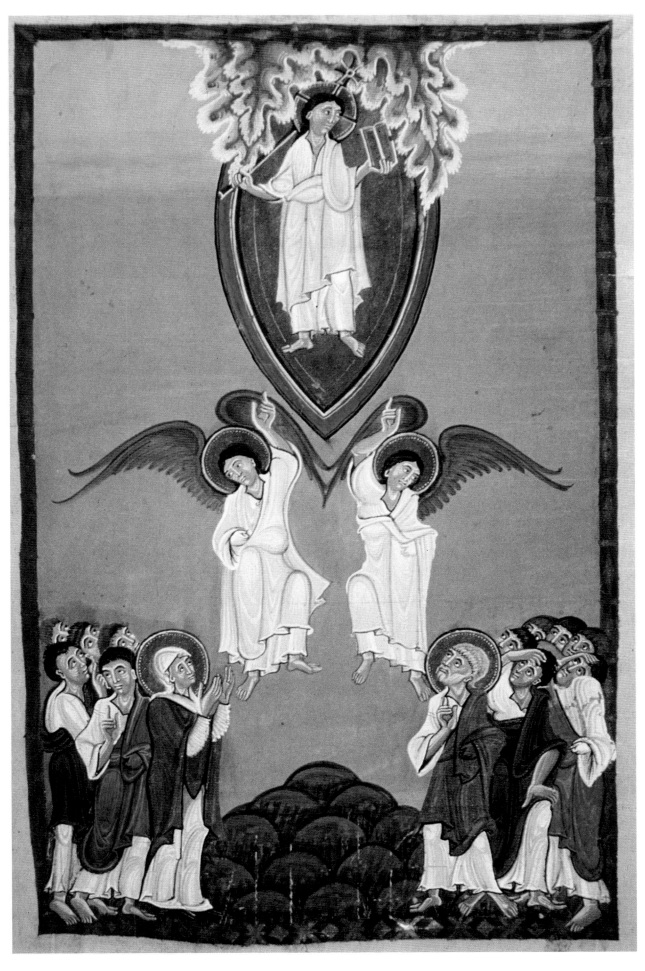

Perquod celum
pat suctum;
Perquod regnum
celosu promissu·eta
Perquod Inuenim;
eundi uiciii;
Perquod assequimur
pueniendi uiticale·
Perquod adipiscim·
tegescendi uiciii;
Perquod habebim·
perhennem atie
dulcedinis uisione·

Nā nūc; kōmodo;
lū Inpterenci;
Inhocloco; Inhoc
secu; Inhoc mōmen
loco;

Inhoc tempore·
Perpsum quiurbia
ea regnaut Inseclii
sctotum; aā

PARS

SECV

NDA;

Quidai
eis

Iudee·

Quidpre
ponis·

quid asseriis·

Aldefons

Iudeus

P· Congru Iudeos ∴

Opposite: St Ildefonsus, *De virginitate Sanctae Mariae*
10th century, 215 x 159 mm, 106 ff., in Latin, Visigothic minuscule. Florence, BML, MS Aschb. 17
A Spanish manuscript, this may have been produced in Castile. The portions which are illuminated provide an interesting example of Mozarabic art. The manuscript belongs to that group in which the decoration is not limited to simple ornament (as in many codices of the tenth century made in southern Spain), but extends to illustrations of the text. Among the full-page illuminations, the first shows the author praying (f. 2r), two others are scenes from the Gospels: the Women at the Sepulchre and an Annunciation framed by a Moresque arch. Smaller illuminations are inserted in the text, and there are some ornate initial letters. The illustration shows titles and large initials, and a small scene of Ildefonsus conversing with a Judean, inserted between the lines almost without regard to continuity, in a style reminiscent of calligraphy.
Islamic influence is evident in the schematic rendering of the figures, which are nevertheless striking in their immediacy.

Right: *Psalter*
10th century (*c*. 926-39); 128 x 88 mm, 200 ff., Insular minuscule supplementing Caroline minuscule. London, BL, Cotton MS Galba A. XVIII
The first part of this manuscript was made around Liège towards the end of the ninth century. It was continued in the first half of the tenth century at Winchester in England, at the Old Minster, probably having been presented to that monastery by the English king Athelstan (924-40). The English additions consist of a Calendar, discussions of calculus, prayers, a litany in Greek, and four full-page illuminations, of which one, a Nativity (f. 85) is now at the Bodleian Library, Oxford. The earliest part of the book has initials of gold interlace of a Franco-Saxon school. The page illustrated is of Christ in a mandorla with the angelic hosts and prophets on four levels (f. 2v). The scene is rich in pathos. It is enclosed in a border with grotesques at the four corners. The entire composition converges upon the figure of Christ. The figures, densely crowded, suggest by their gestures and expressions their intense involvement. The style is southern English, and represents the early Winchester style which combined Carolingian elements with echoes of the classical tradition.

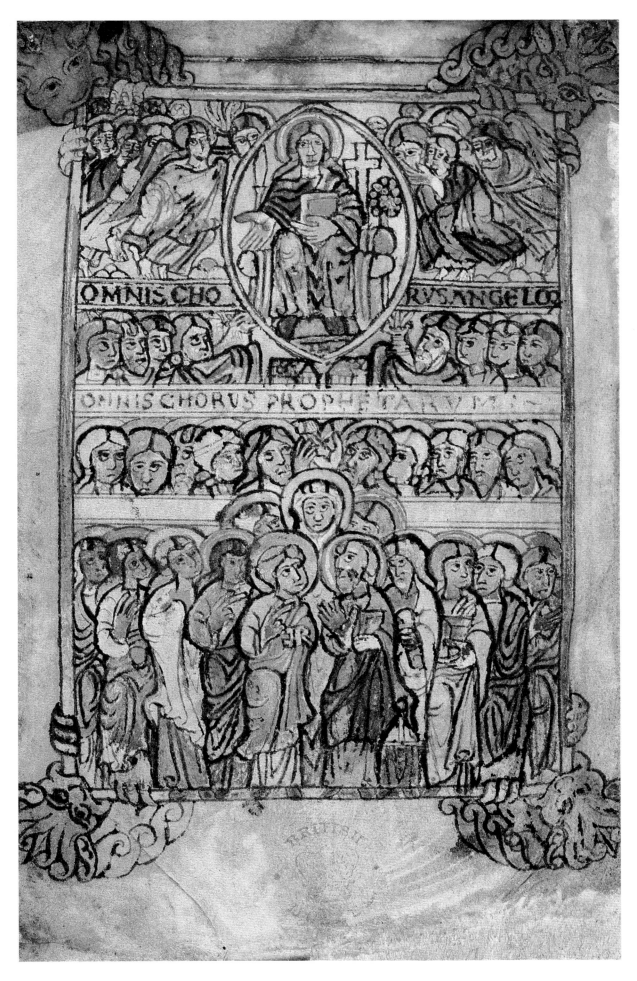

Prudentius, *Psychomachia*; *Physiologus*; bound with other texts

10th century, 260 x 170 mm, 47 ff., in Latin, Caroline minuscule. Brussels, BRA, MS 10073-74

This manuscript may have been produced in the river Meuse area; it was in the Benedictine Abbey of St Lawrence near Liège and passed, probably during the eighteenth century, to the library of the dukes of Burgundy; during the Napoleonic period it was taken to Paris, but returned to Liège after the restoration of the monarchy.

The book of Prudentius (a fourth- to fifth-century Christian poet) and the *Physiologus* are similar in style and technique. For the Prudentius the outlines of the designs were traced in before the text was written. The artist ceased work at the fiftieth illustration; from that point on, the copyist left spaces that were never filled. The sketch-like illustrations are mostly heightened with green and ochre. The linear drawing represents a clear break with the classical style. The pages reproduced are from the preface to the *Psychomachia*: at the left, Abraham hands a sacrifice to Melchizedek; at the right, Sarah the wife of Abraham stands at the entrance to a tent, while Abraham receives from three angels the unexpected news of the birth of a son. The lively pen-drawing give a sense of immediacy, and if at first the drawing seems almost hasty, examination reveals a wealth of detail that makes the little scenes appear finished.

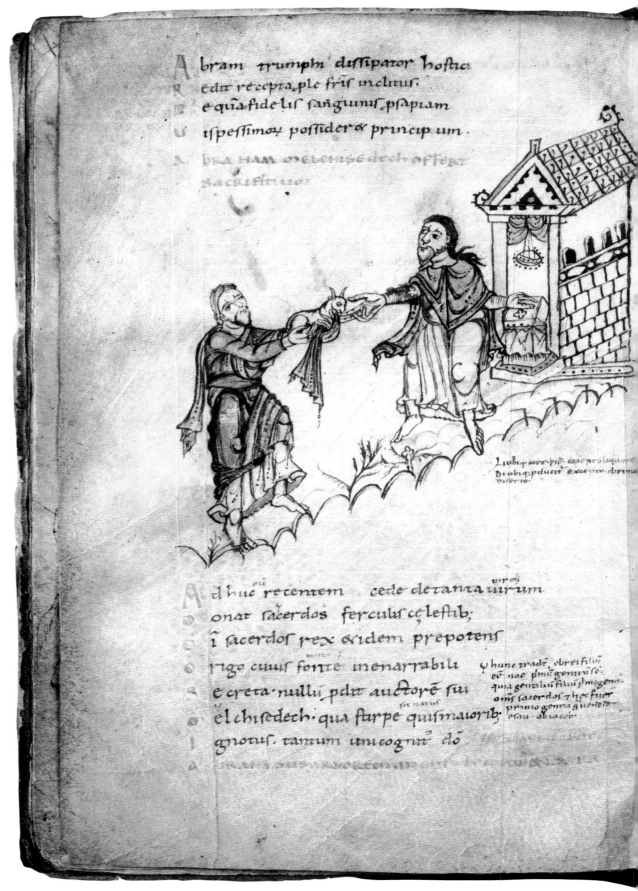

Mox &triformis angloy trinitas
enis retulit hospitis mappalia;
t iam meta sara maluum fertilis
unus inuente mater exanguis stup&
erede gaudens &cachinnipennens;
&c adfiguram prenotata est linea
uam nra recto uia resculpat pede +
igilandum inarmis pectorumfidellum
mnemq; nri portionem corporis
uig capta foede seruat libidini
omi coactus liberandamuurib;
os esse large uernularum dumes
iquid trecenti bisnouenis addims
ossint figuranouerimy mistica;
ax ipse xpe quisacerdos uerusest
arente inenarbiliunosai atq

Alagalia uiessease
pastoris t edisma nuundara
agrestui q̄ mappalauilli.
uocant oblonga senruis
lateribz; quasinauii carine

suadit uinuit frequentat ierar demonstrar
nouerimmisticafigura siquis possin
ircocum bisnouenisacddns
&tuugilandu maxime
fidelium pectori
rede liberanda
omem passione
nri corporis

octobeatitudinem essi par
patienna: paupras: spi
mansue tudo tristina
Sedmdm amor iustine
misecta paupras

Overleaf
Page 88 left: *Bible*
10th century (before 988), 434 x 320 mm,
375 ff. Visigothic minuscule. Madrid, BN,
MS Vit. 13-1
Known as the *Codex Toletanus* or *Hispanensis*, this Bible was written by four copyists for Servando, bishop of Ecija or Baza, in Andalusia. The manuscript's decoration is in the Andalusian-Mozarabic style, with eastern influences, and belongs to a group of tenth-century codices characterized by sobriety of decorative treatment, ornamented with arches, initials decorated with zoomorphic motifs – sometimes fantastic, sometimes realistic – or made of angels, and stylized plant motifs or arabesques. There are also pendrawings of the minor prophets Micah, Nahum and Zechariah. The page illustrated has the canon tables framed in a Moresque arch with the symbols of St Luke (the bull) and St John (the eagle).

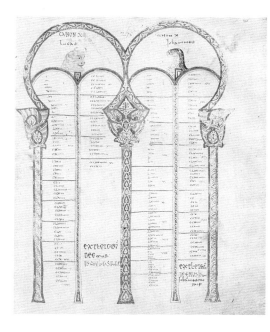

Opposite: Beatus of Liebana, *Commentary on the Apocalypse of St John*
10th century (920-30), 346 x 240 mm, 144 ff., Visigothic minuscule in two columns. Madrid, BN, MS Vit. 14-1
An Asturian monk, Beatus of Liebana, wrote this work *c.* 775-6. In the preceding century during the Fourth Council of Toledo, the Apocalypse had been officially accepted by the Spanish Church and defined as a 'canonical work to be read in churches between Easter and Pentecost'. This codex, which comes from the monastery of S. Millàn de la Cogolla (Old Castile), has twenty-seven illuminations of the Castilian Mozarabic school in a style close to that of Florentius in the St Gregory the Great *Moralia in Job* (below).

Here a scene of vintaging symbolizes the Last Judgment. Above on a cloud is a personage 'like unto the Son of man', with a sickle in his hand, while angels appear before the temple. ('Thrust in thy sickle, and reap: for the time is come for thee to reap; for the harvest of the earth is ripe'.) In the centre, another angel 'which had power over fire' watches a reaper and vintager at work; at the bottom, the grapes are in the 'great winepress of the wrath of God' – 'and blood came out of the winepress' (Revelation 14, 14-20). The imagery is stylized, but is more naive and popular in style than that of Florentius. The bright colours lack the drama and power of some other illuminations inspired by the Apocalypse.

Right: St Gregory the Great, *Moralia in Job*
10th century (945), 480 x 345 mm, 501 ff. Visigothic minuscule. Madrid, BN, MS 80
This manuscript was made in the monastery of Valeria (San Pedro de Varelanca), Tordomar (Old Castile). It was copied and illuminated by Florentius. It first belonged to Toledo Cathedral. The decoration consists of initial letters with interlace, or simply written in red, or in green or yellow outlined in red, and titles of coloured and ornamented majuscules. The six full-page illuminations are, respectively, a large Alpha (f. 1v), Christ Pantocrator (f. 2r), the monogram of Christ (f. 2v), a labyrinth with the repeated phrase: *Florentium indigum memorare* (f. 3r), a peacock (f. 3v), and at the end, a large Omega. The decoration is of the Castilian Mozarabic school, but like that of other Spanish manuscripts of this period, it shows eastern influence. The illumination illustrated is of Christ in Glory between angels inside a blue circle symbolizing the celestial universe, and the symbols of the four Evangelists below. The illustration refers to the divine vision described by the Prophet Ezekiel (Ezekiel 1, 5-28). The figures are much stylized and given emphasis by the colours, alternating bright red and yellow.

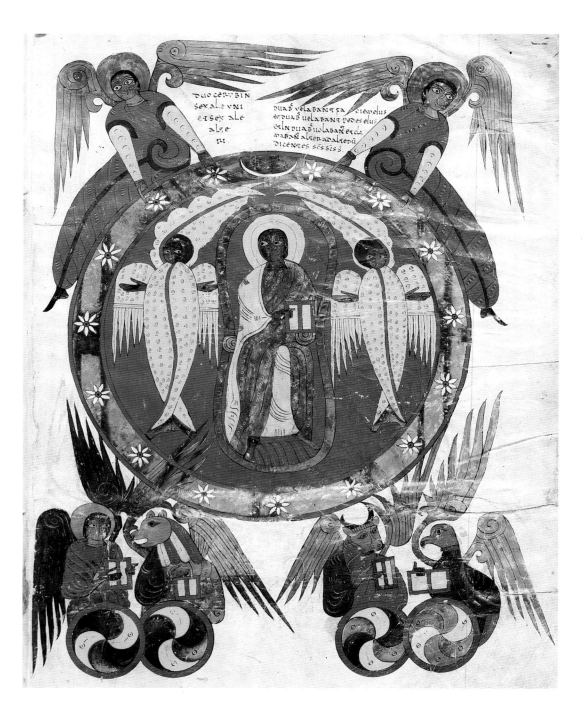

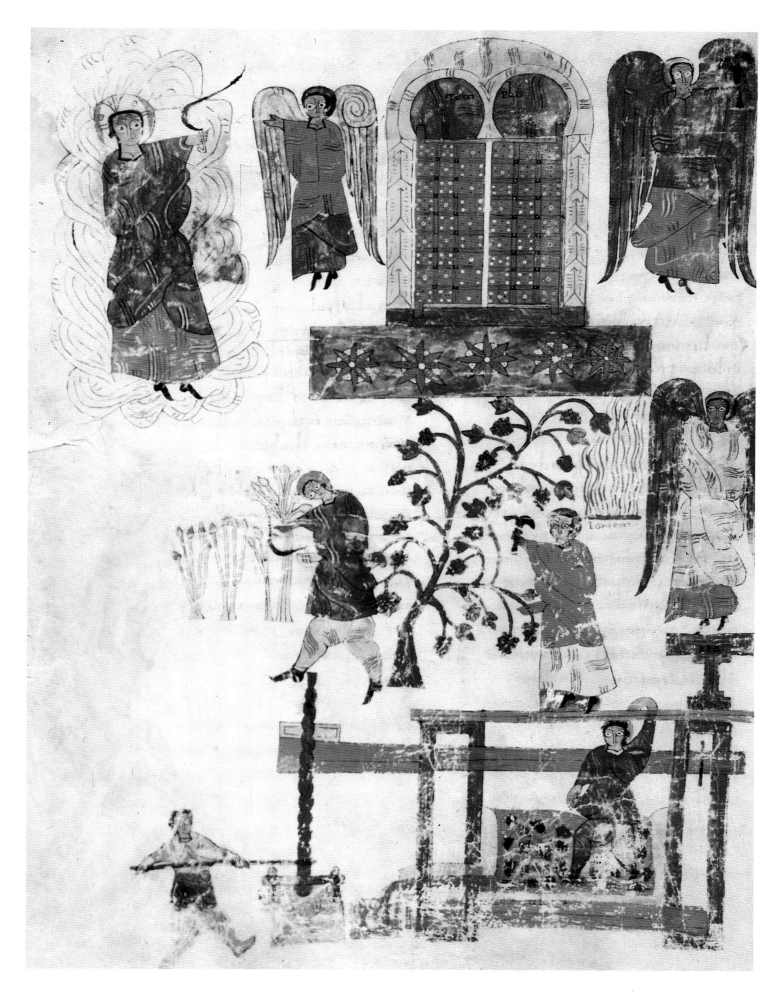

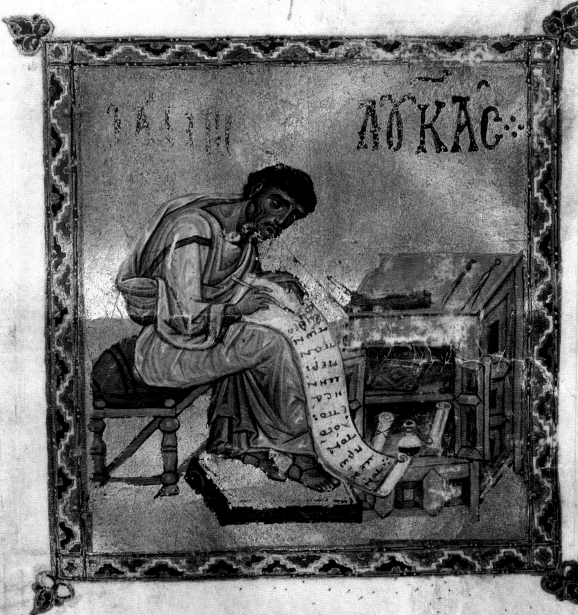

Opposite: *Acts of the Apostles; Apocalypse*
10th century (944-56); 180 x 130 mm, 367 ff., Greek minuscule. Vienna, ÖBN, MS Theol. Gr. 302
Made in Constantinople, this manuscript is dated by the patriarchs and emperors whom it mentions to sometime between 944 and 956. The illumination shows St Luke writing his Gospel on a scroll supported upon his knees, in the Graeco-Roman fashion. The cupboards of his desk and its inclined top display his copyist's equipment. The codex is also embellished with fine ornate initials and geometric motifs.

Left: *Gospels*
10th century (964), 175 x 120 mm, 392 ff., calligraphic Greek minuscule. Paris, BN, MS Gr. 70 (Regius 3424)
The decoration of this Gospel-book is of the Byzantine school. The beginning of St Luke's Gospel has finely ornamented capital letters. The design is centred, a recurrent feature of Byzantine decoration. The initial E suggests goldsmith's work.

Above left and right: *Bible*
10th century; Greek minuscule and uncials. Copenhagen, KB, Cod. GKS 6
This manuscript is an example of the Byzantine style, and is similar in design to other Greek manuscripts. However the writing is arranged in a different way from page to page: as plain columns or as columns with bases and capitals, as borders, or as spheres or ornaments of various kinds. The script is clear and regular. Shown above left is the beginning of the Lamentation of Job (Job 29) arranged as three columns with bases and capitals. Though without ornament it is decorative.

Below: Oppian, *Cynegetica*
Early 11th century, 235 x 190 mm, 67 ff., Greek
minuscule. Venice, BNM, MS Gr. 479 (881)
This work includes numerous illuminations – one
on almost every page – illustrating scenes of hunt-
ing or fishing, animals, mythological scenes or
battles (Achilles, Alexander, etc.). It is in the
Byzantine style, and the artist combines fantasy
with close observation. The simple scene of fish-
ermen with the lively fish and their full net
suggests a peaceful, idyllic natural harmony.

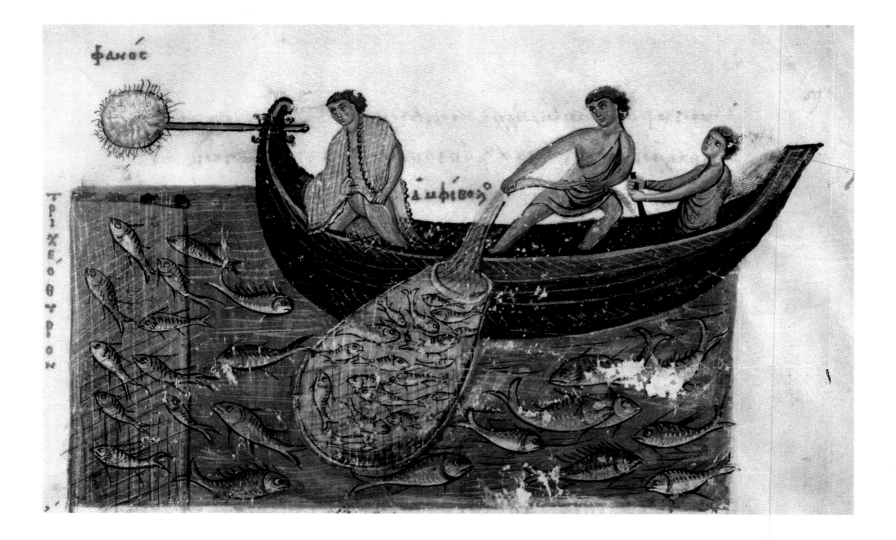

Opposite: *Gospels*
11th century, 350 x 250 mm, 42 ff., in Latin,
Caroline minuscule. Brescia, BCQ
This is a late example of the school of Reichenau
or nearby Einsiedeln. The Benedictine abbey of
Reichenau was founded during the tenth century.
The book went to the monastery of S. Salvatore e
Giulia, Brescia, and during the sixteenth century
it belonged to a Dr Tommaso Lamberti, Brescia,
whose coat of arms appears of f. 1r. It has
numerous illuminated pages. The canon tables
are in arches with columns, variously ornamen-
ted. Readings from the Gospels are preceded by
full-page illuminations, and have a large illumina-
ted initial with gold vine-leaf ornament and bor-
der. The style that reached maturity around 1000
in the school of Reichenau is of a German type
with Ottonian characteristics: anti-classical, with
sharp outlines. In the Descent of Christ to the
inhabitants of Hell, illustrated, the figures are
nervously modelled, the effect is vibrant and
expressive.

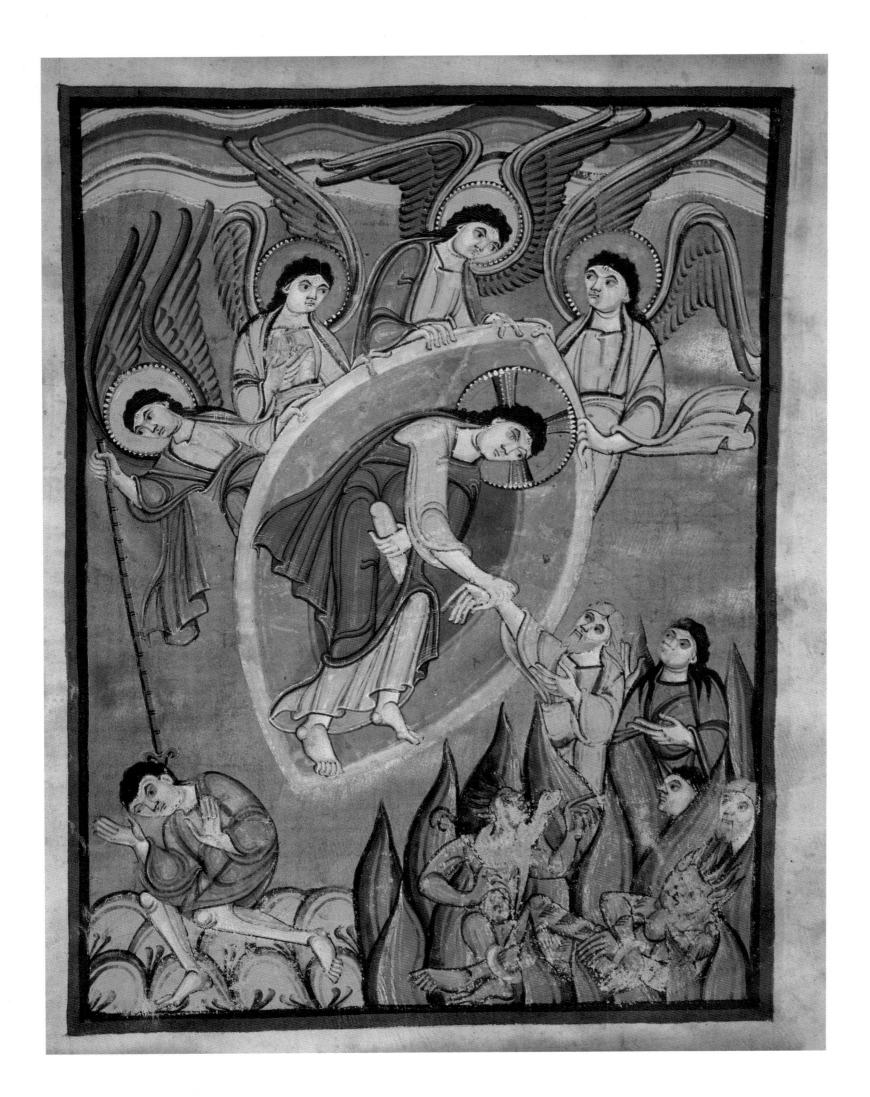

Left: St Augustine, *De Civitate Dei*
12th century (*c*. 1120); 350 x 250 mm, 226 ff.,
Caroline minuscule. Florence, BML, MS Plut.
12.17

This manuscript was most probably made at
Canterbury, possibly at the Abbey of St Augusti-
ne. At f. 226r there is a note: '*Liber petri de
Medicis Cosimi filii*': evidently the work belonged
for a period to the Medici family of Florence.
This is one of the earliest illuminated manuscripts
of St Augustine's *The City of God*. It includes
four full-page illuminations: the first (f. 1v)
shows, on three levels, the Judgment, the works
of war and the works of peace; the second (f. 2v)
the City of God; the third (f. 3v) St Augustine
teaching, the fourth (f. 4r), groups of students.
There are also ten illuminated initial letters.

The City of God, illustrated, is presented as an
edifice with Christ in a mandorla, angel-
musicians, saints and martyrs. At the lowest level
an angel with a fiery sword guards the gates of
Paradise.

The linear, apparently rapidly executed drawings
represent an Anglo-Saxon tradition. The eye is
drawn up toward the top of the composition in a
manner foreshadowing the effect of Gothic archi-
tecture. The page as a whole has power and
grandeur, even though the technique of the draw-
ings is simple.

Opposite: *Martyrologium Sancti Bartholomei*
Last quarter of 11th century, 355 x 254 mm, 190
ff., in Latin, Beneventan script, New York,
PML, MS 642

This manuscript was written and illuminated in
Italy at Carpineto. It was in the collection of the
English bibliophile Henry Yates Thompson
(1838-1928). The work includes a letter from
Abbot Teodemaro of Montecassino to Charle-
magne, the Rule of St Benedict, a lectionary, etc.
The ornamentation consists of two large illumina-
ted initials, 216 smaller ornamented letters, one
page with ornamented letters, written on gold
bands alternating with blue and pink.

The large initial O illustrated is a superb design of
interlace and fantastical creatures. The Italian
scriptorium notable for this type of decoration,
which combined vegetal and zoomorphic motifs
and reflected Insular and Ottonian illumination,
is the monastery of Montecassino. A style that
had developed during the tenth century at Bene-
vento was given fresh life here, and spread
throughout the Romanesque south.

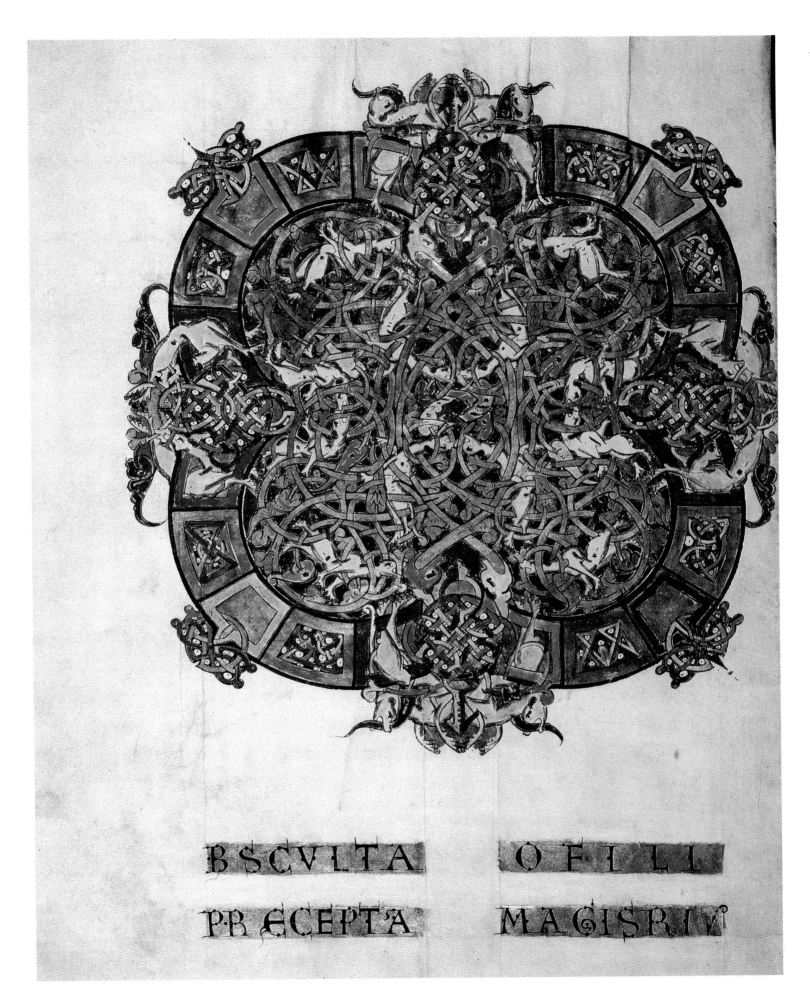

BSCVLTA OFILI
PRECEPTA MAGISRIV

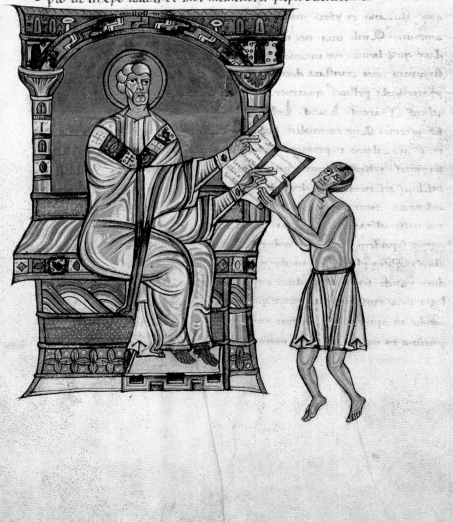

Left: *Gospels of Countess Matilda of Tuscany*
11th century, 335 x 225 mm, 106 ff., in Latin,
Caroline minuscule. New York, PML, MS 492
This manuscript was written and illuminated in
the Cluniac monastery of S. Benedetto di Polirone, now S. Benedetto Po (Mantua), during the
time of Abbot Guglielmo (d. 1099).
A *Liber Vitae* or list of benefactors, added at the
end of the book in 1099, names Countess Matilda
of Canossa (1046-1115) as the principal benefactor. There are illuminated initials, decorated
canon tables, author-portraits of the Evangelists
and scenes from the New Testament. The latter
are pen-drawings with dark outlines, delicate
shading and decoration of gold dots. The page
illustrated has an illumination from St Matthew's
Gospel, with careful script, and a miniature
painted in a different technique. Warner has
pointed out the Byzantine characteristics of many
of the figures, and the evidence of Ottonian
influence, particularly in the initial letters. Since
Cluniac illumination shows a fusion of Byzantine
and Ottonian elements, it is possible that the
illuminator of this work from Polirone was familiar with the work of Cluny, and took his inspiration from it.

Opposite: *Sacramentary*
10th to early 11th century, 255 x 175 mm, 296 ff.,
in Latin, Caroline minuscule by several hands.
Brussels, BRA, MS 1814-16
The manuscript was probably written and illustrated in the Benedictine monastery of St Gall.
It was taken to Paris at the French occupation of
Liège in 1794 and returned to the library of the
dukes of Burgundy in 1815. The illumination is
very rich and heavy, in the style of St Gall. There
are numerous gold initial letters and main titles in
gold uncials. The miniature shown is of St Gregory the Great, seated on his bishop's throne and
holding his crozier. His bishop's robes are dull
red for the habit, gold for the stole, gold-striped
green for the dalmatic, blue for the chasuble,
gold for the pallium and black for the maniple.
The stiff posture of the figure emphasizes the
gesture of the outstretched open right hand. The
two curtains form an enclosure, and provide a
simple setting.

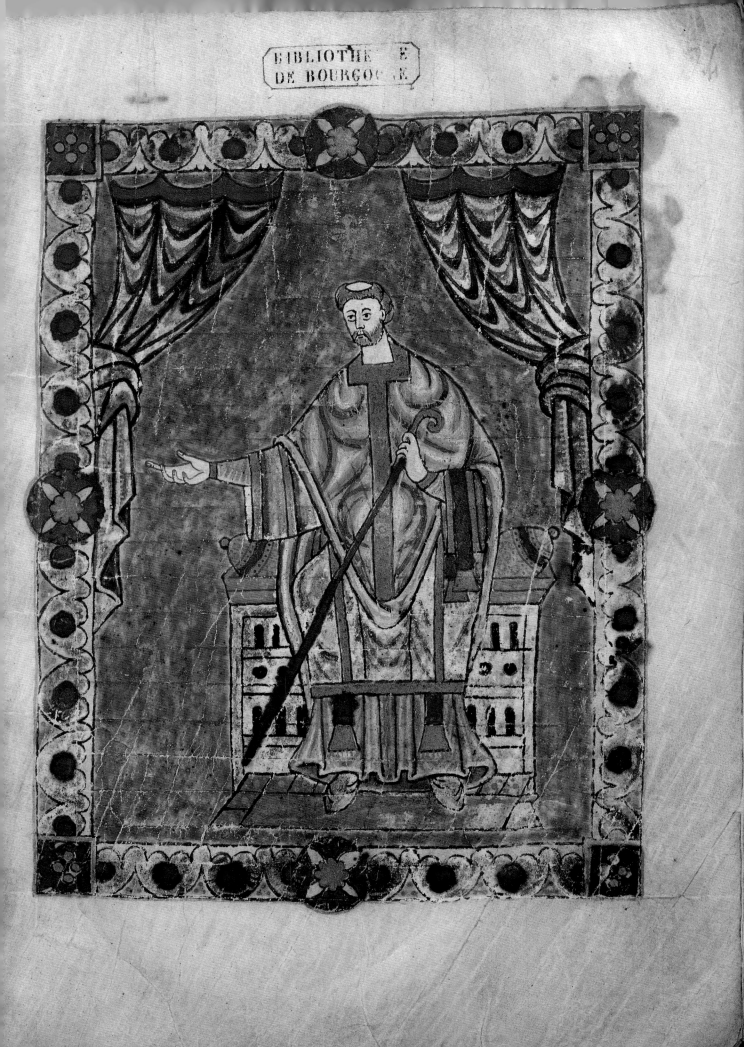

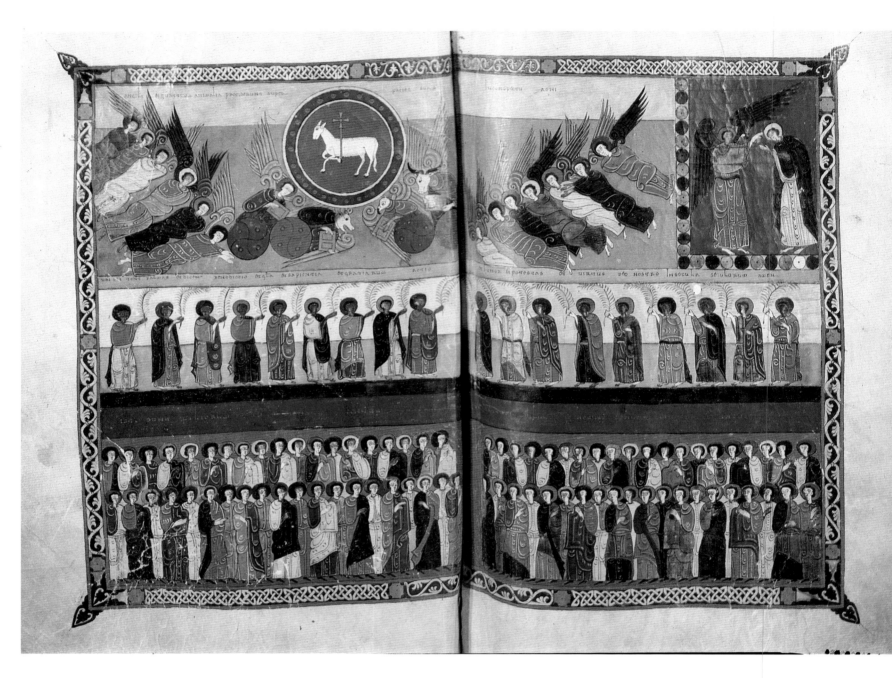

Left: Beatus of Liebana, *Commentary on the Apocalypse of St John*
10th to 11th century, 360 x 250 mm, 282 ff., in Latin, Visigothic minuscule by various hands, in two columns. Madrid, BN, MS 33
This manuscript comes from the monastery of S. Millán de la Cogolla, Castile. The illumination in the Mozarabic style shows the four living beings (a lion, a bull, a man, and an eagle) that represent creation's most noble, strong, wise and agile, later taken as symbols of the four Evangelists. The Lamb is at the centre of a circle around which the four beings seem to revolve with great wings. Outside the circles are twenty-four personages in four groups: they may represent the twenty-four priestly orders of the First Book of the Chronicles (I Chronicles 24, 1-9), or twelve Patriarchs and the twelve Apostles. They are shown praising the Lord (Revelation 4, 6-11).

Above and opposite: Beatus of Liebana, *Commentary on the Apocalypse of St John*
11th century (1047), 360 x 280 mm, 312 ff., in Latin, Visigothic minuscule in two columns. Madrid, BN, Vit. MS 14-2
This book is the work of a scribe named Facundus for Ferdinand I (the Great), King of Castile and León (d. 1065). It contains ninety-eight illuminations of the León Mozarabic school, showing Romanesque influence, which make this manuscript unique, and also one of the finest examples of medieval Spanish illumination. The colours are exceptionally rich, strong and vibrant, yet do not detract from the subjects' message. The double-page illumination (above) represents the Adoration of the Lamb (Revelation 7, 4-12), and the single page (opposite) Noah's Ark with stylized beasts.

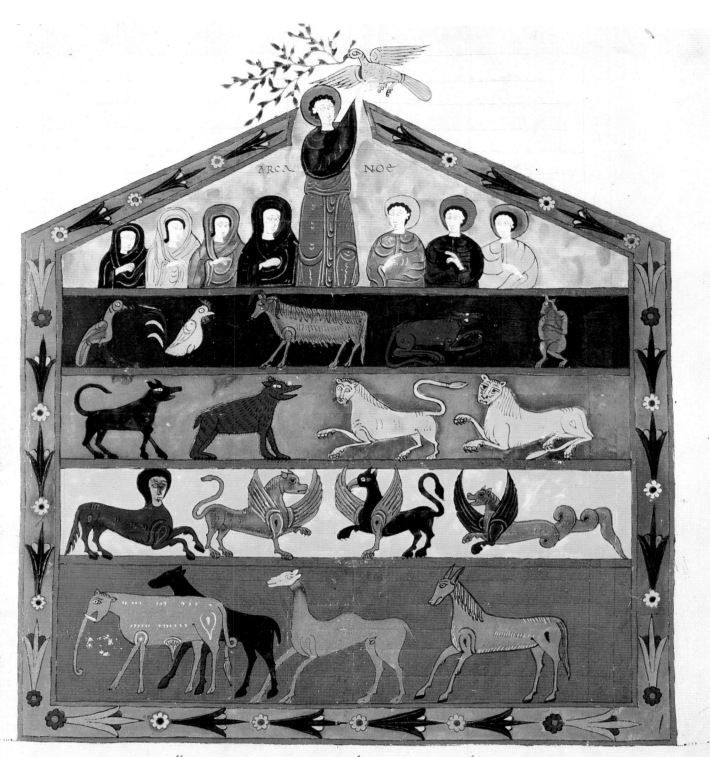

ARCA NOE

nohę . sequio appellatair : Sicua dñs . yacryo nohę Inomni arra
expuar Ipsius lumce : quam nñn solus lucais Inumcair ĕra .
ci Imponĕra : prophetaubia : aruncenis Incauudiemo aquę
hic ipa : faciat nos requiescere pōramaib Ipse solus quam
aboporibs ñir eamoorib manum domo sua salbuacair ĕra . quia
ñirarum acerui quam Ofacruausora solus dñi sibi bñe ubñdo fēsua

99

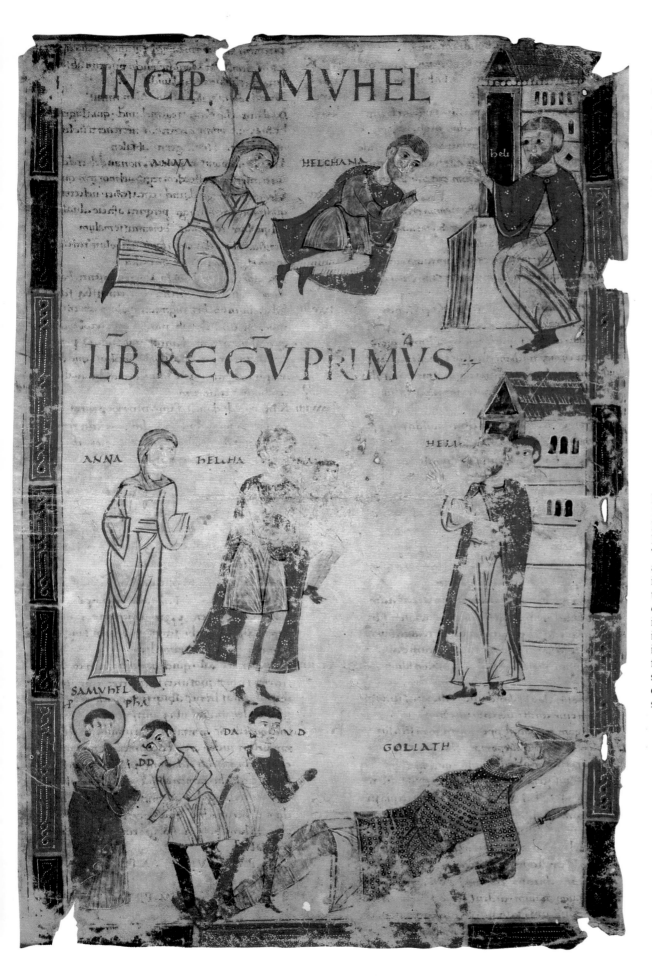

Left: *Bible*
End of 11th century, detached leaf, 414 x 273 mm, Caroline minuscule in two columns. Washington, DC, NGA, B 17, 714
This page from a large Bible was used as a protective cover for the manuscript. It is illuminated with scenes from the First Book of Samuel. The Bible was one of a group made in the area of Rome-Umbria at the end of the eleventh century, in the time of Gregory VII (1073-85). The style is naive, with the figures and their clothing represented in outline, and the colour is bright and lively, without shading.

Right: *Eadui Gospels*
11th century (*c.* 1020), 224 x 164 mm, 194 ff., in Latin, Anglo-Caroline minuscule. Hanover, KM, MS XXI, 36
This codex was written by Eadui Basan, a monk at Christ Church, Canterbury, and sumptuously illuminated in the same monastery by an artist of the Anglo-Saxon school in a style similar to that of the Arundel Psalter (British Library). St John is placed in a rather crowded composition, holding a pen and a knife, and a parchment scroll inscribed with the beginning of his Gospel. The figure below is Arius, a heretic, who holds a scroll stating his refusal to recognize the divinity of Christ. An acanthus border encloses the scene.

100

Right: Bede, *De locis sanctis libellus*, and works by various authors
11th century, 225 x 140 mm, 168 ff., in Latin, Caroline minuscule. Barcelona, ACA, MS Ripoll 151

The scriptorium of the Benedictine monastery of S. Maria, Ripoll, Catalonia (founded in 888), was important in the history of Catalan illumination, and throughout the Middle Ages was one of the most important Mediterranean centres. The ornamentation of this manuscript includes initial letters with zoomorphic and vegetal motifs, titles and initials alternately black and red. The page illustrated shows the Virgin and Child, somewhat roughly executed in an archaic style, recalling the Romanesque taste for the primitive, but not uninfluenced by Byzantine painting.

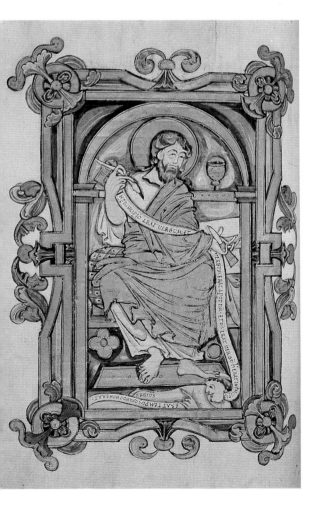

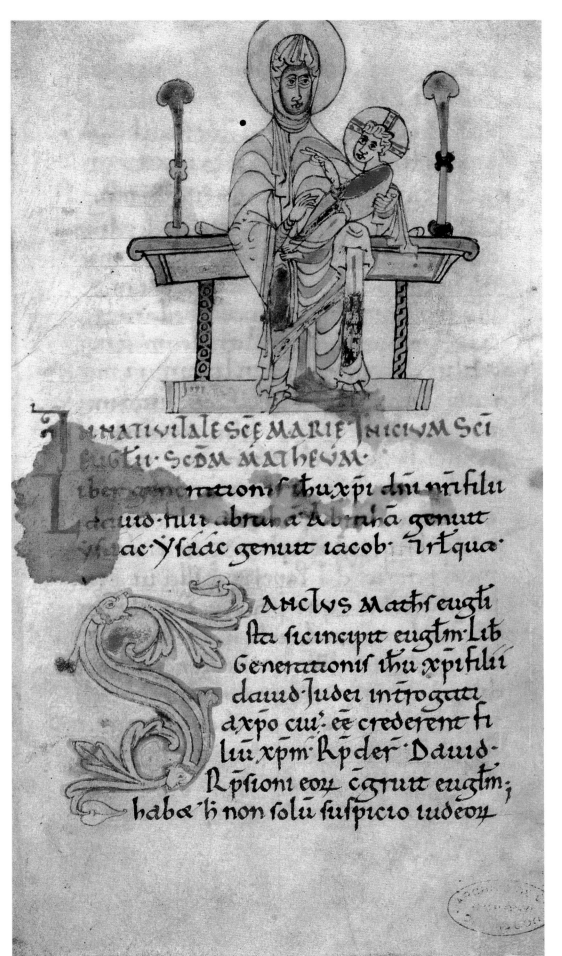

Right: *Pericopes*
Early 11th century, 278 x 185 mm, 109 ff., in Latin, Caroline minuscule, Wolfenbüttel, HAB, Cod. Guelf. 84-5 Augusteus 2°
The manuscript from which this initial is taken is in the style of the Reichenau school. The C (*Cum natus esset*) on a purple background is set inside a sober and elegant architectural frame. It introduces a reading from the Gospel of St Matthew (Matthew 2, 1).

Below: *Menologion*
10th to 11th century (976-1025), 365 x 285 mm, 434 pp.; Greek minuscule. Rome, BAV, MS Gr. 1613
This *Menologion* was produced in Constantinople during the reign of the Emperor Basil II (976-1025). It is considered one of the purest expressions of the phase of Byzantine illumination that began during the second half of the tenth century, a period characterized by distancing from classical art and from the illusionistic rendering of space. The faces take on an austere, ascetic expression. The representation is linear.

Opposite: Cicero, *De officiis; Rhetoricorum ad Herennium liber quartus*
First half of 12th century, 198 x 125 mm, 50 ff., in Latin, Caroline minuscule. Milan, BT, Cod. 769
The ornamentation of the manuscript includes several initial letters decorated with vegetal and zoomorphic motifs, abstract decorations and small human heads as well as coloured capital letters. In the margins are small pen-sketches of animal heads and human heads and hands. Shown is a page with the letter Q (*Quamquam te Marce*): within the letter, a teacher seated at a lectern shows a book to a student. Three birds support the circle of the Q with their beaks and a fourth zoomorphic form completes the group. Colour is applied sparsely, chiefly red, yellow and green to the background with light brush-strokes of green and red on the clothing and faces and on the bodies of the animals. Composition and technique are both simple but display a pleasing fantasy.

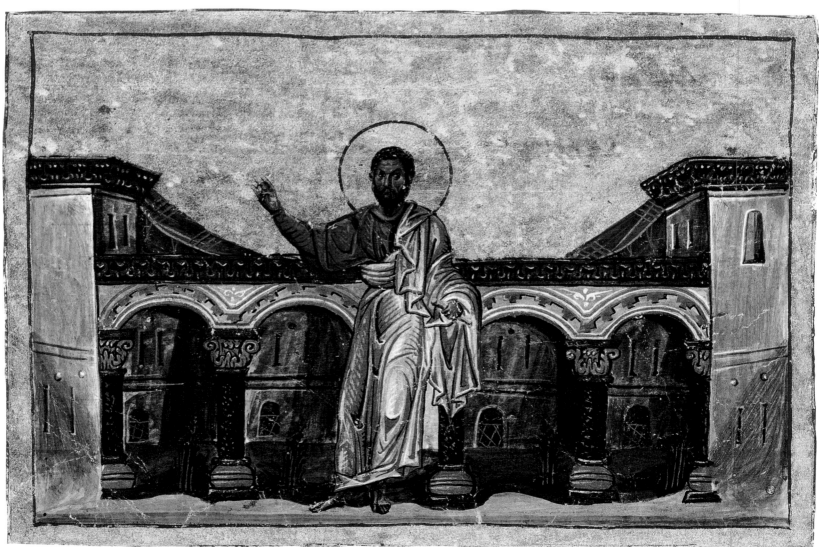

Incipit ... ad filium suum

Quamquam te Marce fili annum

iam audientem Cratippum

idque Athenis abunda

re oportet praeceptis in

stitutisque philosophie.

... summa et doctoris

auctoritatem et urbis

quorum alter te scientia

augere potest.

altera exemplis. tamen ut ipse ad meam utili
tatem semper cum graecis
latina coniunxi neque id in philosophia solum sed etiam in dicendi exer
citatione feci idem tibi censeo faciendum ut par sis in utriusque
orationis facultate. Quam quidem ad rem nos ut videmur mag
num adiumentum attulimus hominibus nostris ut non modo graeca
rum litterarum rudes sed etiam docti aliquantum se arbitrentur
adeptos et ad dicendum et ad iudicandum. Quam ob rem disces tu quidem
a principe huius etatis philosophorum et disces quamdiu
voles. Tamdiu autem velle debebis quoad te quantum proficias
non penitebit. Sed tamen nostra legens non multum a peripate
ticis dissidentia. Quoniam utrique socratici et platonici volumus esse
de rebus ipsis utere tuo iudicio. Nihil enim impedio. Orationem
autem latinam efficies profecto legendis nostris pleniorem. Nec vero hoc
arroganter dictum existimari hoc velis. Nam philosophandi scientiam con
cedens si id mihi
... ornate dicere tam in eo etatis studio consumpsi si id mihi
assumo. videor id meo iure quodam modo vendicare. Quam ob
rem magnopere te hortor mi cicero ut non solum orationes
meas sed hos etiam de philosophia libros qui iam illis fere se aequarunt
studiose legas. vis enim dicendi maior est in illis. Sed hoc
quoque colendum est equabile et temperatum orationis genus
Et id quidem nemini graecorum video adhuc contigisse. ut idem
in utroque genere laboraret sequereturque et illud forense genus
dicendi et hoc quietum disputandi nisi forte demetrius phale
reus in hoc numero haberi potest. disputator subtilis orator
parum vehemens dulcis tamen. ut teophrasti discipulum possis
agnoscere. Nos autem quantum in utroque profecerimus aliorum sit

Below: *Exultet*
12th century, parchment scroll 6855 x 230 mm (10 pieces), Beneventan script. Rome, BC, MS 724
This scroll, possibly from Benevento, is decorated on the side-edges with a band of stylized leaves, and other ornamental bands separate the scenes, placed as usual in a direction against that of the writing. In addition to the illustrations there are large initial letters: a V with a Christ in a mandorla and a large E ornamented in the style of Montecassino (p. 95).
The part of the scroll illustrated shows the lighting of the Paschal candle, inside an architectural frame suggestive of a church. The composition with its bright colours is simple but solemn in effect, in a local style with Byzantine influence.

Below: St Ambrose, *Writings*
12th century, 183 x 125 mm, 181 ff., in Latin, Caroline minuscule, with rubrics and the first words of each section in capitals. Milan, BT, Cod. 452
On the verso of the last folio is the note: '*Hunc librum donavit nob. d. Clainus prepositus et rector s. Andree...*'. The illuminations consist of titles in red and large initial letters with red, yellow and green interlace in the style of Irish illumination.
The page illustrated (f. 53r) contains clear Carolingian script interrupted by the rubric *Incipit liber de bono mortis*, and an ornamented Q of *Quoniam de anima*. The page as a whole is harmoniously designed. The ornamentation of the initial letter is typical of the manuscripts produced at Montecassino, and in southern Italy generally, during the Romanesque period.

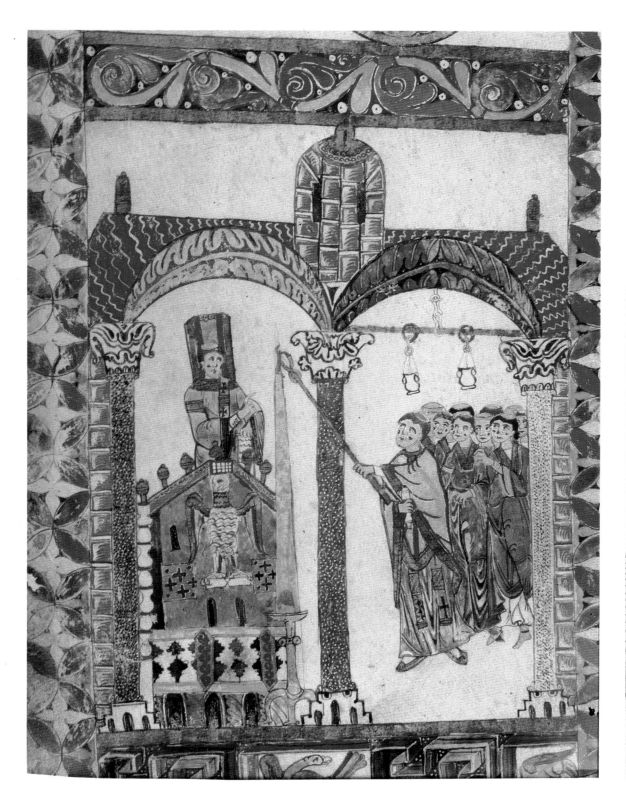

Below left: Beatus of Liebana, *Commentary on the Apocalypse of St John*; St Jerome, *Commentary on the Book of Daniel*
11th to 12th century, 372 x 280 mm, 126 ff., in Latin; minuscule, perhaps Catalan, in two columns. Turin, BN, MS I. II. 1
This manuscript, possibly from the scriptorium of Gerona Cathedral, Catalonia, is probably a copy of an earlier Beatus, made in 975 in the kingdom of León. The decoration is very rich, based on the Visigothic style of the illuminations of the Beatus of Gerona, but with a new sensibility that is already Romanesque. The codex thus marks a particularly important point in the history of twelfth-century Catalan illumination. The page illustrated has the Prophet Elijah and the Patriarch Enoch with two olive-trees, symbolic, perhaps, of Jeshua and Zerubbabel, restorers of the temple at Jerusalem, and the two candlesticks 'standing before the God of the earth' (Revelation 11, 3-5). The scene is contained in a Moresque arch.

Below right: *Leaf from a Great Bible*
Last quarter of 12th century, 540 x 365 mm, in Latin, late Caroline minuscule in two columns. Washington, DC, NGA, B 22, 919-920
Folio from a little-known large Bible, with illumination typical of the Tuscan school of the end of the twelfth century. It resembles, among other manuscripts, the Corbolino Bible of 1140. The page shown is at the beginning of the Gospel of St Mark.

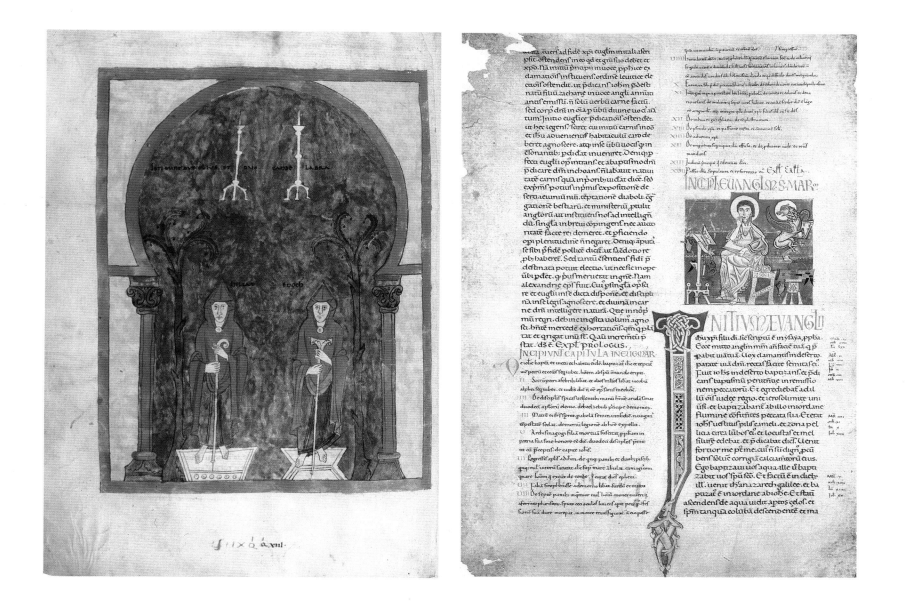

Overleaf
Page 106: Lambert of Saint-Omer, *Liber Floridus*
Second half of 12th century, 425 x 298 mm, 105 ff., in Latin, early Gothic minuscule. Wolfenbüttel, HAB, Cod. Guelf. 1 Gudianus latinus
From the school of Saint-Omer in northern France, this codex contains fifty-five illuminations of a variety of subjects. Shown is an Angel of the Annunciation and the Madonna and Child. The work is strongly anticlassical, and shows traces of the Ottonian style, while it has a vigour that is already Romanesque.

Page 107: St Gregory the Great, *Dialogues*
Second half of 12th century, 277 x 203 mm, 152 ff., in Latin, early Gothic minuscule by various hands. Brussels, BRA, MS 9916-17
This manuscript is a product of the Meuse school, illuminated as well as written by several different hands. The scenes illustrated are episodes from the life of St Boniface: above, he is shown multiplying wine; below, the Saint is seated at table with a disciple commanding that alms be given.

Celū suꝑioꝭ celi ꝕo discretū tenuino. & equalibꝫ undiꝗ ſpacıſ collocatū. Beata
ciuitateſ continet anglicaſ. que ad nos exeunteſ. etherea ſ coꝑa ſumūt ut poſſint
hominibꝫ etıā ın edendo ſımıları. eademꝗ ıbı reuſe deponunt. Hoc dſ aꝗſ glacıalıbus
tēꝑaut ne ınferıora ſuccendıt elemēta. Dehınc ınferıuſ celū �ñ unıforꝙı. ſ. multıplıcı
motu ſolıdauıt. nuncupanſ eū firmamētū aꝑt ſuſtentatıone ſupıoꝛe aquaꝛ. Aꝗſ fir-
mamēto ımpoſıta. celıſ ꝙdē ſpırıtalıbꝫ humılıoꝛeſ. ſ. tñ omñı creatā coꝑalı ſupıoꝛeſ. ad mun-
datıoñe dıluuıı ſeruata. alıı ũ rectıᷤ ad ıgñe ſyderū tēꝑandū ſuſpenſaſ affirmāt. Iñ celū
ᷓctaꝗꝫ. vıı ſyda pendēt errantıa. uıdelıcet lyna. ᷓmcurıı. lucıfer. ſol. mars. ıouıſ. ſatınus.
Sol aut eſt medıᷤ. ſ. caloꝛeſ altıtudo tēꝑat.

Fons mıſericordıe mat uıte. porta ꝑpetue lucıſ. hodıe marıa ũgo ergaſtulo mundı relıc-
to ımpartıᷓ gloſa celoſ aſcendıt. gaudete exultanteſ dıe ıſta. & eı aſſumptıoñe celebrate
qꝫ cū deo ıhu xpo regnū poſſıdenſ mıro ſcemate ıᷓꝑatū a patre. regnatura ſedet ı arce
ᷓcelı. curıa & mılıtıa eꝫ ᷓgaudentᷓ ſupna. et eꝫ uıuıt felıcıterꝙꝫ regnat ı etnū

Ave maria grā plena

quod non potuit implere: ut miraculum q̊ tacei
uoluit. minime abscondi potuisset: Gregorius.

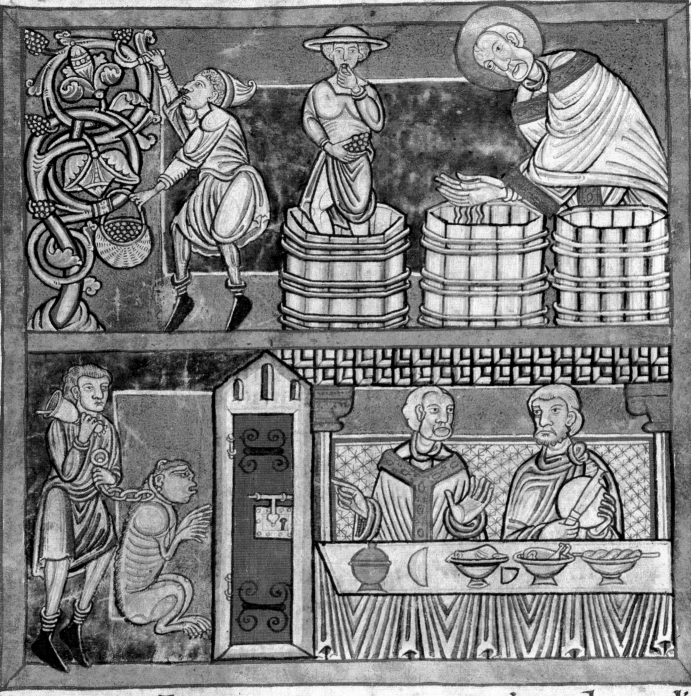

Redemptor nr̃ p mortale corpus omne q̊ egit. hoc nob
in exemplo actionis pbuit: ut p nr̃aru uirtū mo
dulo. eius uestigia sequentes. in offenso pede opis.
psentis uite carpiamus uiam: Miraculum namq;
faciens. & taceri iussit. & tam̃ taceri ñ potuit: ut uī

f unde pene numeri figurandi que scribendi alphabeti ordine sequentes hoc modo.
.i. ii. iii. iiii. v. vii. viiii. x. xx. xxx. xl. l. lx.
A B Γ Δ E Z H Θ I K Λ M N Ξ .
lxx. lxxx. c. cc. ccc. cccc. o. dc. dcc. dccc.
O Π P C T V Φ X Ψ ω.
Similiter habent istas tres alias karacteras p numero una dicit apud illos episimon. cui figura est hec. S. et ponit in numero p sex. Alia dicunt copi. cuius figura hec est. G. et ponit p numero in nonaginta. Tercia nominant. cui figura = hec. λ. et ponit in numero p nungentos.

Qui et ideo mox numeros digitas significare didicerint nulla interstante mora. litteras quoq; pariter iisdem prefigere sciunt. Verum hec hactenus. nunc ad reporia quantu ipse temporu conditor ordinatorq; dns adiuuare dignabit. exponenda ueni amus.

Bede, Aratus, Hippocrates, St Isidore, St Augustine and others, *Didactic writings*
12th century, 394 x 262 mm, 203 ff., in Latin, Caroline minuscule in two columns. Madrid, BN, MS 19

This manuscript is usually attributed to the scriptorium of the Benedictine monastery of S. Maria, Ripoll, Catalonia, although it shows Italian influence. The illustrations are allegorical or mythological, or illustrate astronomy. There are also pen-drawings of symbols of the winds and the seasons. The style is classical, while the technique is similar to that of Catalan Romanesque frescoes. The page illustrated gives a system for counting up to one million, and despite the instructive purpose the composition is free and lively.

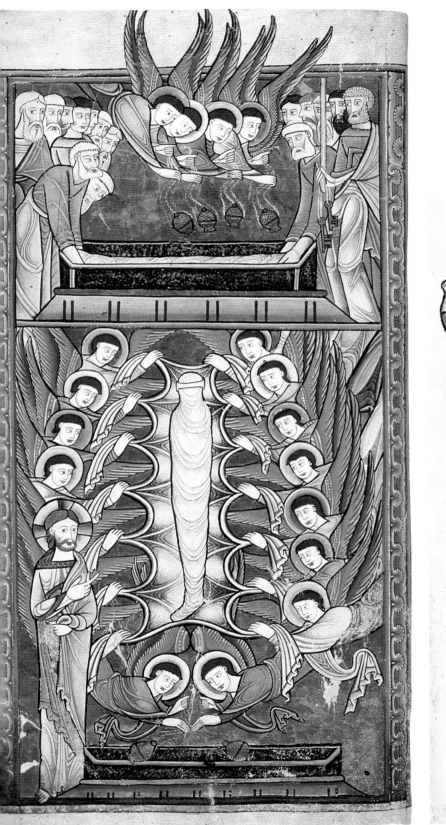

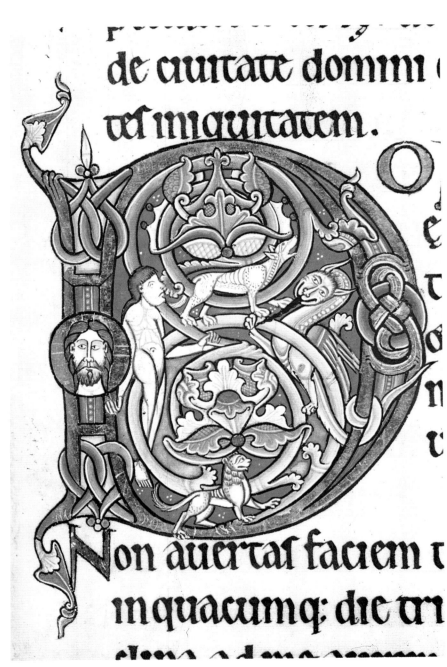

de ciuitate domini

vel iniquitatem.

Non auertaf faciem t

in quacumq: die tri

Above and right: *Psalter*
12th century (*c.* 1170), 290 x 184 mm, 210 ff.,
early Gothic bookscript (protogothic). Glasgow,
UL, MS Hunter U. 3.2
From northern England, perhaps York, copious-
ly and skilfully illuminated, this manuscript is
one of the finest examples of English Roman-
esque art. The style of the illuminations combines
Byzantine influence and the linear local style.
The initial D of Psalm 102 (Vulgate 101) is
formed from stylized motifs including leaf-scrolls,
animals and a nude human figure, possibly sym-
bolizing the soul facing a beast (symbol of impie-
ty). At left is an Assumption from the same
manuscript.

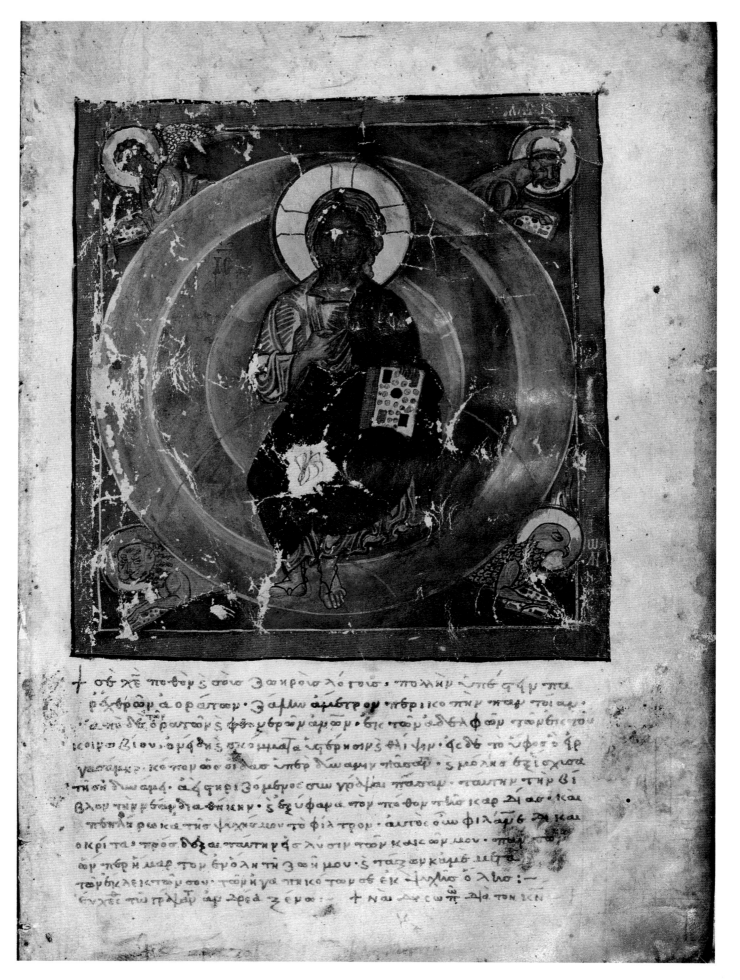

† ΟΘ ΧΕ ποθον ϲοιο ϑαϲρΘ λογοιο · πολληϲ ϲΘε αϑϲ πα
ρ αβολΘ αⲟⲣⲁτⲱⲛ · ϑαρωⲛ ⲁⲙⲉⲧⲣⲟⲛ · πϑρικοπηⲛ πϑⲁⲭ ⲧⲟⲓ ⲁⲛ ·
αⲛ ⲓⲛ ⲟ ⲟⲣⲁⲧⲟ ⲭⲛ · φⲑⲩⲃⲣⲟⲙⲁⲣⲁⲙⲱⲛ · ⲃⲓϲ ⲧⲟ ⲣⲁ ⲇⲉⲗ φⲟⲛ ⲧⲁⲛ ⲃⲓⲥ ⲧⲟⲛ
ⲕⲟⲓ ⲛ ⲃⲓ ⲟⲩ ⲟⲙϑ ⲛ ϲ ⲫⲓ ϲⲱⲙⲁⲧⲁ ⲓⲥ ⲃⲣⲛ ⲟⲓⲛ ⲟ ϑⲓ ⲩ ϑⲓⲛ · ϑⲥ ⲇⲉ ⲧⲟ ϑϑⲟⲛ ⲥⲉ
ⲅⲁ ⲥⲁⲙⲭ · ⲕⲟ ⲡⲟ ⲟⲟ ⲥⲓ ⲁ ⲟ · ⲛϑⲣ ⲇⲩⲁⲙⲛ πⲁⲥⲁⲛ · ϛ ⲙⲟⲗⲛⲁ ϑ ⲭ ⲟⲭ ⲟ ⲁ
ⲧ ⲟ ⲇⲩⲁⲙⲭ · ⲁ ⲅ ⲟ ⲩⲣⲓ ϛ ⲟⲙⲃⲣⲟ ⲥ ⲥⲓⲛ ⲅ ⲟⲇ ϑⲁⲓ πⲁⲥⲁⲛ · πⲁⲛⲧⲩ ⲧⲩⲛ ⲃⲓ
ⲃⲗⲟⲩ ⲧⲩⲛ ⲃⲁⲭ ⲇⲓ ⲁ ϑⲩ ⲕⲩ ⲛ · ϛ ⲃ ⲩ φⲁⲙⲁ ⲧ ⲟⲛ πⲁ ϑⲟⲣ ⲧ ⲩ ⲟ ⲕⲁⲣ ⲇⲓ ⲁ ⲟ · ⲕⲁ
πⲟⲛ ⲗⲁ ⲣⲟ ⲕⲁ ⲧ ⲩⲥ ⲯⲩⲭⲁ ⲙⲟⲩ ⲧⲟ φⲓ ⲗⲧ ⲣⲟⲛ · ⲁⲩⲧⲟⲥ ⲟⲩⲛ φⲓ ⲗⲁ ⲣ ϑ ⲭ ⲕⲁⲓ
ⲟ ⲕⲣⲓ ⲧ ⲁ · πⲣ ⲟⲟ ⲇⲟ ⲝⲁⲛ πⲁⲛ ⲧⲓ ⲭ ⲅ ⲟ ⲗ ⲩ ⲟⲓ πⲱⲛ ⲕⲁⲕ ⲟⲛ ⲙ ⲟⲩ · πⲁ
ⲱⲛ πϑⲣ ⲩ ⲙⲁ ⲣ ⲧⲟⲛ ϑⲩⲟ ⲗⲛ ⲧⲓ ϑⲟⲩⲓ ⲙⲟⲩ · ϛ ⲧⲁ ⲟ ⲩ ⲕ ⲓ ⲙ ϑ ⲗϑ ⲧ ⲁ
ⲧ ⲁ ⲣ ⲟⲩ ⲗ ⲁⲓ ⲕ ⲧ ⲟ ⲙ ⲟ ⲛ · ⲧ ⲟ ⲙ ⲛ ⲓ ⲅ ⲁ πⲛ ⲓ ⲕ ⲟ ⲧ ⲟ ⲛ ⲟϑ ϑ ⲕ ⲧ ⲯⲗⲓ ⲟ ⲟ ⲗ ⲛ ⲟ : —
ⲉⲩ ⲭ ϑ ⲥ ⲧ ⲱ πⲣⲁ ϑⲩ ⲁ ⲣ ⲥⲣⲉ ⲁ ⲍ ⲉ ⲛ ⲟ : — † ⲛ ⲁⲓ ⲁ ϑ ⲥ ⲱ π ⲇⲓ ⲁ ⲧ ⲟ ⲛ ⲭⲛ

op̄ ē. Ora. ⁊ obſecra. ne in impietā mā pich̄
ret elecho tua .& opinione tanta enob n̄
respondentib˙ ⁊ ta ſi ego p obediente ue
niā bene pareo. tu tā pincōnſidantiā
iudiciū male impaſſe uidearis. Expli

ct p̄facio. Incip̄ lib.,

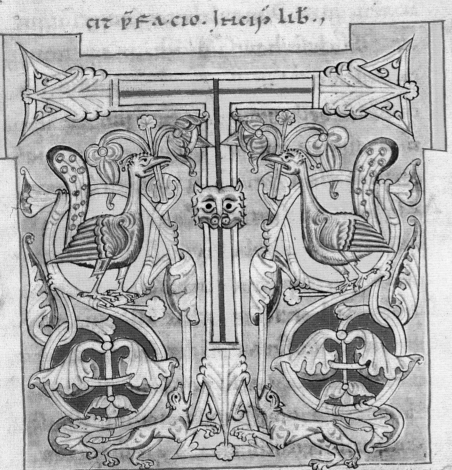

RADVNT FABVLE POETARVM DE SECTIS
QVONDAM VDR AM

Tradunt fabule poetarū. deſectio
quondam. ydram capinbus.

Opposite: *Gospels*
12th century (1109), 310 x 216 mm, 126 ff., Greek
minuscule. Vienna, ÖNB, MS Suppl. Gr. 164
This manuscript was written by a monk named
Andreas, probably in the monastery of Olene, in
the Peloponnese. It contains various ornaments,
and the titles of the four Gospels are framed on
three sides with harmonious abstract geometric
decoration. There are also four Evangelist
author-portraits.
The figure of Christ in Majesty is represented
within concentric circles that isolate him and add
to the solemn dignity of the composition, in
conformity with the conventions of Byzantine
painting. The symbols of the four Evangelists
appear at the corners.

Left: Johannes Cassianus, *De Incarnatione*
12th century, 260 x 180 mm, 53 ff., in Latin,
Caroline minuscule. Madrid, BN, MS 5780
This manuscript is an important example of Spa-
nish Romanesque art. At the beginning of the
volume's prefatory page and of each book is a
large initial, drawn with a pen and painted with
lively colours. Its motifs of fantastic birds and
beasts and stylized foliage are typical of Roman-
esque art.

111

Below: Pliny the Elder, *Historia naturalis*
12th to 13th century, 405 x 300 mm, 166 ff., early Gothic minuscule, various hands, in two columns. Florence, BML, MS Plut. 82.1
The illustration of this manuscript is of the German school. Pliny is shown presenting the Emperor Titus with a scroll. At the middle of the tree is a small figure, presumably representing the illuminator, holding a scroll with the legend *Petrus* *de Slaglosia me fecit* (Slaglosia is present-day Slagelse in Denmark). The figures are stiff and stylized but the details, such as the animal that supports the Emperor's feet and the tree, are lively and inventive. The combination of the formal with the grotesque and fantastic is characteristic of the Ottonian style and German illustration in general.

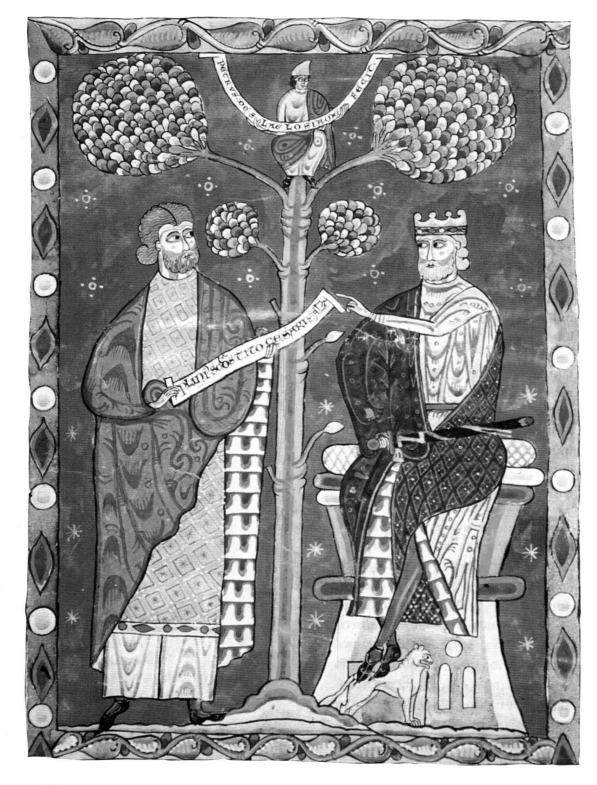

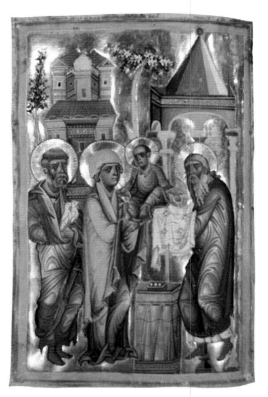

Above: *Epistolary*
13th century (1259), 250 x 187 mm, 104 ff., in Latin, minuscule tending to Gothic bookscript. Padua, BC
This codex was written, and according to some scholars also illuminated, by Giovanni da Gaibana in 1259 at Padua. The style shows Byzantine as well as Ottonian influences. The images stand out against the gold backgrounds in a manner that recalls the great masters of thirteenth-century painting Duccio and Cimabue. In the Presentation in the Temple, the stateliness of Byzantine painting gives way to a vibrant humanity.

Opposite: Giustiniano, *Infortiatum, cum glossa accursiana*
13th century, 439 x 312 mm, 289 ff., Gothic bookscript (textualis). Turin, BN, MS E. I. 8
The illuminations in this work are of the Bologna school, and show French influence. They are attributed to Oderisi da Gubbio. They include such little scenes as the one illustrated in which a dying man is seen dictating his last testament.

T de balneo q̄ cantarellus dicit̄.
nter aquas pelagi feruens aq̄ manat et ipȧ;
N e fluat in pontū fictile claudit opus.
C um mare feruescat locus oppugnat̄ ab undis
V is aliquis potūt eger adire locum
C antarus hūana finuit̄ uirtute micenoi
N am plagas ueteres consolidatq̄ nouas
V lcera que puut̄ cutis ex humorib; extra
C antarus abstergit lumina clara facit.
S anguinus opturat uenā qñq; fluente
S ubuenit artheticis fit medicina podū
V talis ad febres et frigora set tū huī²
V sus aq̄ lateri continuat̄ obest

Pietro da Eboli, *De balneis Puteolanis*
13th-14th century, 183 x 130 mm, 21 ff., Gothic bookscript (textualis). Rome, BAV, MS 1474
This manuscript is a product of southern Italy, most probably of the Neapolitan school. It includes eighteen illustrations to Pietro da Eboli's twelfth-century text, depicting the life at Bagni di Pozzuoli where patients went for the thermal cure. These illustrations provide a rare and interesting glimpse of spa life in the Middle Ages, and their decoration is an important example of southern Italian art of the period. There are echoes of Byzantine art, and features that are already in the Gothic style alongside still-continuing Romanesque elements. The colours are rich and luminous, with golden backgrounds, black outlines and white highlights.
The people bathing in a group (private bathing was for the few) are shown standing up, as was then the custom. The figures of the bathers are Gothic in their proportions and the expressiveness of their faces and gestures, while the water is represented without any attempt at perspective and the fish are drawn schematically, recalling the taste for simplicity that is part of the Romanesque tradition. The foliage above the bathers, enclosing the scene, is delightfully stylized, almost architectural. Shown above is the page of text that accompanies the illustration.

114

Left: Justinian, *Digesta*
End of 13th century, 320 x 220 mm, 483 ff., Gothic bookscript (textualis) in two columns. Milan, BT, Cod. 824
This manuscript was made in France, probably at Lyons: the city's coat of arms appears on f. 375v. The ornament is in French Gothic style. The fifty-two illuminations, possibly the work of two artists, are extremely lively and expressive. The scenes, though so tiny, seem complete, as with the one shown, of fruit-picking.

Below left: *Chansons de geste*
13th century, 326 x 244 mm, 231 ff., Gothic bookscript (textualis) in two columns. Milan, BT, Cod. 1025
This volume has four miniatures and four large gold initials on illuminated backgrounds. Other initials are painted alternately in red and blue, with small decorative motifs. The illuminations are of the French Gothic school. Here, soldiers are escorting a wine-cart drawn by oxen. The initial letter O in gold introduces the *chanson* entitled '*Le charroi de Nîmes*'.

Opposite: *Genealogy of Christ and Chronology of the Popes and Emperors*
Parchment scroll, 13th century, 3670 x 310 mm (5 pieces), in Latin, Gothic bookscript (textualis) in two columns. Milan, BT, Cod. 489
This scroll is illuminated with scenes chiefly from the Old and New Testaments, borders, initials, and circles containing the names of the popes, emperors and patriarchs. The script and illumination combine to give an effect that is irregular, and the pen-and-ink drawings of the section shown are not devoid of ingenuity. The shape of the crucified Christ's body foreshadows the forms of great Italian *Crucifixions* of the thirteenth century.

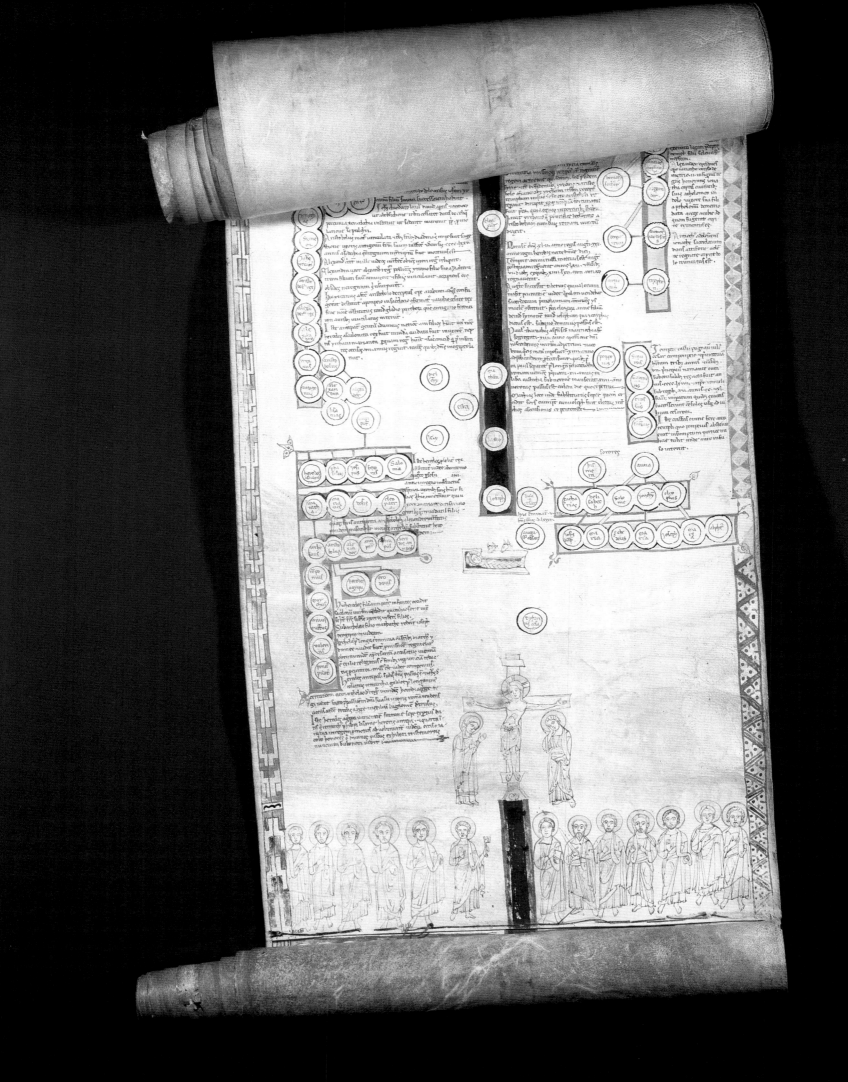

taille tel conduiseor com be
song li estoit por la iornee et
quant les trompes ⁊ les na
quaurs ⁊ les tabors coumen
cierent a soner les batailles
sentrauindrent les vnes con
tre les autres si fierement
q̃ toute la terre trambloit
despies des cheuaux. Et quant
les batailles furent toutes
assamblees. Lors coumença
li estors si fiers ⁊ si merueil
lous que iusques a celui ior

par le bon exemple quil veo
ient en lor seignor que li paien
furent mout plus pdant q̃
li macedonois. Car alixandres
le faisoit si bien ⁊ si vighe
rousement comme cil qui sa
bandonoit en tout perils et se
portoit en tout les lieus si no
blement que uolsissent li
paien ou non lor couuint tor
ner les dos. Coment alix et
son ost et auoec lost du roy
dauir ⁊ dautrs fu desconfis.

nauoit on veu si perillouse
bataille. ⁊ es tout fuissent
li macedonois mains que
les autres. Ne que dent il
se portoient si uaillaument

Quant dauirs vit que ses
gent fuioient si fu mout
dolans. ⁊ es ne que dent il
senfui maintenant. Et qit
alixandres les uit fuir. Il cou

Opposite: *The True Story of Good King Alexander*

End of 13th century, 232 x 175 mm, 86 ff., Gothic bookscript (textualis) in two columns. Brussels, BRA, MS 11040

This manuscript was made in an area today in Belgium. The miniature on the page reproduced depicts the battle between Alexander the Great and Darius.

Below left: *Chronica regia coloniensis*
Mid-13th century (1237-50), 328 x 230 mm, 162 ff., Gothic bookscript (textualis) by three different hands. Brussels, BRA, MS 467
Made probably at Aachen (Aquisgranum), this manuscript includes coloured initial letters and thirteen miniatures such as that of Charlemagne, shown below, with architectural motifs as backgrounds.

Below: *Fortune-telling Tracts*
13th century (*c.* 1240), 170 x 127 mm, 72 ff., Gothic bookscript (textualis). Oxford, BL, MS Ashmole 304 (25168)
This manuscript was made at the Abbey of St Albans by the monk Matthew Paris. In the scene shown (f. 31v), Socrates, with Plato at his shoulder, is writing predictions. During the Middle Ages the two philosophers were regarded as diviners.

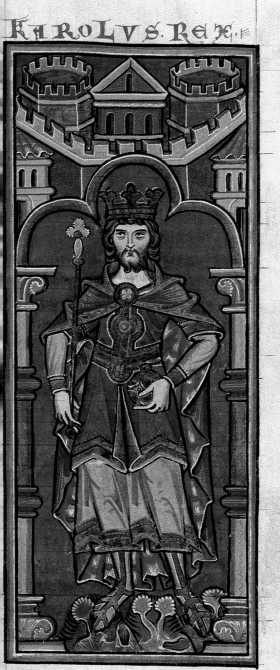

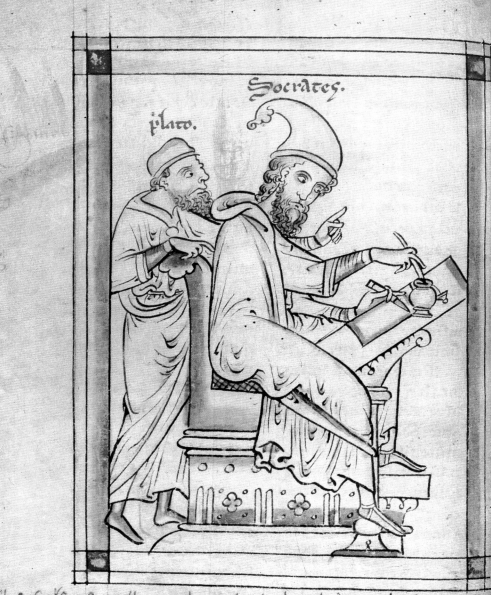

Below: Jean de Mandeville, *Romans*
14th century (1396), 292 x 230 mm, 111 ff., Gothic bookscript (textualis). Milan, BT, Cod. 816
This codex was written in 1396 by the clergyman Richard Hemon. The extremely fine decoration is by an artist of the French school. The frontispiece shown is framed with an ivy-leaf border – typically small red and blue leaves and gold buds. At the top a small figure armed with a club attacks a dragon, below a dog chases two deer, and birds perch among the foliage. The initial C is elegantly ornamented with arabesques.

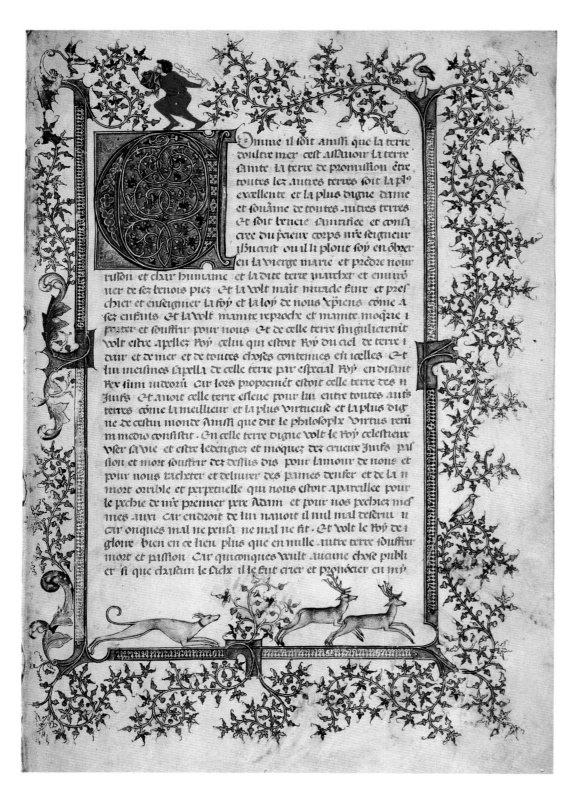

Opposite: Johannes de Jauna, *Catholicon*
End of 14th century, 402 x 283 mm, 515 ff., Italian Gothic bookscript (textualis). Milan, BT, Cod. 612
This codex belonged to the library of S. Michele, Murano, Venice, and was written by Camaldoni monks of that monastery. With its profusion of gold and colours and the liveliness of the scenes, it is a splendid example of Venetian illumination. It is by an artist of the circle of Cristoforo Cortese who worked in Venice at the end of the fourteenth century. The border of the page shown (f. 87v) includes flowers, birds, a man playing the bagpipes, and, at the foot of the page, a lady with a unicorn seated in a woodland glade. The initial letter I contains a group of monks: the author is shown at his desk, intent upon his writing.

Pages 122, 123: *Visconti officium*
Second half of 14th century, 250 x 178 mm, 124 ff., Italian Gothic bookscript (textualis). Florence, BNC, Fondo Landau Finaly, MS 22
This manuscript was made for Gian Galeazzo Visconti and Filippo Maria Visconti, Dukes of Milan, and it is signed by the copyist: '*Frater Amadeus scripsi*'. The twenty-seven illuminations of this famous book include scenes of the Old and New Testaments, and numerous other scenes and figures enclosed in large, splendid initial letters. Most of the pages have ornamented borders including foliage, birds, animal, heraldic devices, as well as portraits, figures of saints and allegorical figures. A feature are the architectural elements, particularly bold Gothic spires. The illuminations were made by artists of different periods. The earliest are the work of Giovannino de' Grassi and his son Salomone, notable Lombard exponents of the International Gothic style; they were assisted by several collaborators, among them Porrino de' Grassi. The illumination of the codex was interrupted by the death of Gian Galeazzo, and it was completed for Filippo Visconti at the beginning of the fifteenth century by Belbello da Pavia and his students, with eighty-two masterly illuminations. The two pages illustrated are among those illuminated by Belbello.

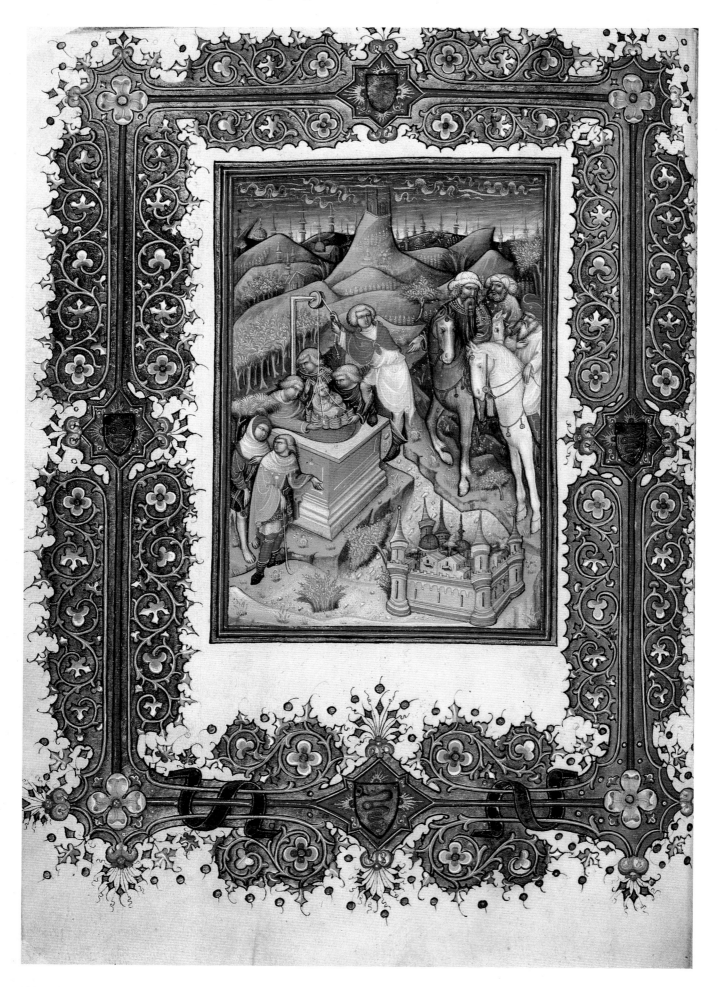

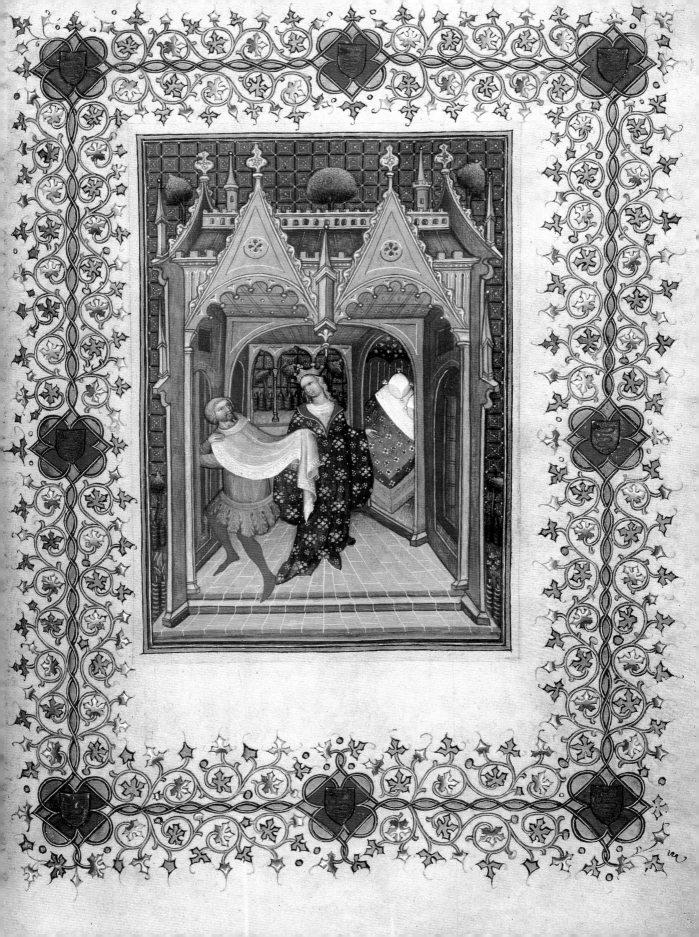

Missal, known as the *Ambrosiana Missal*
Second half of 14th century, 390 x 265, 318 ff.,
Italian Gothic bookscript (textualis). Milan, BSA
The writing of this work was completed on 24
May 1370 by '*presbiter Fatius de Castoldis benefitialis ecclesie Sancte Eufymie*'. It was illuminated
for Gian Galeazzo Visconti, who later presented
it to S. Ambrogio in Milan to mark his coronation
there in 1395. The manuscript has six miniatures
as well as numerous initials decorated in a style
that shows strong French influence by Anovelo
da Imbonate, a follower of Giovannino de' Grassi. Other intials are in a Lombard style. Anovelo
was a traditional artist, but also sensitive to the
development of Late Gothic painting. His designs were elegant, although the proportions of
his figures are not always pleasing, nor are the
colours invariably harmonious. The page shown
(f. 153v) has coats of arms and the large illumination of Christ in Majesty with the symbols of the
four Evangelists at the corners. The illumination
is signed: '*Hoc de Imbonate opus fecit Anovelus*'.

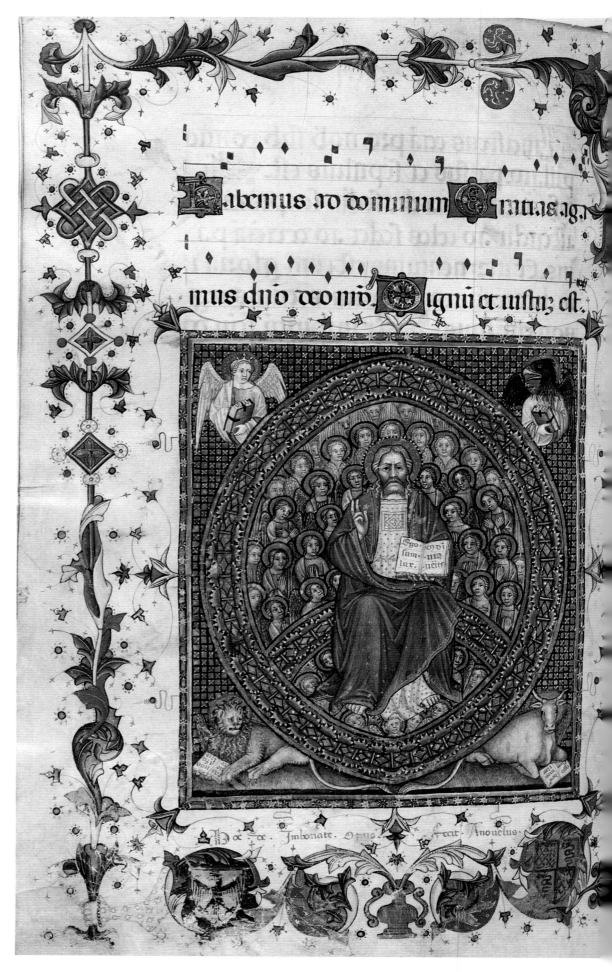

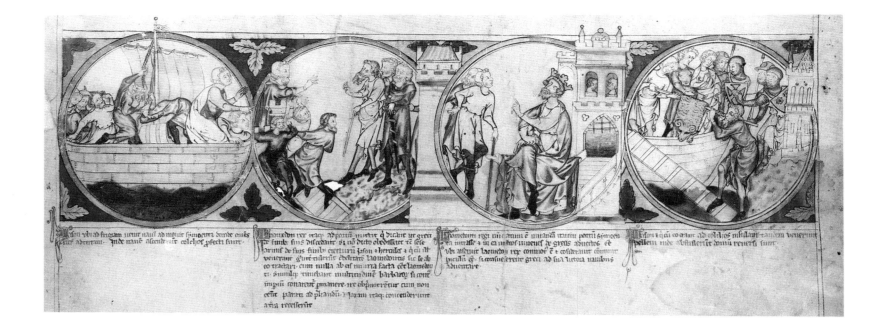

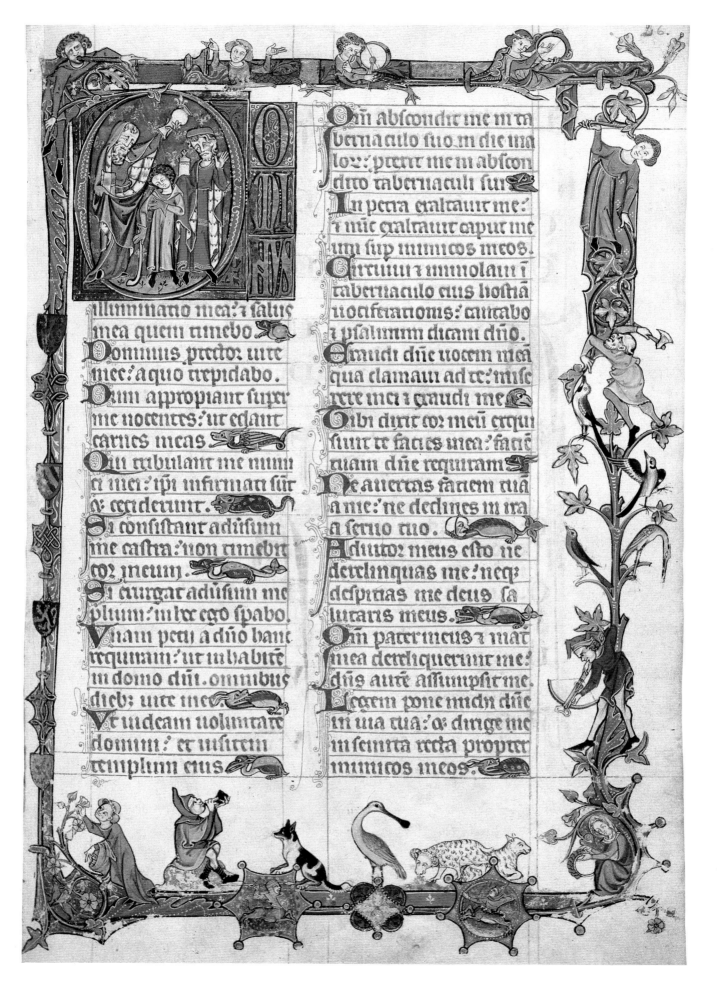

Made in Castile, this codex presents on each page
two kings in decorative arches. The figures are
painted in gouache with profuse matt gold.

Left: *Crònica de los reyes de Judea y de los
gentiles, consules y emperadores romanos, todos y
reyes de España y Portugal, hasta el rey Don
Dionis*
14th century, 290 x 200 mm, 44 ff., Gothic
bookscript (textualis), in two columns. Madrid,
BN, MS 7415

Opposite: *Peterborough Psalter*
Early 14th century (before 1319); 300 x 194 mm,
141 ff., Gothic bookscript (textualis), in two
columns. Brussels, BRA, MS 9961-62
This codex is linked stylistically to a group of five
contemporary manuscripts made for the English
Fenland monasteries in the East Anglian style. It
is celebrated for the quality and abundance of its
illuminations, and is unique in being copied
entirely in alternating gold and silver.
Illuminations appear on the first twelve pages of
the Calendar; on twenty-six other pages with
subjects from the Old Testament; as ten historia-
ted initials enclosed in borders, and numerous
smaller initials. This illumination is attributed to
a London workshop directed by an able master.
The page reproduced has a border of exquisite
workmanship, with a number of beasts and cur-
ious small figures such as a man blowing a horn,
a siren, a man with bird's feet, a woman with a
tambourine and a battle of centaurs (in the
roundels). Inside the initial D is the scene of
David anointing Samuel.

127

Salisbury Psalter and Book of Hours
14th century (*c.* 1385-89); 225 x 152 mm, 148 ff., Gothic bookscript (textualis), in two columns. Edinburgh, NLS, Advocates MS 18.6.5
This codex is one of a group of eight fourteenth-century English manuscripts made for Eleonor de Bohun, Duchess of Gloucester (d. 1399). All the manuscripts of the group show Italian, French, and Flemish influence on the English style. They mark the revival of illumination in the period following the Black Death. This Psalter contains twenty-four initials with scenes of the Passion, and other decorated initials. It is believed to have been written and illuminated in a London workshop. The elegant border frames the text with stylized floral motifs. In the initial D, David plays the harp for King Saul. The figures are exceptionally finely drawn.

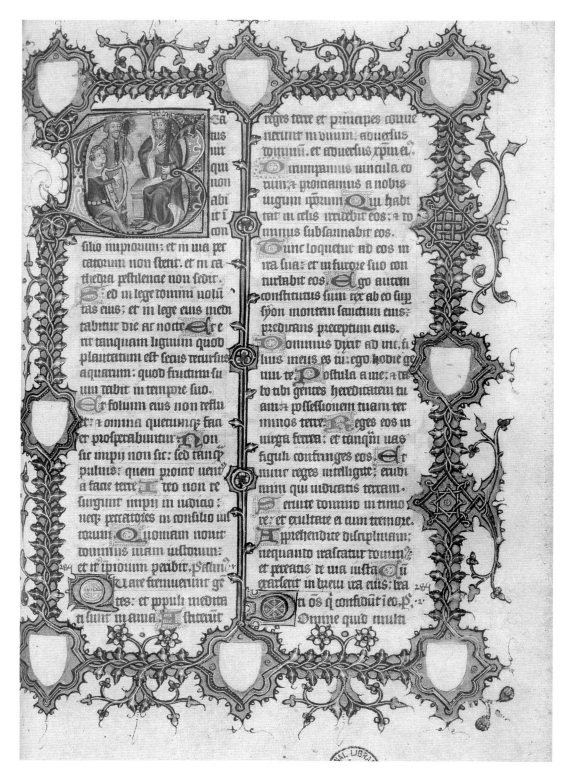

Opposite: Giovannino de' Grassi, *Taccuino di disegni*
End of 14th century, 260 x 185 mm, 31 ff., Bergamo, BC, MS VIII. 14
This manuscript contains numerous signed paintings, mostly by Giovannino. In 1542 the owner's name was Lotto: his monogram appears in the work. It then became the property of Pasquale Licini and, in 1630, of Sillano Licini. In the nineteenth century it belonged to the Secco Suardo family of Bergamo, who in 1856 presented it to the Biblioteca Civica.
The paintings of birds show keen observation. Human figures are finely painted in delicate colours. The manuscript is an important example of Gothic Lombard art.

Page 130: Dante, *La Comedia*
14th century (1337), 370 x 260 mm, 109 ff., cursive Gothic bookscript (textualis) in two columns. Milan, BT, Cod. 1080
One of the earliest codices of the *Divine Comedy*, this has a colophon at the end of the text by the copyist Francisco da Barbarino, and the date 1337. It was possibly begun in Florence; and was in northern Italy early in its history: northern Italian dialect forms, particularly those of the Veneto, have been observed at the end of the *Purgatory* written in a fifteenth-century hand. The decoration is of the Florentine school, by an artist still imbued with the influence of Giotto. The page illustrated is the beginning of the *Paradiso*. The border contains angels, cherubim, the Archangel Michael, and Christ blessing. At the foot of the page, Dante receives a crown of laurels from an angel. The initial L contains the Coronation of the Virgin with angels.

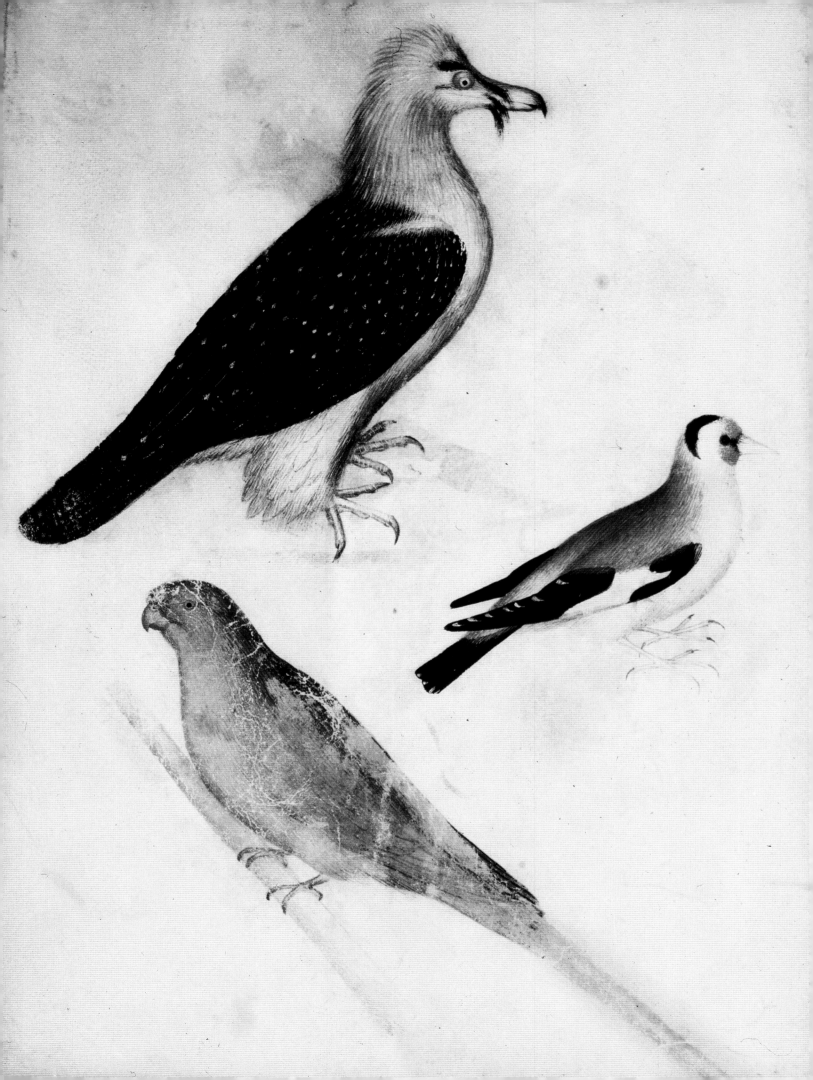

Comincia la terza Cantica dela Com
media di Dante alaghiere difioreça:
nela quale si tratta de Beati. 7 della
Celestiale Gloria. 7 de meriti 7 premii
de santi. Et diuidesi in viiij. parti.
Canto primo. nelsu principio. lau
tore proemiça ala seguente Cantica:
7 sono nello elemento del fuocho 7
Beatrice solue ad lautore vna que
stione. Nelquale canto lautore
promette di Trattare delle cose di
uine in uccando lasciença poetica.
cioe Appollo chiamato li deo della
Sapiença.

In cel che piu della sua luce prende
fu io 7 vidi cose che ridire
ne sa ne puo chi dilasu discende.

Per cappressando se alsuo disire
nostro intellecto si profonda tanto
che dietro lamemoria non puo ire.

Veramente quanto delregno santo
nella mia mente potei far thesoro
sera ora materia delmio canto.

O buono Appollo alultimo Lauoro
fammi deltuo valor si fatto uaso
come dimandi dar lamato alloro.

Infino aqui lun giogho diparnaso
assai mi fu ma or con amendue
me uopo intrar nelaringo rimaso.

Entra nel pecto mio 7 spira tue
sicome quando Marsia traesti
della vagina delle membra sue.

O divina virtu se miti presti
tanto chel ombra del beato regno
segnata nelmio capo io manifesti.

Uenir vedrami altuo diletto legno
7 coronarmi allor di quelle foglie
che lamateria 7 tu me fara degno.

Si rade volte padre sene coglie
p triumphare o Cesare o poeta
colpa 7 vergongna delhumane uoglie.

Che parturir letitia insu lalieta
delphica deyta douria lafrunda
penea quando alcun dise essetia.

P ca fauilla gran fiamma seconda
forse dietro dame conmiglor uoci
se pregheran peche cirra risponda.

LA GLORIA DI COLVI
KE TVCTO MOVE. P
LUNIVERSO. PENETRA
ET RISPLENDE: INVNA
PARTE PIV E MENO
ALTROVE

di questo stato p luoco eterno cioe mostr
andoli lo inferno el purgatorio. E. Qual
fiozetti. Qui da exemplo dante avoler
mostrare come era tuto cambiato del uo
lere in che ello era posto quanto uilta la
sagli. E dice si come li fior di prati per
lo ghielo dela nocte se piegiano e chiude
si e poi quando lo sole li riuedeno si driza
no e auranysi cosi la sua uirtute pigata
e chiusa da la uiltate si drizo. e aprissi
p lo detto di uirgilio. e tomo sopra lo pri
mo proposto. e con franchezza disse a uir
gilio che ra adunato di seguilo e come
tuti due aueano uno medesime uolere
si come appar nel testo. E qui e finita la
in tenaione del secondo capitolo.

Canto terzo oue si tracta de la porta edelin
trata delinferno e del fiume da cheronte.
e di coloro che muoreno sença opere di
fama.

Per me seua nela cita dolente
per me si ua nel eterno dolore
per me sua tra la pduta gente.
Justicia mosse il mio alto fattore
fecemi la diuina potestate
la somma sapiencia el primo amore.
Dinanzi a me non fuor cose create
se non eterne. a io eterno duro
lassiate ogni speranza uoi chentrate.
Queste parole di colore oscuro
uidio iscritte al sommo duna porta
perchio maestro il senso lor mee duro.
E elli a me come persona acorta
qui se conuien lassiar ogni sospetto

ogne uilta conuien che qui sia morta.
Noi siam uenuti al loco ouio to detto
che tu uedrai le genti dolorose
channo perduto il ben del intellecto.
E poi che la sua mano ala mia pose
con lieto uolto ondio me confortai
me mise dentro ale segrete cose.
Quiui sospiri pianti e alti guai
risonauan per laer sença stelle
perchio al cominciai ne lagrimai.
Diuerse lingue orribile fauelle
parole di dolore accenti dira
uoci alte e fioche e son di man con elle
faceuano un tumulto il qual saggira
sempre i quella aria sença tempo tinta
come la rena quando turbo spira.
Et io chaueua error la testa cinta
dissi maestro che e quel chio odo
e che gente che par nel duol si uinta.
Et elli a me. questo misero modo
tengono lanime triste di coloro
che uissero sença fama e sença lodo.
Mischiate sono a quel cattiuo choro
di glangeli che non furon ribelli
ne fuer fedeli a dio ma per se furo.
Cacciali cieli per non esser men belli
ne lo profondo inferno li riceue
chalcuna gloria i rei aurebber delli.
Et io maestro che e tanto greue
a lor che lamentar li fa si forte.
rispose dicerolti molto breue.
Questi non anno speranza di morte
e la lor cieca uita ee tanto bassa
chenuidiosi son dogni altra sorte.
Fama di lor il mondo esser no lassa
misericordia e giusticia li sdegna
no ragioniam di lor ma guarda e passa.
Et io che riguardai uidi una insegna
che girando corria tanto ratta
che dogni posa mi parea indegna.
E dietro li uenia si lunga tratta
di gente chio no auei creduto
che morte tanta nauesse disfatta.
Poscia chio uebbi alcun riconosciuto
uidi e conobbi lombra di colui
che fece per uiltate il gran rifiuto.
Incontinente intesi e certo fui
che questa era la secta di cattiui
a dio spiaceti et a nemici sui.
Questi sciagurati che mai non fuor uiui

Opposite: St Gregory the Great, *De cura pastorali*

15th century (1466), 215 x 134 mm, 117 ff., round humanistic script (*rotunda*). Milan, BT, Cod. 515
The text states that this codex was copied in 1466 by Gerolamo Rontenpeck, clergyman of Rebedorf and chaplain at Rome, for the Bishop of Trento, Giovanni Hinderback de Hassis, elected in 1465, who was himself also at Rome, legate of the Emperor Frederick III to Pope Paul II. The page shown is framed on three sides by white vine interlace and scrolls, with a bird, a lion, and *putti* in the lower margin holding a medallion with two coats of arms. The initial P contains the scene of Pope Gregory the Great blessing the crozier of the Archbishop of Ravenna, to whom the work is dedicated. The splendid illumination is of the Neapolitan school with influence of Ferrara. It may have been made by Gioacchino de Gigantibus of Rothemberg (eastern Bavaria), a calligrapher and illuminator at the court of King Ferdinand of Aragon at Naples.

Page 131: Dante *La Comedia*, with commentary by Jacopo della Lana
Early 15th century, 349 x 248 mm, 310 ff., Italian Gothic bookscript (textualis) in two columns. Padua, BS, MS 67
This manuscript represents Paduan illumination influenced by the work of artists who reached the Veneto during the late fourteenth century, bringing new styles that were readily assimilated into the prevailing Late Gothic style of illumination. The new type of design using pen and watercolour became widespread and popular, particularly at Padua. It was a reflection of a painting-style from Bologna concerned with narrative rather than decoration. A small watercolour placed at the beginning of a Canto depicts Dante and Virgil about to embark.

Above: *Tarot cards*
First half of 15th century, 174 x 87 mm. Bergamo, AC
These fifteenth-century tarot cards were made for the dukes of Milan. Three series were made for Filippo Maria Visconti, as we know from the heraldic symbols decorating them; 67 cards belonged to the Visconti of Modrone, now in the Brera, Milan; 48 cards to Giovanni Brambilla, now owned by Count Lanzo of Mazzatino, Milan; and an almost complete series of 75 cards are divided today between the Colleoni family of Bergamo, the Pierpont Morgan Library, New York, and the Bergamo Art Gallery, from which two are illustrated. This last series is considerable from the artistic point of view, and exceptional for the story of playing cards, missing only two. They are painted in tempera on a red base with stamped gold and silver. The backs are dark red. Twenty-six cards were exchanged by Count Alessandro Colleoni of Bergamo with his friend Baglioni for some other work of art, and Baglioni subsequently bequeathed the cards to the gallery. The cards are attributed to the painter and illuminator Bonifacio Bembo, with the exception of five later cards attributed to the Pseudo Antonio Cicognara.

ASTORALIS

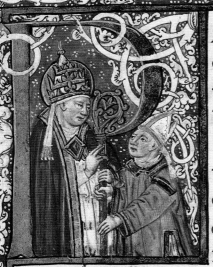

cure me pondera fuge
re delitescendo voluisse
benigna frater kme atq
humillima intentione
reprehendis Que ne
quibusdam leuia esse vi
deantur presentis libri
stilo exprimo ome quod
penso de eorum grauedine vt & hec qui va
cat incaute non expetat & qui incaute expe
tit adeptum se esse pertimescat Quadripetita
tita ç disputatione liber iste distinguitur
vt ad lectoris sui aium ordinatis allegatioib
quasi qbusdam passibus gradiatur Nam cum
req necessitas exposcit pensandum valde est
ad culmen regiminis qualiter quisq veniat
atq ad hoc rite perueniens qualiter viuat &
bene viuens qualiter doceat & recte docens
infirmitatem suam cottidie qnta cosideratioe
cognoscat ne aut humilitas accessum fugiat
aut peruentioni vita cotradicat aut vita doctri
na destituat aut doctrinam presumptio extol
lat Prius ergo appetitum timor temperet post
aut magisterium quod non a querente susci

Right: *Le livre des sept âges du Monde*
15th century (*c.* 1460), 440 x 300 mm, 350 ff., Gothic bastard (*bastarda*) script (bookscript influenced by cursives, ultimately of documentary origin). Brussels, BRA, MS 9047

Made at Mons around 1460, this extraordinary codex is from the atelier of Jacquemart Pilavaine, of which it shows the typical border decoration with acanthus leaves and stylized fruit and flowers, not of exceptional workmanship. Exceptional, however, are three miniatures, which can be recognized as by Simon Marmion, known as 'the prince of illuminators' by his contemporaries. This celebrated painter and illuminator was among the Burgundian artists who, in the second quarter of the century, adopted a new form of mystical realism, successor to the medieval mysticism now nearing its end. Here the landscape of mountains and seas is dominated by the spheres surrounding God the Father.

Opposite: *The Hours of Mary of Burgundy*
15th century (*c.* 1470-80), 225 x 163, 187 ff., Gothic bastard (*bastarda*) script, Vienna, ÖNB, MS 1857

This Book of Hours may be the work presented, still unfinished, by the citizens of Bruges to Charles the Bold in 1467. It was in the possession of Matthias of Hapsburg, later emperor, who was governor general of the Netherlands until 1580, and who gave it to the library in Vienna. It contains twenty-four Calendar illustrations, twenty full-page miniatures, seventy-eight pages with decorated borders, and many historiated initials. The first part of the book, possibly written by Nicolas Spierinc, has thirty-four leaves in gold and silver writing on black panels, surrounded by coloured borders. The illuminations were painted during the reigns of Philip the Good and Charles the Bold. The artist responsible for the most splendid pages – the four large scenes and the fifteen small representations of saints – was undoubtedly the Flemish artist known to us only as the Master of Mary of Burgundy. The others are attributable to the atelier of Alexander Bening around 1480 and up to 1520-30. In the

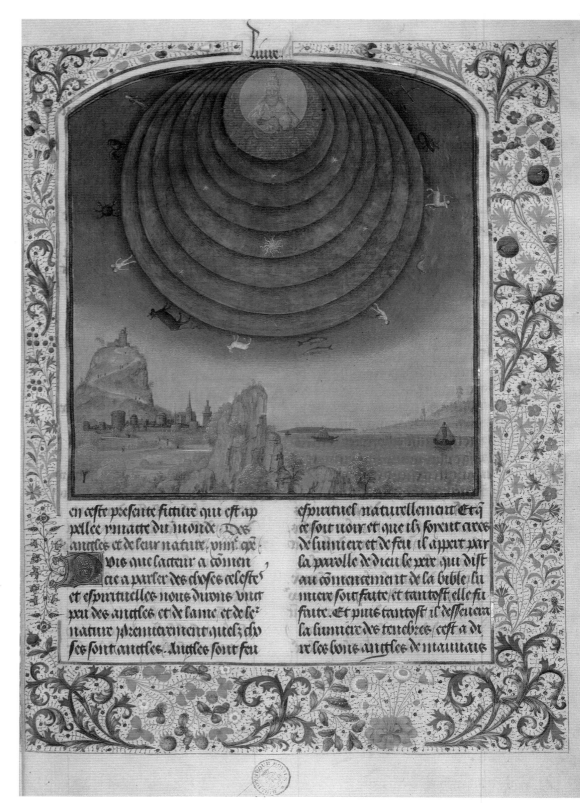

page shown, a princess, who may be Mary of Burgundy or Margaret of York her mother-in-law, is seated at a window opening on to the choir of a Gothic church. Beyond, Mary kneels before the Madonna and Child, opposite a figure sometimes identified as her husband. The slight stiffness in the depiction of the figures is accentuated by the sharp folds of their garments; the composition, the colouring and the detail are all remarkable, and the expressions have vivacity.

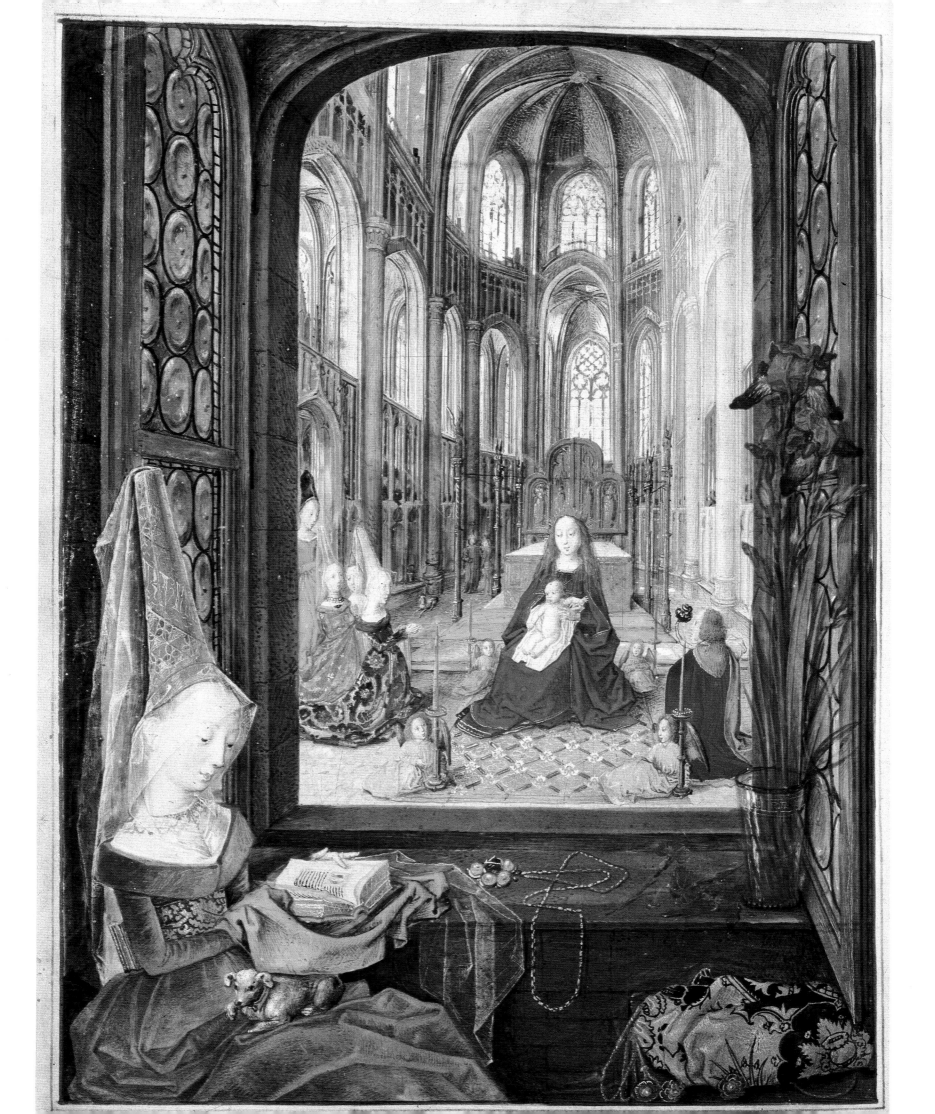

Book of Hours
15th century (*c.* 1486); 190×133 mm, 88 ff., Gothic bastard (*bastarda*) script. Vienna, ÖNB, MS 1907

This codex contains five full-page illuminations and numerous decorated and historiated initials. The text includes prayers, most in Latin but many in Flemish, probably at the request of Maximilian who wrote notes on the Calendar. The five large illuminations, exceptional in both design and colouring, are attributed to the Flemish Master of the *Hortulus Animae*. The remainder of the subject matter is similar to that found in several productions of the atelier of Alexander Bening, working at Ghent and Bruges. The page illustrated shows the Emperor Maximilian (1493-1519) kneeling before St Sebastian, who holds a bow and arrow. The youthful figure of the Emperor is clad in armour and wears a cloak with an ermine collar. Behind him is a tall Gothic building. The border, following a new style, has a gold background on which are depicted flowers, butterflies and other insects, all perfectly true to nature and painted with strong shadows to give an effect of relief. The two personages are depicted with more freedom than had hitherto been customary, and are clearly inspired by contemporary painting.

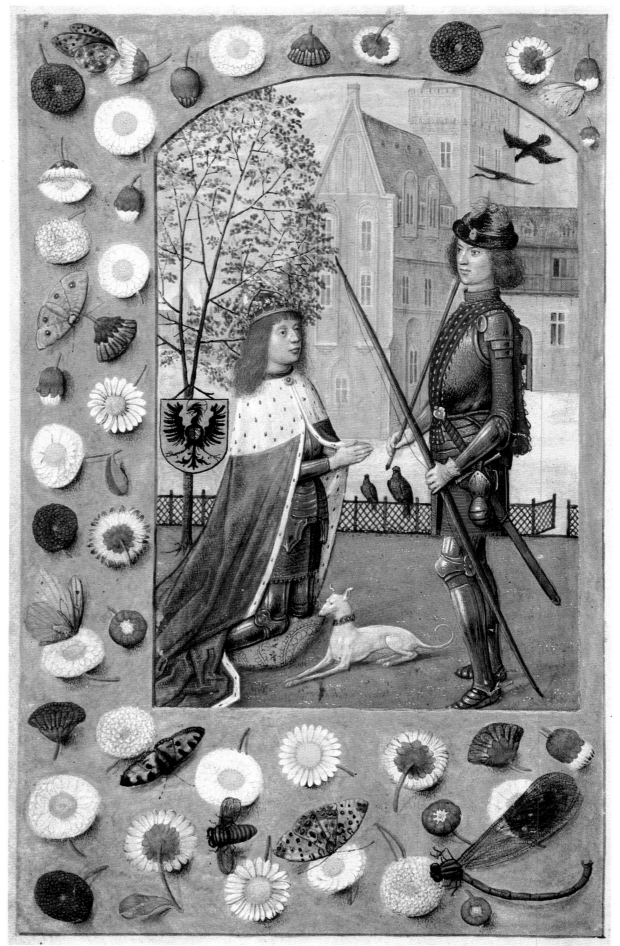

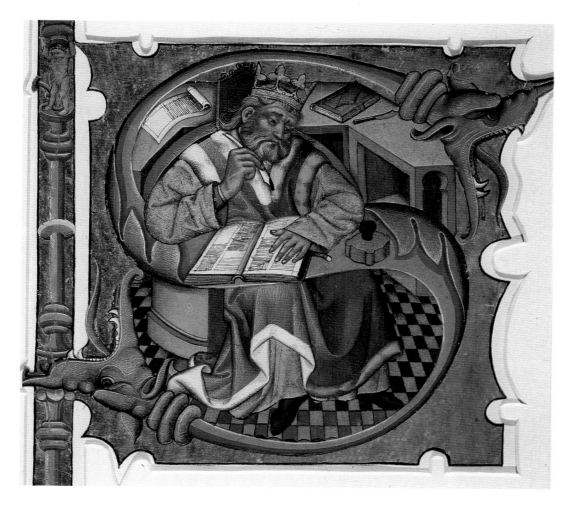

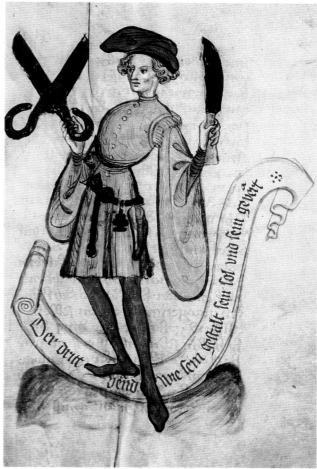

Above left: *Antiphonary*
15th century (1431-36). Washington, DC, NGA
This historiated initial is one of thirteen in a
Spanish codex. Permeated by Italian and Flemish
influences, the choir-book was among a series of
twenty made for Seville Cathedral, attributed to
the Master of the Cypresses, sometimes identi-
fied with Pedro de Toledo, who worked around
1430. This initial S encloses a scene of King
David writing with a calamus, with his ink-well at
his side. Behind him are wooden shelves with a
book, kept horizontal rather than standing, ac-
cording to the custom of the time, a knife and a
parchment scroll. Design and colouring are both
most effective.

Above right: James of Cessolis, *Liber de moribus*
15th century (*c.* 1408), 220 x 152 mm, 159 ff.,
Gothic bastard (*bastarda*) script. Cambridge,
Mass., HU, Houghton Library, MS tip. 45
This codex is one of the earliest illustrating the
game of chess. It contains twelve full-page colou-
red illustrations, probably made in Vienna and in
the German style. The figures have the typical
shapes of International Gothic: slender and ele-
gant, with narrow waists. Shown is a pawn with
artisans' tools: scissors representing a tailor, a
knife for a butcher, and a pen-holder and inkpot
(hanging on a belt) for a scribe.

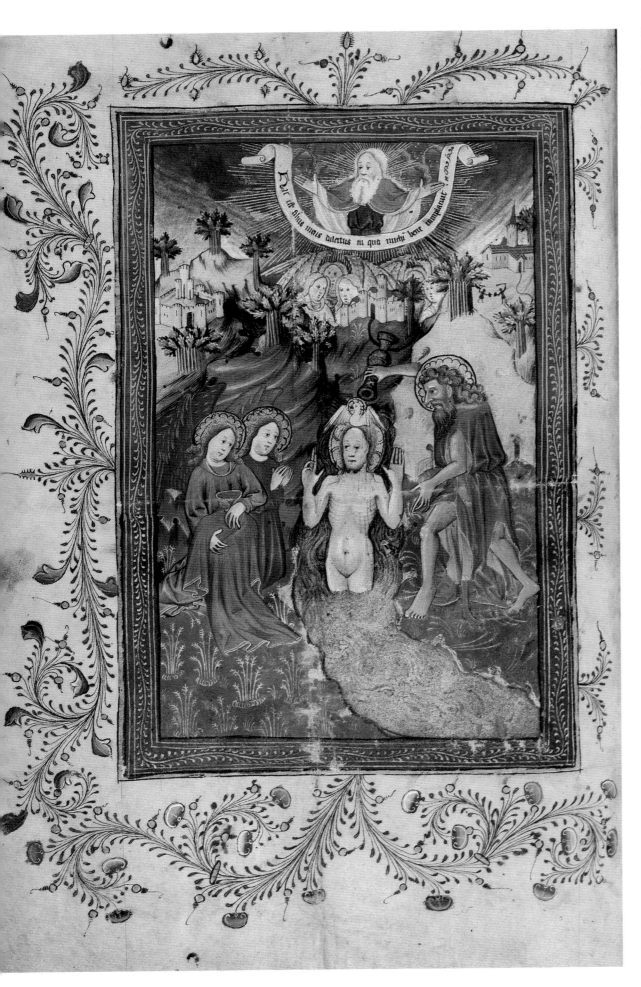

Left: *The Mirror of the Life of Christ*
Second half of 15th century, 325 x 225 mm, 162 ff., Gothic bastard (*bastarda*) script. Edinburgh, NLS, Advocates MS 18.1.7
This is one of a number of surviving manuscripts of Nicholas Love's translation of the *Meditationes vitae Christi*, a popular devotional work often wrongly attributed to St Bonaventura. Love, prior of the Charterhouse of Mountgrace in Yorkshire, made his translation in 1410 to combat the influence of Lollardy. The manuscript contains seventeen full-page miniatures, interesting for their content while somewhat rough in execution. In the lower margin of the miniature of the Coronation of the Virgin appear the book's first owner, Edmund, 4th Baron Grey de Ruthin (created Earl of Kent in 1465), and his wife, Lady Katherine Percy.
The page illustrated represents the Baptism of Christ taking place in a hilly landscape, watched over by a crowd of angels and God the Father. The illumination, done in England, shows Flemish influence.
Though the colouring and composition are simple, the miniature is not devoid of sensitivity and spatial sense.

Opposite: *Domenican Breviary*
Last quarter of 15th century, 260 x 181 mm, 252 ff., Gothic script. Cambridge, Mass., HU, Houghton Library, MS Richardson 39
This codex appears to have been made for a Dominican convent in Alsace, and the historiated initials and borders would seem to have been illuminated in the same convent. The faces, even those of the males, have the rosy cheeks and red lips that often appear in the work of female illuminators. The type of foliage in the borders is of a fifteenth-century German style, influenced by models of Göttingen manuscripts. The page, written in two columns, is bordered on three sides by stylized floral ornament interspersed with the kings of the Old Testament. The initial O encloses the scene of the Presentation in the Temple. The design and colours are simple and naive, but executed with care, even to the smallest details.

138

Below: *Bible of the House of Alba*
15th century (1422-30), 404 x 288 mm, 515 ff.,
Gothic bookscript (textualis) in two columns.
Madrid, PL, vit. 1
This manuscript belonged to Luis de Guzmán,
25th Master of the military order of Calatrava,
and came into the possession of the House of
Alba. The Bible contains a translation from
Hebrew into Spanish by Rabbi Moses Arragel of
Gudalajara for Luis de Guzmán. The text is
surrounded by the exegesis written in Castilian
and is illustrated with 334 illuminations of which
six are full page, with twenty-nine historiated
initials and many decorated initials. These illumi-
nations are done by various Castilian illuminators
of Toledo, with differing degrees of skill, but all
in a local style completely removed from external
influence. The artists neglect the setting to con-
centrate on the figures. The dominant colours,
black, red, green and violet, do not blend; and
neither the burnished gold nor the white applied
to emphasize the faces is well used.

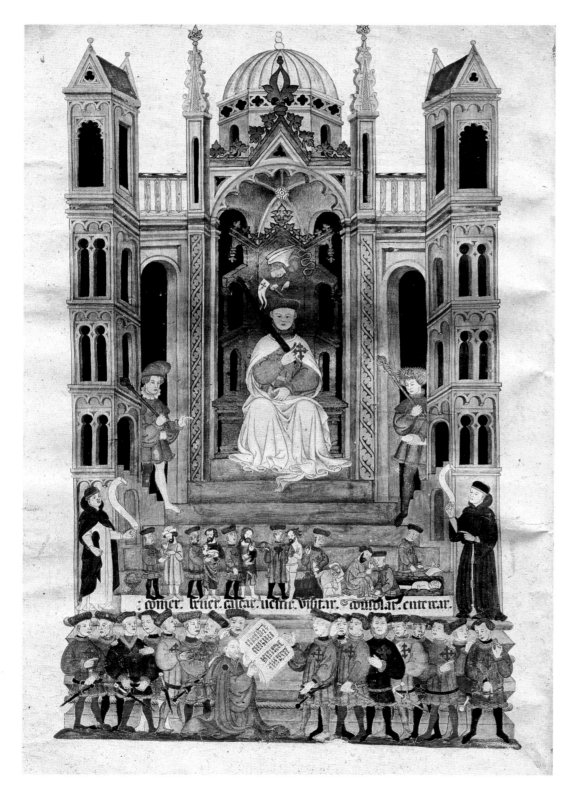

Opposite: Sancho IV (the Brave), *Castigos y Documentos*
Paper, 15th century, 370 x 265 mm, 83 ff., Gothic
cursive bookscript in two columns, Madrid, BN,
MS 3995
This book has the text interspersed with narrative
miniatures of the Castilian school, of unsophisti-
cated design and lively colours.

Cauallo ⁊ Elos ſus vaſſallos en
lo vieſo eſtar en aquella Cuyta tor
naro a el por le auſſer ⁊ Don peſo
coronel ⁊ los aragoneſes como seā
que vna ya caſo vencidos veyedo
los nauaſſos eſtar atremas con ſu
ſeñor que ſe nõ ayudaua boluiero
las tiendas delos cauallos contra
ellos ⁊ fuero los aferir muy de tie
sio en manera quelos vencieron.

E quando en foyendo el dicho Juan
coruala conlos ſuyos ſeyendo ven
cidos en manera que podieri eſcapar
partaſſe le eſta moſa otra vegada en
la cerviz del cauallo ⁊ tomole la ſpe
da en manera quelo nõ dexo yr ⁊
⁊ Juan coruala ſeyedo muy eſpan
tado deſta moſa dixole. Dos dña
filana por que me fazedes cito mal
⁊ ella le dixo eſte galardõ quiſeſ

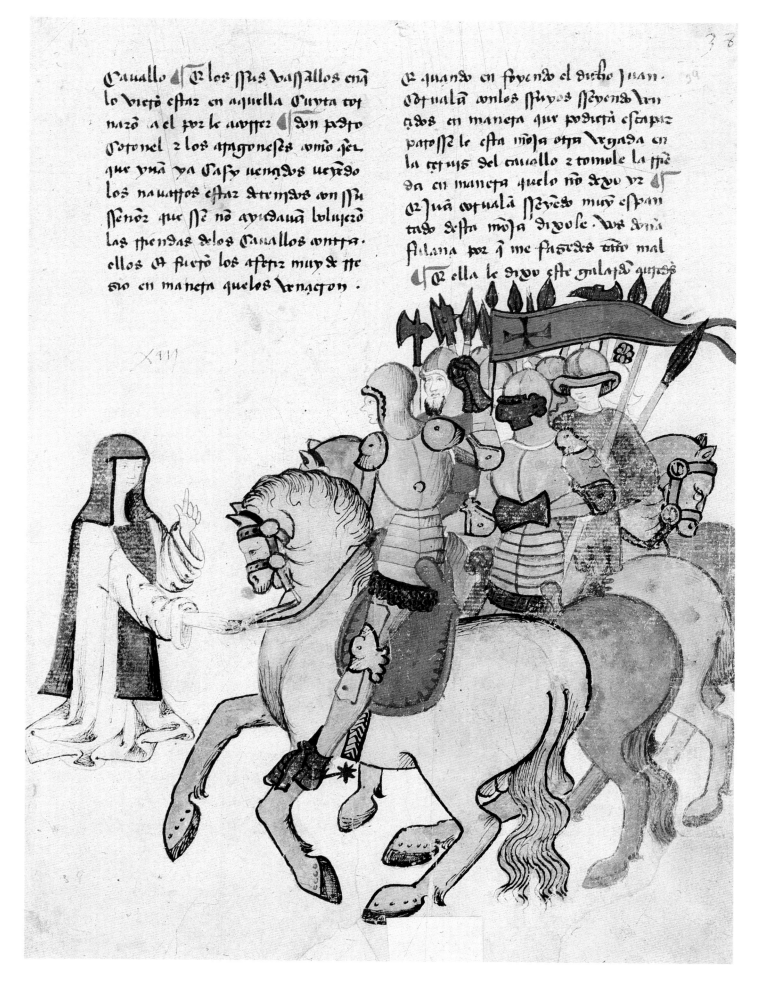

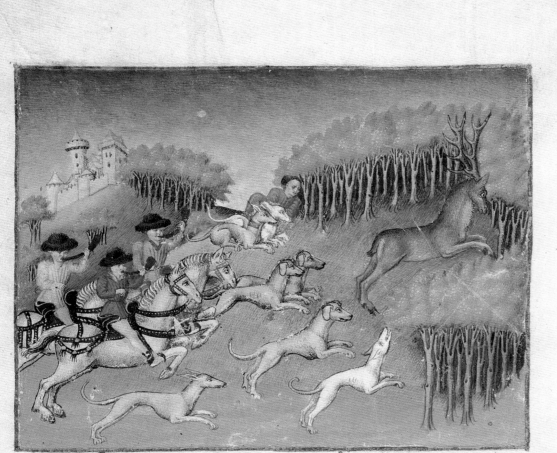

ase et ce te dona grant auisent
de toy retraire. Si preng garde
enchacant aquelle main le cerf
que tu chaceras se destourneza
en fuyant ou adestre ou a sene
fire car il est de certain que en
faisant ses vises il se destorne
voulentiers a une main z celle
ou se destoume main rent
tout le iour comunement.
¶ Ces deux choses que ie tay
dites doiment grant auisent
en chacant ce st de faire les
brisiees pendans et ainor
auisement aquesse main iz
se destoument. Car se tes
chiens chacent se contre ongle

est adux se venes par ou iz
seront ales tu se saias par les
brisiees pendans et si doment
auisement de retraire ses chies
pour desfaire sa vise. Puis
nous diuons coment sen doit
vesaissier au cerf ce que sen
chace ¶ Quant sen enuoye
ses chiens au ves sen y doit
enuoier tel qui ait congnoi
sance du roy des saiges chiens
et la cause si est que slopent
vein aucune partie des chies
chacant combien que tous
ceulx que sen auoit laissie
couve ny feussent une z q
ny eust gaire de chiens et q

Left: Henri de Ferrières, *King Practice and Queen Theory*
15th century (1440-50), 292 x 216 mm, 159 ff., Gothic bastard (*bastarda*) script in two columns. New York, PML, MS 820
Probably made for Bertrand du Guesclin, Constable of France, this northern French manuscript contains miniatures attributed to the young Jean Fouquet (*c.* 1420- *c.* 1481). Fouquet was one of the most celebrated French illuminators of the fifteenth century. A native of Tours, he was for a period in Rome, and was not unaffected by the works of the great Italian Renaissance masters, and was influenced also by Flemish art. The hunting-scene shown is full of life and atmosphere, a colourful, harmonious composition.

Opposite: *Bible of Federigo da Montefeltro*
15th century (1476-78), 2 vols, 442 x 596 mm each volume, 241 and 311 ff., round humanistic script (*rotunda*), Rome, BAV, MS Urbinate lat. 1, 2
Federigo da Montefeltro, Duke of Urbino (1474-82), commissioned richly illuminated works from Florence and Ferrara, particularly scientific works and books on architecture, geometry and military science. This Bible was made in the artistic milieu of Florence between 1476 and 1478, in an important workshop magisterially directed by Francesco di Antonio del Cherico, then at the height of his brilliant career. Although relying upon classical forms, the artist gives the figures of humans and animals a contemporary interpretation that brings a new expressiveness. The thirty-five large miniatures (150 x 260 mm), twenty in the first volume and fifteen in the second, are placed at the top of the pages at the opening of chapters. There are numerous small scenes in roundels, ornaments and initials spread throughout the book, and one large illuminated page of Genesis. The illustration (f. 27 of the first volume) shows the arrival of Jacob and his sons in Egypt: an animated family procession with dromedaries passes through a landscape of cultivated fields, with peasants ploughing and a distant walled town, in a winding movement that enhances the perspective. The page is surrounded with a rich floral border, with candelabra and six small scenes in medallions, all colourfully executed with great skill.

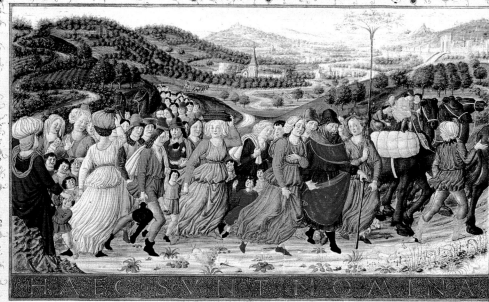

HAEC SVNT NOMINA

filioꝝ isrł qui ingressi sunt in ægyptū cū Iacob
singuli cū domibᵗ suis introierunt Ruben: Syme
on: Leui: Iudas: ysachar: zabulon et Beniamin
Dan: et Neptalim. Gad: et Aser: Erant igitur
omes animæ eoꝝ q egressi sūt de femore Iacob
septuagīta. Ioseph aūt in ægypto erat. Quo
mortuo et uniuersis fribᵗ eius: omi q̄ cognatio
ne sua: filii isrł creuerūt et quasi germinantes
multiplicati sē: ac roborati nimis impleuerūt
terrā. Surrexit interea rex nouus super ægyptū
qui ignorabat Ioseph. Et ait ad pplm suū. Ec
ce populus filioꝝ israel mltus: et fortior nobis ē
Venite sapienter opprimamus eū: ne forte mul
tiplicetur: et si ingruerit contra nos bellū: ad
datur nr̄is inimicis: expugnatisq̄ nobis egredi
atur de terra. Preposuit itaq̄, magistros operū
ut affligerēt eos oneribᵗ: ædificaueruūt q̄ urbes
tabernaculoꝝ Pharaoni Phiton: et Ramesses.
quātoq̄, opprimebant eos: tanto magis multi
plicabantur: et crescebat. Oderantq̄ filios isrł
ægyptii: et affligebat illudentes eis: atq̄, ad a
maritudinē perducebant uitā eoꝝ operibus
duris luti: et lateris: omni q̄ famulatu quo in
terræ opibus premebātur. Dixit autē rex æ
gypti obstetricibus hebreoꝝ: quaꝝ una uoca
batur Sephora: altera Phua: precipiēs eis. Qn̄

obstetricabitis hebreas: et partus tēpus aduene
rit: si masculus fuerit interficite eū: si femina
reseruate. Timuerunt obstetrices deum: et nō
fecerunt iuxta preceptū regis ægypti: sed con
seruabat mares. Quibᵗ ad se accersitis rex ait.
Quid nā est hoc quod facere uoluistis ut pueos
seruaretis? Quæ r̄nderūt. Hon sūt hebreæ si
cut ægyptiæ mulieres. Ipe enim obstetricādi
hēnt scientiā: et priusꝗ ueniamus ad eas pa
rūt. Bene ergo fecit deus obstetricibᵗ. Et cre
uit pplus cōfortatus ꝗ est nimis. Et qa timue
rūt obstetrices deū: ædificauit illis domos. Pre
cepit autē Pharao omni pplo suo dicēs. Quicqd
masculini sexus natū fuerit: in flumē proiecite:
quicqd fæminei reseruate: · C II ·
Gressus est post hæc uir de domo Leui accepta
uxore stirpis suæ: q̄ cōcepit et peperit filium.
Et uidēs cum elegantē: abscōdit mensibᵗ tribᵗ.
cūq̄, iam celare non posset: sumpsit fiscelam
scirpeā: et liniuit eā bitumie ac pice: posu
it q̄ intus infantulū: et exposuit eū in carep
to fluminis stāte procul sorore eius: et cōn
sidrāte euentū rei. Ecce autē descēdebat fi
lia Pharaonis ut lauaretur in flumine: et pu
ellæ eius gradiebātur p crepidinē aluei. Quæ
cū uidisset fiscellā in papirione misit unā de

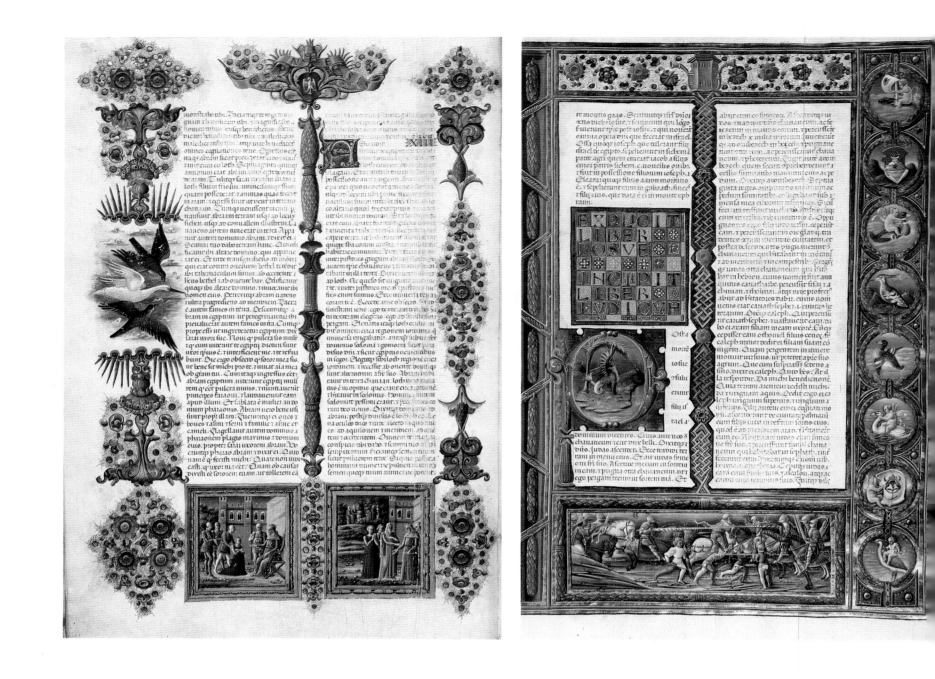

Above: *Bible*, known as the *Borso Bible*
Second half of 15th century, 375 x 265 mm, 2 vols., 311, 295 ff., late Italian Gothic bookscript in two columns. Modena, BE, MS V.G. 12 (lat. 429)

This Bible was copied and illustrated at the court of Ferrara for Borso d'Este (1450-51). Written by Pietro Paolo Marone, it was illuminated between 1455 and 1461, and is celebrated for the sumptuousness of its illuminations. The pages are framed with ornaments, flowers, animals, scrolls, gold bars, medallions, and numerous heraldic devices of the Estensi family; nor are architectural motifs lacking. Small scenes illustrating the text appear in the margins, in perfect harmony with the decorations. There are numerous historiated initials and decorated initials. Almost all the Estensi illuminators collaborated on this outstanding work under the direction of Taddeo Crivelli and Franco de' Russi. Artists included Giorgio Tedesco (or di Alemagna), Marco dell'Avogaro, Giovanni da Lira, Giovanni Todesco da Mantova, Giovanni da Gaibana, Sebastiano del Portello, Rodrigo Bonaccorsi, Cristoforo Mainardi, Jacopo Filippo Medici (l'Argenta), Pietro Maiante, G. M. Spari, Niccolò di Achille, and the Roman painter Malatesta di Pietro Romano. For the decorative portions they took their inspiration from Belbello da Pavia and, for the figures, from the painters Pisanello, Andrea Mantegna, Piero della Francesca and Cosimo Tura.

Opposite: Homer, *Iliad*
15th century (1477), 408 x 270 mm, 423 ff., Greek humanistic italic. Rome, BAV, Cod. Vat. Gr. 16226

Written by Giovanni Rosi and dedicated to Francesco Gonzaga, whose coat of arms appears at the foot on the first two pages, this codex contains richly ornamented initial letters and splendid illuminations of the Renaissance Ferrara school.

The page illustrated is the beginning of the *Iliad*, with the text within an architectural frame. At the top are three illustrations to the work, richly coloured and detailed. At the foot, *putti* support a shield with the coat of arms of Francesco Gonzaga.

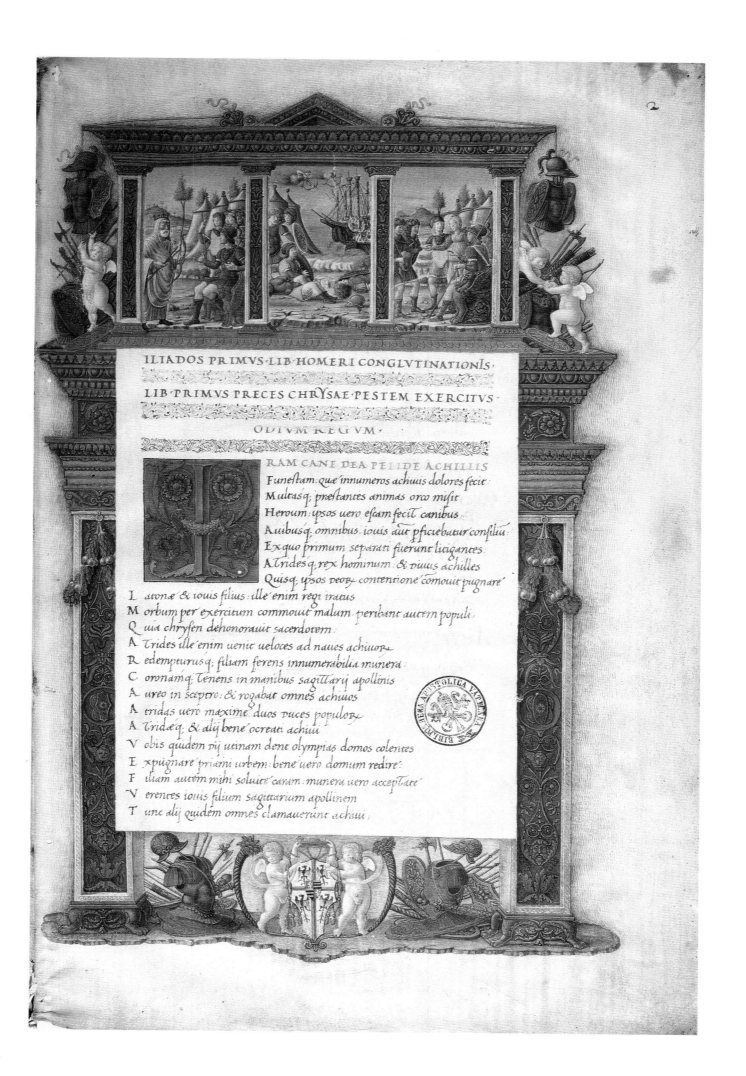

ILIADOS·PRIMVS·LIB·HOMERI·CONGLVTINATIONIS·

LIB·PRIMVS·PRECES·CHRYSAE·PESTEM·EXERCITVS·

ODIVM·REGVM·

RAM CANE DEA PELIDE ACHILLIS
Funestam. quæ innumeros achiuis dolores fecit.
Multasq; prestantes animas orco misit
Heroum: ipsos uero escam fecit canibus
Auibusq; omnibus. iouis aut pficiebatur consiliu.
Ex quo primum separati fuerunt litigantes.
Atrides q; rex hominum. & diuus achilles
Quisq; ipsos deoß contentione comouit pugnare

Latonæ & iouis filius. ille enim regi iratus
Morbum per exercitum commouit malum. peribant autem populi.
Quia chrysen dehonorauit sacerdotem.
Atrides ille enim uenit ueloces ad naues achiuoß
Redempturus q; filiam ferens innumerabilia munera.
Coronam q; tenens in manibus sagittarij apollinis
Aureo in sceptro. & rogabat omnes achiuos
Atridas uero maxime duos duces populoß
Atride q; & alij bene ocreati achiui
Vobis quidem dij utinam dent olympias domos colentes
Expugnare priami urbem. bene uero domum redire.
Filiam autem mihi soluite caram. munera uero accepßate
Verentes iouis filium sagittarium apollinem
Tunc alij quidem omnes clamauerint achiui

Camaldoli Gradual, Part III

15th century (1409), 671 x 483 mm, 149 ff., late Gothic bookscript. Florence, BML, Cor. 3

Made in the monastery of S. Maria degli Angeli, Florence, this codex contains eighteen splendid historiated initials with colourful foliage and small figures. In the largest of these are scenes of the highest quality – works by Lorenzo Monaco (1370-1425) and by Beato Angelico with the help of artists of the school of the Angeli dei Camaldolesi. The detail illustrates the initial S from a choir-book (f. 80v). Under the influence of the International Gothic style the illuminator refines the lines of thin figures, moved by passion or rapt in contemplative ecstasy.

146

Gradual
15th century, 808 x 580 mm, 79 ff., late Gothic bookscript. Siena, LP, Cor. 4

This codex has five ornamented pages, and some of the initials are historiated with such scenes as the Adoration of the Magi, the Presentation in the Temple and the Marriage at Cana. The Adoration of the Magi, shown, is the work of Gerolamo da Cremona, an illuminator who came from Lombardy to the Veneto school, went to Mantua where he continued the work of Belbello da Pavia, and then came to Siena where he illuminated choir-books (1467-75). In these miniatures he exhibits an almost baroque exuberance, with jewels, acanthus, rich Renaissance motifs, and ardent figures swathed in opulent clothing. Ferrara influences can be seen in the floral motifs and filigree tracery.

Opposite: *Les belles heures* of Jean, Duke of Berry
Early 15th century (1410-12), 238 x 170 mm, 225 ff., Gothic bastard (*bastarda*) script, New York, MM
This Book of Hours was illuminated by the Limbourg brothers (see also p. 150). The page reproduced here, by Herman Limbourg, shows an episode of Christ's Passion.

Right: Matteo Palmieri, *Città di Vita*. Poem in *terza rima* with Latin exposition by Leonardo Dati
15th century (1473), 380 x 280 mm, 303 ff., humanistic script in two columns. Florence, BML, MS Plut. 40. 53
This codex has diagrams representing the cosmos and the constellations, as well as various ornaments and historiated and decorated initials. Shown are the signs of the zodiac and other astrological symbols, the work of a fifteenth-century Florentine illuminator influenced by Botticelli, Cosimo Rosselli, and, perhaps most clearly, by Antonio del Pollaiuolo.

Below: Dante, *La Comedia*, with commentary
Paper, 15th century, 310 x 209 mm, 109 ff., humanistic cursive script. Milan, BT, Cod. 1083
The pages of this codex are an example of a heavily corrected text with a commentary written in a smaller script. It was written and illustrated in the Veneto.

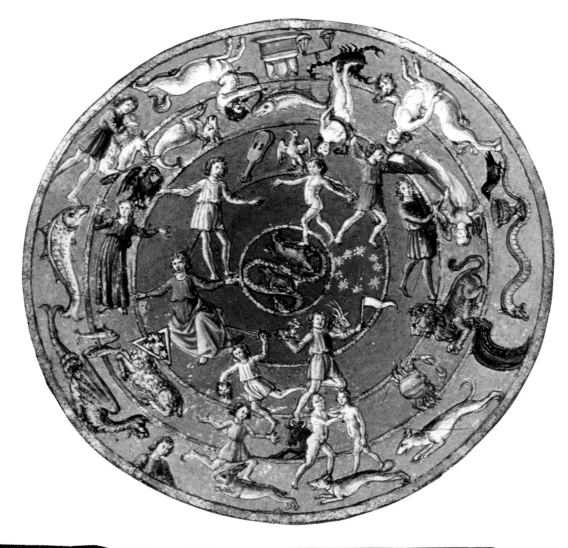

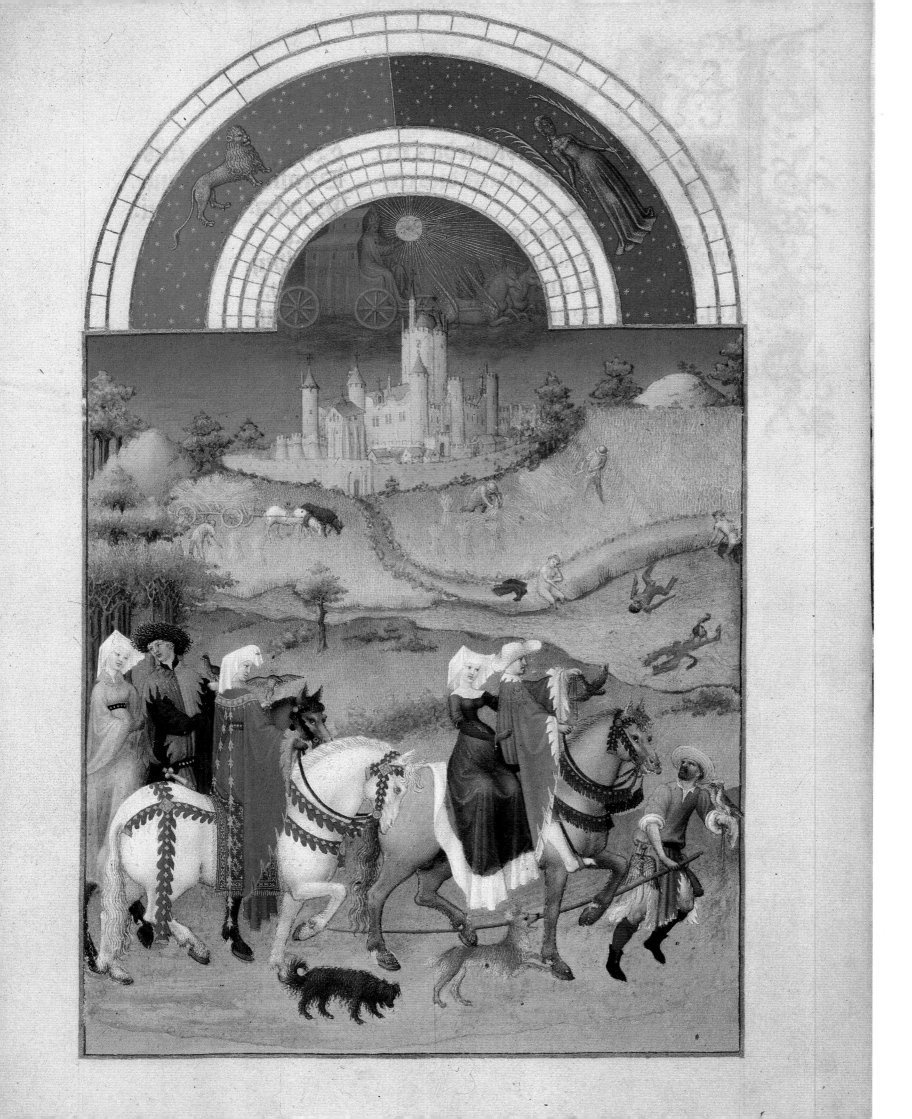

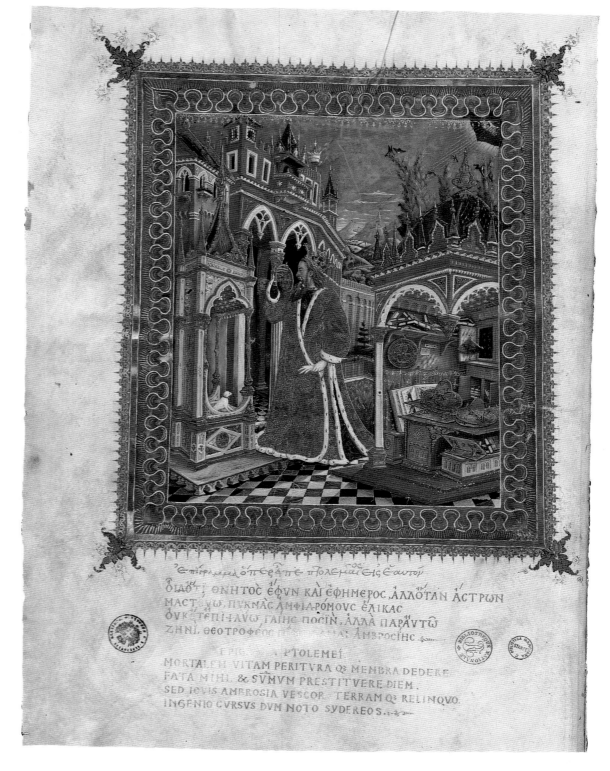

Opposite: The *Très riches heures* of Jean, Duke of Berry

Early 15th century (*c.* 1413-16), 238 x 170 mm, 225 ff., Gothic bastard (*bastarda*) script. Chantilly, MC

At the death in 1416 of the Duke of Berry, this Book of Hours was inherited by one of his daughters, Bonne, briefly married to Amedée VII of Savoy, by way of whom it passed to their descendants, Duke Charles I of Savoy and his wife Blanche of Montferrat.

It is the masterpiece of the Limbourg brothers, who all three died in 1416 (in the same year as the Duke of Berry) with the manuscript unfinished. The Duke and Duchess of Savoy commissioned Jean Colombe to complete the illumination between 1485, the year of the Duke's marriage, and his death in 1490.

Illustrated is the month of August. Overlooked by the Château d'Etampes, a richly dressed party of riders sets out with their hawks on their wrists, led by a falconer on foot who carries a long pole. On the hillside behind the party, peasants cut the ripe corn, bind the sheaves and load the cart that will carry the harvest home. A bather is about to enter the River Juine, while others are seen swimming. Thus are represented side by side one of the pastimes of the nobility and the life and seasonal labours of the countryside familiar to the Duke of Berry.

Above: Ptolemy, *Geographia*

15th century, 587 x 435 mm, 103 ff., Greek and Latin capitals and humanistic script in two columns. Venice, BNM. MS Gr. Z. 388 (333)

This manuscript is a copy of a work in the Vatican (Gr. 77), and was made for Cardinal Bessarione. A scholar, bibliophile and patron of the arts, Bessarione collected and gave to Venice a personal library that formed the earliest and most important basis of the Marciana Library. This codex is one of the collection's most sumptuous and remarkable. The illuminations are in the style of Belbello da Pavia. Gold illuminates the landscape and clothing of the strongly dramatic scenes. The last part of the book contains 49 pages with coloured maps.

The miniature shown has a border inspired by Oriental art. At the centre stands Ptolemy, richly robed and wearing a golden crown. His features are Oriental, with almond-shaped eyes. To his left is his study with his golden instruments on a table and suspended on the wall; books are stored on a shelf, on low chests and in an open cupboard. A small dog sits inside a second tabernacle.

Behind are seen two Gothic palaces, one with a projecting balcony and, on the corner, a smoking Venetian-style chimney. We also see a garden with tree-tops, and in the far distance, green hills and castles. The scene is illuminated with rays of gold from a sun at the right.

151

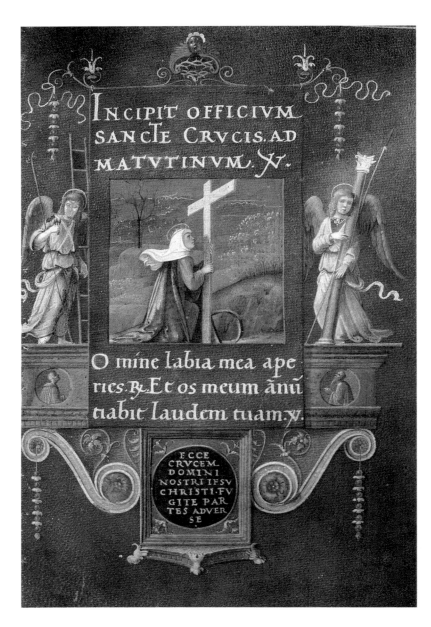

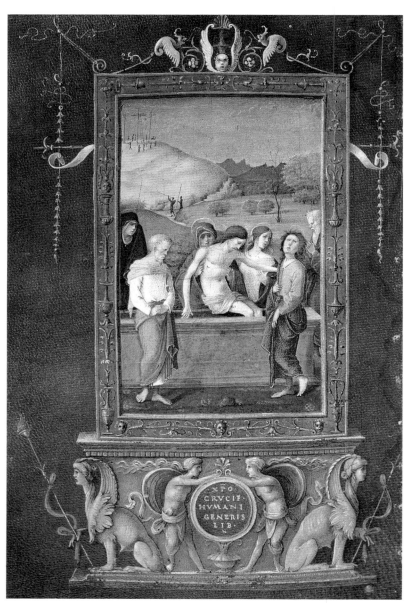

Above: *Horae beatae Mariae Virginis, cum calendario*
16th century, 144 x 96 mm, 210 ff., humanistic script. Genoa, BB
Written on purple parchment with gold, this book is a return to the sumptuousness of luxury manuscripts of late antiquity and the High Middle Ages. It contains numerous illuminations – six full-page and fifteen smaller subjects, framed with borders of sturdy architectural motifs, and with angels, fruit, fantastic animals, medallions, jewels and delicate cameos. Each month of the calendar has the sign of the zodiac. The illumina-

ted scenes of exquisite workmanship were first attributed to Giulio Clovio, later to Francesco Marmitta of Parma. Even as illumination declined, supplanted by printing, Marmitta evokes a countryside reminiscent of Giambellino, and figures whose faces recall Perugino. Shown are pages with the opening of the *Officium Sanctae Crucis* and *The Resurrection*, enclosed in light classical frames.

Opposite: *The Calendar*
16th century (*c.* 1540), detached leaves, 152 x 102

mm, ff. 108-9; Gothic bastard (*bastarda*) script. London, BL, Add. MS 18855
These two loose pages contain four full-page illuminations attributed to the Flemish artist Simon Bening, who worked at Bruges and specialized in Books of Hours. The subjects are the seasonal labours, destined for a Book of Hours in the medieval and Flemish Renaissance traditions. The page illustrated shows a scene of sheep-shearing, the labour of the month of June, in an impressionistically rendered landscape in which can be seen taking place many of the activities associated with the life of a country house.

152

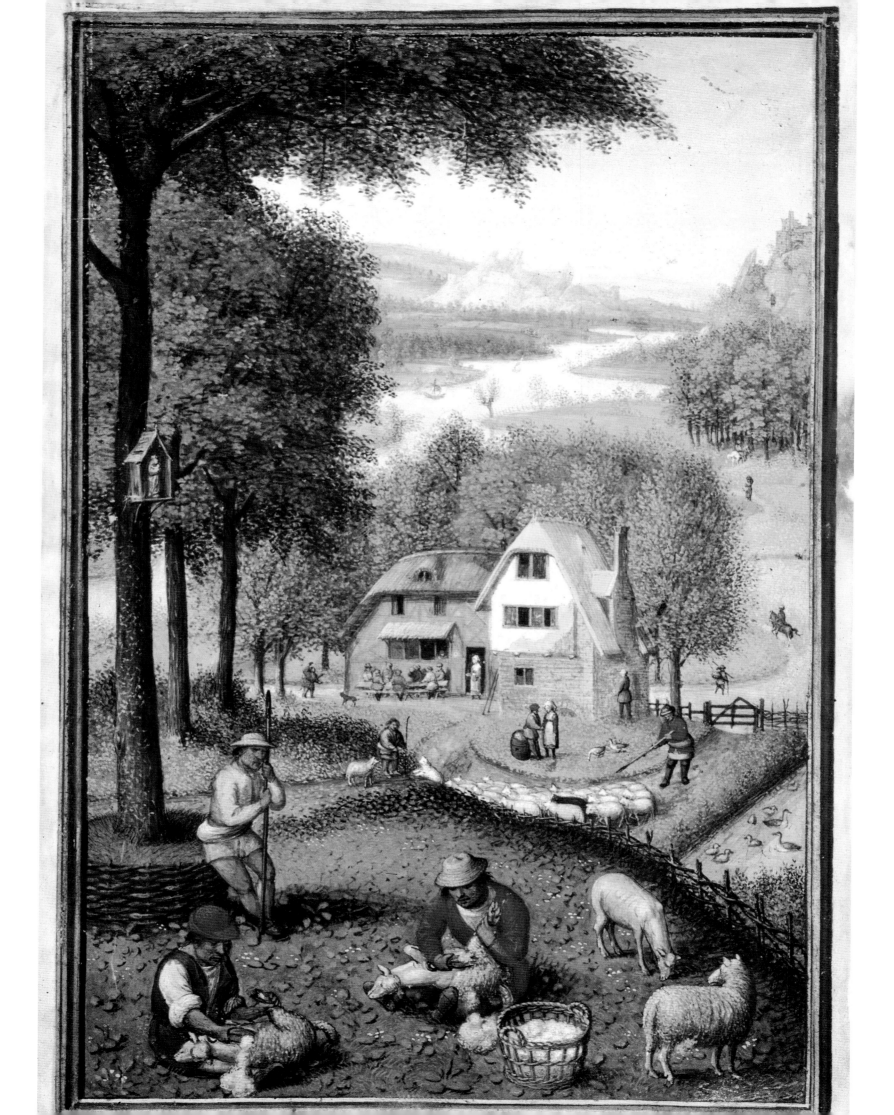

Below: *Book of Hours of Isabella of Aragon*
Early 16th century, 285 x 205 mm, 48 ff., Gothic
bookscript, Milan, BT, Cod. 2144
This prayer-book in Latin and Italian was made
for Isabella of Aragon, widow of Gian Galeazzo
Maria Sforza, Duke of Milan. It may have been
made at Bari, where Isabella was in 1500: it was
written and illuminated between 1511 and 1518.
Illustrated are two pages with scenes of the Old
and New Testaments and the lives of the saints.
At right at the foot of the page appears the coat
of arms of Aragon and Sforza supported by *putti*.

Opposite: Jean de Bueil, *Le jouvencel*
16th century (*c*. 1530), 360 x 255 mm, 228 ff.,
French Gothic bastard (*bastarda*) script. Vienna,
ÖNB, Cod. 2558
Probably made in Brittany for Jean de Laval of
Chateaubriand, the book includes nine illumina-
tions in architectural frames in gold or colours,
and many decorated initials in the text, in a good
French style. Shown is the conquest of the city of
Crator. Cannon point towards the city, which is
under seige by soldiers who are seen attempting
to scale its walls.

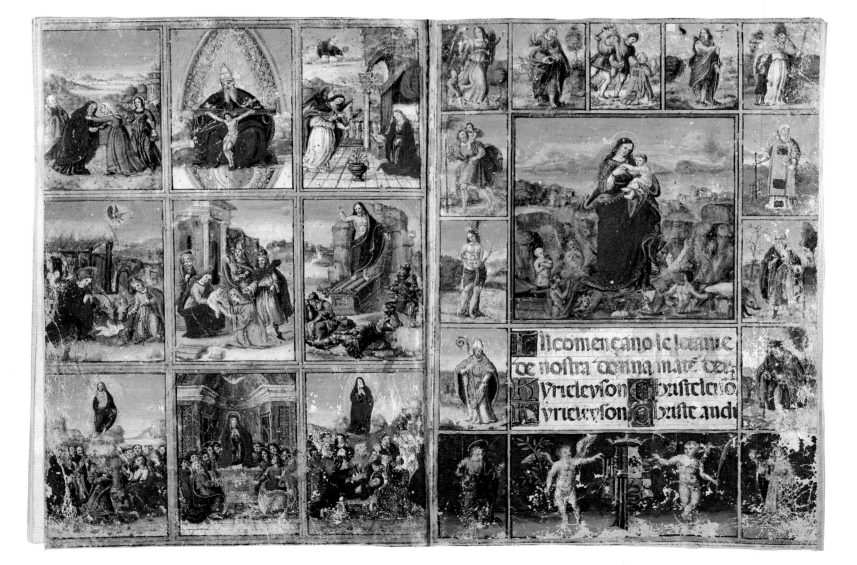

Et pource qu'il estoit enferme en l'une des tours prin-
cipales de la ville de C'earhoe. en icelle pourieta. adaisa et
ymagina la prinse de la ville. ainsi que est rccite au chap[itre]
suiuant. Et par ainsi peult apparoir l'auctorite du prouer-
be mys au commencemet de ce chapxe touchant les dif-
ficultes que fortune baille et presente a ceulx qu'elle veult
pouoir a la fin. Et syci est determine la fin de ce prit chap[itre].

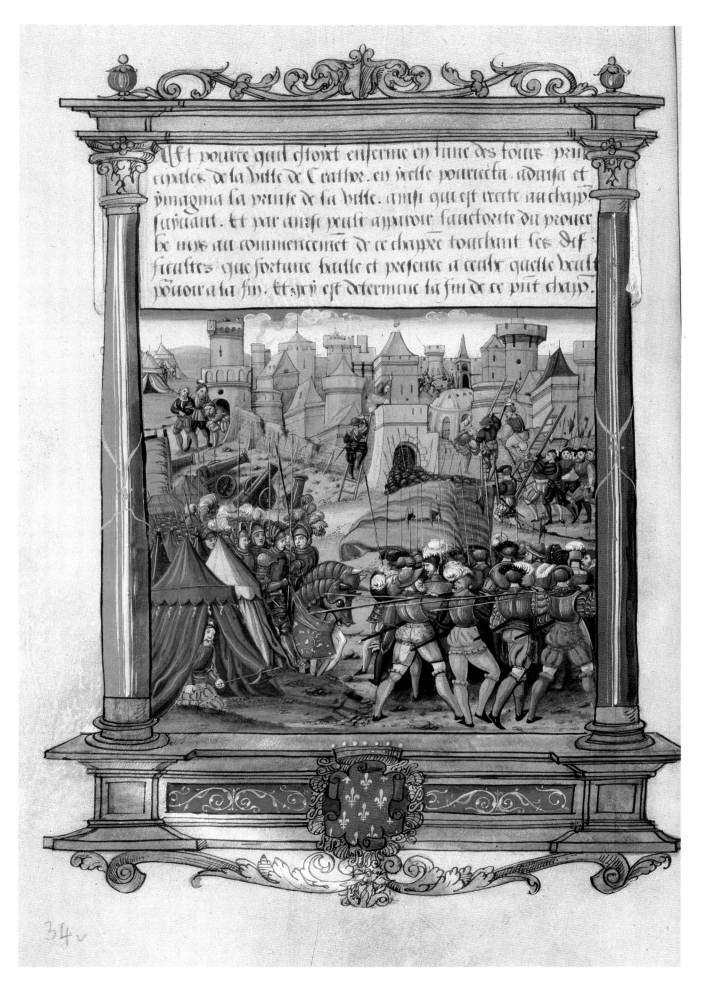

Right: *Gradual*
Mid-16th century (*c.* 1542-46), 470 x 650 mm, 179
ff., Gothic bookscript. Milan, BT, Corale A
This choir-book includes twenty-one large initials, illuminated and decorated, numerous other large illuminated initials within the text, and some with extremely ornate decorations, drawn with a pen and generally coloured green and black. These mid-sixteenth century examples are signs of an age of transition. They recall Lombard art of the early sixteenth century, with the influence of Luini and Gaudenzio Ferrari. The work is attributed to Agostino Decio. In the large initials he creates lively scenes, full of movement and colour.

Below: *Armorial*
Paper, 16th century, 405 x 275 mm, 126 ff.
Madrid, BN, MS 1196
A Castilian codex, this has watercolour paintings of the coats of arms of several families, portraits of the counts of Barcelona, and, shown here, a sketch of Barcelona harbour.

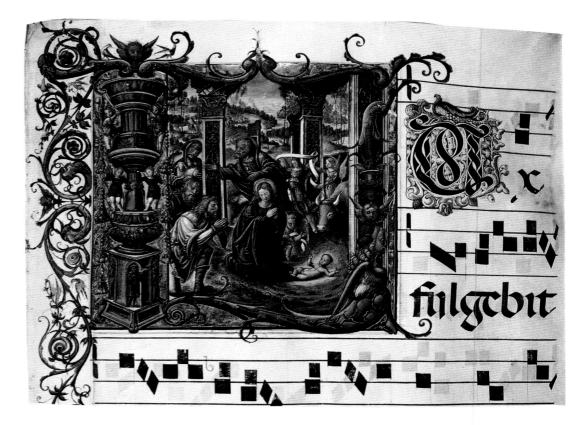

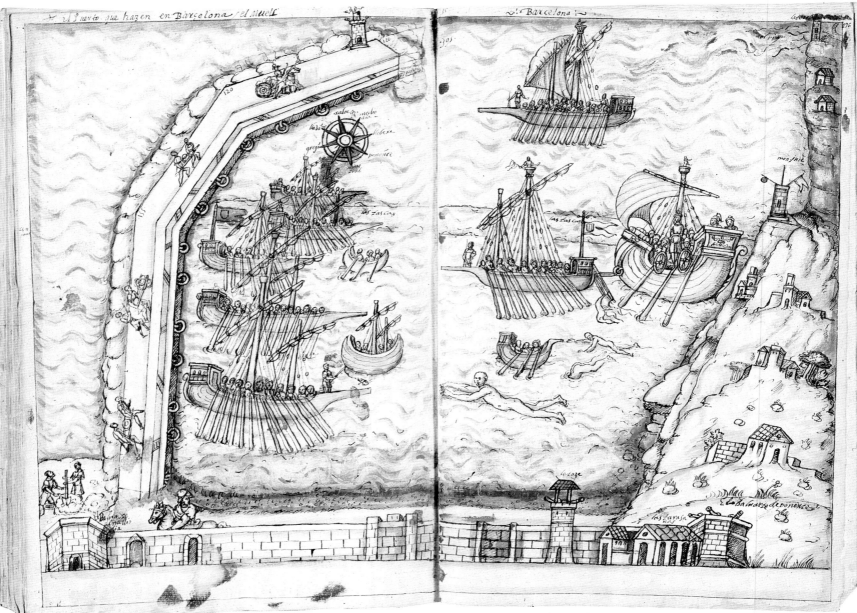

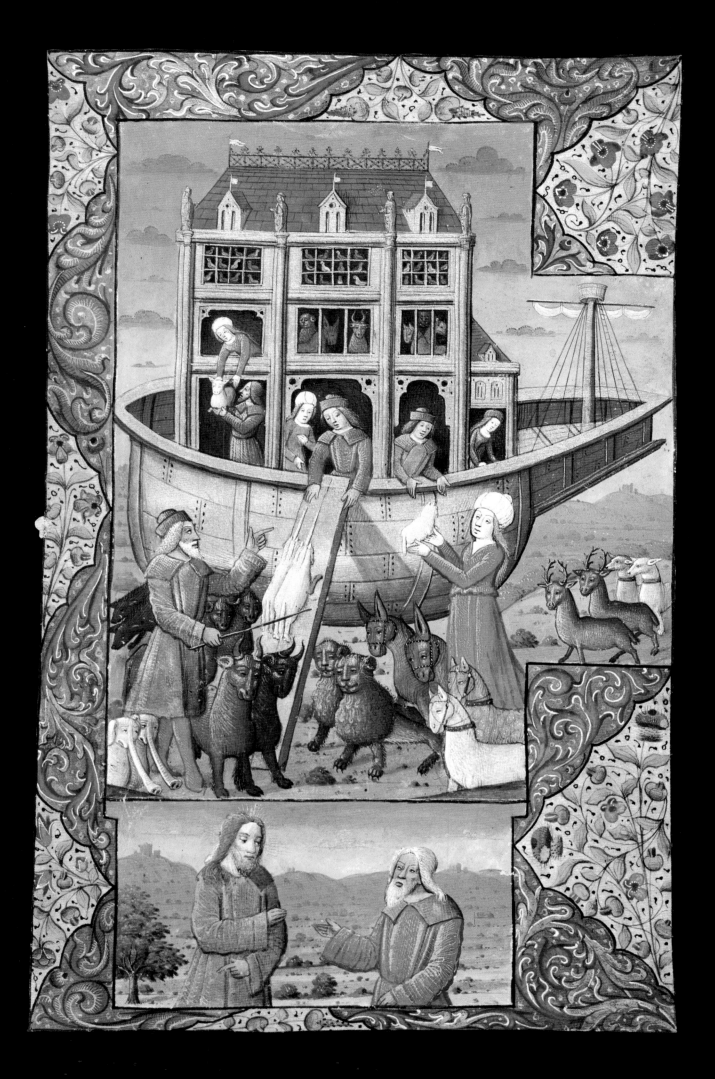

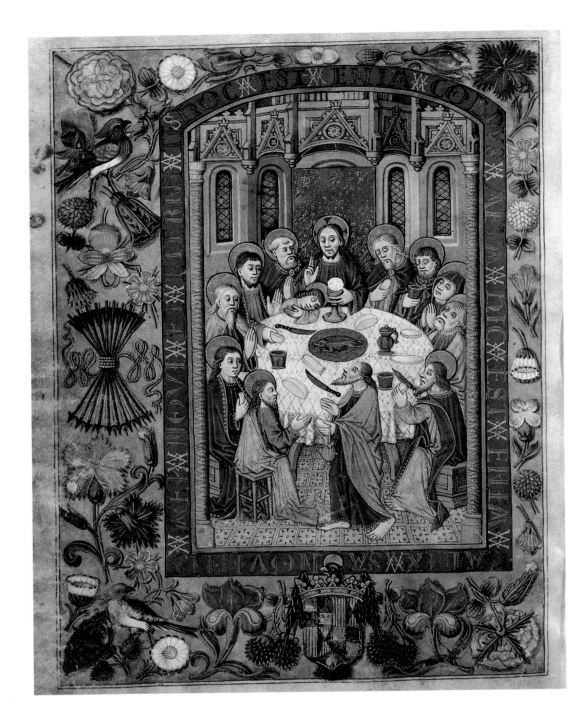

Opposite: *Book of Hours of the Virgin*
16th century (*c.* 1515), 171 x 124 mm, 389 ff.,
Gothic bastard (*bastarda*) script. New York,
PML, MS 399
This codex was probably made at Bruges in the
workshop of Gerart Horenbout and Simon Be-
ning, as witness the broad and monumental effect
of some of the scenes. The subject illustrated,
'Boats in May', represents a pleasure-outing on a
stream, with a building in a Flemish style, and on
the wooded bank beyond, a party of riders. The
atmosphere is gentle and evocative.

Page 160: *Genealogy of the Infante Don Fernan-
do of Portugal*
First half 16th century, 559 x 394 mm, 13 loose ff.
London, BL, Add. MS 12531
This splendid codex, made for Don Fernando of
Portugal (1507-34), brother of King John III,
contains a genealogy of the family surrounded
with small scenes. The illumination is attributed
to Simon Bening, the most celebrated Flemish
artist of Bruges from the end of the fifteenth
century to the early sixteenth. He specialized in
the production of marvellous small Books of
Hours. The abundant rich colours are typical of
his illuminator's art, the most perfected in Eur-
ope at the period. The page illustrated has the
family tree of the kings of Aragon, bordered by
animated, lively scenes of religious life and bat-
tles, depicted with the clarity and precision of a
master.

Previous page
Page 157: *Book of Hours*, known as the *Hours of
Charles V*
Early 16th century, 230 x 153 mm, 168 ff., Gothic
bastard (*bastarda*) script, Madrid, BN, Vitr. 24-3
Product of a Parisian atelier, this book has nume-
rous full-page illuminations, moderate in execu-
tion but extremely colourful and lively, with rich
landscapes. Most of the scenes are from the Old
and New Testaments. Shown is Noah's Ark. The
elaborate borders represent nature at the diffe-
rent seasons.

Above: *Institucion de la regla y hermandad de la
cofradia del sanctissimo Sacramento*
16th century (1502), 245 x 183 mm, 46 ff. Cam-
bridge, Mass., HU, Houghton Library, MS typ.
184
This codex was made for Isabella the Catholic
(1451-1504), wife of Ferdinand of Aragon and
Queen of Castile. It was made at Toledo, perhaps
by Juan de Tordesillas, in a Spanish-Flemish style
with colours more sombre than those used by
northern masters. Shown here is the Last Supper,
within a border of birds and flowers, some styli-
zed, some naturalistically represented, in a style
and design that clearly show Flemish influence.
Below is the Queen's coat of arms.

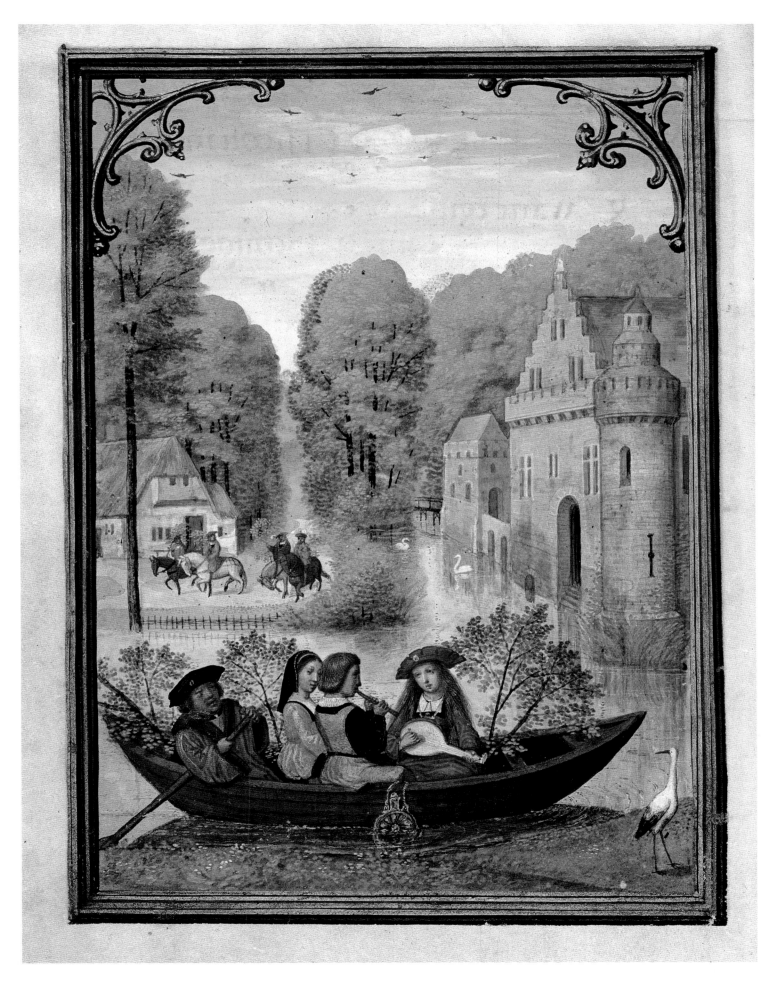

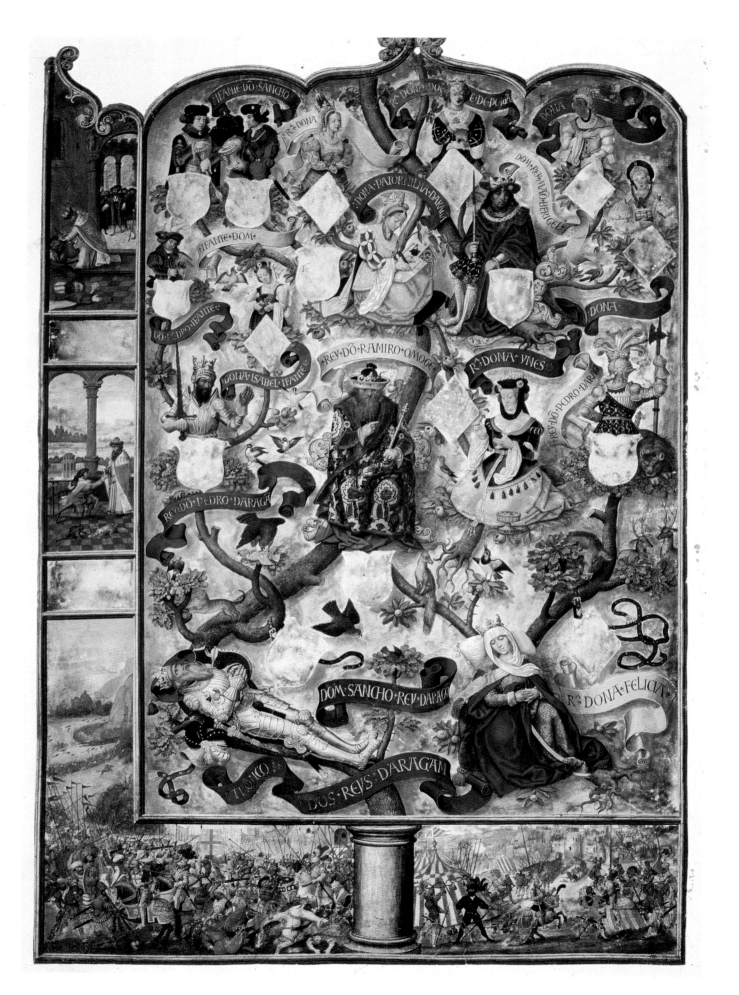

Great libraries
and their
manuscript
treasures

List of
illuminators

Select bibliography

Index

The writer among his books. Attributed to
Bernardino de' Conti, from *Historia di Milano*
(History of Milan) by Bernardino Corio, Milan, 1503

Great libraries and their manuscript treasures

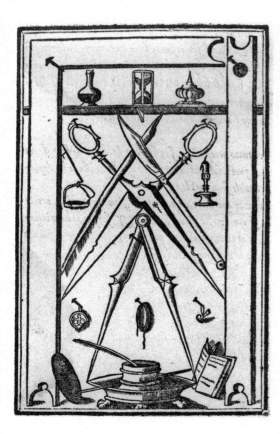

Writing instruments. From an engraving in *La vera arte de lo excellente scrivere* (The True Art of Good Writing) by G. Antonio Tagliente, Venice, 1539. Here, among other instruments, are represented a set-square, a ruler, scissors, a pair of compasses, a candlestick, an erasing knife, a quill and an ink-pot

Barcelona
Archivo de la Corona de Aragón

This library was instituted in the fourteenth century, when King Peter III of Catalonia and IV of Aragon wished to secure the future care of the royal documents. In addition to the records of ten centuries, the archives contain 233 manuscripts saved from a fire in 1835 at the monastery of Santa Maria, Ripoll, and 244 from the monastery of San Cugat del Valles, the earliest of which is of the thirteenth century; the *Epistulae Hincmari ad Karolum* and the *Ars Prisciani*, both tenth century; a Boethius, *De musica*, of the twelfth century; volumes of Petrarch, and many others.

The palace which houses the Biblioteca Queriniana in Brescia. Cardinal Querini, the founder of the library, had it built to a design by the Brescia architect Marchetti. From an engraving by F. Zucchi based on a drawing by F. Battaglioli, 1751

Bergamo
Accademia Carrara

Among the museum's rich and important collection of paintings and drawings are 26 tarot cards, of which 23 were illuminated by Bonifacio Bembo and three by Antonio Cicognara.

Bergamo
Biblioteca Civica Angelo Mai

The library began with a bequest from Cardinal Giuseppe Furietti to the city of Bergamo in 1760 to which were added the libraries of suppressed monasteries, and, after the restoration, the important fund of the Lyceum of Bergamo and other valuable bequests. Among its most precious manuscripts are the Life of Bartolomeo Colleoni, written in silver by Cornazzano, the *Dante*

Grumelli, a palimpsest of 1402, the *Tacuinum Sanitatis* of Giovannino de' Grassi, and many others. The library's holdings include more than eight thousand manuscripts.

Berlin
Deutsche Staatbibliothek

Berlin's State Library, Staatbibliothek Preussischer Kulturbesitz, was established in 1947 under the name Westdeutsche Bibliothek. The major part of the collection is composed of acquisitions.

Following the foundation in 1964 of the Stiftung Preussischer Kulturbesitz, the library was incorporated into it and took the new name. In 1967, the foundation was moved to a large, modern building in West Berlin. Without counting special collections, the library's holdings include some two and a half million volumes. A large quantity of materials pertaining to art and natural sciences has been added.

The manuscript collections of the State Library have never been comparable to those of the Bibliothèque Nationale, Paris, or the British Library, London, or even to those of the State Library of Munich, which became the repository of so many monastic libraries. In 1933 the Library's holding of Western manuscripts was 13,492; in 1955 it was 3,829, the manuscripts having been distributed widely over Germany.

The Library's main activities are collecting, processing and providing foreign literature. The Staatbibliothek Preussischer Kulturbesitz is also engaged in the cataloguing of handwritten works nationally.

Brescia
Biblioteca Civica Queriniana

Cardinal Angelo Maria Querini, Bishop of Brescia, founded this library in 1747, endowing it with his personal library, and providing it with funds and a building. Querini then gave it to the city of Brescia, and it was opened to the public in 1750. The 2,900 manuscripts, almost all Latin and Italian, include thirty-nine illuminated works, among them a Gospels of the sixth century, with canon tables of the tenth century and splendid Ottonian illuminations; fragments of a St Cyprian of the fifth century; an English Psalter illuminated in the fourteenth century; a St Jerome of the eighth century, an an illuminated Greek Gospels of the tenth century.

Brussels
Bibliothèque Royale Albert Iᵉʳ

The Royal Library dates only from 1837, but has as its foundation a library created in Brussels by Philip II on 12 April 1559, for which were gathered in the royal palace all the volumes of the royal collection that had hitherto been dispersed, particularly at Lille and The Hague, as well as an important group of codices belonging to Mary of Hungary, most of which had been in Bruges, Ghent and Antwerp. These formed a nucleus of 333 manuscripts.

Philip II inherited from his father Charles V other important collections, and precious manuscripts came from the library of the dukes of Burgundy, in which works of the greatest illuminators had been gathered. Fire destroyed the palace and a great part of the library in 1731. The volumes remaining were removed in 1754 to a new building, the Domus Isabellae. In 1772 the Empress Maria Theresa had the library opened to the public. In 1837 the present Royal Library was created by a decree of Leopold I, uniting the manuscripts section owned by the state with the printed books section owned by the city to form a single state institution.

Cambridge, Mass.
Harvard University Library

In 1638, two years after the founding of the 'small school for the devout', John Harvard gave the school some four hundred books. From the beginning, the library enjoyed many bequests, particularly from the Hollis family of London merchants, whose donation in 1774 provided income still used to

buy books. In 1764 a fire destroyed the library, and only 404 volumes were saved. Two years later the library was housed in a new building similar to the library of Queen's College at Oxford, and the library's holdings were increased notably, going from 4,350 volumes in 1766, to 30,000 in 1830, to 334,000 in 1895, and to 675,000 in 1915. Among the library's donors were Benjamin Franklin, Carlyle, and Amy Lowell. The library also has a noteworthy collection of American history based on the collection of Professor Ebeling of Hamburg, donated to the library in 1818 by a Boston merchant. The first building used for the library was built in 1841; a second followed in 1915 — the colossal Widener Library — but it, too, was found to be too small. In 1942 the Houghton Library was inaugurated for the collections of rare books and manuscripts: made to hold 50,000 volumes, it has become inadequate, and now holds 400,000 rare books, including 1,300 manuscripts from before 1600. Among the rare items conserved in the Houghton are a Gutenberg Bible on paper, the first book printed in Africa, a collection of antique Russian maps, and 3,600 incunabula, collections of Dante, Tasso, Luther, Erasmus, Machiavelli, Cervantes, etc., and the West's richest collection of Russian first editions. Although Harvard cannot compete with the large libraries of Europe in terms of medieval manuscripts, it is a leader among collections of first editions of European and American literature.

Cambridge
University Library

Although in the later fourteenth century

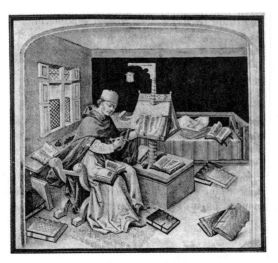

Brussels, Bibliothèque Royale Albert Iᵉʳ. Flemish miniature. From *Avis pour faire le passage d'outre-mer*, fifteenth century

Brussels, Bibliothèque Royale Albert Iᵉʳ. Flemish miniature of J. Pilavaine's workshop. From *Le livre du gouvernement des princes*, 1452

Cambridge University possessed a small collection of books, probably kept in chests in its treasury, the earliest references to a library occur in two Wills of 1416, one of which bequeaths three volumes 'to remain forever in the new library at Cambridge'. That library was housed in the university buildings known as the Old Schools, where it occupied two rooms. Until Bishop Moore's books arrived in 1715 these rooms provided all the accommodation necessary, while the only staff comprised the librarian and (from 1653) a single assistant. By 1500 there were some six hundred volumes, printed and manuscript, in the Library, and more were added until 1529. Thereafter, however, the general neglect or destruction suffered during or after the Reformation by all English libraries caused the progressive erosion of the Library's holdings. The manuscripts it now possesses have, with a very few exceptions, all been acquired from the 1570s onwards.

In 1574 Matthew Parker, Archbishop of Canterbury, presented twenty-six manuscripts, including six in Anglo-Saxon, several notable texts of English chronicles, and a tenth-century volume procured *c.* 1241 from Greece by Robert Grosseteste, Bishop of Lincoln, containing *inter alia* the *Testaments of the Twelve Patriarchs* which Grosseteste translated for the first time into Latin. In 1581 the theologian Theodore Beza gave the *Codex Bezae*, a fifth-century New Testa-

Chantilly, Musée Condé. The cat and the mouse, illustration of a German translation of a book of moralizing tales (c. 1480)

ment in parallel Greek and Latin versions with some unique readings, still the Library's most treasured possession. In 1632 the Duchess of Buckingham presented a collection of Oriental manuscripts which had belonged to the Leyden scholar Thomas Erpenius, including some of the oldest surviving manuscripts in Malay. In 1664, after complicated negotiations, the university acquired the library of Thomas Holdsworth, Master of Emmanuel College, Cambridge. Probably the largest private library of its day in England, it comprised 10,095 printed books and 186 manuscripts, the latter including a ninth-century Juvencus with near-contemporary Welsh glosses and verses added, and an important early fifteenth-century collection of Chaucer's works.

In 1715 King George I bought the library of John Moore, Bishop of Ely, and presented it to Cambridge University. Estimated to contain some 29,000 printed volumes and 1,790 manuscripts, it trebled the size of the existing collections. Its many important manuscripts include one of the two earliest extant copies of Bede's *Historia Ecclesiastica*, perhaps written *c.* 737; a ninth-century copy of Palladius' *Opus Agriculturae* written at St Denis, one of several manuscripts acquired by Moore which once belonged to French religious houses; the tenth-century Gospelbook with Gaelic additions known as the *Book of Deer*; and a life of Edward the

Confessor in French verse with a notable sequence of illuminations, *c.* 1250. The work of arranging and cataloguing this collection extended over many years. The strains of accommodating it, and the (at first reluctant) take-up of the University Library's entitlement to copies of every book published in Great Britain under the Copyright Act of 1709, led to the provision of additional space and, in due course, additional staff, though in 1823 the staff still numbered only five.

A five-volume catalogue of all the Library's Western manuscripts was published in 1856-67, and has recently been reprinted photographically. In the later nineteenth century significant additions of manuscripts once more began to be made to the Library's holdings. Many illuminated items were given by Samuel Sandars, and in 1898 the extensive and important Taylor-Schechter collection of Hebraica was acquired from the Cairo Genizah, though only in recent years has this been intensively studied. Manuscript accessions during the past half century have increasingly been of archival material, including business papers such as the nineteenth-century records of Jardine Matheson, merchants in the Far East; correspondence and personal papers of politicians and scientists; and medieval and modern record of the diocese and cathedral of Ely. In 1934, after five centuries on its original site, the University Library moved to a new building on a less constricted site, where it now houses some 250 staff, tens of millions of printed books, and many thousands of manuscript volumes.

Chantilly, Musée Condé. February, from the *Très riches heures* of the Duke of Berry

Chantilly
Musée Condé

The Duke of Aumale, heir to the prince of Condé, founded a museum in 1889 and bequeathed it to the Institut de France in 1897. A man of letters and bibliophile, the Duke had assembled one of France's most splendid libraries. He had inherited the collection of the Condé family, and that of King Louis-Philippe, and to these he added important acquisitions, particularly illuminated manuscripts. He was responsible for the acquisition of the *Très Riches Heures* of the Duke of Berry, the most precious manuscript in the collection. Among the many other manuscripts are the Danish Ingeborg Psalter of the thirteenth century; the St Louis Psalter, and a famous manuscript by Jacopone da Todi, as well as many other works notable for their bindings.

Cividale del Friuli (Udine)
Biblioteca del Museo Archeologico Nazionale

The collection was formed in 1725 on the basis of the former Cathedral library, and has not been expanded since the 1930s. Among the manuscripts is a fragment of a Gospels of the fifth to sixth century, with interpolated signatures in Latin, German and Slavic; part was presented to Charles IV of Luxembourg in the belief that it had been written by St Mark himself, another part was given to the Venetian Republic in 1420. There is also the Egbert Psalter of the tenth century, known as the *Gertrudianus* because in the eleventh century it was taken to Russia by a princess named Gertrude; it returned to Germany, to the Thuringian court, a century later decorated with full-page illuminations on purple, and with the figures of the bishops of Trier. Also in the collection is the St Elizabeth Psalter made for the Landgrave Hermann (d. 1217), with illuminations of the Saxon school; a large two-volume Bible of the eleventh century from Aquileia with two full-page illuminations; a Paul the Deacon, *Historia Langobardorum*, of the first half of the ninth century; the *Pontificale Grimani* of the sixteenth century; Missals, Antiphonares, Homelies, a thirteenth-century Processional, choirbooks, etc.

Copenhagen
Det Kongelige Bibliothek

The history of the Royal Library before the reign of Christian III (1534-59) is uncertain;

however, it is known that Christian II (reigned 1513-23) interested himself in the library and possessed a private collection. Two thousand volumes presented to the university library in 1605 by Christian IV came from the collection of Christian III. Frederick III (reigned 1648-70), a noted collector, commissioned a library building which was completed 1673. In 1786-7, Count Otto Thott, a great bibliophile, provided the library with 4,154 manuscripts by an endowment made on his death in 1785. In 1793 the public was permitted to use the Royal Library. In 1849 the Library passed to the state and was joined to the University Library; in 1906 it moved to its present home, the palace by Hans Holm, which stands in Christians Brygge.

The Library holds some fifty-two thousand manuscripts; among the most important are the *Dalby-Boken* of the eleventh century, the oldest Danish illuminated codex, believed to have come from the cathedral of Dalby, Skåne; the *Kong Magnus Lagaborters Norske Landslov*, a remarkable example of Norwegian illumination of 1323-50, in a style free of the Byzantine influence then prevalent in European illumination; a rich collection of illuminated codices from the fifteenth to sixteenth centuries from European libraries, such as the splendid Book of Hours of Cardinal Charles of Bourbon (1450-80), illuminated by Jean Fouquet (Gl. Kgl. Salm 1610, 4°). *Le Livre du Roy Modus et la Royne Racis*, of about 1410 (Thott 415, 2°); an English illuminated Psalter, the Folgunge Psalter, written *c.* 1175.

One of the treasures is the Icelandic manuscript the *Flatey Book*, written between 1380 and 1400, in which is narrated the epic of Leif Ericsson (son of Eric the Red) who reached America five hundred years before Columbus. The work also contains the sagas of medieval Norwegian kings. It is composed of 905 columns. It was acquired for the library by Bishop Bryniulf from John Finsson of Flatey.

Dublin
Trinity College Library

The Library of Trinity College is the largest research library in Ireland: its collections of manuscripts and printed books have been built up since the end of the sixteenth century. The first 'Manuscripts Room' was established in the mid-seventeenth century to house the collection of Archbishop James Ussher, a collection that is especially rich in medieval manuscripts, mostly Latin, but also in French, English and Irish. It was at this

Dublin, Trinity College Library, built during the first half of the eighteenth century by the Irish architect Thomas Burgh. Eighteenth-century engraving by J. Malton

period that Bishop Henry Jones donated to the Library its two most famous manuscripts: the Book of Kells and the Book of Durrow. In the eighteenth and nineteenth centuries there was a rapid and extensive growth in the collections of manuscripts of all kinds, such as material for the study of Irish history, like the Depositions of 1641 and papers relating to the rebellions of 1798 and 1803; many manuscripts in Irish, including the Book of Leinster; important elements of the Vatican archives; records of the Inquisition in Italy; the Book of Armagh; a collection of Icelandic manuscripts; and many Oriental manuscripts. In the nineteenth century there were accessions of Egyptian papyri, including a splendidly decorated copy of the *Book of the Dead* dating from around 2000 BC, the Library's oldest manuscript. The papyrological collection was greatly increased at the end of the century from the Egyptian excavations of Flinders Petrie and Grenfell. During the last hundred years the main accessions of the Department have been collections of modern papers.

Durham
The Dean and Chapter Library

Durham's Benedictine priory (founded in 1083), inherited books from the Anglo-Saxon monasteries of Holy Island (also known as Lindisfarne), Jarrow and Monkwearmouth. Although the supreme expression of eighth-century Northumbrian art, the Lindisfarne Gospels, created at the behest of St Cuthbert's successor, Eadfrith, is now at the British Library in London, a strong body of Anglo-Saxon works survives at Durham, ranging from a sixth-century Italian uncial leaf of a fragment of Maccabees, to the tenth-century Rituale from Chester-le-Street and the Community of St Cuthbert.

During the time of Laurence, prior of Durham (1149-53), an inventory of the library records 436 volumes, some of them the work of Durham monks.

The dissolution of the monasteries by King Henry VIII in 1539 saw the smooth transition in Durham from the former prior and convent to a new Dean and twelve canons. Durham still possesses 332 of its pre-dissolution books, the largest number surviving *in situ* of any English monastery. Special note may be taken of the eighth-century copy of Cassiodorus Senator's *Commentary on the Psalms* (with two full-page depictions of David), of the pastel-shaded decoration of the eleventh-century books of Bishop William of St Calais, and of the vigorous bright colours and gold of Hugh of le Puiset's twelfth-century books.

Edinburgh
National Library of Scotland

The Library originated in the 1680s as the law library of the Faculty of Advocates (the Scottish bar), founded largely through the influence of Sir George Mackenzie of Rosehaugh, the Lord Advocate. In 1925 the Faculty gave the library, with the exception of legal books and manuscripts, to the Scottish nation, when it became the National Library of Scotland. Manuscript acquisition began before the end of the seventeenth century, and the collections now extend to over thirty thousand volumes of mainly Scottish historical and literary papers, including family and business archives, ranging from the tenth century to the present day. The emphasis is on the eighteenth and nineteenth centuries, with extensive collections relating to Scottish literary figures such as Sir Walter Scott and Thomas Carlyle, but a distinguished collection of medieval manuscript books has also been assembled, including, for example, the Bohun Psalter and Hours, the Iona Psalter and the Murthly Book of Hours.

The Escorial
Real Biblioteca

In 1556, shortly after ascending the Spanish throne, Philip II (1527-98) directed the organi-

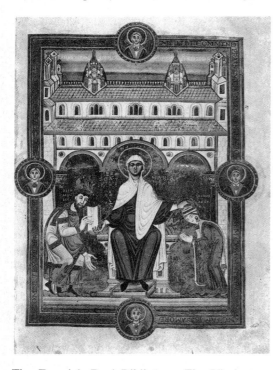

The Escorial, Real Biblioteca. The Virgin enthroned between Henry III and Queen Agnes. From a Gospel-book written in gold for the Emperor, Echternach, *c.* 1043-6

zation of a public library under the care of the Oratorian friars of the monastery of S. Lorenzo at El Escorial. One of the first works to enrich the collection was an illuminated *Apocalypse* that had belonged to Mary of Hungary, sister of Charles V. Next acquired were the autograph texts of four works by St Theresa of Avila (1515-82), the reformer of the Carmelite Order: her *El Camino de la Perfección*, the first draft of *The Way of Perfection*; her autobiography; the *Book of Foundations* (a history of the Descalzos convents she had founded); and the *Modo de visitar los conventos* ('How to Visit Convents'). Then were added a Gospels written in gold for the Emperor Henry III; a manuscript on the baptism of infants, believed to be by St Augustine; a Greek Gospels that belonged to St John Chrysostom; Breviaries, Missals, choir-books, etc. The collection's most important acquisitions, in the reign of Philip II, were the collection of Aragonese kings of Naples, brought to Spain by Ferdinand, Duke of Calabria; a group of Arab and Greek manuscripts acquired at Venice; the library of 400 Arab, 300 Greek, and 200 Latin manuscripts, many from Mount Athos, bequeathed to the King in 1575 by the Spanish ambassador to Venice and Rome, Diego Hurtado de Mendoza. Under the reigns of Philip's successors the library was further expanded by several valuable collections, among them that of Gasparo de Guzmán, Count of Olivares, minister of Philip IV, and his son, the Duke of Medina de Las Torres, including one thousand manuscript books. In 1671 a fire destroyed at least 18,000 volumes. After two centuries of slow decline, in 1837, following the expulsion of the Oratorians, the library was left in the control of a single friar. In 1885, the care of the library was given to Augustinian monks, who reorganized it. The most precious volumes were transferred to Catalonia during the Spanish Civil War. After 1939, the Brothers recovered the dispersed books. The *Apocalypse* of Mary of Hungary returned to the Library in 1963: it arrived at the Escorial from France in a package bearing no indication of the sender.

Florence
Biblioteca Medicea Laurenziana

This library originated as the personal collection of Cosimo de' Medici; to this was soon added a large part of the collection of manuscripts of the library of S. Marco, which Cosimo had founded (1434). The library was further enriched by Cosimo's

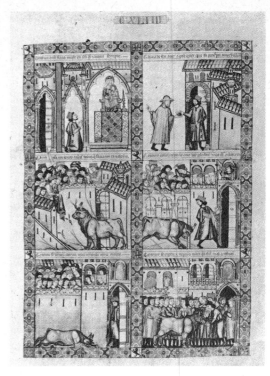

The Escorial, Real Biblioteca. Page from the Book of Canticles of Alfonso the Wise. Castilian, thirteenth century. The six scenes illustrate the miracle of a pious man who is saved from a bull when the Virgin Mary sends the bull to sleep and pacifies him

sons, Piero and Giovanni, and particularly by Lorenzo the Magnificent, who had copies made of manuscripts from all parts of Europe with the intention of creating a public library. After the expulsion of the Medici the library was confiscated and given to the monastery of S. Marco. In 1508 it was acquired by Cardinal Giovanni de' Medici, later Pope Leo X, and taken to Rome, where it remained in the Medici villa until 1522. At the death of Leo X, Cardinal Giulio de' Medici commissioned Michelangelo to provide a library in the monastery of S. Lorenzo, Florence. The work was beset by problems, and was discontinued altogether in 1526. Eventually the building was completed for Cosimo I, and the library opened to the public on 11 June 1571, with some three thousand manuscript books. The imposing room designed by Michelangelo still contains reading-stands which he also designed, and these display splendid examples of illuminated manuscripts. The library's holdings include 10,722 manuscripts. Among its most important possessions are antiquities such as Greek and Latin juridical and literary papyri (more than 1,570), including a fragment of Callimachus; a fragment of an Ode by Sappho; the *Medici Virgil* of the fourth to fifth century; the *Pandette*

pisane of the sixth century, a contemporary archetype of Justinian; the Gaius of the sixth century; the *Adversus paganos* of Paulus Orosius of the sixth century; the Syriac Gospels of the sixth century, which begins with twenty-six illuminated pages; the *Codex Amiatinus* of the seventh to eighth century, written in the monastery of Jarrow-Wearmouth, Northumbria; the *Odes* of Horace, of the tenth to eleventh century, with marginal notes by Petrarch; a Bible in paleo-Slavic of the fourteenth century; a Greek Gospels of the tenth century with illuminations of the Evangelists on gold backgrounds; a Thucydides from the tenth century, the oldest known; several manuscripts acquired by Lascaris in the Orient for Lorenzo de' Medici. Some manuscripts are of great value for the history of music, such as the Virgil with neumes of the tenth century; the Medici Antiphonary of the thirteenth century with early mensural notes, and the celebrated *Squarcialupi Codex* with fifteenth-century Italian songs set to music. Others are remarkable for their illuminations, such as the *Diurni domenicali* with illuminations attributed to Angelico and Lorenzo Monaco; the Book of Hours of Lorenzo the Magnificent, illuminated by Francesco di Antonio del Cherico, and codices decorated by Attavanti, Cherico, and other celebrated Renaissance illuminators.

Florence
Biblioteca Nazionale Centrale

This is a major library, richly documenting Italy's cultural evolution. Its nucleus was the seventeenth-century collection of Antonio Magliabechi, to which many other col-

lections were soon added. In 1747, at the direction of the Grand-Duke Giangastone de' Medici, it was opened to the public, and immediately thereafter began to grow, with contributions from old Florentine families and scholars. In 1771, Grand-Duke of Tuscany, Leopold of Lorraine, heir to the Medici, added to the Magliabechi Library the Mediceo-Lotaringia-Palatina Library. In 1860 Florence was annexed to the Kingdom of Italy, the dukes left, and their library was made part of the Magliabechiana, which in 1865, when Florence became the capital of Italy, assumed the name and functions of a national library. The Palatina library, begun by Ferdinand of Lorraine, became an important collection of manuscripts in 1816 with the acquisition of the library of the Poggiali Guadagni family, a rich collection including several humanistic codices from illustrious collections, such as a Plutarch written and illuminated for the Aragons. To this were added other important donations or acquisitions. Among the most important recent acquisitions was the Landau-Finaly library, given to the city of Florence and deposited by the commune in 1949 in the national library. Landau, a Hungarian banker, had acquired in France the library of Ambroise Firmin-Didot, which included, among other works, part of the famous *Visconti Officium*, illuminated for Gian Galeazzo Visconti by Giovannino de' Grassi. In 1967, the *Officium* was reassembled from its various parts thanks to the acquisition from the Visconti Dukes of Modrone of the second part of the work, illuminated by another celebrated Lombard artist, Belbello da Pavia.

The national library now holds some 24,250 manuscripts, among then the Galileo Col-

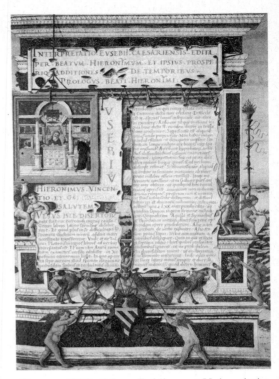

Geneva, Bibliothèque Publique et Universitaire. Humanistic miniature for the opening of Eusebius' *De Temporibus* in St Jerome's Latin translation. Venice, late fifteenth century. The writing is presented as if on ancient scrolls

lection and the richest Italian collection of codices of Dante. From its original location in the Customs House adjoining the Uffizi, where it began its life as a public library, it was moved in 1933 to a new building designed by the architect Armando Bazzani.

Geneva
Bibliothèque Publique et Universitaire

This library was founded in 1559 following the institution of the university. It was expanded with important collections, such as that of Calvin after his death, and that of the Florentine humanist Pietro Martire Vermigli. It was opened to the public and began regular functioning during the eighteenth century. During this century it was given seven codices found in a tomb in St Peter's, and a great Bible. Of great importance is the Eusebius' *De Temporibus* in St Jerome's Latin translation, a fifteenth-century manuscript from Venice. The library's manuscripts now number some ten thousand.

Genoa
Biblioteca Civica Berio

In 1775, Abbot Carlo Giuseppe Vespasiano Berio opened this library to the public. His

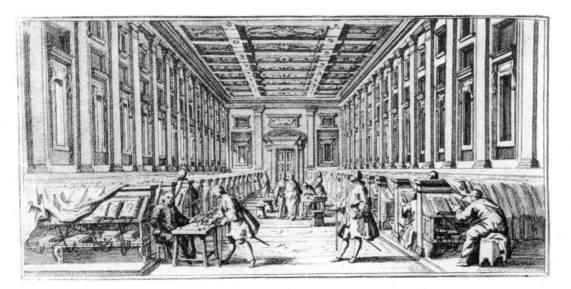

Florence, Biblioteca Medicea Laurenziana. Late eighteenth-century engraving by F. Bartolozzi

heirs offered it to Victor Emmanuel I of Savoy, who gave it to the city of Genoa in 1824. Later acquisitions by the city, donations and private bequests added to the library's holdings. In 1831 it was moved from its original building at Campetto to rooms in the Piazza de Ferrari. It now has some two thousand manuscripts, including the purple parchment *Ufficio* donated in 1848 by the Marquis Marcello Duratto, illuminated by Marmitta and with a jewelled binding. It also has six Antiphonares illuminated by Bartolomeo Neroni, called Il Riccio; a large Bible of the twelfth century with Romanesque illuminations, from central Italy; a small *Codex malabaricus*, and a codex of Catullus and Tibullus of the fifteenth century.

Glasgow
University Library

Although the University was itself founded by Papal Bull in 1451, the earliest record relating to its library date from 1475 when the first donations were listed; of these early manuscript gifts, nothing has survived. In 1577 the University was reorganized along new, Protestant lines, and this event, known as the *Nova erectio*, may be regarded as the birth of the present-day collection. Various documents in the University Archives show that in 1581 the Library had a total of eighty or so volumes on its shelves. By 1691, when a manuscript catalogue of the Library's collections was prepared, the total had increased to 3,300. Most of these books still survive, with their seventeenth-century press marks written on their title pages.

The single most important collection in the Library is without doubt the Hunterian Collection of 10,000 printed books and 650 manuscripts, forming one of the finest private libraries of the eighteenth century. Assembled by William Hunter (1718-83), anatomist, teacher of medicine, Physician Extraordinary to Queen Charlotte, collector of coins, medals, paintings, shells, etc. in addition to books and manuscripts, it was bequeathed, together with all his other collections, in 1783, and was finally received by the University in 1807. Of the 650 manuscripts, around two-thirds are medieval or Renaissance.

Since the beginning of the nineteenth-century the Library has received, by way of gift, bequest or long term deposit, some forty additional named collections. Several of these, such as the Euing and Ferguson collections, also contain medieval manuscripts and incunabula. By 1988 the Library

system contained well over eighteen thousand manuscripts.

Descriptions of holdings of medieval and Renaissance manuscripts can be found in the profusely illustrated exhibition catalogue by Nigel Thorp: *The Glory of the Page: Medieval and Renaissance Illuminated Manuscripts from Glasgow University Library* (London 1987).

The Hague
Koninklijke Bibliotheek

Confiscated from the Stadtholder William V of Orange following the arrival in Holland of French troops in 1795, the collection was placed in the Binnenhof at The Hague, and put at the disposal of members of parliament, various officials, and properly authorized scholars. Under the reign of Louis Bonaparte it was designated a royal library, and its holdings were expanded with acquisitions and donations. It was transferred to Amsterdam in 1807. In 1810, when Holland was annexed to the French Empire, the library, now called the Groote Hollandsche Bibliotheek, was brought back to The Hague and given to the city, which opened it to the public. After the restoration of the monarchy the Library regained to its former name of 'royal library', and was enlarged. Its current manuscript holdings number some 4,500, 200 of which are illuminated.

Heidelberg
Universitätsbibliothek

The oldest German university, Heidelberg was founded in 1386 by the Elector Rupert I, and the core of its library was created by the Elector Otto Heinrich in the mid-sixteenth century. In 1622 Maximilian I gave the library to Pope Gregory XV, and it was returned to the university only in the next century. Today the library has nearly four thousand manuscripts, many of which are illuminated, among them the celebrated *Manasse Codex* (the most famous collection of Minnesingers), which may have been made at Zürich during the fourteenth century. There are also 5,500 papyri.

Leningrad
Saltykov-Schedrin Library

Already very rich as an Imperial library, this library began with a valuable group of Polish works brought to St Petersburg in 1794. It was opened to the public in 1814. A litera-

ture library, it was destined to become the representative collection of Russian literature of all ages. The eleven thousand manuscripts taken from Warsaw were returned in 1921, but the library still possesses precious codices, including a Bede, *Historia Ecclesiastica gentis Anglorum* from Northumberland of the eighth century, and libraries from monasteries suppressed in 1917.

London
British Library

When the British Library was established by Act of Parliament in 1973, the Reference Division was formed in the main from the four library departments of the British Museum, that in turn began as three collections of manuscripts books and other materials, whose acquisition by the state in the eighteenth century led directly to the establishment of the British Museum by the British Museum Act of 1753. The 1753 Act provided for the safe preservation of the three collections in the care of a board of Trustees 'for publick use to all Posterity' – a phrase which neatly encapsulates the main aims and functions of today's Library. The Act also effectively created the first state library accessible to the public in Britain.

The three foundation collections of books and manuscripts in the British Museum's Library departments were all made by individual collectors. Foremost among them, because it was the bequeathing of his collections to the nation which was the spur to the establishment of the British Museum, was Sir Hans Sloane.

This physician, amateur scientist, antiquarian and President of the Royal Society built up collections of natural history, geological, zoological and medical phenomena, antiquities from Greece, Rome, Egypt and the Orient, drawings, coins and medals, and many books and manuscripts whose value and importance were recognised in his own lifetime. When Sir Hans died in 1753 he bequeathed his collections to the nation, provided that his daughters were paid the sum of £ 20,000.

The government accepted the bequest, deciding to house it with another state-owned collection, the Cotton collection of medieval manuscripts, cartularies, state papers and antiquities, whose importance may be judged from the fact that it counted among its treasures the *Lindisfarne Gospels*, two copies of *Magna Carta*, and the manuscript of *Beowulf*. This collection was made by Sir Robert Cotton during the reigns of Elizabeth I and James I and was donated to the

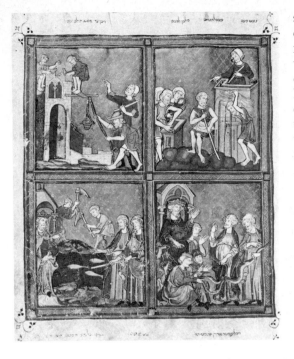

London, British Library. Four stories of Moses from a manuscript of the *Haggadah*, early fourteenth century

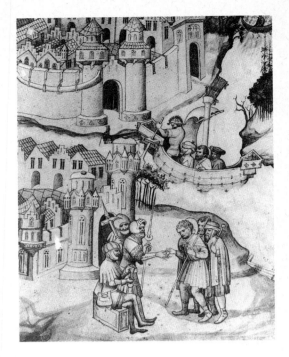

London, British Library. Navigation and the payment of a landing tax. Miniature from Sir John Mandeville's *Travels*, a famous fictional account of the early fifteenth century

state in 1700 'for publick use and advantage' by Sir Robert's grandson, Sir John Cotton, but had not been available to scholars for many years.

At the same time, the government also bought the Harleian collection of manuscripts, charters and rolls made by Robert Harley, first Earl of Oxford and one-time chief minister to Queen Anne, and his son Edward, the second Earl.

By the time the British Museum, housed in Montagu House, a former ducal mansion in Bloomsbury, opened in 1759, a fourth important collection had been added to the first three. This was the the old Royal Library (so-called to distinguish it from the library collected by George III, most of which also found its way into the British Museum) which was begun in the 1470s by Edward IV, added to by succeeding monarchs, and given to the Museum by George II in 1757.

This magnificent gift brought to the Museum thousands of manuscripts and printed books, including such items as the fifth-century Greek biblical manuscript, the *Codex Alexandrinus*.

Today, after two centuries of further acquisitions, the Department of Western Manuscripts possesses one of the largest and finest collections in the world, containing manuscripts of all kinds and all ages in Western languages: Greek and Latin papyri, ancient Biblical codices, illuminated manuscripts of incalculable value, other medieval manu-

scripts both secular and religious, great archives of post-medieval historical papers, famous literary autographs, and vast collections of music, maps, plans, topographical drawings, charters and seals.

Manuscripts belonging to particular named collections are numbered within that collection. In most cases the numbering is straight through; for example, the Harley collection is numbered from 1 to 7660; on the other hand the Cotton and Royal collections have retained earlier press-marks. Sir Robert Cotton's library was a narrow room with fourteen presses, each one surmounted by the bust of one of the twelve Roman Caesars together with the two imperial ladies, Cleopatra and Faustina. Thus Cotton MS Nero D iv (the *Lindisfarne Gospels*) was originally the fourth manuscript along on the fourth shelf down (shelf D) in the press with the bust of Nero on top. In the case of the old Royal Library the presses were numbered rather than named (e.g. Royal MS 20 C iii). The Sloane manuscripts on the other hand were numbered from I to 4100 after their reception in the British Museum. It is this collection which is considered to be the true basis of the Department's holdings; most of the manuscripts which have been acquired since 1756 have been numbered in a series of 'Additional' manuscripts which started from 4101 and had reached 62,000 by 1982. However a few large collections were acquired in their entirety and have retained their own separate numeration. The number of a manuscript appears in the descriptive label of each item on exhibition.

Individual manuscript items may be anything from a single document to a book containing as many as 500 or more leaves. The Department usually binds groups of single documents, such as letters, into volumes for ease of handling; the main part of the collection now comprises upwards of 100,000 such volumes. The visitor to the Library's galleries may see a considerable number of them stored in the glass-fronted presses in the Manuscript Saloon.

The breadth of the collection is enormous and it is impossible to do more than outline briefly what is contained in it. The permanent exhibition attempts to give a reasonably comprehensive impression but even this is the merest tip of the iceberg.

The term 'manuscript' for many people means a medieval manuscript and the Department certainly has a collection in this field unparalleled in Britain. The series of English and continental illuminated manuscripts displayed in the Grenville Library gives some idea, not only of the richness of the collection, but also of the history of

medieval art, for it is mainly in the illuminated manuscript that the painting of the period has survived. The Library's greatest artistic treasure is perhaps the *Lindisfarne Gospels*, a copy of the four Gospels which was written and illuminated in the monastery of Lindisfarne, on Holy Island, about 698; the *Harley Golden Gospels* dates from a century later; it was made about 800 at the court of Charlemagne; the *Benedictional of St Ethelwold* (963-984), a collection of pontifical blessings for use at mass on different days of the year, is the finest surviving example of Anglo-Saxon art of the Winchester school. Other notable illuminated manuscripts are *Queen Mary's Psalter* and the *Luttrell Psalter*, both produced in England during the first half of the fourteenth century, and the *Bedford Hours*, a masterpiece of French book painting of the early fifteenth century.

Lucca
Biblioteca Capitolare Feliniana

The library's holdings include 315 manuscripts. The collection was formed largely of manuscripts and printed books left by Bishop Felino Sandei (1444-1503) to the Chapter Library of Lucca Cathedral, and was enriched by codices from the Biblioteca Capitolare founded by Bishop Jacopo I (801-18). During the first years of the fifteenth century, important manuscripts were

added from monasteries and convents in the diocese of Lucca. Among the manuscripts is *Codex 490* of the end of the eighth century from the scriptorium of Lucca Cathedral, and numerous works from the ninth and tenth centuries.

Madrid
Academia de la Historia

Created in 1735 by a Madrid lawyer, Julian de Hermosilla, this collection was transferred in 1738 to the royal library, and in 1846 was housed in the Nuevo Rezado (Calle León). In 1796 it held 926 manuscripts. The most important manuscript book in its collection is the *Commentary on the Apocalypse* illuminated in the tenth century. The addition of the library of St Isidore brought numerous codices of the fourteenth to sixteenth centuries. With the libraries of the monasteries of San Millán de la Cogolla and San Pedro de Cardeña came another twenty-six codices, Missals of the seventh to tenth centuries, Lectionaries and liturgical books from the twelfth, fourteenth and fifteenth centuries, and historical codices from the tenth century written in Visigothic script, many sumptuously illuminated.

Madrid
Biblioteca Nacional

When Philip V, the first Bourbon king of Spain, reached that country in 1700 he found a collection of some eight thousand volumes, the library of Philip IV, to which he himself added books brought from France. The collection was donated to form the royal public library in 1712. After a fire in 1734, and the subsequent building of a new palace, the royal books were placed in shelves in various halls and rooms. Shortly after, a Book of Hours written and illuminated in Paris c. 1460 for Queen Juana Henríquez of Aragon, mother of Ferdinand the Catholic, which had been given by Philip IV to Cardinal Teodoro Trivulzio in 1642, was restored to the library. In 1798 the library acquired manuscripts confiscated from the suppressed colleges of San Bartolomé and Cuenca of the University of Salamanca. A precious collection of manuscripts on America was given to the library in 1807 by a West Indies official. In June 1813 the English and Spanish armies under the Duke of Wellington defeated the French at Vitoria and captured the French baggage-wagons. Among these was the carriage of Joseph Bonaparte containing works of art taken as spoils,

Milan, the Ambrosiana palace and church of S. Sepolcro. Early nineteenth-century engraving. Open to scholars since 1609, the Biblioteca Ambrosiana is considered the first public library of the modern age

including 220 paintings and 30 books. Three of the most precious manuscripts taken from the royal collection were a Sallust and a Virgil, both splendidly illuminated, and an *Illustrated History of the Incas*. Informed of the source of these priceless works, the Duke of Wellington immediately offered to return them, but Ferdinand declined, not wanting 'to take from you what has come into your possession by means as just as honourable'. In 1894 the library was transferred to a new building. It now has some three thousand manuscripts.

Manchester
John Rylands University Library

The John Rylands University Library was formed in 1972 with the merging of the John Rylands Library and the Library of the Victoria University of Manchester.

The original university library dates to 1851, when James Heywood presented twelve hundred volumes for the basis of a library. The library grew through exceptional gifts, most of them the selective collections of distinguished scholars. By the time of its merger with the John Rylands Library, the university library possessed some hundred thousand rare books.

The planning of the John Rylands Library commenced in 1890 when Mrs Enriqueta Augustina Rylands decided to establish a library as a memorial to her husband, who had died in 1888.

The library was a decade in the building and equipping: the opening ceremony was held in 1899, and the Library opened on New Year's Day 1900.

Mrs Rylands had purchased the Althorp collection assembled by George John, 2nd Earl Spencer: Spencer had begun buying Caxton editions in 1789, and had expanded his interests to works that displayed excellence in printing. By the time of his death in 1836 his library included over forty thousand printed books and was, in the words of the French bibliographer Renouard, 'the most beautiful and richest private library in Europe'. An acquisition of comparable importance, but of manuscripts, was made by Mrs Rylands in 1901 with the purchase of the collection of the 25th and 26th Earls of Crawford and Balcarres, containing more than six thousand manuscripts in some forty-eight languages, and including one of the world's most important collections of jewelled and ivory bindings. The John Rylands Library also has the earliest known fragment of the New Testament (the St John's fragment), of the first half of the second century; the oldest extant copy of the Nicene Creed, of the sixth century; Sumerian, Babylonian, and Assyrian tablets dating back as far as 3000 BC; and such precious items as a manuscript of the Works of St Cyprian of the eighth century.

Milan
Biblioteca Ambrosiana

Founded by Cardinal Federico Borromeo and opened to the public in 1609, the Ambrosiana thus has claims to be the first public library of modern times. Readers were given access to over fifteen thousand manuscripts and thirty thousand printed books. The Cardinal dedicated both his own income and the private wealth of the Borromeo family to the library's construction, and directed the search throughout Italy for interesting manuscripts.

Most important of those acquired was the Bobbio collection, from the library of the monastery of Bobbio founded in the early seventh century. It included seventy-two codices, such as the Bible of Ulfilas of the eighth century, several classical texts such as a Cicero, a Seneca, and fragments of classical works in palimpsest. Also important and more numerous was the Gian Vincenzo Pinelli collection, with more than 550 manuscripts including important fragments of a early *Iliad*, know as the *Ilias picta*, now 52 pages, written and illustrated around the fourth century, providing valuable evidence of the art and costume of the period. Among the library's most outstanding acquisitions was the *Codex Atlanticus* of Leonardo da Vinci and other Leonardo manuscripts donated in 1637 by Galeazzo Arconati. The Trotti-Bentivoglio collection, donated in 1907, was an important part of the Trivulzio library, and of the 460 manuscripts it contained, some came from the library of the Visconti family. After four centuries of growth, the Library's remarkable collection, second only to that of the Vatican Library, contains more than thirty-five thousand manuscripts.

Milan
Biblioteca Trivulziana

This library is among the most celebrated private libraries of Europe. It takes its name from the ancient Milan family of Trivulzio. The family possessed a collection of manuscript books during the fifteenth century, but it was the Marchese Alessandro Teodoro and the Abbot Don Carlo, toward the end of the eighteenth century, who set about acquiring codices in large numbers, with taste and fine discernment, and who can be considered the library's true founders. Circumstances were favourable: it was a time of the suppression of numerous monasteries and the sale of private libraries. Don Carlo collected 397 codices, including the famous

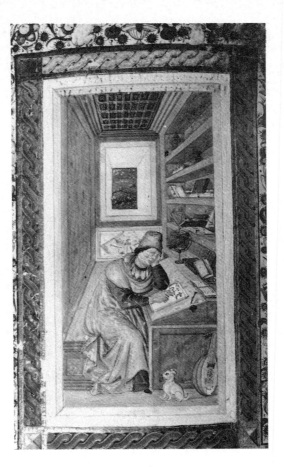

Milan, Biblioteca Trivulziana. Petrarch in his study. Florentine miniature attributed to Francesco di Antonio del Cherico in Petrarch's *Rime e Trionfi*, fifteenth century

Leonardo *Libretto di annotazioni e disegni*. In 1935 the library was given by Prince Luigi Alberico to the city of Milan, and was attached to the Historical Archives of the Castello Sforzesco. Today, the Trivulziana holds fifteen hundred manuscripts (the earliest dating from the eighth century) of which 130 are illuminated.

The earliest work in the collection (785) is the Iulianus Antecessor, *Epitome latina Novellarum Iustiniani*. Others are the splendid *Breviarum Ambrosianum* of 1396, illuminated under the direction of Giovannino de' Grassi; the fifteenth-century Missal made for Cardinal Ippolito I d'Este by Martino da Modena and other Ferrara artists; an original Leonardo manuscript (the *Codicetto autografo*); two celebrated manuscripts made for Massimiliano Sforza, the *Liber Jesus* and the Grammar by Donatus, the latter with a magnificent fifteenth-century binding, the fourteenth-century Bible with illuminations of the workshop of Pacino di Bonaguida; the famous Dante *Divina Commedia* of 1337; the Petrarch *Canzoniere* with illuminations by Francesco di Antonio del Cherico, and

numerous Books of Hours of Italian or other schools.

Modena
Biblioteca Estense

This, one of the most celebrated libraries in Italy, has its origins in the humanistic library assembled by members of the house of Este in Ferrara from the end of the fourteenth century. In 1598, when the Estense domain was diminished to Modena and Reggio, the library was taken to Modena, and eventually placed by Francesco II in the royal palace. In 1761 it was opened for public use.

It has 13,359 manuscripts, of which more than five hundred are illuminated, of various schools – Ferrara, Bologna, Lombardy, Tuscany. Among the most famous works are the Borso Bible and Breviary with illuminations by Taddeo Crivelli; the Breviary of Ercole I; the Bolognese choir-books that belonged to the Olivetan monastery of S. Michele in Bosco, illuminated by Niccolò di Giacomo; the Book of Hours of Renée of France; the Missal of Anna Sforza; the *De Sphaera*, written by Giovanni Sacrobosco for the Duke of Milan and illuminated by Belbello da Pavia; the *De excellentium virorum princibus*, by Antonio Cornazzano, a copy with dedication, and written in gold and silver; fifteen manuscripts of Matthias Corvinus, many the work of Attavante; the *Chronicon imperatorum et pontificum*, with the initials of Leonello d'Este, once attributed to Pisanello and now to Bonifacio Bembo; the *Life of Christ* with 45 illuminated plates by Albrecht Glockendon, one of the most outstanding examples of sixteenth-century German illumination, and many others. Also precious are the *Cronica* of the thirteenth century by Sicardo of Cremona, the illuminated *Liber de temporibus et aetatibus* of the thirteenth century, and the Dante manuscripts.

Montecassino
Biblioteca dell'Abbazia

This library is the ancient monastic library of the abbey founded in 519 by St Benedict of Nursia, which like the Abbey itself has been many times plundered and replenished. During the nineteenth century the library became the property of the state, but remains in the charge of the monastery. Works on religion predominate, but a large part of the collection consists of literature and history. A section of the library has always been named the 'Paolina room' in

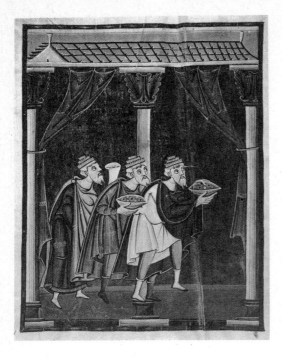

Munich, Bayerische Staatsbibliothek. The Magi, miniature from the *Pericopes of Henry II*, Reichenau, early eleventh century, commissioned by Henry II for the foundation the Cathedral of Bamberg

honour of Paul the Deacon. The library's holdings include 1,100 manuscripts. Among the precious codices are the *Commentary on the Epistles of St Paul* (*Ambrosiaster*) of the sixth century; the St Isidore *Sententiae* of the eighth century, an early example of Beneventan script, the St Augustine palimpsest of the seventh century; and the *Enarrationes in psalmos*, also a palimpsest of the seventh century. Among other valuable holdings are the autograph *Cronica* by Riccardo da San Germano of the thirteenth century; the *Codex 82* with what is believed to be an autograph letter from St Thomas Aquinas to Abbot Bernard, of the thirteenth century; magnificent codices with miniatures and drawings of the Montecassino school, such as the Alcuin *Astronomy* of the ninth century; the Rabanus Maurus with 361 illuminations; the *Sermones et homiliae diversorum patrum* written in the eleventh century at the time of Abbot Theobald; the two splendid Homilies of the eleventh century, of which one was made for Abbot Desiderius; and the *Exultets* from the eleventh and twelfth centuries.

Moscow
Lenin Library

The National Library of the Soviet Union began in St Petersburg in 1828 as the library of the Rumjancev Museum, and was brought to Moscow in 1861. Its collection of codices numbers some twenty-five thousand. It is the largest European library, and one of the most important in the world.

Mount Athos
Dionisiou Monastery Library

The monastery is on a peak of the Athos peninsula in Greece. The founder was Dionysios of Koresos, near Kastoria (northern Macedonia), who began the work with the help only of his disciples (1370-74). The costs of completing the construction were provided chiefly by Alexius III, Emperor of Trebizond (d. 1390). The library building is a wing of the monastery. It has 804 manuscripts, of which 125 are written on parchment (three are palimpsests), 641 are on papyrus and 11 on silk. Most of these are theology or liturgical books, the Gospels, the Acts of the Apostles, the Epistles, martyrologies, patristic works, etc., but some are the works of classical authors. Of the codices and scrolls, 58 have historiated initial letters. The Sacristy has some one hundred manuscripts of more recent date, many of them parchment fragments.

Munich
Bayerische Staatsbibliothek

The Munich library was founded in 1558 by the scholar and bibliophile Duke of Bavaria, Albert IV. The library received both his acquisitions and many books that he had inherited from his father, William IV, and he made the collection available to scholars and court officials. The library was housed in the ducal residence. A collection acquired was that of the banker Johann Jakob Fugger, rich in Greek and Hebrew manuscripts, some of which are believed to have belonged to Pico della Mirandola, the first Italian humanist to read Hebrew. The collection next to be added was that of one of Albert's uncles, the Archbishop of Salzburg, a condition of the gift being that the Duke took responsibility for two natural sons of the prelate. Other important manuscript acquisitions were the *History of the Church of Ravenna*, a tenth-century papyrus; a group of printed books and manuscripts from Hartmann Schedel, one of the first German humanists; a *Protestant Theology*, which, on the advice of an ambassador from the Pope, was stored on a shelf well out of sight and almost never exhibited.

In 1602 a catalogue of the library's Greek manuscripts was published, the first to be printed in Germany.

When the Swedish troops of Gustavus Adolphus sacked Munich in 1632 the library was ransacked and its holdings destroyed or dispersed. Many volumes and manuscripts entered the collection of William of Weimar at Gotha; four books were acquired by the Earl of Arundel who accompanied Charles I of England to the Imperial Diet at Regensburg, and are now in the British Library; one Greek manuscript is now in the Bodleian Library, Oxford.

The only important acquisition during the eighteenth century was that of the collection of Pietro Vettori, the humanist commentator on Cicero. During the period of the Napoleonic Wars, 150 Bavarian religious orders were suppressed, and some one third of their libraries, including many valuable manuscripts, went to the Munich library. A

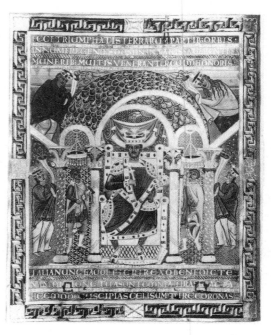

Emperor Henry II enthroned. From the Sacramentary made in Regensburg (where it is preserved), *c.* 1010

move to larger quarters in the Ludwigstrasse was made in 1843.

During World War II the library was repeatedly bombed and lost at least 500,000 pieces, among them many volumes from the Fugger collection. It has now been restored to its old splendour.

Among its most precious codices are the *Pericopes of Henry II* of the eleventh century from Reichenau; a Gospels of Otto III (from *c.* 998), and fragments of *Parzival* by Wolfram von Eschenbach from the thirteenth century.

Naples
Biblioteca Nazionale

Founded by Charles III, Bourbon King of Naples, the library was temporarily housed in the Capodimonte palace and then transferred to the Palazzo degli Studi (now the National Museum). In 1804 Ferdinand IV opened it to the public under the name of Royal Library of Naples; its name was changed subsequently to Bourbon Library, and then to the National Library in 1860. In 1922, in order to gather the public libraries of Naples into one complex, the library was moved to the magnificent rooms in the Royal Palace, annexing the libraries of San Giacomo, Provinciale, Brancacciana, of San Martino, and the office of the Herculaneum papyri. It now has some thirteen thousand manuscripts. Among the most important are the 1,785 papyri from Herculaneum, of which 793 have been unrolled completely and 169 partially, and contain the works of Epicurus and Philodemus; a group of parchment pages of the seventh to eighth centuries (*Charisius*) with fragments in palimpsest of the third, fifth, and sixth centuries of Lucan (*Paralipomena*), the *Digest*, the *De arboribus* by Q. Gargilius Martialis; a papyrus of the fifth to sixth centuries with contracts from the period of the Goths; and precious parchments dating from the fifth century to the Renaissance. There are also two Gospel-books written on purple vellum, one from the fifth and one from the ninth century; biblical fragments in Coptic from the fifth century; an illuminated Greek Gospels from the eleventh century. There are also manuscripts in Beneventan script and a considerable group of fifteen-and sixteenth-century illuminated codices of the schools of Italy, France and Flanders. Among these is the *Horae Beatae Mariae Virginis*, called 'La Flora', and the Book of Hours of Alfonso of Aragon. The library was also given the Breviary of Ferdinand I of Aragon, a fifteenth-century work with thirty-five illuminations of the Naples school by Cristoforo Maiorana.

Naples
Biblioteca Oratoriana dei Gerolamini

This library was founded near the end of the sixteenth century like Rome's Biblioteca Vallicelliana by the Fathers of the Congregation of the Oratory of St Philip Neri (called – first at Rome and then at Naples, where the name has remained – 'Gerolamini'). It was the first library in Naples to be open to the public (1685). In 1866 the orato-

New York, Pierpont Morgan Library. Miniature from a *Bestiary*, probably made in Lincoln, England, at the end of the twelfth century. According to the inscription, the fish is a sardine, 'abundant' in 'Tyre of Syria'

ry and its palace became the property of the state, but they remained under the care of members of the group. The library holds 410 manuscripts, and among the most important of these, fourteen are illuminated: the *Divina Commedia* with Latin annotations, illuminated in the fourteenth century; the *Annales et Historiae* of Tacitus; the *Comoediae cum notis* of Terence; the *Tragediae* of Seneca; the *Epistolae et Panegiricus Traiano dictus et De Viris Illustribus* of Pliny; the works of Apuleius; the *De Oratore ad Q. Fratrem* of Cicero; the *Epistola e Testamento del Petrarca* (Letter and Will of Petrarch) of Boccaccio; the *In Codicem* of Cino da Pistoia; St Augustine's *De Civitate Dei*; the *Opuscula Astronomica*; the *De auscultatione phisica* of Themistius, written for Andrea Matteo Acquaviva; two Offices of the Virgin of the fifteenth century with splendid illuminations.

New Haven, Conn.
Yale University Library

Founded in 1701, together with the founding of the university, the library enjoyed gifts from benefactors, both the famous and the well-to-do. Newton donated his *Optics* and Halley gave his edition of *Apollonius*. Elihu Yale gave goods to be sold for the college's benefit along with a large consignment of

books, including a fourteenth-century *Speculum humanae salvationis*, believed to have been the first medieval illustrated manuscript to reach North America. In gratitude for these and other gifts, the college was named in Yale's honour.

In 1733, Yale received nine hundred volumes from Bishop Berkeley; later gifts included a Gutenberg Bible from the abbey of Melk from 1454-55. Also among the library's holdings is a papyrus fragment of Genesis that is said to be the earliest piece of a codex, and the earliest of any Christian biblical manuscript.

A new building, the Beinecke Library, was added in 1964; among its holdings is a three-volume *Lancelot du Lac*, illuminated for Guillaume de Termonde (died 1312). Today, the library has over seven million books and is the second largest university library in the world and the fourth largest library in the United States, preceded only by the Library of Congress, the Harvard University Library, and the New York Public Library.

New York
Metropolitan Museum of Art

The Museum was founded in 1870. Among its many collections is a valuable holding of antique illustrated books (in particular printed works). Medieval art, represented by important donations, was gathered in 1938 at Fort Tryon Park in a museum known as the Cloisters because of the architectural structure using Gothic elements, capitals, columns and arches from French cloisters, built with the generosity of J. D. Rockfeller, Jr. The collection, conceived as part of the museum, includes several illuminations.

New York
Pierpont Morgan Library

John Pierpont Morgan (b. 1837) collected books on a large scale, making most of his acquisitions during annual visits to Europe. In 1896 he bought in London a Gutenberg Bible on parchment and four folios of Shakespeare; the next year he bought the manuscript of Keats' *Endymion*; in 1899 he bought two complete collections, one of French literature of de Forest and the personal library of a London bookseller, James Toovey. In 1900, he bought the library of Theodore Irwin of Oswego, New York, which included the *Hamilton Gospels* on purple parchment from the tenth century, an Apocalypse that had belonged to Jean,

Duke of Berry, four books by Caxton, and another copy of the Gutenberg Bible. In London again he bought, among other works, autograph manuscripts of *Don Juan*, and eight other works by Byron which he had presented to the countess Guiccioli. In 1902 he spent £ 130,000 to add the most important collection, that of Richard Bennett of Manchester, including 24 works by Caxton, the *Lactantius* from Subiaco of 1465, another copy of the *Book of St Albans*, and, most important, a magnificent series of illuminated Gothic French and English codices, most of which had belonged to William Morris. In the same year he purchased the Ashburnham Gospels, a ninth-century manuscript with a jewelled binding, while in 1903 he bought the drawings by William Blake for the *Book of Job* and the Kerr collection of French chivalric romances.

At this time his acquisitions were kept piled on the floor of the small basement room of the Morgan house at 219 Madison Avenue. In 1906 a new building was completed on Thirty-sixth Street next to the Morgan home. With its façade inspired by the Palazzo del Tè, Mantua, bronze doors, and study with walls of red damask and a ceiling from a Lucca palazzo, the structure was justly proclaimed 'one of the seven wonders of the Edwardian world'. New additions to the collection included codices from a ninth-century Coptic monastery, Greek and Egyptian papyri, and 15 works by Caxton, including one of the first illustrated books in England, *The Myrrour of the Worlde* (1481), from Lord Amherst. However, perhaps even more capable at acquisitions was his librarian, Belle Da Costa Greene, whose taste and erudition became legendary. She negotiated the purchase of the Gospels of the Countess Matilda of Tuscany for seven months until the price dropped from £10,000 to £8,000. When Pierpont Morgan died in Rome in 1913, the library passed to his son, who in 1924 made it public and granted funds for its maintenance. In the meantime, other important manuscripts had been acquired: *The Rose and the Ring*, by Thackeray; an Old Testament with illuminations of the thirteenth-century French school, a gift of a Polish Cardinal to Shah Abbas of Persia; four manuscripts with jewelled bindings, once the property of the Abbey of Weingarten; a collection of Psalms from the eighth century, and again, in 1919, in London, six manuscripts of great beauty and a parchment copy of a Venetian Aristotle of 1483 from the Thompson collection. J. P. Morgan, Jr. died in 1943; Greene retired in 1948.

Top: New York, Pierpont Morgan Library. Miniature from Gaston de Foix's *Livre de Chasse*. Early fifteenth century Parisian work. Above left: New York, Pierpont Morgan Library. Mid-thirteenth-century Parisian miniature from a canon law manuscript, possibly the *Decretum Gratiani*. Above right: New York, Pierpont Morgan Library. Miniature surrounding a printed text, in a volume of Aristotle's *Metaphysics*. This Latin version was printed in Venice by Nicolas Jenson in 1483

174

Oxford, Bodleian Library. Page from the Bolognese jurist Azzone dei Porci's *Summa*. Late thirteenth-century Bolognese work illuminated by a Master Guglielmo

The funds provided for acquisitions were greatly reduced, but thanks to the talent and energy of the new director of the library, Frederick B. Adams, Jr., who organized an Association of Friends who contributed to finance new acquisitions, the rhythm and quality of the acquisitions was maintained. The director following Adams was Charles Ryskamp; Charles E. Pierce, Jr., recently became director.

Part of the special attraction of this library is the result of its having resisted the temptation to grow, thus maintaining the atmosphere of a private home in which books can be studied and enjoyed.

Oxford
Bodleian Library

Almost nothing is known about the origin of the first library of the University of Oxford, though there is evidence of the University's having owned two manuscripts, a Bible and a copy of Exodus, before 1350. About 1320, Thomas de Cobham, Bishop of Worcester, had funded the construction of a library room in St Mary's Church, but be-

cause of a prolonged dispute with Oriel College over the possession of books which he had left for the Library, it appears not to have come into use before the enactment of an effective statute in 1412.

Between 1435 and 1443-4 the university received a series of donations, totalling over 280 volumes, from Humphrey Duke of Gloucester, younger brother of King Henry V. The authorities then decided to rehouse the collections, and in 1445 asked Duke Humphrey's permission to name after him the library room it was proposed to add above the Divinity School then being constructed. This was completed in 1488, and was furnished with two rows of desks projecting from the walls on two sides. This collection, besides containing traditional University texts such as biblical commentaries, medical treatises and works of scholastic theology, reflected Duke Humphrey's interest in the new Italian Humanism. It included many rediscovered classics, translations into Latin of Plato, Aristotle and Plutarch, and works by Dante, Boccaccio, and Petrarch, in obtaining which Humphrey was much assisted by the Milanese humanist Piercandido Decembrio. However, because of inadequate funding, and probably also as a consequence of attacks on prereformation libraries during the reign of Edward VI, the library was dispersed in about 1550, the furniture apparently being sold about 1556. Thus for half a century, although each individual college had its private library, the University possessed no central library.

Thomas Bodley, born in 1544 of a Protestant family, received his early education in Calvin's Geneva, where he studied with Beza and with Chevallier, who taught him Hebrew. After an academic career in Oxford, where he was a fellow of Merton College, Bodley entered the public service, eventually becoming Elizabeth's ambassador in the Netherlands (1588-96). While resident at The Hague, it seems likely that he visited the library (founded 1585) of the University of Leiden. In 1598 he wrote to the Vice Chancellor of the University of Oxford proposing to restore the now desolate library at his own expense, and to furnish it with shelving and books. This proposal was accepted by the Congregation of the University. In 1600 the new shelving was completed, but the search for books continued, and the opening of the library was postponed until 8 November 1602, by which time the shelves had finally been furnished with some three hundred manuscripts and more than seventeen hundred printed volumes. Its first catalogue, printed in 1605, lists six thousand volumes. The placing of the

windows in Duke Humphrey's Library imposed on Bodley the medieval system of desks projecting from the walls, but instead of using lecterns, he adopted a new system of stalls, such as had been used in Merton College in 1591, and which offered space for many more books. The ceiling was magnificently decorated with the arms of the University on the panels, and with Bodley's own arms at the intersection of the beams. Manuscripts and printed books were at first grouped together, and arranged in roughly alphabetical order within divisions corresponding to the medieval faculties of Theology, Medicine, Jurisprudence and Arts. The books on the central shelves were chained, shelfmarks being written on the fore-edges, which faced outwards. Readers were guided by a chart or list placed at the end of each press. Books of smaller format, kept in two locked closets, and particularly valuable items in the Archive cupboards, could only be obtained on application to the Librarian. Bodley was very successful in attracting donations of books, both from his friends in the political and learned worlds, and from corporate bodies. A notable group of manuscripts was donated by the chapel of St George at Windsor, and another by the canons of the Cathedral of Exeter. Bodley, with his own money and funds given by his

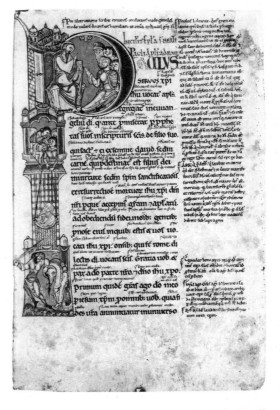

Oxford, Bodleian Library. *Incipit* of St Paul's *Epistles*, glossed in the margin and between the lines. Mid-twelfth-century English manuscript in Latin, possibly made at Winchester

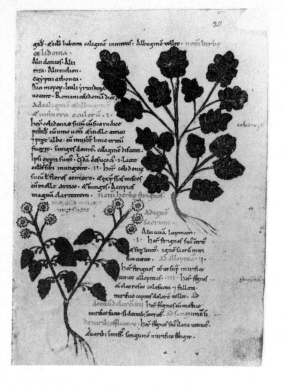

Oxford, Bodleian Library. Page of a *Herbal* from the Abbey of St Augustine, Canterbury. Late eleventh-century English manuscript. The plant on the upper right is the greater celandine, of the poppy family, which was thought to be useful in curing warts

friends, also purchased books on a large scale. A London bookseller, John Norton, bought books there and imported them from the Continent, while another, John Bill, was commissioned to tour abroad and to buy books in France, Italy, Germany and Spain. In 1610, Bodley entered into an agreement with the London Stationers' Company, which agreed to present to the Library on demand a free copy of any book registered at Stationers' Hall; this arrangement was later incorporated in the Copyright Acts. Today, the Bodleian is one of six libraries in Britain with this privilege.

A first extension of the Library was completed between 1610 and 1612, apparently the first library room in Britain to use the system of shelving on the walls only, with galleries giving access to the upper shelves. Sir Thomas Bodley died in 1613. After his death, but following plans he had devised with his Oxford advisers, the Library was enlarged by the completion of the Schools quadrangle, in which it occupied the top storey over rooms devoted to teaching and examining. Important benefactions continued to be received, such as Archbishop Laud's gifts, one of which contained a group of ninth-and tenth-century manuscripts re-

scued from Swedish soldiers after the sack of the cathedral of Würzburg in 1631. In the following centuries the Library has continued to attract major benefactions of both books and manuscripts, as well as obtaining material by purchase and legal deposit. Its current holdings are estimated at 5.1 million volumes, of which over 100,000 are of manuscripts. The manuscript collections are particularly rich in materials for the study of English literature and history (including many modern papers). For example, the Vernon manuscript, recently published in facsimile, contains probably the largest extant corpus of Middle English literature. Other important holdings include manuscripts of Shelley, and modern writers such as Barbara Pym. In history, the Clarendon papers provide an indispensable archive for the study of the seventeenth century, while modern collections include papers of Lord Milner Clement Attlee and many other major figures.

Many of the Library's treasures also directly reflect the interest of its founder and his first Librarian Thomas James. These include works recovered from the libraries of the monasteries dissolved during the Reformation, making the Bodleian a world centre for medieval studies. Among these works are notable holdings of manuscripts of the Church Fathers, the collection of which, in order to refute errors in editions produced by the Roman Church, was a prime aim of James's prodigious scholarship. Thomas Bodley's zeal for collecting books was boundless, ranging far beyond Europe as far afield as China and Central and South America, from which material appears in the Library at an early date. Bodley's own interest in Hebrew led to the acquisition of much printed and manuscript material in that language, and he engaged the company of English merchants at Aleppo to acquire works in Arabic, Persian, Syriac and other tongues. Subsequent donations such as those of Archbishop Laud and Edward Pocooke, and (in the field of Hebraica) the acquisition of the Oppenheimer and Michael collections, have given the Library a pre-eminent position in the Orientalist field, the Hebrew manuscripts being often regarded as the finest in the world.

Padua
Biblioteca Capitolare

Begun towards the end of the twelfth century, this library was enriched during the fifteenth century with the collection of Bishop Jacopo Zeno, donated by Bishop Pietro

Foscari, and in the sixteenth century with the libraries of Bishops Barozzi and Dandolo. The Library's holdings include 322 manuscripts. Among its codices, many illuminated, are an Anthiphonary of the twelfth century; a Sacramentary of the ninth century; an illuminated Gospel of St Isidore of 1170; an *Epistolarium* illuminated by Giovanni da Gaibana of 1259; and examples of the *Decretum* of Gratian with marginal glosses, extravagantly initialed.

Padua
Biblioteca del Seminario Vescovile

Founded in 1671 by Cardinal Gregorio Barbarigo, this library was enriched by the acquisition of the collection of Count A. Speroni Alvarotti and, later, by a series of bequests and donations. The holdings include 1,120 manuscripts.

Among the codices are the Claudian from the twelfth century; four codices of the *Divina Commedia*; a Teutonicus *Descriptio Terrae Sanctae*, with illuminations of the Veneto school of the thirteenth century; and a Psalter of the thirteenth century that belonged to Bartolomeo Carrara, with nine full-page miniatures.

Paris
Bibliothèque de l'Arsenal

In the mid-eighteenth century the Marquis of Paulmy d'Argenson occupied the old home of the Grands Maîtres de l'Artillerie in Paris. A passionate bibliophile, he gathered in the Arsenal a splendid collection of manuscripts and books that in 1786 he sold to the Count of Artois, brother of Louis XVI and the future King Charles X. This collection, sequestered during the French Revolution, was kept where it had been assembled and considerably enriched.

In the 1797 the library was declared public; in 1816 an ordinance gave it back to the Count of Artois, with the name Bibliothèque de Monsieur. During the 1840s it became the Bibliothèque publique et royale de l'Arsenal. In 1923-26 it was made, by decree, part of the Réunion des Bibliothèques Nationales; since 1977 it has been a department of the Bibliothèque Nationale.

Its collection of manuscripts and autographs – one of the richest in France – is composed of twelve thousand pieces that date from the ninth to the nineteenth centuries; among its two hundred illuminated codices of great value are the Book of Hours illuminated by Jean Mouret (1444), the Gospels known

Interior views of the Bodleian Library, Oxford. Seventeenth-century engravings by David Loggan

'free' desks in the Italian manner, in part on inclined shelves (*tabulae*) leaning against the walls on which the books seem to have been laid with the back cover, which had a label with the title, facing up. Two chests in a back room were used to store particularly precious books, some of which were shown to the Neapolitan visitor: Petrarch's *I Trionfi* and *De remediis utriusque fortunae*, a large Book of Hours of the Virgin, Ovid's *Metamorphoses* in French and Latin. These works were illuminated in the Gothic style, and were evidently considered more important than the humanistic manuscripts of which the library possessed a great quantity, such as the *Grandes Heures* of the Duke of Berry with illuminations by Jacquemart de Hesdin, and two French translations of Petrarch presented to Louis XII, illuminated by artists of the Loire school.

François I, with his interest in Roman history and the heroic feats of antiquity, was more favourably inclined to humanistic influences, as can be inferred from his books, French translations of Justinian, Thucydides, Appian, and Diodorus Siculus as well as the *Destruction de Troie la Grant*, the *Roman de la Rose*, and other medieval romances.

The humanist Guillaume Budé, in a collection of maxims presented to the king in 1519, maintained that the glory of a prince depended on his role as protector of literature; the king appointed him royal librarian.

as the Golden Gospels of Charlemagne from the Abbey of Saint-Martin-des-Champs, Paris, and a *Roman de la Rose* from 1390.

Paris
Bibliothèque Nationale

At the end of the fifteenth century the outstanding libraries were those of Renaissance Italy, with an outpost at the court of Matthias Corvinus of Hungary. A century later only the Vatican remained pre-eminent: Budapest had fallen into the hands of the Turks, several famous fifteenth-century collections had disappeared, and others were eclipsed by new institutions north of the Alps and in Spain. Thus, France became the principal heir to the humanistic tradition and, by right of conquest, the leading foreign owner of Italian humanistic manuscripts.

A taste for literature had been traditional at the French court since the reign of St Louis (1226-70). In 1373 Charles V had assembled on three floors of one of the towers of the Louvre a library with 917 volumes, which in 1424 were acquired by the Duke of Bedford, brother of Henry V, and were dispersed in England after his death. The next collection dates from the expedition of Charles VIII to

Naples in 1495. Among the booty of the Aragon reign — tapestries, paintings, marbles, and porphyry taken to the Amboise residence of Anne òf Brittany — was a library of more than one thousand volumes, including several works in Greek.

The idea of the royal library as a national possession originated during the reign of the cousin and successor of Charles, Louis XII (1499-1511), who had inherited from his father, Charles Duke of Orléans, a library of more than two hundred manuscripts, formerly kept in the Château de Blois. To these were added the Aragon volumes of Amboise, a large part of the library of the defeated Duke of Milan from the castle of Pavia, and manuscripts acquired by Ferdinand I's widow, and from a Flemish gentleman, Louis de Bruge, who had been able to procure several of Charles V's books in England. This composed a valuable but disorganized collection of Gothic and Renaissance manuscripts. An inventory of the books at Blois, compiled in 1518 by Guillaume Parvy, librarian and Domenican confessor of the king, listed 1,626 volumes, of which 41 were in Greek, 4 in Hebrew, and 2 in Arabic. A Neapolitan visitor, Antonio de Beatis, secretary of Cardinal Louis of Aragon, has left a description of the library from 1517. The books were mainly arranged on two rows of

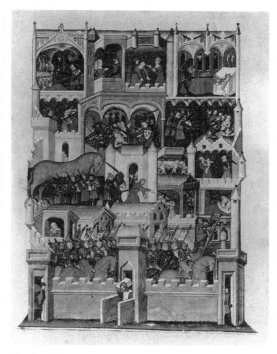

Paris, Bibliothèque Nationale. Miniature from the *Histoire ancienne jusqu'à César*, Paris, early fifteenth-century. The successive scenes, like those of a Mystery play, show the Greeks bringing the wooden horse into Troy and the sack of the city

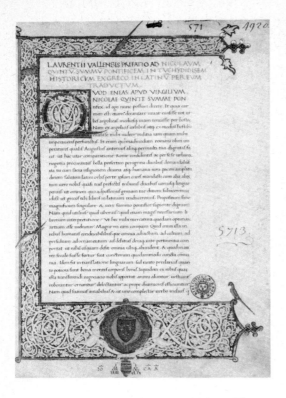

Paris, Bibliothèque Nationale. Page from Thucydides, *De bello Peloponnesium, c.* 1470

While it appears that Budé took this post as a sinecure (as did his immediate successors), his desire to promote Greek studies independently of the Sorbonne persuaded the king to create a royal college, the forerunner of today's Collège de France. Readers of Greek, mathematics, and Hebrew were nominated in 1530, and of Latin in 1533, and collecting of Greek manuscripts began for these students. The Dauphin's tutor, Girolamo Fondulo from Cremona, acquired fifty manuscripts during an expedition to Italy; others came from the French ambassadors to Venice and Rome, particularly through Guillaume Pélicier, Bishop of Montpellier and ambassador to Venice from 1539 to 1542, who acquired thirty-eight manuscripts from a refugee at Corfu, and the collection of Greek and Latin volumes of Giovanni Francesco d'Asola, brother-in-law of Aldus Manutius. Emphasis was placed on the library rather than the college thanks to Pierre du Châtel, 'reader to the king' beginning in 1537, with the task of reading aloud to the sovereign Greek and Roman authors, and Master of the Royal Library at the death of Budé in 1540.

The present library was born in 1544 when the books at Blois, which then numbered 1,894, were brought to a gallery of the palace at Fontainebleau and added to the King's 268 Greek manuscripts (which grew in number to 540 a few years later) and to

the collection of the Bourbon family, which had been confiscated following the defection of its constable. François I began a project to rebind all the Greek books and the books from Blois, a project continued in grand style by Henry II: 900 bindings from his reign (1547-59) are still in existence. In the 1570s the books, by then numbering 3,650, were moved to Paris, and there, near the university and accessible to men of letters, the library prospered. Under Henry IV (reigned 1589-1610) the books were placed in the monastery of the minor Franciscan friars (Cordeliers), then in a *dépendance* of the monastery in the rue de la Harpe. The first catalogue, from 1622, listed nearly six thousand works, which were augmented by the bequest in 1656 of the collection of Jacques Dupuy, which included a fifth-century codex of the third *decade* by Livy, one of the earliest surviving classical manuscripts. In 1692 the library, by then in the rue de Vivienne, was opened to the public twice a week. This was continued for a few years, and was begun again in 1735. During the twenty years following the fall of the Bastille, 95 per cent of the books were taken to the national library by right of conquest, including some seventy thousand manuscripts. Under the great librarian Léopold Delisle (1874-1905) the volumes were finally catalogued and organized.

Perugia
Biblioteca del Museo Capitolare

This consists chiefly of a group of 47 codices that belonged to the chapter of the cathedral, now deposited in the cathedral's museum. Among them is a *Fragmentum evangelii* of the sixth century; a *Liber evangeliorum* of the eighth century, the *Expositiones super Sacram Scripturam* by various Church Fathers of the eleventh century, richly illuminated, which belonged to the house of canons of Perugia until the thirteenth century, a Missal of the thirteenth century written in the Holy Land, with large illuminated figures, and several other precious Missals.

Rome
Biblioteca Angelica

Angelo Rocca, Augustinian, Bishop of Tagaste, founded this library with his own books; and on 23 October 1614 it became the first library in Rome to be opened to the public. Soon added to the library were the rich collections of the Vatican librarian Luca Holstein and Cardinals Noris and Bona. The

major addition, however, was made in 1761 when Father Vasquez, general of the Augustinians, acquired for 30,000 scudos the grand library of Cardinal Passionei. This first belonged to the Augustinians and then passed to the Italian state. The library's holdings now include 2,664 manuscripts. Among the codices is a ninth-century *Necrology*; a St Gregory of the eleventh century; an *Iliad* of the twelfth century; a *Divina Commedia* with commentaries by Mino Vanni d'Arezzo of the fourteenth century; another *Divina Commedia* with chapters by Jacopo Alighieri and Bosone da Gubbio. There are also eleven Arab codices.

Rome
Biblioteca Corsiniana

This library was founded by Cardinal Lorenzo Corsini, later Pope Clement XII (1730-40), expanded by Cardinal Neri Corsini (the younger), and was opened to the public in the Palazzo Riario alla Lungara in 1754. In 1883 Prince Tommaso Corsini gave it to the reconstituted Accademia dei Lincei. It was united to the academy library and expanded by additions of collections and gifts, among them the Orientalist Library of Leone Caetani.

The library's original collection included 3,598 manuscripts. It now contains 4,594. Among these are some in Caroline minuscules that date from the eleventh and twelfth centuries, and many humanistic manuscripts from the fifteenth century, of which 182 are dated or dateable.

Rome
Biblioteca Vallicelliana

This library's origins are in the collection of St Philip Neri and the Congregation of the Oratory that he founded in 1564. The form of instruction followed by the Congregation began with readings, and thus called for an ample library. The original collection had been given to Philip Neri by the Portuguese scholar Achille Estaco, whose Will of 25 May 1581 is effectively the library's foundation document. In the course of the centuries numerous collections have been added, as gifts or aquisitions. In 1873 the library was transferred to the Italian state, and was opened to the public.

The manuscripts now number 2,929, and include 127 Greek codices, of which the earliest is eighth century. Among the works in Latin are St Augustine, *Enarrationes in psalmos* and an Alcuin Bible, both of the

ninth century. Finely illuminated are Columella, *De re rustica*, of the fifteenth century, Riccobaldo da Ferrara, *Il pomerio della chiesa di Ravenna*, of the fifteenth century; and the *Lives of Sts Gregory, Jerome and John* of the fifteenth century. Among the Italian works is a *Laudi spirituali* of the fifteenth century. There is also a collection of hagiographic and patristic manuscripts of the eleventh to thirteenth centuries, and codices in Beneventan script, of which the Vallicelliana possesses the largest collection after that of the Vatican.

Rossano Calabro (Cosenza)
Biblioteca e Archivio del Seminario
e dell'Episcopio

This library and archive holds numerous manuscripts among its 2,400 volumes, of which the jewel is a sixth-century Greek Gospels illuminated and written in gold and silver on purple parchment.

Siena
Piccolomini Libreria

This library was founded in 1495 by Cardinal Francesco Todeschini Piccolomini (later Pope Pius III) to house the collection of his uncle Pius II. Beneath frescoes by Pinturicchio (1502-59), on desks carved by Antonio Barili, are displayed splendid choir-books illuminated by Liberale da Verona, Sano di Pietro, Gerolamo da Cremona, Pellegrino di Mariano and Guidoccio Cozzarelli. These belonged to Siena Cathedral and to the Hospital of S. Maria della Scala (fifteenth century).

Stockholm
Royal Library

This collection of rare books and manuscripts is composed for the most part of spoils of war or acquisitions from the continent: few Swedish medieval manuscripts survived the Reformation. Gustavus I, first Protestant ruler of Sweden (1523-60), and his sons Eric XIV and John II formed the collection which can be considered the beginning of the library. It included books taken from the Franciscan monastery of Stockholm and other Swedish monasteries. Gustavus Adolphus (1594-1632) and his daughter Christina enriched the collection, but Christina later appropriated the finest books when she abdicated and went to Rome in 1654, and the best of what was left

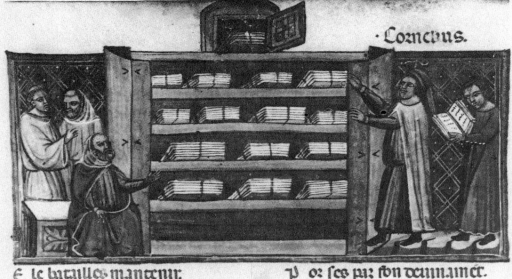

Paris, Bibliothèque Nationale. Well-ordered books on shelves. Early fourteenth-century Italian miniature from the *Roman de Troie*, a poem of more than 30,000 lines written *c.* 1160 by Benoît de Saint-Maur

disappeared to creditors. Several acquisitions were made under Charles X (reigned 1645-60), who also gave works taken as spoils of war from Denmark and Poland. In 1697 a fire at the palace destroyed all but 284 of the library's 1,386 manuscripts. At the end of the eighteenth century, the library was transferred to the building where it is today. The most important acquisitions since that time are medieval Swedish manuscripts – the largest such collection in the world – and early Icelandic manuscripts of which the collection is second only to that of Copenhagen University Library, and the private library of Gustavus III (reigned 1771-92). Sven Hedin donated a collection of manuscripts dating from AD 200 to 300, and an important Japanese collection was given by the explorer A.E. Nordenskjöld. The library now has 1,360 manuscripts. The jewel of the illuminated manuscripts is the *Codex Aureus*. Another important work is the first Bible in Swedish, written at Vadstena in 1526, and illustrated with wood-engravings hand-coloured by the sisters of the abbey of St Bridget and glued into the book. The Royal Library now possesses a rich collection of Bohemian works, among the most important the *Codex Gigas*, or 'Devil's Bible', written in the Benedictine monastery of Podlazice in Bohemia (1204-27), and taken from Prague castle by the victorious Swedish army in 1648. There are also many Books of Hours of the fifteenth and sixteenth centuries from continental

scriptoria, and the autograph writing of St Bridget.

Turin
Biblioteca Nazionale

The library was opened in 1714 in the university. In 1720 Victor Amadeus II, Duke of Savoy, transferred to it the ducal library, open to the public and scholars. Thus began the Royal University Library, classified among the national libraries in 1876.
The ducal collection had been a true library only from the beginning of the fifteenth century, the time of the bibliophile Amadeus VIII, nephew of Jean, Duke of Berry. Many splendid illuminated manuscripts were added to the collection as gifts at that period, such as those of Bonne, mother of Amadeus VIII, and of his daughter-in-law Anne of Lusignan, who brought a famous codex on music from Cyprus. During the sixteenth century the library was taken from Chambéry to the ducal palace at Turin, and continued to grow. Charles Emmanuel I acquired Arab, Greek, and Hebrew codices, as well as codices and incunabula from abbeys and private collections. Thus, during the first half of the seventeenth century the library was rich with splendid illuminated manuscripts; but during the second half it was devastated by fire. At the beginning of the eighteenth century it was reassembled for Victor Amadeus II. Between 1820 and

1824, as the university library, it gained sixty manuscripts from the St Columban's Abbey at Bobbio to add to the codices from Bobbio in the former ducal library, so creating one of the most important collections. The earliest of these works date to the fourth-fifth century. In 1973, having been bombed during World War II, the library was finally housed in a new building and was able to open again to the public. The library's holdings include 3,700 manuscripts.

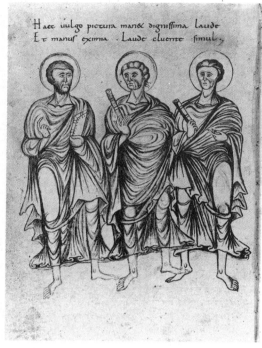

Vatican City, Biblioteca Apostolica Vaticana. Illustration of unidentified saints with scrolls, from manuscript Pal. lat. 834, which includes the *Martyrology* of Bede and the *De natura rerum* of Isidore, ninth century

Uppsala
Uppsala University Library

This library is an instance of a single manuscript (the *Codex Argenteus*) being more important historically than the institution in which it is stored (even though the Royal University Library of Uppsala is the oldest and the largest Swedish library).

The university was founded in 1477 by Archbishop Jacob Ulfsson, but it was King Gustavus Adolphus (reigned 1611-32) who, in 1620, had the precious medieval library of the Abbey of Vadstena and the collection of the Franciscan monastery of Stockholm and that of the Dominicans at Sigtuna transferred to the library. During the Thirty Years War, many Polish and Livonian volumes were brought to Sweden as spoils of war. In 1648 Queen Christina gave 120 historical

works from her collection, but in the same year she appropriated many precious manuscripts (Cicero, Virgil, Seneca, etc.) from the university library. M. Gabriel de La Gardie and, later, Charles XI offered valuable collections, and thus the number of the volumes had grown to about 30,000 by the end of the seventeeth century. During the following centuries, many other Swedish books were added. Apart from the *Codex Argenteus* of the sixth century, another valuable work owned by the library is the *Codex Cesareus*, an illuminated Gospels written in Germany around 1050 for the Emperor Henry II and probably intended for presentation to Goslar Cathedral. There is also, a gift of La Gardie, the *Uppsala Edda*, an Icelandic manuscript of the early fourteenth century, and a Norwegian manuscript of the thirteenth century, the *St Olav's Saga*, of great historical interest. The library came to its present building, designed by G.F. Sundvall, in 1841. Today its holdings include eight thousand manuscripts.

Vatican City
Biblioteca Apostolica Vaticana

A pontifical library is known to have existed as early as the first centuries AD, but the present Vatican Library's formation started with the final return of the popes to Rome, in the humanistic climate that then pervaded Italy. Eugene IV (1431-47) began to form a library, adding to the few manuscripts left by Gregory XII a personal selection of 350 volumes. Additions continued under a series of humanist popes: Nicholas V; Calixtus III (1455-8), who had an inventory made that listed 1,153 volumes, of which 800 in were Latin and 353 in Greek; Paul II (1464-71), during whose papacy Greek works were added from the library of Cardinal Bessarione, and from other Greek scholars. In 1475 Sixtus IV assigned scholars to the service of the library, gathered the volumes together in a special building, and appointed a librarian, Bartolomeo Sacchi, known as Platina, who made an inventory that listed 2,524 volumes. In 1481 the number of books had grown to 3,498. Examination of the first 2,059 numbers in the Vatican Latin collection shows that these works were primarily Bibles and Biblical commentaries, writings of the Fathers of the Church, collections of sermons up to those of Nicholas of Cusa, works of the major medieval authors from Bede to Alcuin to Rabanus Maurus, of St Bernard, and of the theologians from Peter Lombard to Duns Scotus, Albert Magnus, Thomas Aquinas and William of Occam;

there are then ascetic tracts and lives of the Fathers, among them those written by Giovanni Tortelli, and others translated from the Greek by Ambrogio Traversari. At number 'Vat. lat. 1461' classical and humanistic texts begin: the works of the Latin lexicographers such as Sextus Pompeius Festus; grammars, from those of Donatus, Villadei and Balbi to those of the humanists from Guarino to Pomponius Laetus; pedagogical works beginning with the Plutarch's *De Liberis educandis* translated by Guarino, to the humanist tracts on agriculture by Columella and Pier Crescenzi; poetics, histories, geographies, Latin and Greek philosophy translated by humanists, such as the *Iliad* translated by Valla, Xenophon translated by Poggio, Herodotus translated by Matteo Palmieri, and the humanist's works from Boccaccio to those of the fifteenth century. The list demonstrates the universality of the Vatican library from its beginnings.

Among the many bequests to the library was that of Fulvio Orsini in 1600 which included the fragment of Virgil known as the *Vergilius Romanus*, the oldest codex known of the comedies by Terence, the so-called *Bembino*, the Virgil of the fifth century known as the *Vatican Virgil*, the autograph of the *Canzoniere* by Petrarch, part of a collection consisting of 182 Greek manuscripts, 300 Latin and 33 vernacular. It was incorporated into the Vatican collection together with manuscripts by Antonio Carafa in 1591. In 1618, 30 manuscripts from the monastery of Bobbio came to the library. In 1623, the Library received the Palatine library of the Elector Frederick V, which had been taken by Maximilian I of Bavaria from

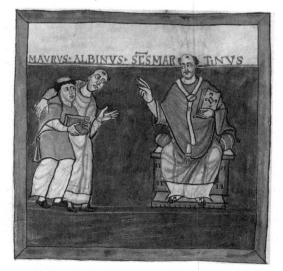

Vatican City, Biblioteca Apostolica Vaticana. Alcuin presents Rabanus Maurus to St Martin, from *De Laude Sanctae Crucis* by Rabanus Maurus, *c.* 850

Heidelberg, and was given to Pope Gregory XV. It included 3,500 manuscripts. In 1657, Alexander VII, Chigi, gave the Vatican Library the fifteenth-century library of Federigo da Montefeltro, Duke of Urbino, with 1,779 codices, many of which had been made in the workshop of Vespasiano da Bisticci. The most important acquisitions of the nineteenth century were those of Father Francesco Ehrle, first 'Keeper' of the Vatican Library, who in 1891 acquired the manuscripts of the papal library of Avignon. In 1902 the Barberini family sold its library to Leo XIII: it included some ten thousand Latin manuscripts and 593 Greek. Pope Pius XI deposited in the Vatican the 'Fondo Rossiano' consisting of some four hundred illuminated codices, mostly Italian liturgical works, some Carolingian manuscripts, and many volumes of Dante, Petrarch and Boccaccio. The Vatican Library now holds nearly sixty-two thousand manuscript books.

Venice
Biblioteca Nazionale Marciana

The core of this library is the mangificent collection of Greek and Latin manuscripts given to Venice in 1468 by Cardinal Bessarione. A palace, known as the Old Library, to house the collection was designed by Jacopo Sansovino, and the rooms were embellished with paintings by Titian, Veronese, Tintoretto and other masters. From the sixteenth to eighteenth centuries the library received many great collections, such as those of Contarini, Recanati, Farsetti and Nani. In 1789-1815, the holdings of suppressed monasteries were added, among them those of SS. Giovanni e Paolo, Venice, S. Michele, Murano, and S. Giovanni di Verdara, Padua, as well as further private libraries. The library was moved to the Zecca (the Old Mint) and now displays bindings and illuminated manuscripts. The Library's holdings include 12,742 manuscripts.

The codices in the collection include the Grimani Breviary, masterpieces of Flemish illumination (school of Ghent and Bruges, fifteenth to sixteenth centuries); Gospelbooks of the eighth century; the Psalter of Basil II; French-Veneto codices, among them the *Entrée d'Espagn*; a manuscript of Dante, known as the *Dante Marciano*, of the fourteenth century with illuminations of the Venetian school; a copy of Pliny from Pico della Mirandola; the *Martianus Capella*, illuminated by Attavante; the Grimani Lectionary, made for Cardinal Marino Grimani, with illuminations attributed to Giulio Clovio; the *Geographia* by Ptolemy copied

for Cardinal Bessarione in the ninth century and *De bello Punico* by Silius Italicus with illuminations of the Veneto school of the ninth century, and others.

Vienna
Österreichische Nationalbibliothek

Emperor Maximilian I (reigned 1493-1519), poet and author, possessed a magnificent

and Latin translations of Aesop and the *Politics* of Aristotle. Conrad Coltes, a Nuremberg humanist who served as Imperial librarian until his death in 1508, described the collection as 'small but beautified by its Greek, Latin and exotic [that is, Hebrew and Arab] authors'. Maximilian apparently kept the books in chests, divided among various residences, chiefly at Innsbruck and Wiener Neustadt.

Some of Maximilian I's manuscripts were

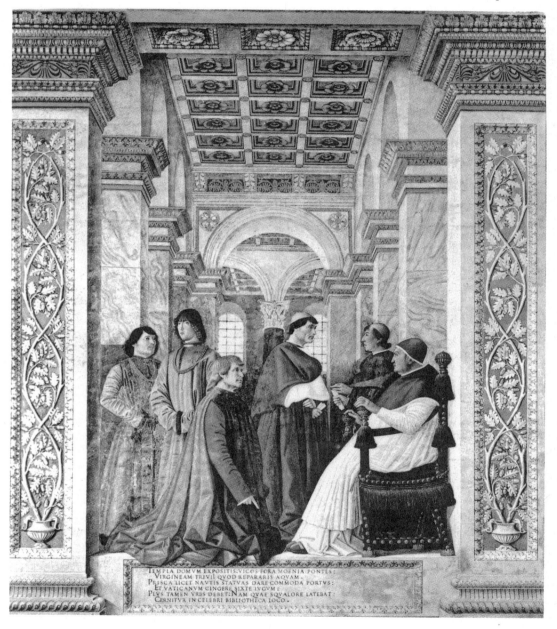

Pope Sixtus IV appoints the humanist Bartolomeo Platina (kneeling) director of the Biblioteca Vaticana. Standing in front of the Pope is Cardinal Della Rovere, the future Pope Julius II. The Pope's nephews also take part in the scene. Fresco by Melozzo da Forlì, now in the Vatican Gallery

library, in part inherited from his father Frederick III. It included several splendid examples of Bohemian illumination from King Wenceslaus IV (reigned 1378-1419), romances of chivalry, manuscripts of Terence

certainly among the books seen by Hugo Blotz in 1575 in Vienna, on the first floor of a Minorite monastery, in a state of confusion and affected by damp, when, as the first librarian of the Hofbibliotek of the Empe-

181

ror, he started to organize the collection. His brief catalogue, of which a copy went to Maximilian I's great nephew, Maximilian II, at Prague, lists 7,379 volumes. Between 1548 and 1551 books had been acquired for the library by Wolfgang Lazius, professor of medicine at the university of Vienna and court historian, who travelled in Austria, south Germany, Alsace and Switzerland in search of manuscripts in monastic libraries. Furnished with royal letters of introduction, he seems to have 'borrowed' whatever

its vast holdings such manuscripts of artistic importance as an illustrated *Dioscorides* of the sixth century, discovered at Constantinople by the imperial ambassador, and the Syrian Gospels written for Ferdinand I by an envoy of the Patriarch of Antioch.

Washington, DC
Library of Congress

The Library of Congress was created as a

brary that Thomas Jefferson had formed as ambassador in Paris, Amsterdam, Frankfurt and London, gathering over a period of fifteen years works that dealt with America, or that were rare or precious. The Library of Congress thus began its life as a large library with an international character. In 1851 it suffered another fire which destroyed the majority of the materials, about 35,000 volumes, and it was necessary to begin again. The library was rehoused in an iron building, still inside the congressional building, and its regrowth was begun with acquisitions and donations. In 1867 the library of the Smithsonian Institution was deposited in the library, and $500,000 were given for the progress and diffusion of sciences. Only in 1889 did construction begin on a new building, which was completed in 1897. The library, on its way to reaching one million volumes, was transferred to the new building and became, as well as the Library of Congress, the National Library of the United States.

Today, the library's holdings include more than 36 million manuscripts, including over 300,000 music manuscripts. There is dispute as to which library is the world's largest, the Library of Congress or Russia's National Library.

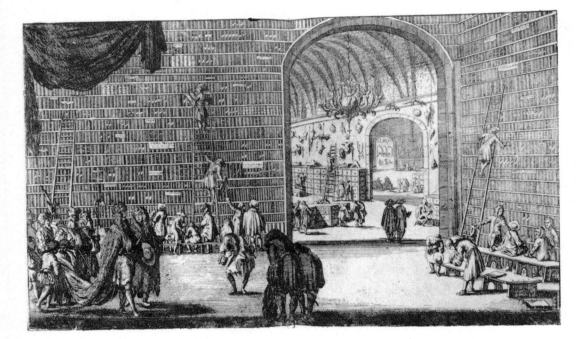

Vienna, the Österreichische Nationalbibliothek in a late seventeenth-century print. Suspended in the archway and on the walls beyond can be seen the natural history collections. Engraving from Edward Browne, *Sehr denkwürdige und sonderbare Reisen*, Nuremberg, 1686

seemed of particular interest and sent it to Vienna. The *Historiae Apostolicae* of the Pseudo-Abdias, from the monastery of Ossiach in Carinthia, is an example. Since there was no room to consult books in the monastery, Blotz instituted a liberal system of loans, with Imperial approval. In 1726 Charles VI opened the library to the public. Busbeck, imperial ambassador in Turkey, acquired 274 Greek manuscripts, and the Hungarian Sambucus 565 Greek and Latin manuscripts. The library continued to grow during the eighteenth century. The magnificent Baroque library-room was created by Fischer von Erlach the younger to the design of his father, and frescoed by Daniel Gran. In 1738 the collection of Prince Eugene of Savoy was acquired, including manuscripts of French chivalric romances. As well as the historical archives of Austria and the Hapsburgs, today the Hofbibliothek has among

Library for the American Federal Government, and became a national library because of the size and completeness that it gained with the passage of time. During congressional sessions in New York in 1789, the need to have a certain number of books available to the delegates became clear, and a proposal was made to nominate a commission to make an appropriate selection. However, because of both the opposition of certain members and the intervening acquisition of a private library, no further discussion of the subject occurred until the Congress established itself at Washington, DC, in 1800. The origins of the largest American library date to that year and the setting aside of $5,000 for the acquisition of books and the establishment of a place for the library in the capitol. In 1814, English troops burned the capitol and reduced the library to cinders. Congress then bought the 6,000-volume li-

Washington, DC
National Gallery of Art

Among the newest government-supported museums in the world, the National Gallery owes its creation to several major private collections—Mellon, Widener, Kress, Dale, and Rosenwald—acquired at its inception in 1941. This collection, while it consists for the most part of paintings, prints, drawings and sculpture, includes many pages from illustrated manuscripts.

Wolfenbüttel
Herzog August Bibliothek

Julius, Duke of Brunswick-Wolfenbüttel (1568-86), is regarded as the founder of this library. As he came to power the monasteries were suppressed and officials were encouraged to obtain volumes for the ducal collection, as when 282 books and manuscripts were brought from the monastery at Marienberg to Wolfenbüttel. The library was also enriched during this period with a collection of the writings of Luther, and an illuminated Gospels of 1194 from the abbey of Helmarshausen in Westphalia, given by the Landgrave William of Hesse. The next

duke, Heinrich Julius (1589-1613), acquired a collection of 165 manuscripts, many of them very early, that had belonged to the Protestant historian Matthias Flaccius Illyricus. Among them was the Greek St John Chrysostom of the sixth century; two *Books of Laws* of Charlemagne; and a Claudian of the thirteenth century from Arbroath in Fifeshire. At the Duke's death in 1613 the library held ten thousand volumes. Although given by his successor, Friedrich Ulrich, to the university of Helmstedt, this library was reunited with the ducal collection in 1814. A duke of a collateral branch of the family inherited the Duchy of Brunswick in 1634. Duke Augustus of Brunswick-Lüneburg was a scholar and an able and assiduous collector who devoted funds to a library.

In 1627, this library had ten thousand works; in 1661 it had 116,357 works, in 28,415 volumes, most in Latin and German, including a number of illuminated codices. The Duke himself wrote the title on each volume, and compiled a catalogue that extended to four volumes, each of several hundred pages and surprisingly detailed. Books and manuscripts were acquired through agents, or by erudite correspondents such as the Jesuit Athanasius Kircher, who procured for the Duke a Syrian Gospels of 634. Augustus confiscated manuscripts from the monasteries of St Blasieu in Brunswick and from Marienthal, near Helmstedt, but also received as gifts, or otherwise acquired regularly, many volumes, among them one hundred from Cardinal Mazarin. A Bavarian Missal and three Greek manuscripts had belonged to Guarino Veronese; and the earliest manuscript, the *Codex Arcerianus*, a collection of sixth-century Roman authors on land-surveying which had belonged during the Middle Ages to the monastery of Bobbio and during the Renaissance to the Amesbachs of Basel, was acquired in the Low Countries. The medieval Icelandic work the *Eyribiggia Saga* came by way of Denmark and Holstein; a notebook came from Aquitaine, one of the few documents saved from destruction during the French Revolution; from England came an illustrated Wycliffe Bible. The Duke's correspondence with his agents is bound in thirty volumes, and the accounts are preserved in the state archives. Augustus opened the library to ecclesiastics and other 'worthy persons'.

The Duke willed the library to the first-born of the Wolfenbüttel line, and directed that its growth should continue. In 1689, 105 manuscripts from the abbey of Weisenberg in Alsace came to the library, more than half of them earlier than 900; in 1710, 467 manuscripts came from a Danish statesman; in 1753, the private collection of Duke Louis Rudolf was added. During the Seven Years War Richelieu placed the library under his personal protection; fifty years later, when Wolfenbüttel was occupied by Napoleonic troops, some four hundred volumes were sent to Paris. Most were recovered, although a work of lesser value with a missing folio was substituted for the Wolfenbüttel Bible. Formerly in the free state of Brunswick, Wolfenbüttel became part of the state of Lower Saxony in 1954. The Library now contains more than eight thousand manuscripts.

List of illuminators

The scriptorium of the Benedictine monastery of Echternach, from an illumination in an eleventh-century Gospels (Bremen, Staatsbibliothek)

The list that follows is select (as is the section on 'Great libraries'). Included are those artists best known for their work as illuminators. Well documented information exists for some artists; others have been identified only through the study of manuscripts. Those named for the earliest periods are chiefly the monks who organized scriptoria in which important works were written and decorated. Completely absent from this list are those anonymous artists who during the early Middle Ages decorated precious volumes with consummate skill.

Adalbert

Regensburg (Ratisbon), 10th century. A monk at St Emmeram, with his brother-monk Aribo, Adalbert restored the *Codex Aureus* of Emperor Arnulf (Bayerische Staatsbibliothek, Munich, Cim. 55), and added a portrait of Abbot Romwald (975-1001), who had had the manuscript restored.

Adalbertus or Albertus Vulterrensis

12th century. In 1169 Adalbertus wrote and illuminated the Pisa Bible. This was for a time at the monastery of Gorgona, and is now at the Certosa di Calci, Pisa.

Adelaide (Adelheid)

Alsace, 13th-14th century. Adelaide was a nun at Unterlinden who according to tradition was an expert calligrapher and illuminator.

Adelricus

Corvey, 822-56. One of the monastery's illuminators whose signature appears beneath a full-page miniature on f. 3 of the *Vatican Terence*, in the Biblioteca Apostolica Vaticana, Rome (lat. 3868).

Ademar

France, 11th century. A monk at the monastery of St Martial at Limoges whose name appears in a manuscript from that monastery decorated with splendid initial letters in the characteristic style of the school of Limoges; the work is now in the Bibliothèque Nationale, Paris (lat. 1121).

Adeodato di Monza

Lombardy, 16th century. An Olivetan monk, both a calligrapher and illuminator, Adeodato decorated choir-books for the monasteries of S. Michele in Bosco, Bologna, and S. Stefano, Genoa.

Aegelmund

England, early 11th century. Aegelmund's name appears in a Psalter illuminated at St Augustine's, Canterbury, now in the British Library (Harley MS 603). It is the earliest of several copies of the *Utrecht Psalter*.

Aimardus

France, 12th century. Aimardus worked on a manuscript containing the *Legende* of St Martial of Limoges, ornamenting it with richly decorated initials.

Amato di Fucarino

Sicily, first half of 15th century. A priest, Amato illuminated an elegant, small Breviary for the abbess of S. Maria Maddalena, Corleone, in 1443; the work is now in the Biblioteca Comunale, Palermo.

Anciau de Cens (or Ancelet)

France, first half of 14th century. In 1327 Ancelet collaborated with Jean Pucelle and other artists in the illumination of the famous Bible known by the name of its copyist, Robert de Billyng, today in the Bibliothèque Nationale, Paris (lat. 11935). He also participated in the illumination of the Belleville Breviary, named after its owner, Jeanne de Belleville (lat. 10483-484). With the great number and variety of its decorative motifs and the skill of its execution, this breviary is one of the masterpieces of French illumination of the period.

Andrea de' Bartoli

Bologna, 14th century. The probable artist of the Sienese Giottesque miniatures in the *Chanson des Vertus et des Sciences*, today at the Musée Conde, Chantilly, made *c.* 1349 for Bruzio Visconti of Milan. In 1359 Andrea illuminated codices written by his brother Bartolomeo for Cardinal Albornoz.

Angelica

Spain, end of 15th century. A nun of St James of Ripoli, Angelica wrote and

illuminated several choir-books for Tarragona Cathedral.

Anno

Germany, 10th century. A scribe and illuminator, Anno collaborated in the decoration of the *Pericopenbuch* made for Gero, archbishop of Cologne (969-76), today in the Landesbibliothek, Darmstadt (rus. 1948). This is the masterpiece of a group of Reichenau codices whose illuminations are copied from those of the Carolingian court school, sometimes known as the 'Ada' school after a supposed half-sister of Charlemagne.

Anovelo da Imbonate

Lombardy, 14th century. A follower of Giovannino de' Grassi (q.v.), but a traditionalist and painter of more modest stature, whose work suffers from harsh colour-contrasts and ungainly forms. His most important work is the Missal made for the coronation of Gian Galeazzo Visconti, today in the Library of S. Ambrogio, Milan, made in 1394. Also by his hand are a Missal of 1402 in the Biblioteca Capitolare, Milan, and a manuscript of the *Leggenda dei santi Aimo e Vermondo* in the Biblioteca Trivulziana, Milan (cod. 509). *See p. 124.*

Antonio da Monza

Lombardy, 15th century. According to tradition this monk was one of the most important illuminators in Lombardy. Many precious manuscripts, masterpieces of Lombard art, were formerly attributed to him, but most have now been identified as the work of Giovanni Pietro da Birago (q.v.).

Antonio de Holanda

Originally from Holland, active 1518-40. Identified by his son as the illuminator of Breviaries for King Manuel and Queen Eleonora of Portugal. He also collaborated with Simon Bening (q.v.) on the *Genealogy of the Infante Don Fernando of Portugal*, now in the British Library, London. *See p. 160.*

Antonio di Nicolò di Lorenzo

Florence, second half of 15th century. In 1475 Antonio illuminated a *Comunione dei Santi* for the church of the Annunziata, Florence, where it is today.

Argenta, L', see Medici, Jacopo Filippo.

Arias

Spain, end of 15th century. Arias illuminated a Book of Hours for Isabella I, and between 1485 and 1490 decorated choir-books for the monastery of St Thomas, Avila.

Arragel, Rabbi Moses

Spain, 15th century. A calligrapher and illuminator who worked at Maqueda in 1439, decorating a Bible translated into Castilian, now in the possession of the dukes of Alba.

Atelier of Wenceslaus

Bohemia, end of 14th century. A group of artists gathered in Prague around Wenceslaus IV (1378-1419), working in the royal library from 1387 to 1405. Their masterpiece was the six-volume Wenceslaus Bible in the Österreichische Nationalbibliothek, Vienna (cod. 2759-2764). Executed between 1380 and 1390, it shows Italian and French influences.

Attavante degli Attavanti

Florence, 1452-1517. Born in Valdelsa, Attavante was influenced by Ghirlandaio and Verrocchio, in whose workshop he is believed to have studied, and also by Pollaiuolo. His work is decorative, at the expense of dramatic power. His masterpiece is the Urbino Bible (Biblioteca Apostolica, MS urb. lat. 1 and 2), made for Vespasiano da Bisticci for duke of Urbino, Federigo da Montefeltro, which is dazzling in colour and admirable in the clarity of its calligraphy. After 1483 Attavante worked almost exclusively for Matthias Corvinus, King of Hungary. Among his most important works for the king are the Missal now in the Bibliothèque Royale, Brussels (MS 9008), and two volumes in the Trivulziana, Milan (MSS 817, 818). Among Attavante's other works are a Missal in Chieti Cathedral, illuminated in 1506 for S. Maria degli Angeli (Biblioteca Medicea-Laurenziana, Florence, corale 4), and a seven-volume Bible that he organized. It was commissioned by John II, King of Portugal, and copied by Sigismondo de' Sigismondi of Ferrara and Alessandro da Verrazzano between December 1495 and July 1497. This Bible, today in the National Archives at Lisbon, is the most sumptuous book created by a fifteenth-century Florentine.

Avogaro, Marco di Giovanni dell'

Veneto, mid-15th century. Working in Ferrara, Avogaro left many illuminated manuscripts, including a Suetonius (1452-53) and a Livy (1451). He collaborated on the illustration of the famous Borso Bible (made for Borso d'Este), depicting Sts Mark and Luke in a style inspired by Mantegna. *See p. 144.*

Azzi, Stefano

Bologna, 1388-1410. Pupil of the celebrated Nicolò di Giacomo (q.v.), Azzi worked as an illuminator on the *Statuti dei notai* of 1382, the registers of notaries, and the new tables of the Consiglio dei Seicento.

Baemler (or Bamler), Hans

Germany, 1435-1504. Probably born in Augsburg, Baemler is known chiefly as a printer, but two miniatures from 1457 bear his signature. These are now in the Pierpont Morgan Library, New York (MS 105).

Balsamo, Giacomo de

Bergamo, mid-15th century. Balsamo illuminated choir-books for Bergamo Cathedral.

Bamier, Jo

Augsburg, 15th century. Illuminator and also printer, Bamier illuminated a manuscript of St Augustine's *City of God* that is today in the Spencer Library, Althorp.

Bapteur, Jean

Freibourg, early 15th century. Bapteur worked in the service of the dukes of Savoy. From 1428 to 1435 he illuminated an Apocalypse later completed by Jean Colombe. The manuscript is now in the Escorial, Madrid. He was a skilled and talented artist of the French school.

Bartolomeo da Ferrara

End of 15th century. A monk who worked at Siena between 1471 and 1473. Around 1455, Borso d'Este entrusted to him the illustration of a Gradual and an Antiphonary which he donated to the Carthusian monastery of Ferrara which he had founded.

Bartolomeo de Carreria

France, 16th century. The illuminations in the magnificent Roman Missal of the counts of Challant are attributed to this artist. Today in Aosta, the Missal is one of the most important examples of French Renaissance illumination.

Bartolomeo di Antonio

Florence, mid-15th century. In collaboration with his brother, Bartolomeo illuminated a four-volume Lectionary for S. Maria del Fiore, Florence, today in the Medicea Laurenziana (cod. Edili 144-147). Especially notable are two large scenes of the Miracles of St Zenobius.

Basso, Tommaso di Cesare

Modena, end of 15th early 16th century. Basso worked in Bologna from 1484 to 1507 on choir-books for S. Petronio, and later decorated a Breviary for Ercole I of Ferrara in collaboration with Matteo da Milano (q.v.) and Cesare delle Vieze (q.v.). His style is close to that of the French school, and shows the influence of Ercole de' Roberti.

Beato, Angelico

Florence, 1387-c. 1455. Among the works on which this most spiritual and refined of late Gothic-early Renaissance artists collaborated, while working at S. Maria degli Angeli, is a precious *Domenican Diurnale* (no. 3), in the Biblioteca Medicea Laurenziana. *See p. 146.*

Beauneveu, André

Paris, end of 14th to early 15th century.

Beauneveu is known to have worked on a Psalter for the Duke of Berry (Bibliothèque Nationale, Paris, franc. 13091) between 1360 and 1397, creating with his pupils 24 superb miniatures.

Bedford Master

France, first half of 15th century. This artist is named for his patron John, Duke of Bedford, Regent of France under Henry VI. The duke and his wife Anne received between 1414 and 1435 a Breviary and a Book of Hours, now in Paris and London respectively, that were made by a prolific artist who worked in Paris in collaboration with other artists, including the Rohan and Boucicaut masters. He shows himself open to new ideas; he used refined gradations of colour, with rounded outlines and faces, and supple clothing. He displays little interest in expression and attitude. He is in the forefront among landscape miniaturists, even though in this he cannot be classed with the celebrated Limbourg brothers. Among his numerous works are the *Livre de Chasse* of Gaston de Foix, the *Chroniques de Froissart*, and the *Bible historiale* of Guyart des Moulins.

Belbello da Pavia

Lombardy, mid-15th century. Active c. 1430-67, Belbello is the most distinctive figure of Lombard illumination of the period. His identity, long unknown, was established by Toesca only in 1912, and his name by Pacchioni in 1915. He was famous throughout the Po Valley, and worked not only for the Visconti, but also for the Gonzagas and the Estensis, and for other patrons in Lombardy, the Romagna and the Veneto. His style was formed in Lombardy under such teachers as Giovannino de' Grassi (q.v.), Michelino da Besozzo Molinare (q.v.), and the Burgundy masters of the French manuscripts preserved in the library of the Castello, Pavia. He is the artist of the second part of the *Visconti officium*, left unfinished by Giovannino de' Grassi (today in the Biblioteca Nazionale Centrale, Florence), which already displays his individual style, more sumptuous than that of his predecessors, more vigorous in design and with dark, almost nocturnal colouring, in which gold rays cross a violent blue sky. Gold is used to heighten landscapes and on clothing, perhaps an echo of Byzantine mosaics and Venetian icons. Even the decorations of his codices are exuberant and dynamic. His works have a dramatic tension and an 'expressionistic' tendency that derives from Carolingian and Ottonian illumination.

While recalling that of the Florentine Lorenzo Monaco (q.v.), his style is typically northern Italian, particularly in the Missal he illuminated in 1461 for Barbara of Brandenburg for Mantua Cathedral. He had no followers, but influenced such artists as Taddeo Crivelli (q.v.) and Gerolamo da Cremona (q.v.). *See pp. 120, 144, 147, 151.*

Belin, Jean

France, 14th century. A calligrapher and illuminator who worked at Dijon between 1344 and 1382. In collaboration

with his wife Maria in 1357 he illuminated the *Livre qu'on dit vices et vertus* (Book of Vices and Virtues) for the Duke of Burgundy, and in 1373 the *Sept Seaumes* (Book of Seven Psalms) for the Duchess.

Bembo, Bonifacio

Lombardy, second half of 15th century. In his youth Bembo was an admirer of Masolino, who had worked in Castiglione Olona; he was influenced by the art of the Zavattari family, painters working in Milan at that time, directed toward a Renaissance of style, and foreshadowed Vincenzo Foppa.
The Tarot cards (New York, Pierpont Morgan Library; Bergamo, Carrara Academy) are clearly linked with the *Historia di Lancillotto del lago* (Biblioteca Nazionale, Florence, MS pal. 566), in which 289 pen-drawings narrate the adventures of knights and ladies, according to the then-ascendent French taste, but with a wit that is no longer Late Gothic. Bembo also collaborated on the *Oroscopo* made for Duke Galeazzo Maria Sforza, compiled by Raffaello da Vimercate (Biblioteca Trivulziana, Milan, no. 1329), in which the prince is portrayed with a boldness near to caricature, as he receives the homage of a kneeling courtier. This courtly-heraldic art is seen also in *Armiranda acta*, by G.M. De Carrara (Biblioteca Trivulziana, no. 763), illuminated after 1457. *See p. 132.*

Benedetto da Padova

Second half of 15th century. Benedetto painted the miniatures of a four-volume codex of *Decretali*, printed at Venice in 1477, and of an *Horarium* of 1480. The miniatures in an *Aristotle*, printed at Venice in 1482, are also attributed to him. He is frequently identified with Benedetto Bordone, who died in 1539.

Bening, Alexander

Ghent, second half of 15th century. Bening is probably the artist known as the Master of the Hours of Mary of Burgundy. A painter and illuminator as early as 1469, he is considered the greatest innovator of Flemish illumination of the 15th century. He adopted the new realistic style of the great painters, particularly that of Hugo van der Goes, and transformed the style of decorations on the borders of pages. Among his many works are the Book of Hours and the *Legend of St Hadrian*, for Charles the Bold (Nationalbibliothek, Vienna, cod. 1857; Österreichische Nationalbibliothek, 11996), the Book of Hours and the *Tract on Morals* for Margaret of York (1475), and the Book of Hours for Maximilian, Archduke of Austria (Nationalbibliothek, Vienna, cod. 1907). His most celebrated work, however, is the Grimani Breviary (Biblioteca Marciana, Venice), and small Books of Hours, three of the most precious of which were owned by, respectively, Mary of Burgundy after her marriage to Maximilian, her son Philip I (Philip the Handsome), and his wife, Joanna the Mad. He influenced his son Simon (q.v.) and pupil Gerart Horenbout (q.v.).

Bening, Simon

Ghent, 1483-1561. Son of Alexander (q.v.). He worked at Ghent and Bruges but also in Antwerp, Brussels and London. He illuminated books for the Emperor Charles V and Ferdinand, Infante of Portugal, among others. His works include a Missal of 1530 now at Dixmude, the *Genealogy of the Infante Don Fernando of Portugal*, and the Hennessy Book of Hours (Brussels, Bibliothèque Royal, cod. II, 58) with fine skill and rare mastery. *See pp. 153, 158, 160.*

Berardo da Teramo

Abruzzi, first half of 14th century. Berardo illuminated and signed an Antiphonary at the church of S. Flaviano near Giulianova. Five illuminations taken from this work are today in the Fondazione Cini, Venice.

Beringarius

France, 9th century. Calligrapher and illuminator at Saint-Denis, in 870 he collaborated with his brother Luithardus on the celebrated *Codex Aureus* (Bayerische Staatsbibliothek, Munich, Cim. 55), commissioned by Charles the Bald, of whom there is a portrait at the beginning of the work. One of the masterpieces of the school of Saint-Denis, this was taken to Germany during the Carolingian period, was restored at Ratisbon, and provided a model for the art of illumination in that city.

Bernardino de Canderroa

Spain, 16th century. Between 1514 and 1518, collaborated on a masterpiece of Spanish illumination, a Missal made for Cardinal Cisneros of Toledo. This seven-volume work is today in the Biblioteca Nacional, Madrid (MS 1540-1546).

Bernardino di Modena

13th-14th centuries. Author of a Bible, known as the Gerona Bible, with energetic figures, made for and today preserved in Gerona Cathedral. An excellent representative of the Bolognese school of his time.

Bernardo di Tolosa

Mid-14th century. Bernardo worked at Avignon, assisted by a female illuminator named Marie. He illuminated a few Avignon codices, and others for Charles V of France. From 1390 to 1392 he illustrated a Missal and other volumes for Pope Clement VII.

Birago, Giovanni Pietro da

Milan, second half of 15th century. The identification of Birago with the Pseudo-Antonio da Monza has been confirmed as has the attribution of several masterpieces of Sforesco illumination. We know of his career, beginning with choirbooks at Brescia, followed by the splendid manuscripts in the British Library,

such as the Book of Hours of Bonne of Savoy, one of the greatest examples of the Renaissance style, and the *Sforziade* by Giovanni Simonetta, to the Donato *Grammatica* in the Biblioteca Trivulziana (cod. 2167), and the *Pontificale* of the Vatican Library. His early works show Paduan influence and that of Ferrara. An emulator of Cicognara, he first appears untouched by the Renaissance climate of Milan, but soon became a follower of Bramante and Leonardo during their Milan periods.
Apart from the splendid manuscripts in the British Library, among the Biblioteca Trivulziana's his most important work is the *Liber Iesus* (Biblioteca Trivulziana, cod. 2163), which like the Donato *Grammatica* was made for the education of Massimiliano Sforza, son of Ludovico il Moro. These recall the atelier of Cristoforo and Ambrogio de Predis (q.v.).

Blandius

Hungary, second half of 15th century. Blandius is known to have worked around 1470 in the atelier of Matthias Corvinus, King of Hungary, at Buda.

Boccardi, Giovanni, also called Boccardino il Vecchio

Florence, 1460-1529. Follower of Attavante (q.v.), Boccardi worked with his son Francesco on the choir-books of Montecassino and Perugia. His work represents the last of the splendid and active Renaissance Florentine school. Among his most important patrons were Matthias Corvinus, King of Hungary, and Pope Leo X.

Bondol, Jean de, called Jean de Bruges

Second half of 14th century. Born at Bruges, active between 1368 and 1381, he was an illuminator at the French court of King Charles V, who held him in great esteem. With him begins the movement that in the course of twenty years made Paris the unrivalled centre for the art of illumination.

Bonfratelli, Apollonio di Capranica

Rome, 16th century. Bonfratelli was in the service of the Pope from 1523 to 1572 as illuminator 'Cappellae et sacrestiae apostolicae'. A page illuminated by him, now in the British Library, London, with the Adoration of the Shepherds, recalls Raphael. The figures in the borders, the swags and other motifs are of an eminently architectural character, in the style of Michelangelo, and in imitation of the frontispieces of printed books of the period.

Boucicaut Master

France, first half 15th century. The artist is named for a Book of Hours made *c.* 1410-15 for Jean le Meingre (or Maingre) de Boucicaut, Marshal of France (Musée Jacquemart-André, Paris, MS 2). He frequently worked with the Bedford Master (q.v.), but his style is less purely pictorial, more elegant, drier, less

complex, with a sense of space and perspective, and clear, cool colours.

Bourdichon, Jean

France, 1457-1521. Bourdichon worked at Tours around 1479 for Louis XI, King of France, Queen Carlotta of Savoy, and for their successors, Anne of Brittany, her husbands, Charles VIII and Louis XII, and her son Francis I. Jean Bourdichon's work is in the Flemish style, and his enchanting figures are reminiscent of those of Jean Fouquet (q.v.).
The *Grandes Heures* of Anne of Brittany, now in the Bibliothèque Nationale, Paris (MS lat. 9474), is one of the most splendid Books of Hours ever made. It was commissioned around 1500.

Boyvin, Robert

France, 16th century. Boyvin collaborated on the decoration of *De antiquitatibus Judeorum*, now in the Mazarin Library, Paris (MS 1581), carried out in 1501 for Cardinal Georges d'Amboise. For the same cardinal he also illuminated a Livy in 1503.

Brailes, William de

England, 13th century. Brailes lived in Catte Street, the street of illuminators in Oxford. He signed his works with the words '*me fecit*', '*me depeint*' or just with his name. He introduced a characteristic type of initials with long-nosed, round-eyed, animated small figures. The decoration of the initials and margins is remarkable in both design and colouring: intense blue with brown, rose-pink and burnished gold; he also made pen-drawings in red and blue.

Caporali, Giacomo and Bartolomeo

Perugia, second half of 15th century. These brothers worked on the choir-books of S. Pietro, Perugia, around 1472. Their works are exuberant in the Florentine style.

Cherico, Francesco di Antonio del

Florence, second half of 15th century. Cherico is known to have worked between 1463 and 1485. With his work, Florentine illumination took a new direction. He was no longer content to decorate a page or an initial letter but instead created large, populous scenes inspired by contemporary life. In his Graduals the scenes take on a new vigour and liveliness and begin to show the characteristics of painting. His work culminated in a splendid Bible for Federigo da Montefeltro, but was not limited to the decoration of religious or liturgical books. His secular illustrations were made for the collections of the most illustrious patrons of the time. Two of his most important works are the splendid Petrarch and Virgil, both in the Biblioteca Riccardiana, Florence, illuminated in dazzling colours. Another Petrarch (Biblioteca Trivulziana, Milan, cod. 905) is of equal beauty, exquisite in design and in sweet and festive colours. He approaches the old subject-matter of humanism

with freshness. His landscapes are enchanting, with small trees with tall trunks; his human figures express a refined sensitivity, the feminine faces sweet. Medallions and cameos, part of a new decorative style, are used copiously in the *Officium* of Lorenzo the Magnificent, considered his masterpiece. *See p. 143.*

Cicognara, Antonio

Cremona, end of 15th century. From 1482 to 1483 Cicognara worked on the choir-books of Cremona Cathedral. Like the better-known artist Gerolamo da Cremona (q.v.), he was inspired by the late illumination of Bembo (q.v.), but influenced also by the style of Ferrara, where he lived for a time.

Clovio, Giulio

Rome, 1498-1578. A Croatian, Clovio lived in various Italian cities, but chiefly in Rome, where he was summoned to the papal court by Paul III. Many works have been attributed to him, including a Lectionary (New York Public Library, MS 91), an Offices of the Virgin (New York, Pierpont Morgan Library) and a self-portrait (Florence, Uffizi). His style is more that of painting than illumination, descriptive rather than ornamental. Indeed, he can be considered the last of the Renaissance illuminators. A friend of Giulio Romano, an admirer of Raphael and Michelangelo, he worked first for Cardinal Domenico Grimani and then for Cardinal Marino of the same family. He illuminated the *Commentary on St Paul's Epistle to the Romans* (John Soane Museum, London) and, for Cardinal Alessandro Farnese, a Book of Hours (Pierpont Morgan Library, New York), a sumptuous codex that recalls Bruegel, whom he had met at Rome in 1553, and Dürer. The poems of Eurialo d'Ascoli (Vienna, Albertina) is a homage to Raphael and to his friend Giulio Romano, whose ardour shows Venetian influence. *See p. 152.*

Coene, Jacques

Flanders, end 14th century. An illuminator in Bruges, Coene was also a painter and architect (he worked on Milan Cathedral). In Paris around 1404, he illuminated, among other works, a Bible for Philip of Burgundy in collaboration with Haincelin de Haguenot (q.v.) and Imbert Steiner. He also decorated a Book of Hours for the Visconti (Biblioteca Reale, Turin, no. 77), another for the Duke of Berry, before 1402, in collaboration with Jacquemart de Hesdin, and a Boccaccio (Bibliothèque de l'Arsenal, Paris, no. 5193).

Colombe, Jean

Bourges, end of 15th century. Jean Colombe dominated the last period of French illumination, imprinting his style on the Rouen school, and marking the close of the Middle Ages with a grand manner. He worked particularly for Charles I and Carlotta, dukes of Savoy, and completed the *Très riches heures* of Jean, Duke of Berry, which had been left unfinished in 1416 by the Limbourg brothers (q.v.).

Cortese, Cristoforo

Venice, first half of 15th century. Italian painting styles, French-Lombard Gothic and Byzantine art had a strong influence on Venetian illuminators like Cristoforo Cortese. He was also influenced by the strong colours and opulent forms of Niccoló da Bologna. Among other works he illuminated a Missal for the Domenicans of SS. Giovanni e Paolo (Biblioteca Marciana, Venice, MS lat. III 97). *See p. 120.*

Cozzarelli, Guidoccio

Siena, 1450-1516. Illuminated the margins and initial letters of the four Antiphonaries of the Ospedale di S. Maria della Scala now in the Biblioteca Piccolomini, Siena.

Crivelli, Taddeo

Ferrara, c. 1425 to before 1479. Crivelli, educated in Lombardy, was the principal artist of the famous Bible made for Borso d'Este (the Borso Bible). This was written entirely by the Milanese Pietro Paolo Maroni, but the work of decoration was given to various artists. Crivelli's skill in painting landscapes and animals links him to Belbello (q.v.). *See p. 144.*

Decio, Agostino

Milan, 16th century. The art of illumination, already in decline, continued chiefly in Books of Hours and choir-books. Decio's style was dominated by his Lombard origins; following in the footsteps of Leonardo and Guadenzio Ferrari he ornamented the famous choir-books of the Certosa di Pavia, and a Gospels in the Biblioteca Trivulziana, Milan, made for Francesco II Sforza, Duke of Milan, and for his wife, Christiana of Denmark (cod. 2148). The Missal in the Pierpont Morgan Library, New York (MS 377), dated 1535, is an important early work. The Treasury of Vigevano Cathedral houses a Missal, a Gospels and a Epistolary in his more mannered, Raphael-esque style. *See p. 156.*

Dreux, Jehan

Bruges, 15th century. Between 1440 and 1464 Dreux worked for Philip the Good and Charles the Bold as court illuminator. His work was in the Flemish style of the period. Among his works are those once attributed to the Master of *Girart de Rousillon* (Vienna, Österreichische Nationalbibliothek, cod. 2549). He collaborated on the *Chroniques de Hainaut*. His landscapes are less realistic than those of Marmion (q.v.)

Evangelista da Reggio

Ferrara, second half of 15th century. A friar, a scribe and an illuminator who worked from 1478 on several codices for Reggio Cathedral, imaginative in his decoration, though less than powerful and finished in his miniatures.

Eyck, Jan and Hubert van

Flanders, first half of 15th century. These great masters of Flemish panel painting during the period of Philip the Good also collaborated on the illuminations of several codices, such as that, possibly for William IV, duke of Bavaria, count of Hainaut and of Holland, made around 1417. The Turin Hours, a portion of the *Très Belles Heures* of the Duke of Berry with Eyckian miniatures, was destroyed by fire in that city's library in 1904 (photographic records remain). Another portion ('Milan Hours') is in the collection of the Museo Civico, Turin. The van Eycks inspired the style of subsequent illuminators.

Fouquet, Jean

France, c. 1420-c. 1481. Fouquet, the greatest 15th-century French illuminator, had visited Italy in his youth, and, having stayed in Rome, he was not uninfluenced by the Italian Renaissance masters. Among his numerous works are the *Heures d'Etienne Chevalier* of c. 1460, which is divided among various libraries – the Bibliothèque Nationale, Paris, the Musée Condé, Chantilly, the Louvre, the Wildenstein Collection, New York, etc.; *Les Statuts de l'ordre de Saint-Michel* of 1470 in the Bibliothèque Nationale, Paris (MS fr. 19819); and a Boccaccio of 1458 in the Bayerische Staatsbibliothek, Munich (cod. gall. 369). His compositions are lively, light, supremely balanced.
He had many pupils and imitators, among them Jean Colombe, who, however, could not equal the genius of his master. *See pp. 142, 147.*

Francesco da Castello

Milan, Budapest, early 16th century. Francesco da Castello took Lombard influence to Hungary, where he worked at the court of Matthias Corvinus, collaborating on the *Breviarium Hungaricum* and numerous other illuminations.

Francesco dai Libri

Verona, 1452-c. 1514. Francesco is known from pages of a Pontifical made for Cardinal Giuliano della Rovere, now in the Pierpont Morgan Library, New York (MS 306). In this work motifs from Mantegna are combined with inspiration from Liberale da Verona (q.v.).

Franco Bolognese

Bologna, early 14th century. Among the best artists of the 14th-century Bologna school, at a time when the influence of Giotto was leading to a more ample and monumental style of illumination, Franco's illuminations are marked by a sense of joyous festivity that dispels Byzantine severity. The backgrounds have greater vivacity of colour than the flat tones of the Italian primitives. Among his works are two Graduals in the Biblioteca Estense, Modena, and the Decretals of the Bibliothèque Nationale, Paris (MS lat. 1988).

Gatta, Don Bartolomeo della

Florence, 1448-1502. A Camaldoli monk, della Gatta represented in a more monumental style the fresh countryside and the peaceful piety of Gherardo and Monte del Fora (q.v.), inspired by Piero della Francesca. Among his works is an Antiphonary (Capitolo della Metropolitana, Urbino, cor. 6), outstanding for an initial with a striking scene of the martyrdom of St Agatha.

Gerolamo da Cremona

Second half of 15th century. Among the major figures of Italian Renaissance illumination, Gerolamo was inspired by the late illuminations of Bembo (q.v.), and achieved an individual and unified style, drawing on wide influences. Among his works are additions to the Missal of Barbara of Brandenburg of Belbello, and the splendid choir-books in the Biblioteca Piccolomini, Siena, which reveal a close study of the Ferrara style, as well as Gerolamo's relationship with Liberale da Verona (q.v.), with the schools of illuminations of central Italy and, naturally, with the Cremona school. He shared in developments in the Veneto, and finally worked in Siena after 1457. In the last period of his work, influenced by Liberale, he strengthened his already rich palette. His figures, which had been crystallized in the manner of Marco dell'Avogaro (q.v.), broke into impetuous movement. *See p. 147.*

Gherardo and Monte di Giovanni del Fora

Florence, c. 1440-97; 1448-91. These two brothers, illuminators, painters and mosaicists, represent the apogee of Florentine illumination. Their work is characterized by its strong colours and rich ornamentation, with embellishments and branches that twine around vases and candelabras, with animals, human figures, and cameos with landscape backgrounds influenced by the Flemish style.
They illuminated a Homer, now in the Biblioteca Nazionale, Naples, an *Epistolario* in the Biblioteca Laurenziana, Florence, a Missal in the Vatican Library (cod. Barb. lat. 610), as well as Breviaries, Missals, and Psalters. The brothers, whose styles so mingle as to be difficult to distinguish, also show interest in the events of their time which they represent in their illuminations, as for example in the Roman Missal of S. Egidio (Museo Nazionale, Florence, MS 67). The solemn scene of the consecration of that church by Pope Martin V in Florence in 1435 is depicted in a style related to Ghirlandaio, not without Flemish influence, and in the manner of true painting.

Giacomo da Fabriano

Rome, second half of 15th century. Giacomo's style is reminiscent of the Ferrara school. His name appears in many codices in the Vatican, among them a Diodorus Siculus and a St. Augustine, *De Civitate Dei*. He was the director of

an active workshop where illuminated manuscripts were prepared for Popes Pius II and Sixtus IV, and he also worked for Federigo da Montefeltro.

Gigantibus, Gioacchino de

Naples, second half of 15th century. Originally from Bavaria, Gigantibus was one of the most popular illuminators in Naples at the time of Ferdinand of Aragon. He favoured the Italian motif of the 'white vine' interlace border, as in a *Commentary on Plato* by Bessarione, now in the Bibliothèque Nationale, Paris (MS lat. 12946), of 1476. *See p. 132.*

Giorgio

10th-11th centuries. Giorgio was one of eight illuminators who collaborated on the Menologion of Basil II (Vatican Library, Vat. gr. 1613), which at the end of the 15th century was given to Ludovico il Moro, Duke of Milan.

Giorgio Tedesco (or di Alemagna)

Ferrara, 15th century. Giorgio was working for Lionello d'Este in Ferrara in 1441, one of the most important illuminators of that city. He collaborated on several works, including the famous Borso Bible. Inspired by Pisanello, he created balanced compositions in warm, graceful colours. The *Missale Romanum* (Biblioteca Estense, Modena, W. 5.2), known as the Borso d'Este Missal, was once attributed to Taddeo Crivelli (q.v.) but is now believed to be his work. The manuscript is one of the most exquisite examples of Ferrara illumination, with its fusion of Gothic and Renaissance elements, and colouring influenced by Flemish art and by the clarity of Piero della Francesca. *See p. 144.*

Giovanni di Benedetto da Como

Second half of 14th century. The earliest known Lombard illuminator, worthy representative of the by then established courtly style, Giovanni ornamented, between 1350 and 1378, the *Uffiziolo* for Bianca of Savoy, wife of Galeazzo II Visconti (Staatsbibliothek, Munich, MS lat. 23216). He painted initials and full-page miniatures with originality, even if not always with precision. He was influenced by the Bologna school, but also by the French and Flemish styles of illumination, well known at the Visconti court through manuscripts brought there from France, possibly by Bianca of Savoy herself. Very similar to the *Uffiziolo* in Munich is the Bibliothèque Nationale's MS lat. 757, illuminated around 1380 for an unknown patron, which is more refined in its expressivity and imbued with a strong realism. Both represent animals in a way that foreshadows the work of Giovannino de' Grassi, and both provide interesting documentation for the history of dress.

Giovanni da Gaibana

Ferrara, 13th century. Giovanni worked on the magnificent *Epistolarium* that is today in the Treasury of Padua Cathe-

dral, providing 16 large miniatures on gold backgrounds representing the life of Jesus, the Virgin, Martyrs and saints. His style although chiefly Byzantine also shows Ottonian influences, particularly in the iconography. *See pp. 112, 144.*

Giovanni di Paolo

Siena, 15th century. Although he preserved the medieval Gothic inheritance, Giovanni di Paolo was the first to introduce a new accent. His twelve miniatures in the Antiphonary of the Abbey of Leccerto, now in the Biblioteca Comunale, Siena (MS G.I. 8), introduce several Renaissance innovations in the rendering, such as perspective, a descriptive depiction of the surroundings, and both delicacy and freshness. These can be traced to the illustrations of the *Divina Comedia*, of which he illuminated the *Paradiso* (British Library, London, MS Yates Thompson 36), while the *Inferno* and the *Purgatorio* were illuminated by his Sienese contemporary Lorenzo Vecchietta. A comparison of the work of the two artists shows the style of Vecchietta to be pungent, violent and abrupt, while that of Giovanni is spirited and delicate with lively joyous colours. Keeping close to the poem, he developed a precise and ordered iconography.

Giovanni di Ugolino da Milano

First half of 15th century. A minor artist who around 1436 illuminated 'with unfailing exuberance and flamboyant Gothic architecture' a Roman Missal for Fermo Cathedral, among other works.

Giraldi, Guglielmo

Ferrara, mid-15th century. A vigorous illuminator, active between 1445 and 1476, reminiscent of Tura and Piero della Francesca, Giraldi illustrated the Bible and choir-books of the Certosa di S. Cristoforo, and with Franco de' Russi the *Divina Comedia* for Federigo di Montefeltro (Biblioteca Vaticana, cod. urb. lat. 10), a magnificent example of Renaissance illumination. He also illustrated a *Trattato del ben governare* (Biblioteca Trivulziana, Milan, cod. 86), with exquisite detail and Flemish refinements. His use of colour is original, both in scenes and decoration; but he remains faithful to a monumental conception of the human figure. In a work by Candido Bontempi, *Il libro del Salvatore* (Biblioteca Estense, Modena, T. 5.27), his composition has a Flemish model in Jan van Eyck (*The Madonna with Chancellor Rolin*, Louvre) but takes inspiration also from Piero della Francesca in the fresco of *Sigismondo Malatesta before his Patron Saint*, Rimini.

Giusto de' Menabuoi

Emilia, end of 14th century. The expert illuminator in 1379 of a Petrarch, *De Viris Illustribus*, presented to Francesco de Carrara (Bibliothèque Nationale, Paris, MS lat. 6069, I). His work, with its affinity with painting, is reminiscent of that of the Bolognese miniaturists who had gravitated to that city around the early 14th century, attracted by its calligraphers.

Goderannus

Flanders, 11th century. Calligrapher and illuminator, Goderannus worked in the abbey of Lobbes, and in 1083 signed a two-volume Bible now at Tournai, and the Flavius Josephus *Antiquitates Iudaeorum (Antiquities of the Jews)* now in the Bibliothèque Royale, Brussels.

Grassi, Giovannino, Salomone and Porrino de'

Milan, end of 14th century (died 1398). The most brilliant courtly illuminator of the century. Giovannino's work spanned architecture and sculpture, painting and illumination. He depicted the common people as well as courtly society, with the acute objectivity of the Late Gothic Lombard artist. He had a particular predilection for studies of animals. In 1389 he was commissioned to work on the construction of Milan Cathedral, of which he became engineer, expected to create statues, design capitals and ornaments for windows, and to paint pictures. Of these works, little remains, but the Biblioteca Civica, Bergamo, has one of his works, the *Taccuino*, or notebook of designs, on parchment, with pen-drawings of animals, some with shading and white highlights, portraits revealing lively observation in every particular. His masterpiece of illumination is the *Visconti officium*, made before 1395, belonging to the Visconti of Modrone. The ornamentation is elegant and graceful, brightly coloured yet harmonious and delicate, creating new effects with vegetal and zoomorphic motifs. The full-page miniatures, most of a very high quality, are idealized and delicate in treatment. The second part of the manuscript (Biblioteca Nazionale, Florence, fondo Landau Finaly, MS 22) has a light and poetic touch; it was done with his son Salomone and another pupil, both less expert than he. Before 5 July 1398, toward the end of his life, he probably illuminated with the help of his son Salomone and his brother Porrino, the Beroldo Breviary (Biblioteca Trivulziana, cod. no. 2262), which is evidently the work of three different artists, even though the overall decorative effect is unified. The beauty of the Breviary is in the ornaments and decorated initial letters, derived from architectural motifs such as spires, pinnacles, etc., some of which reflect the Cathedral. Grassi was the greatest representative of late Lombard Gothic, his art combining realistic depiction with design and colours verging on the abstract, anticipating the forms of the 15th-century. *See pp. 120, 124, 128.*

Grillo, Jacopo

Venice, 16th century. Grillo made a Psalter with numerous miniatures for S. Giorgio Maggiore, Venice, dated 1538, in which he re-elaborated elements of book-ornament, but in pale colours that echo the style of central Italy, but which by then also denote an art in decline.

Grimualdus

Montecassino, first half of 11th century. The most skillful illuminator among the monks working at the monastery at the

time of Abbot Theobald (1022-35). Splendid initials by him have survived.

Haincelin de Haguenot

Paris, early 15th century. In the service of Philip the Bold, Duke of Burgundy, Haincelin de Haguenot worked in Paris as official illuminator from 1409 to 1415. He decorated several codices, among them the magnificent *Gaston Phebus*, now in the Bibliothèque Nationale, Paris (MS franc. 616), and two Bibles, both in the Bibliothèque Royale, Brussels, that once belonged to the dukes of Burgundy.

Hennercart, Jean

Paris, mid-15th century. Hennercart worked for the dukes of Burgundy, Philip the Good and Charles the Bold, and was court illuminator from 1456. He illuminated several codices. He compensated for a lack of skill by giving his figures large proportions; nevertheless they are characterful.

Heribertus

Reichenau, end of 10th century. A monk, Heribertus appears to have worked on the Reichenau Gospels, now in the municipal library of Trèves, written for Archbishop Egbert (977-93). The codex contains 60 miniatures attributed to several artists.

Hesdin, Jacquemart de

France, end of 14th century. Among the most famous of the French illuminators working at the end of the 14th century, Hesdin was in the service of the Duke of Berry until 1384. He died around 1415. He collaborated on the magnificent Books of Hours made for the Duke, showing himself an exquisite decorator.

Honoré

France, end of 13th century. Among the first of the non-clerical illuminators, to Honoré is attributed the Breviary of Philip the Fair (Bibliothèque Nationale, Paris, MS lat. 1023). His work influenced numerous later artists. His school— which, like other European schools of illumination, showed the influence of the English art of the period — has the characteristic French feature of pages with gold bars and delicate ivy-leaf borders. Flowers and fruit, and small life-like figures of men and animals appear among the branches. One of the most typical examples of this new style is the *Legend of St Denis* (Bibliothèque Nationale, Paris, MS franc. 2090), made around 1317, which represents with immediacy the life of a Paris street.

Horenbout (Horebout), Gerart

Flanders, end of 15th century. Painter and illuminator, Horenbout was the principal representative of a family of artists living in Ghent. In 1514 he was at the court of Margaret of Austria, daughter of Mary of Burgundy. For her he decorated a small Service-book, and pre-

pared an addition to the Book of Hours for Bona Sforza (1519-21), now in the British Library, which was inherited by Margaret in 1503. He also seems to have been responsible for the finest miniatures in the Grimani Breviary, now in Venice. He worked at Ghent, Bruges, Antwerp and Brussels, and *c.* 1522 went into the service of King Henry VIII in England. *See p. 158.*

Ingobertus

France, second half of 9th century. Between 880 and 888 Ingobertus illuminated the Great Bible of S. Paolo fuori le Mura, Rome, dedicated to Charles the Fat, and considered the most magnificently illuminated codex of the period.

Ippolita Master

Milan, second half of 15th century. This artist was named for his patron Ippolita Sforza who married Alfonso of Aragon in 1465. He made a series of books for her inspired by the late Lombard Gothic style, that the duchess took with her to Naples. Among his other works are the *Trattato di caccia* by Antonio Lampugnano, written in 1459 for Francesco Sforza (Musée Condé, Chantilly); the Virgil in the University Library of Valencia (no. 780); a Cicero *De Officis* (Bibliothèque Nationale, Paris, MS lat. 7703), written in Milan in 1461; and the *De practica seu arte tripudi* by Guglielmo Ebreo da Pesaro (Bibliothèque Nationale, Paris, MS it. 973), a manual of dance probably made for the Sforza court.

Isidoro

Padua, 12th century. Scribe and illuminator, Isidoro made a Gospel-book for the Treasury of Padua Cathedral in 1170, presenting the principal holidays of the year in eight tables and enriching 37 initial letters with fantastical decorative motifs.

Jaquintus

Montecassino, 10th century. A scribe and illuminator, Jaquintus worked on a book of Homilies sometime before 949.

Jean de Bruges, see Bondol, Jean de

Kolderer, Jorg

Innsbruck, second half of 15th century. Painter and architect at Innsbruck, from 1472 Kolderer worked chiefly for the Emperor Maximilian, for whom he illuminated the *Trionfo* and the *Porte de Honneur* in 1512 (both in the Albertina Library, Vienna), as well as other codices. A great master, his influence on the whole Danube school was strong.

Laurentius of Antwerp

Second half of 14th century. Monk and illuminator at Ghent, Laurentius illuminated a Missal in 1366, today in the Meermanno-Westreenianum, The Hague (MS 10 A 14).

Lenoir, Jean

France, mid-14th century. With his daughter, Lenoir worked for King John II and for the King's son, the future Charles V. Between 1372 and 1375 he worked for Jean, Duke of Berry, who had a particular fondness for him. A Bible of Jean de Sy (Bibliothèque Nationale, Paris, MS Franc. 15397) and the Hours of Yolanda of Flanders are believed to be his work.

Leo

Montecassino, second half of 11th century. The scriptorium of the monastery of Montecassino achieved a perfection of ornamentation and figure-painting under Abbot Desiderius (1056-86), when Byzantine artists were called there to embellish the new basilica. The most important example is the *Vita S. Benedicti*, now in the Vatican Library (cod. vat. lat. 1202), which has illuminations by two different artists, one the able hand of the monk Leo, the other rough and careless.

Leonardo da Besozzo

Lombardy, first half of 15th century. He represents a period in Lombard Gothic art that concluded with Neapolitan influence. A son of Michelino da Besozzo Molinari (q.v.), Leonardo was working in Milan in 1421. His illuminated and painted works display a certain detachment from the courtly world, and while he remained within his father's followers' circle, he was inspired by French-Flemish illumination. Among his works is a *Canon maior* of Avicenna and a *Cronaca*, which was part of the Crespi Morbio collection, Milan.

Lescuyer, Adenet

France, mid-15th century. Lescuyer worked at Angers, illuminating the *Miroir des Dames* for Jeanne de Laval and a Gradual for Angers Cathedral. A group of manuscripts including *Les Heures à l'usage d'Angers* and the *Grandes Heures de Rohan*, now in the Bibliothèque Nationale, Paris (MS lat. 9471), has been attributed to him by some scholars.

Liberale da Verona

c. 1445-1529. Educated in the Po Valley, Liberate collaborated with Gerolamo da Cremona (q.v.) and notably influenced him. His choir-books in the Biblioteca Piccolimini, Siena (5, 9, 12), show his development and his sympathy with the Ferrara artists Cossa and Tura, with an expressive intensity seen especially in the famous 'Eolo' of Gradual 12, and the Graduals of Monte Oliveto, today in Chiusi Cathedral (Cor. Q and R). The illuminations in the Museo Civico, Verona, inspired by Ercole de' Roberti, were done in 1496.

Lievin of Antwerp

16th century. This Flemish illuminator is believed to have collaborated on the Grimani Breviary, now in the Biblioteca Marciana, Venice.

Limbourg, Pol, Herman and Hennequin

France, early 15th century. A meticulous inventory of 1413 lists manuscripts and illuminations, including the famous Books of Hours of Jean, Duke of Berry (who died in 1416), the most renowned bibliophile of his time. Considered the precursors of Hubert and Jan van Eyck, the Limbourgs made several precious Books of Hours for the Duke, the most celebrated of which are preserved in the Musée Condé, Chantilly, and in the Biblioteca Nazionale, Turin. The exquisite illuminations in these books transcend the influences that contributed to them; the style is Flemish, but one can see how Italian art, particularly the Lombard style of Giovannino de' Grassi, was also an influence. *See pp. 148, 150.*

Lira, Giovanni da

Ferrara, mid-15th century. Assisted Taddeo Crivelli at Ferrara, participating in the decoration of the Borso Bible (Bible of Borso d'Este) and other works. *See p. 144.*

Lorenzo Monaco

Florence, 1370-c. 1425. A Sienese painter and illuminator, Lorenzo Monaco entered the Camaldoli convent of S. Maria degli Angeli in 1391. He brings to a close Late Florentine Gothic style with illuminations of striking colourings and profound religious feeling. His figures, refined by the influence of the International Gothic style, are tormented by a mystical passion, as in the Gradual of 1412-13 (Florence, Museo Nazionale, H. f. 4). He had many followers, among both painters and illuminators. *See p. 146.*

Loyset, Liédet (Lyédet)

Flanders, 15th century. A student of Simon Marmion (q.v.) Loyset was one of the most illustrious Flemish illuminators of the 15th century, and was certainly the most prolific, illuminating more than a thousand codices. Even if his rather stiff execution detracted from his art, his personal style is of interest. At Bruges he adapted his art to the prevailing taste and chose for his characters an elongated, rectangular face, expressionless and with sharp features and a prominent nose, little varied. His colours are more varied than those of his predecessor at Bruges, Vrelandt (q.v.), but are equally unnaturalistic. In some of his frontispieces, to which he apparently devoted more care, he displays a rare narrative ability, absent in other mannered and lifeless works. As evidence of his great popularity, we find works of three, four and sometimes even five volumes that were decorated by him or by his students.

Magius

Spain, 10th-11th centuries. In 926 Magius and his pupil Emetrius made a copy of the Beatus of Liebana *Commentary on the Apocalypse* (New York, Pierpont Morgan Library, MS 644) with illuminations notable for the abstraction of the figures and the balance of their compositions, which together with the dense colouring produced a strongly expressive effect.

Maiorana, Cristoforo

Naples, end of 15th century. Maiorana worked at the court of Ferdinand I of Aragon at Naples, and illuminated, among other works, a Gospels now in the Bibliothèque Nationale, Paris (MS lat. 10532).

Marliano, Ambrogio da

Lombardy, second half of 15th century. A modest figure, who adorned his pages with the white vine interlace of humanistic codices, but whose figures are archaic in style. His work is regarded as marking the beginning of the Lombard Renaissance. Among other works he illuminated an *Epistolarium dominicanum*, now in the Braidense, Milan (cod. A.F. XI, 10).

Marmion, Simon

France, mid-15th century. Painter and illuminator at Amiens and Valenciennes in northern France, where he worked from sometime after 1458 until 1489. He illuminated for Philip the Good, Duke of Burgundy, a Breviary now lost, and two codices in the Bibliothèque Royale, Brussels, the *Fleur des Histoires* and the *Pontifical de Sens*. Harmonious compositions and pleasing colours demonstrate his exceptional abilities, both in figures and landscapes. *See p. 134.*

Marmitta, Francesco

Parma, 16th century. Marmitta is an artist of splendid and sumptuous effects, who decorated the Missal of Cardinal Domenico della Rovere (Museo Civico, Turin) with rich ornaments and medallions. The faces are stylized, not unlike those of Ercole de' Roberti. Among his other works are the Petrarch of Kassel (Landesbibliothek, MS poet. 4.6.). *See p. 152.*

Martini, Simone

Siena, 1285-1344. Martini marks the beginning of the new Sienese school of illumination, which combined in various ways the design and colours of the Ile de France with the strong colourings of Byzantine art, producing a perfect decoration for books. In the first page of a Virgil that belonged to Petrarch (Biblioteca Ambrosian, Milan), Martini united, using a humanistic idea suggested by Petrarch, Hellenistic pictorial treatment with Gothic forms.

Martino di Giorgio di Alemagna, called Martino da Modena

Second half of 15th century. Famous as one of the collaborators on the decora-

tion of the Borso Bible, Martino was working at Ferrara in 1441 under the influence of Pisanello. In 1485 he moved closer to the style of Cossa and Mantegna in the Choir-books for Ferrara Cathedral, in a Breviary (Biblioteca Nazionale, Palermo, MS I.B. 21) and a Missal (Biblioteca Trivulziana, Milan, cod. 2165), placing small but sumptuous compositions painted in warm colours among the decorations of filigree trees and rosettes that were by then standard motifs in Ferrara illumination. He uses vivid colours and bold foreshortenings and he has a fondness for heavy drapery; but most of all he shows observation and skill in the representation of nature — animals and flowers — which he lovingly animates. Religious inspiration is represented in the saints of the *Ordo Pontificalium Missarum* (Österreichische Nationalbibliothek, Vienna, cod. 1818).

Master *aux Boquetaux*

France, end of 14th century. An important French illuminator of the end of the 14th century. Characteristic of his work are his groups of three or four trees, and his well-developed art of landscape-painting in a lively, realistic style. Among the works attributed to him are two miniatures in a *Poésies* by Guillaume Machaut (Bibliothèque Nationale, Paris, MS franc. 1584) and a two-volume *De civitate Dei (Cité de Dieu)*, in French (MS franc. 22912-22913).

Master of the *Città di Vita*

Florence, mid-15th century. The illuminator of Matteo Palmieri's *Città di Vita* (Biblioteca Laurenziana Medico, Florence, MS Plut. 40.53), he paints solid figures enclosed in panels, yet with animated gestures and an impulsiveness that recall Pollaiuolo.

Master of the *Codex of San Giorgio*

Siena, 15th century. The miniaturist of the so-called *Codex of San Giorgio*, now in the Biblioteca Apostolica Vaticana (MS Arch di S. Pietro, C 129), for Cardinal Jacopo Stefaneschi. This master probably worked in the atelier of Simone Martini at Avignon.

Master of the Cypresses

Seville, 15th century. This artist, once identified with Pedro de Toledo, illuminated manuscripts at a good level. *See p. 137.*

Master of the *Hortulus Animae*

Flanders, late 15th to early 16th century. Active in Ghent between 1480 and 1520, this artist is named for a codex attributed to him which is in the Österreichische Nationalbibliothek, Vienna. Most of his other works were manuscripts for the Emperor Maximilian. *See p. 136.*

Master of the Hours of Mary of Burgundy

Flanders, end of 15th century. An illu-

minator at Bruges, sometimes identified with Claes Spierinc, or more probably, with Alexander Bening (q.v.), this artist decorated, among other works, a Book of Hours for Margaret of Burgundy, daughter of Mary, now in Berlin, and the famous Book of Hours for Mary of Burgundy, his masterpiece, now in Vienna. This is partly written on black parchment, with the first lines in gold and silver, and with rich *trompe-l'œil* border decorations. It is one of the most important manuscripts of the period, exceptional in its richness of colour and in the precision of its design. *See p. 135.*

Master of the *Virgil*

Florence, mid-15th century. The Master of the *Virgil* in the Biblioteca Riccardiana, Florence (MS 492), is an exquisite visual narrator whose work resembles the decoration of bridal chests, with costumes and gestures evoking Pesellino (q.v.), to whom the codex was once attributed. The same is true of the other work by this artist, the Petrarch *Trionfi* (Riccardiana, MS 1129).

Master of the *Vitae Imperatorum*

Lombardy, first half of 14th century. An Olivetan monk of vast industry, he contributed to many manuscripts for Filippo Maria Visconti. He produced dozens of codices, among then the *Liber meditationum* in the Biblioteca Trivulziana (cod. no. 519); the Book of Hours of Maria of Savoy, second wife of Filippo Maria Visconti; the *Vitae imperatorum*, translated by Pier Candido Decembrio, also made for Filippo Maria (Bibliothèque Nationale, Paris, MS it. 131); and numerous others, once in the Castello, Pavia, and now in Paris. His illuminations have clarity of colour and liveliness of design, and in their search for expressiveness foreshadow the Ferrara illuminations of several decades later.

Matteo da Milano

Ferrara, end of 15th to early 16th century. In 1502 with Tommaso da Modena and Cesare delle Vieze (q.v.), Matteo illuminated a sumptuous Breviary for Ercole I d'Este. It was decorated in the same period as the Borso Bible and is considered the most notable work of the late Ferrara Renaissance. The Breviary makes exceptional use of the Renaissance repertoire of architectured motifs and ornament: flowers, gems, pearls, cameos, arabesques, complemented by the perfect lapidary style of the inscriptions.

Mazerolles, Philippe de

France, second half of 15th century. Mazerolles worked for Charles the Bold of Burgundy at Bruges, where he died in 1480. He used both colour and *grisaille* with extreme skill in many codices, among them *The Miracle of Nôtre-Dame* (1456), in the Bibliothèque Nationale, Paris (MS franc. 9198-9199). *See p. 41.*

Mazzeo, Felice

Naples, end of 15th century. Mazzeo

worked between 1491 and 1493 at the court of Ferdinand I of Aragon, illuminating a Plato and a Book of Homilies, now in the British Library. He marks a period in Neapolitan illumination in which decoration became heavy, with abundant classical motifs and gilding.

Medici, Jacopo Filippo, called l'Argenta

Ferrara, second half of 15th century. This artist worked in collaboration with Crivelli on the Borso Bible. He was a virtuoso, even if a little dry. He worked at Bologna in 1465, at Ferrara between 1481 and 1501, and at Brescia, on the choir-books for the church of S. Francesco, now in the Pinacoteca Tosio Martinengo, to which they were given *c.* 1492 by Francesco Sanson, general of Franciscans. L'Argenta prepared seventeen of the volumes, and was the most important artist involved. *See p. 144.*

Michael

Vienna, first half of 15th century. From *c.* 1422 to 1450, Michael worked in the Imperial court of the Emperor Frederick II, illuminating several codices, Missals, Privileges, and Inscriptions.

Molinari, Michelino da Besozzo

Milan, early 15th century. Molinari continued the style of Giovannino de' Grassi (q.v.). He was a transitional artist between Gothic and Renaissance. A painter and illuminator, he first worked at Pavia at the end of the 14th century, then at Milan from 1404 to 1450 on the building of the Cathedral, where the archives contain information about him. Many illuminated works are attributed to him, notably the *Orazione funebre di Gian Galeazzo Visconti* by Pietro da Castelletto (Bibliothèque Nationale, Paris, MS lat. 5888), in which he displays a flowing Gothic rhythm and delicate, diffuse colours in characteristic figures. His style permeated Lombard painting and illumination for fifty years, and he had a host of followers. He influenced Bonifacio Bembo (q.v.), and Belbello (q.v.). Some of the frescos in the Casa Borromeo, Milan, may also be his work.

Neri da Rimini

Beginning of 14th century. An illuminator of the Romagna in the years 1300 to 1322, his work is archaic, and stylistically related to the schools of Bologna and Florence. Among his other works are choir-books for Faenza Cathedral.

Neroni, Bartolomeo, called Il Riccio

Siena, 1520-*c.* 1573. Il Riccio illuminated Antiphonares for the Olivetan monastery of Finalpia near Savona, now in the Biblioteca Berio, Genoa. He marks the end of Sienese Renaissance illumination.

Nicolò di Giacomo di Nascimbene, called Nicolò da Bologna

c. 1330-1402. Director of a very active

workshop, Nicolò developed a style far removed from classical expression, spontaneous in its presentation of daily life, and with an original perspective in which everything seems to be viewed from above. In the choir-books of the Olivetan monastery of S. Michele in Bosco, Bologna (now in the Biblioteca Estense, Modena), and juridical treatises, such as the *Novelle sulle Decretali* (Biblioteca Ambrosiana, MS B. 42 inf.), he displays a marvellous force and realism. He was a great illustrator of secular works, among them the *Pharsalia* of Lucan (Biblioteca Trivulziana, Milan, cod. 691), in which he depicts scenes with medieval costumes: small pictures rich in movement, a trifle unvaried, with the perspective inverted, as in the Pseudo-Nicolò. He had several students and collaborators, among them his son Onofrio, Stefano Azzi (q.v.) and the Domenican Antonio da Bologna, and he exercised a notable influence on the art of illumination of the Romagna, Emilia and the Veneto.

Oderisi da Gubbio

13th century. This celebrated master is mentioned by Dante. His works combine French influences with Italian characteristics as in the famous Gerona Bible, preserved in Gerona Cathedral, and other works. *See p. 113.*

Orimina, Cristoforo

Naples, mid-14th century. This artist's name appears in a Bible made for King Robert of Anjou, now in the library of the seminary of Mâlines.

Ouvraige de Lombardie

End of 14th century. This name designates works painted in a Lombard style imitative of Giovannino de' Grassi (q.v.) by the illuminators of manuscripts of courtly romances, and of the *Tacuina Sanitatis*, who worked in the area dominated by the Visconti. Organic compositions go hand in hand with a lively interest in the real world. Similar styles prevailed in both the old French court and in the newer Visconti court.

Pacino di Buonaguida

Florence, second half of 14th century. Pacino was the first of the Florentine illuminators to be inspired by the new Gothic art, in a style both intimate and dramatic. He adapted his own painting of a Cross-tree (Florence, Galleria dell'Accademia), in the illumination of a Bible (Biblioteca Trivulziana, Milan, cod. 2139), and made other illuminations in the same volume with strong colours and squarish figures, and with the straw yellows that remained typical of Florence and of his workshop, the most active of the second half on the 14th century.

Paris, Matthew

England, 13th century. Also known as a painter, sculptor and goldsmith, Matthew Paris worked at St Albans Abbey

around 1236. He is considered the principal representative of the new style of outline drawing adopted in English illumination during this period. Among other works, he illustrated the *Chronica Maiora*, now at Corpus Christi College, Cambridge (MS 26), and the *Historia Anglorum* (his last work, British Library, Royal MS 14 c. vii). It is believed he died in 1259 because the last item of the *Historia Anglorum*, written in his own hand, is of that date, while on f. 218v, another artist depicts Matthew Paris lying on his deathbed, his elbow resting on a book inscribed: '*Liber Cronicorum Mathei parisiensis*'. He had a number of assistants and signed only one miniature (British Library, Royal MS 14 C vii, f. 6). *See p. 119.*

Pellegrino di Mariano

Siena, end of 15th century. Pellegrino illuminated several choir-books for Siena Cathedral, now in the Museo Pienza, and others for the Ospedale di Santa Maria della Scala, Siena, now in the Biblioteca Piccolimini, Siena. He may be described as a less vigorous follower of Sassetta.

Pesellino, Francesco

Florence, mid-15th century. A painter with a sweet, delicate and luminous style, Pesellino was also an illuminator, as we see from a fresh and energetic page remaining from a codex of *De bello Punico* (Biblioteca Marciana, Venice, XII, 68), made for Nicolò V.

Pestivien, Jean

Paris, 1380-1463. Pestivien worked at the court of Philip the Good of Burgundy, while retaining the influences of the school of Paris.

Petancius, Ragusanus Felix

Budapest, end of 15th century. This artist was at the head of a workshop of illuminators in Buda, working for the Hungarian Kings Matthias Corvinus (1458-90) and Vladislaus II (1490-1516).

Pietro di Pavia

End of 14th century. A friar, Pietro illuminated a Pliny *Historia Naturalis* in 1389, now in the Biblioteca Ambrosiana, Milan. His work was in the French style, with an admirable exactitude and strong realism.

Piramo, Reginaldo da Monopoli

End of 15th century. Piramo illuminated with figures that are predominantly Flemish in style, an Aristotle now in the Österreichische Nationalbibliothek, Vienna, and collaborated on works by his circle (*Cicerone*, Biblioteca Gerolamini, Naples).

Predis, Ambrogio de

Milan, end of 15th century. Primarily a portraitist, Ambrogio worked as an illuminator in the workshop of his brother Cristoforo (q.v.), and he took over its direction after his brother's death. Among other works, he created in 1487 a masterpiece of humanistic Lombard illumination: the *Epithalamium in nuptiis Blancae M. Sphortiae et ducis Johannis Corvini*, of G.F. Marliani. It is painted in warm, dark tones in the manner of Leonardo, and is notable for the harmony of the decoration and figurative elements. Also his work are the profiles of Ludovico il Moro and his son Massimiliano Sforza in the Donato *Grammatica* in the Biblioteca Trivulziana, Milan.

Predis, Cristoforo de

Milan, *c.* 1440 to before 1486. A deaf-mute, Predis worked around 1470, and was a very active illuminator. He was among the most important figures of Renaissance Lombard illumination, who assimilated and fused with Lombard styles the Flemish styles that were spreading into Lombardy during the second half of the 15th century. Along with Zanetto Bugatto and Bergognone, he represents the 'Flemish moment', the period of a stylistic relationship between Lombardy and Burgundy. With time, the Flemish influence became subdued in his style, because both of his closeness to his half-brother Ambrogio (q.v.), a painter in the style of Leonardo, and his repeated contact with the great painting of the Renaissance, particularly the work of Foppa.

His best-known work is the Borromeo Book of Hours (Biblioteca Ambrosiana, Milan, S.P. 42) made in 1474 for a lady of the Borromeo family, which bears comparison with the best Flemish Books of Hours and combines northern, naturalistic motifs and those of the Italian Renaissance. He imbues his landscapes and initials with fantasy, intensifying them with colouring drawn from the Lombard tradition, particularly from Belbello (q.v.). Two works signed by him and dated 1476 are true masterpieces: the choir-book for Bishop Marliani, presented to the Santuario del Sacro Monte, Varese, and the *Leggendario*, now in the Biblioteca Nazionale, Turin (MS 124), which is of the highest decorative and figurative quality in its more than three hundred miniatures. His school continued his style. We find some work by his hand in the choir-book of Ercole I in the Biblioteca Estense, Modena, in the *De sphaera* in the same library and in the Missal in the Capitolare di S. Ambrogio, Milan, but the remainder of the work, sometimes even mediocre, is that of his pupils.

Pucelle, Jean

Paris, 14th century. Pucelle represents the best of the delicate and graceful art inaugurated in France during the reign of the Valois, illumination characterized by the abandoning of gold backgrounds and the adoption of borders with birds, small quadrupeds, grotesques, figures of knights, etc., perfectly drawn and with lively colours. With his collaborators, he represented an art incomparable in the elegance of its forms, the sureness of its lines, the fineness of its figures, taking inspiration for these from England and northern France, and drawing new ideas from Italy, most of all for the borders, in which appear the first architectural elements. Among his works are the Belleville Breviary of 1323-6 (Bibliothèque Nationale, Paris, MS lat. 10483-484); the Bible of 1327 (MS lat. 11935); the Book of Hours of about 1330 in the Musée Jacquemart-André (MS 1); and the Paris Breviary known as the Breviary of Charles V, from about 1380 (MS lat. 1052).

Rapicano, Nicola (Cola)

Naples, end of 15th century (died 1488). Rapicano worked with his sons at the Naples court of Aragon beginning in 1451, and left several works of moderate execution that are now in the Bibliothèque Nationale, Paris, such as a Scotus (MS lat. 3063) and a Strabo (MS lat. 4798) of 1474. His work is distinguished by the lively design and vegetal and zoomorphic motifs in a Flemish style, united with a Florentine inspiration. This style was continued by his sons Rano, Filippo and Nardo, until they came under the influence of the Padua style which had by then reached Naples.

Rohan Master

France, first half of 15th century. This artist is named 'Rohan' for a Book of Hours to which the arms of the Rohan family of Brittany were added on several pages, suggesting their later ownership of the work. The *Grandes Heures de Rohan*, as the book is known (Bibliothèque Nationale, MS lat. 9471), was made *c.* 1418-25 by an artist of the court of Yolanda of Aragon, wife of Louis II, Duke of Anjou and King of Sicily. After collaborating with the Bedford Master (q.v.) on many works, the Rohan Master set up a workshop at the court and worked on several precious Books of Hours for the family, in the Parisian manner. An outstanding artist in the French Gothic style, he is distinguished by the sense of pathos that pervades his miniatures, and by an individual style.

Rolf, Thomas

England, end of 14th century. Rolf is credited with a Missal in the English style made in 1383-4 for Westminster Abbey, for Abbot Nicholas Lytlington and so known as the Lytlington Missal. The work was probably executed at Westminster, and it is now in Westminster Abbey Library. It has many historiated initials and a rich Crucifixion.

Russi, Franco de'

Mantua, second half of 15th century. A pupil at Ferrara of Guglielmo Giraldi (q.v.), Russi collaborated on the famous Borso Bible, illustrating the Book of Leviticus and the Gospel of St Matthew. His work is distinguished by a firm style and modelling, rationality, and also by a violence of gesture that he derived from Mantegna and Donatello, along with a splendid use of colour, as in the portion of the *Divina Comedia* that he was commissioned to illuminate by Federigo di Montefeltro, now in the Biblioteca Vaticana (cod. urb. lat. 365). *See p. 144.*

Sano di Pietro

Siena, 1406-81. Painter and illuminator, a devoted follower of Sassetta, Sano illustrated several choir-books, Graduals and Psalters. His hand is less fine than those of the Sienese artists of the previous century.

Scheerre, Herman

England, end of 14th to 15th century. Scheerre, possibly from Cologne, worked in London. He signed a small illumination with the words '*me fecit*' in a Book of Offices and Prayers in Latin and French (British Library, Add. MS 16998) which is possibly the earliest of the works that he signed with his name. He contributed to the illumination of other manuscripts which contain his name or identifying mottoes, such as Psalter and Hours made for John Duke of Bedford (British Library, Add. MS 42131); and other unsigned codices have been attributed to him. His style is notable for its delicate technique and sensitivity as in the Big Bible of Richard II (British Library, Royal MS 1E 1X). It is probable that Scheerre led an important London workshop of illuminators.

Schreier, Ulrich

Salzburg, second half of 15th century. Schreier worked on several manuscripts, now at Graz, in the Vatican Library and in the Österreichische Nationalbibliothek, Vienna.

Serpin, Jean

France, early 16th century. Serpin was one of the illuminators who gathered round Cardinal d'Amboise, minister to Louis XII, decorating manuscripts for the royal library at Gaillon in Normandy. Among other works is a *De civitate Dei* in the Bibliothèque Nationale, Paris (MS lat. 2070) and a Flavius Josephus in the Bibliothèque Mazarin, Paris (MS 1851).

Siferwas, John

England, end of 14th century. A Domenican, Siferwas signed several illuminations of the magnificent Sherborne Missal, made for the Abbey of Sherborne in Dorset between 1396 and 1407 (now in Alnwick Castle Library), and a portrait of his patron, John, 5th Lord Lovell, and himself, in a Lectionary (British Library, Harley MS 7026). His work shows Italian, Bohemian and Flemish influences, suggesting that he had studied in a Domenican convent on the continent. His art enriched English illumination of the period with thronging figures and a more abundant use of decoration in initials and margins.

Simone da Siena

Florence, end of 14th century. A Camaldoli monk, Simone was one of the major representatives of the school of illumination that flowered in the convent of S. Maria degli Angeli, Florence, the master of which was Lorenzo Monaco (q.v.).

He made chiefly Antiphonaries and Missals, inspired by the painting of Orcagna. Although Sienese, he used the Florentine style for several choir-books decorated with scenes coloured yellow, orange and violent blue. He illuminated many works, and gathered around him numerous followers.

Strozzi, Zanobi di Benedetto

Florence, 1412-c. 1471. Strozzi worked in the convent of S. Marco, between 1446 and 1453 illuminating nineteen books for Cosimo de' Medici il Vecchio with miniatures: portraits of the Evangelists, martyrdoms, the Apostles. The decorative motifs he preferred are large-leaved foliage with various ornaments, especially shining golden berries. An example of this type is the Missal in the Biblioteca Nazionale, Florence. He also participated in the magnificent illuminations for the Graduals of Florence Cathedral (MS Edili 149, 150, 151), made between 1463 and 1471 by himself and Francesco di Antonio del Cherico (q.v.).

Tavernier, Jean le

Flanders, 15th century. Among the most important Flemish illuminators, Tavernier worked for Philip the Good between 1434 and 1460, at Tournai and Bruges. He made the three-volume *Conquêtes de Charlemagne,* now in the Bibliothèque Royale, Brussels (MS 9066-9068). He was above all a specialist in *grisaille* illumination, as in the Book of Hours for Philip the Good, now in The Hague (cod. A. A. 271). His illuminations are among the most beautiful specimens of the art, with scenes filled with movement, even if the landscape rendering is deliberately neglected.

Tegliacci, Nicolò

Siena, *c.* 1336-63. Tegliacci signed a page with an illumination of the Virgin giving the belt to St Thomas, around 1336. The populous scene, set against a gold background, shows the inspiration of Simone (q.v.) in the clear, luminous colour, of Lippo Memmi in the rounded shapes of the heads, and of Pietro Lorenzetti in the expressive intensity of the face of the Virgin, the attitudes of the angels, and the impetuous gesture of adoration of St Thomas. These same influences are to be found in the warm-coloured illuminations of three choir-books in the Museo S. Gimignano, on which the workshop collaborated, and in other works of high poetic inspiration.

Tickhill, John

England, 14th century. Prior of the monastery of Worksop, near Nottingham, Tickhill illuminated (leaving unfinished) a Psalter (New York, Public Library, Spencer Collection, MS 26), one of a group of four manuscripts in the East Anglian style. Common to all are lively small scenes at the foot of pages and in the margins, especially hunting and animal scenes. Tickhill 'wrote this book... and also gilded it', according to an inscription on f.1. The Psalter has many different types of foliage ornaments, and historiated initials.

Torelli, Filippo di Matteo and Giacomo

1440-68. Torelli was the oldest member of the group of minor artists around Francesco di Antonio del Cherico (q.v.), and was also the first to be inspired by him. With a pleasing, fresh style of deco-

ration, he was the master of many illuminators, among them his son, Fra Giacomo Torelli, who illuminated choir-books for Siena Cathedral. He illuminated scenes of the Passion with vignettes in gold borders, small, square, crowded scenes with backgrounds depicted in rigorous perspective.

Vasquez, Alfonso

Spain, 15th century. Collaborator on a famous illuminated Missal made for Cardinal Jimenez de Cisneros.

Vecchietta, Lorenzo *see under* Giovanni di Paolo

Vedramini, Giovanni

Padua, second half of 15th century. Around 1482 Vedramini illuminated the choir-books in Ferrara Cathedral.

Vieze, Cesare delle

Ferrara, early 16th century. Among the works on which he collaborated, with Matteo da Milano (q.v.) and Tommaso da Modena, was the celebrated Breviary of Ercole I d'Este and the Missal of Cardinal Ippolito, now in the University Library of Innsbruck. His art is traditional in style.

Volpe, Mariano

Naples, end of 15th century. Volpe was a scribe and illuminator at the court of Ferdinand I of Naples. He collaborated with other artists on a Psalter for the King of Naples now in the Bibliothèque Nationale, Paris.

Vrelandt, Willem

Bruges, second half of 15th century. A painter and illuminator at Bruges around 1454, Vrelandt worked on several manuscripts, including the *Chroniques du Hainaut,* now in the Bibliothèque Royale, Brussels (MS 9243), the Breviary of Philip the Good, also at Brussels (cod. 9511), and a *Life of Katherine of Alexandria,* now in the Bibliothèque Nationale, Paris (MS franc. 6449). He illuminated in *grisaille*, with strong outlines, and used dark colours, particularly red and blue. His figures tend to uniformity. His landscapes are of the school of Marmion (q.v.).

Wauquelin, Jean

Flanders, mid-15th century. Wauquelin worked at the court of Philip the Good. The books he illuminated between 1445 and 1452 are splendid examples of the Burgundian school. Among them are the *Roman d'Alexander,* now in the Bibliothèque Nationale, Paris (MS franc. 9342), the *Girart de Roussillon,* now in the Österreichische Nationalbibliothek, Vienna (cod. 2549), and the *Chroniques de Hainaut,* now in the Bibliothèque Royale, Brussels (MS 9242).

Zenoni, Giovanni da Vaprio

Lombardy, first half of 15th century. In the circle of the Master of the *Vitae Imperatorum* (q.v.), Zenoni worked on the construction of Milan Cathedral from 1426 to 1449, and was a painter and illuminator for Count Vitaliano Borromeo (parchments in the Biblioteca Trivulziana, Milan).

Select bibliography

Ancient Materials

Isidore of Seville, *Originum sive etymologiarum libri*, XX.

Pliny the Elder, *Historia naturalis*, XIII, 11 (21).

Quintilian, *Institutio oratoria*, Book X, III, 31.

General History

Barberi, F. *Profilo storico del libro*, Rome 1985, pp. 1-50.

Bologna, G. *Il libro attraverso gli esemplari della biblioteca Trivulziana*, 2nd edn., Milan 1984.

Dahl, S. *Histoire du livre de l'antiquité à nos jours*, Paris 1960, pp. 1-88.

Papyrus

Hassan, Ragab. *Le papyrus*, Cairo 1980.

Immè, G.B. 'Il papiro e la fabbricazione della carta-papiro a Siracusa', in *Bollettino dell'Istituto di Patologia del Libro*, 1940, II, pp. 13-22.

Lewis, N. *L'industrie du papyrus dans l'Egypte greco-romaine*, Paris 1934.

Wittek, M. 'Les matières à écrire au moyen-âge', in *Scriptorium*, 1965, X, pp. 270-4.

Paper

Basanoff, A. *Itinerario della carta dall' oriente all'occidente e la sua diffusione in Europa*, Milan 1965.

Briquet, C.M. *Les filigranes. Dictionnaire historique des marques du papier dès leur apparition vers 1282 jusqu'en 1600*. A facsimile of the 1907 edition with supplementary material, edited by A. Stevenson. vol. 4. Amsterdam 1968. Reprinted from 2nd edn., New York 1985.

Gasparinetti, Federico (introduction and notes), *Osservazioni intorno all'arte di fabbricare la carta dedotte da vari autori dell'Accademia R. delle Scienze per la maggior perfezione delle cartiere negli stati di S.A.R. il sig. infante d. Filippo duca di Parma, Piacenza, Guastalla ecc.*, Milan 1962.

Hunter, D. *Papermaking, the History and Technique of an Ancient Craft*, New York 1957.

Lowe, E.A. *Codices Latini Antiquiores*, vol. VI, Oxford 1935-66.

Vidal, L. *L'analyse microscopique des papiers*, Paris-Grenoble 1939.

Writing

Cencetti, G. *Paleografia latina*, Rome 1978.

Diringer, D. *The Alphabet: A Key to the History of Mankind*, London 1968.

Higounet, C. *L'écriture*, Paris 1964.

Jackson, D. *The Story of Writing*, London 1981.

Knight, S. *Historical Scripts*, London 1984. A good visual survey.

Mallon, J. *Paléographie romaine*, Madrid 1952.

Thompson, E. Maunde, *An Introduction to Greek and Latin Palaeography*, Oxford 1912. Detailed all-round introduction.

Thomson, S. Harrison, *Latin Bookhands of the Later Middle Ages, 1100-1500*, London 1969.

Abbreviations

Capelli, A. *Dizionario di Abbreviature latine ed italiane*, Milan 1949.

Casamassima, E. *Trattati di scrittura del Cinquecento italiano*, Milan 1966.

Costamagna, G. *Tachigrafia notarile e scritture segrete in Italia*, Rome 1968.

Lowe, E.A. 'The Oldest Omission Signs in Latin Manuscripts, their Origin and Significance', in *Miscellanea Giovanni Mercati*, vol. VI, Vatican City, 1946, pp. 36-79.

Schiaparelli, L. 'Tachigrafia sillabica latina in Italia', in *Bollettino dell'Accademia Ital. di Stenografia*, vol. IV, 1928, pp. 11-18, 157-68.

Traube, L. *Nomina Sacra*, Munich 1907.

Numerals

Hill, G.F. *The Development of Arabic Numerals in Europe Exhibited in Sixty-four Tables*, Oxford 1915.

Roncaglia, A. 'Note sulla punteggiatura medioevale e il segno di parentesi' in *Lingua nostra*, 1941, III, pp. 6-7.

Form and Composition

Latin, A.M. *Le miniature nei rotoli dell'Exultet*, Montecassino 1899.

Libri, scrittura e pubblico nel Rinascimento. Guida storica e critica a cura di Armando Petrucci, Rome-Bari 1979, pp. 3-78, 137-54.

Maas, P. *Critica del testo. Traduzione di N. Martinelli. Presentazione di G. Pasquali*, 3rd edn., Florence 1980.

Petrucci, A. 'Alle origini del libro moderno. Libri da banco, da bisaccia, libretti da mano', in *Italia medioevale e umanistica*, XII (1969), pp. 295-313.

Reynolds, L.D. and Wilson, N.G. *Copisti e filologi. La tradizione dei classici dall'antichità al Rinascimento*, Padua 1973.

Techniques of Illumination

Brunello, F. *De Arte illuminandi e altri trattati sulla tecnica della miniatura medioevale*, Vicenza 1975. Includes a summary of the medieval techniques of illumination, an explanatory dictionary of the colours used in medieval illumination, and a valuable bibliography.

Manuscript Painting

Alexander, J.J.G. *The Decorated Letter*, London 1978.

—, *Italian Renaissance Illuminations*, London 1977.

Avril, Françoise. *Manuscript Painting at the Court of France, the Fourteenth Century (1310-1380)*, London 1978.

Backhouse, Janet. *The Illuminated Manuscript*, Oxford 1977.

Bologna, G. *Miniature della Biblioteca Trivulziana*, 3 vols, Milan 1973-6.

Françoise, Henry. *The Book of Kells*, London 1974, repr. 1988.

Dominguez Bordona, J. *La miniatura española*, 2 vols, Florence 1929.

Calkins, Robert G. *Illuminated Books of the Middle Ages*, London 1983.

de Hamel, Christopher. *A History of Illuminated Manuscripts*, London 1985.

Diringer, D. *The Illuminated Book*, London 1955.

Donati, L. *Bibliografia della miniatura*, Florence 1972.

Harthan, John. *Books of Hours and Their Owners*, London, New York, 1977, repr. 1988.

—, *An Introduction to Illuminated Manuscripts*, Victoria and Albert Museum, London 1983.

The Hastings Hours, D.H. Turner, London 1983.

George Henderson, *From Durrow to Kells, The Insular Gospel-books 650-800*, London, New York 1987.

Koehler, W. *Die Karolingischen Miniaturen*, Berlin 1930-3.

Les Très Riches Heures du Duc de Berry, Jean Longnon and Raymond Cazelles, London 1969.

Los Reyes Bibliófilos, Madrid 1986.

Lyna, F. *De vlaamische Miniatur 1200-1530*, Amsterdam 1933.

Manion, Margaret. *Medieval and Renaissance Illuminated Manuscripts in Australian Collections*, London, New York 1984.

Martin, H. *La Miniature Française du XII^e au XV^e siècle*, Paris 1923.

Meiss, Millard. *French Painting in the Time of Jean de Berry*, 3 pts., London 1967-74.

Millar, E.G. *English Illuminated Manuscripts from the 10th to the 13th Centuries*, Paris-Brussels 1926-8.

Mütherich, Florentine and Gaehde, Joachim E. *Carolingian Painting*, London 1977.

Nordenfalk, Carl. *Celtic and Anglo-Saxon Painting, Book Illumination in the British Isles, 600-800*, London 1977.

Pellegrini, E. *La bibliothèque des Visconti et des Sforza*, Paris 1957.

Popova, Olga. *Russian Illuminated Manuscripts*, London, New York 1984.

Randall, M.C. Lilian. *Images in the Margins of Gothic Manuscripts*, Berkeley 1967.

Robb, David M. *The Art of the Illuminated Manuscript*, London 1973.

The Rohan Book of Hours, Meiss Millard and Thomas Marcel, London 1973.

Salmi, M. *Italian Miniatures*, London 1957.

Tesoros de España. Ten Centuries of Spanish Books, Madrid 1985.

Toesca, P. *Monumenti e studi per la storia della miniatura italiana*, Milan 1930.

Weitzmann, Kurt. *Illustrations in Roll and Codex: A Study of the Origin and Method of Text Illustration*, rev. edn. Princeton 1970.

—, *Late Antique and Early Christian Book Illumination*, London 1977.

Williams, John. *Early Spanish Manuscript Illumination*, London 1977.

Binding

Colombo, P. *La legatura artistica*, Rome 1952.

De Marinis, T. *La legatura artistica in Italia nei secoli XV e XVI*, vol. 2, Florence.

Devauchelle, R. *La reliure en France de ses origines à nos jours*, vol. 3, Paris 1961.

Harthan, John. *Bookbindings*, Victoria and Albert Museum, 3rd edn., HMSO, London 1985.

Michon, L.M. *La reliure française*, Paris 1951.

Plenderleith, H.J. *The Preservation of Leather Book-bindings*, London 1970.

Production and Commerce

Battaglini, A. *Dissertazione accademica sul commercio degli antichi e moderni libri*, Rome 1786.

Battelli, G. 'Ricerca sulla pecia nei codici del Digestum vetus', in *Miscellanea di scritti in onore di Cesare Manaresi*, Milan 1953, pp. 309-30.

Cavallo, G. *Libri, editori e pubblico nel mondo antico. Guida storica e critica*, Rome-Bari 1975.

Chauvet, P. *Les ouvriers du livre en France des origine à la revolution de 1789*, Presses Universitaires de France, 1959.

Cim, A. *Le livre*, Paris 1907.

Destrez, J. *La pecia dans les manuscrits universitaires du XIII et du XIV siècle*, Paris 1935.

Dorini, U. *Breve storia del commercio librario*, Milan 1938.

Reynolds L.D., and Wilson, N.G. *Copisti e filologi. La tradizione dei classici dall'antichità ai tempi moderni*, Padua 1973.

Taubert, S. *Bibliopola*, Hamburg 1966.

Photographic acknowledgments

Photographs of works are reproduced by permission of the following: Accademia Carrara, Bergamo: 132 left and right. Agenzia Ricciarini, Milan: 98 below. Archivo de la Corona, Barcelona: 101 right. Archivo Oronoz, Madrid: 140. Biblioteca Apostolica Vaticana, Rome: 9, 23, 33, 42, 43, 48, 78, 102 below, 143, 145, 180, 181. Biblioteca Capitolare, Lucca: 60 left. Biblioteca Capitolare, Padua: 112 right. Biblioteca Casanatense, Rome: 104 left. Biblioteca Civica Angelo Mai, Bergamo: 129. Biblioteca Estense, Modena: 144 left. Biblioteca Laurenziana, Florence: frontisp., 167. Biblioteca Marciana, Venice: 92, 151. Biblioteca Queriniana, Brescia: 93. Biblioteca, Vescovile del Seminario, Padua: 131. Bibliothèque Publique et Universitaire / Bulliard-Siza, Geneva: 80. Bibliothèque Municipale, Valenciennes: 70 right. Biblioteca Nacional, Madrid: 73 left and below, 88 left and right, 89, 98 left, 99, 108, 111, 127, 141, 156 below, 157. Biblioteca Riccardiana, Florence: 33. Biblioteca Trivulziana, Milan: 21, 26, 120, 121, 149 below, 154, 156 above, 171 below. Bibliothèque Nationale, Paris: 53, 56 left and below, 57, 60 right, 61 left, 63 left, 75, 76, 77, 91 below left. Biblioteca Nazionale, Naples: 30. Biblioteca Nazionale, Turin: 59, 69, 105 left, 113. Bibliothèque Royal Albert 1er, Brussels: 51, 63 above, 68, 86-87, 97, 109, 118, 119 left, 126, 134, 163. Bodleian Library, Oxford: 2, 8, 119 right, 125 above. British Library (Photographic Service), London: 25, 34, 54, 64 left, 85, 153, 160. Giancarlo Costa, Milan: 4, 29, 33 above left and right, below left and right, 34 above, 36, 37, 38, 39, 41, 56 above right, 64 right, 65 left and right, 81, 104 right, 116 above and below, 117, 124, 130, 133, 164 left and right, 166 right, 169 left and right, 172 left and right, 176, 177 left and right, 178, 179. Giraudon, Paris: 150: Harvard University, Houghton Library, Cambridge, Mass: 125 below, 137 right, 139, 158. Herzog August Bibliothek, Wonfenbüttel: 47, 102 above, 106. Kestner Museum / W. Frost, Hanover: 101 above, Kongelige Bibliotek, Copenhagen: 91 above, left and right. Kongl. Bibliotek, Stockholm: 66-67. Musée Condé, Chantilly: 164. Metropolitan Museum of Art, New York: 148. Kunsthistorisches Museum, Vienna, 36. Museo Archeologico Comunale, Cividale del Friuli: 82. Museo Diocesano, Rossano Calabro: 46 above. National Gallery of Art, Photographic Services, Washington, DC: 100, 105 right, 137 left. National Library of Scotland, Edinburgh: 128. Nues Museum, Berlin: 25. Österreichische Nationalbibliothek, Vienna: 45, 46 right, 61 right, 90, 110, 135, 136, 155. Pedicini, Napoli: 52. © Pierpont Morgan Library, New York: 74, 95, 96, 142, 159, 173, 174. Donato Pineider, Florence: 122, 123. Franco Rapuzzi, Sant'Eufemia, Brescia: 50, 58-59, 93. Real Biblioteca, The Escorial, 166. Sansoni, Florence: 58 left, 70 left, 83, 84, 94, 112 left, 146, 149. Saporetti, Milan: 11, 12, 13, 14, 15, 16 above and below, 17, 18, 19, 20, 21 top, centre, below, 22 top and below, 23 top and below, 26, 27, 28 top and below, 30, 31, 32, 35, 103, 161, 162 left and right, 163 left and right, 167 below, 170, 174 below left, 177 top, 181, 182. Scala, Florence: 147. Stearn's Photographers, Corpus Christi College, Cambridge: 49. Tecnifoto, Genoa: 152 left and right. Trinity College Library, Dublin: 55, 62, 165. University Library, Cambridge: 72. University Library, Glasgow: 109 left and right, 138. Uppsala Universitetsbiblioteket: 44. Victoria and Albert Museum, London: 38.

Index

195